Jacob van Ruisdael
and the Perception of Landscape

Jacob van Ruisdael

and the Perception of
Landscape

E. John Walford

Yale University Press
New Haven and London · 1991

For Edward and Anthony Speelman
in recognition of their dedication to Dutch art and scholarship

Designed by John Nicoll
Filmset in Linotron Bembo by Excel Typesetters Company, Hong Kong
Printed in Hong Kong by Kwong Fat Offset Printing Co. Ltd

Library of Congress Cataloging-in-Publication Data
Walford, E. John, 1945–
 Jacob van Ruisdael and the perception of landscape/E. John Walford.
 p. cm.
 Includes bibliographical references and index.
 ISBN 0-300-04994-3
 1. Ruisdael, Jacob van, 1628 or 9-1682—Criticism and
interpretation. 2. Landscape painting—Netherlands—History—19th century. I. Title.
ND653.R95W35 1991
759.9492—dc20 91-13525
 CIP

18, 886

Contents

Acknowledgements

As a student in Holland, I was deeply impressed by the paintings of Jacob van Ruisdael. Rosenberg's 1928 monograph offered an excellent study of his stylistic development and a catalogue of his works, to which all who study Ruisdael are indebted. Nevertheless, I was struck, as Fromentin had been, that 'there is in the painter a man who thinks' whose paintings have their own way of impressing one with respect for their commanding pictorial strength, their disdain for what is too easy or superfluous, and their sensitivity for both the telling detail, and the essential character of his subject. It also struck me that much of the critical literature on Ruisdael, while sensing the power and poetry of his work, fell short in discussing its character and sources of inspiration, and thus presented Ruisdael as a figure working outside the patterns and precedents of his own time, which did not seem justified.

The offer of the Speelman Fellowship at Wolfson College, Cambridge, provided a welcome opportunity to pursue these questions. I am extremely grateful to Edward Speelman, and to his son Anthony Speelman, for their generous support and encouragement, and to the fellows, members, and staff of Wolfson College, in particular Jack King, Raymond Lister, Graham Pollard, and Mrs Julie Jones, for their friendship, hospitality, and practical support at that time.

For insights into Dutch art and history, I am deeply indebted to the instruction and advice of Professors A.T. van Deursen, J. Roelink, C.A. van Swigchem and M.C. Smit when at the Vrije Universiteit, Amsterdam. I am particularly indebted to the late Professor Hans Rookmaaker, also of the Vrije Universiteit, Amsterdam, who both persuaded me to study and provided the first insights to the History of Art. His friendship, wisdom, and early encouragement have been a lasting inspiration. At an early stage the iconological studies of Eddy de Jongh were instructive, as were those of Wiegand, Fuchs, Kauffmann, and Kouznetsov. Peter Sutton's exhibition of Dutch seventeenth-century landscape painting at Boston in 1988, and his accompanying catalogue were a timely and valuable stimulus. Those others from whom I have learnt are too numerous to list, but special thanks go to two other individuals, to Seymour Slive, to whom all who study Ruisdael are indebted for his generous sharing of his knowledge, and to Michael Jaffé, without whose broadening influence, strategic advice, and vigilant criticism when at Cambridge, the earlier version of this study would never have been realised. More recently the criticism of Peter Sutton and other readers has been valued, sparing me from a number of oversights, but not from my own limitations.

Besides the many individuals in libraries, museums, and commercial galleries, who have generously helped me, but are too numerous to name individually, I would however like to express particular gratitude to the staff of the Rijksbureau voor kunsthistorische Documentatie, The Hague, of the Witt Library, Courtauld Institute of Art, and of the Frick Art Reference Library, New York; also to the staff of the Libraries of the University of Cambridge, the Fitzwilliam Museum, Cambridge, the Victoria and Albert Museum, London, and of Wheaton College,

Wheaton, Illinois. Special thanks are due to A.S. Berkes, Christopher Brown, Klaus Demus, Carlos van Hasselt, Jan Kelch, Helmut Leppien, and John Walsh. For particular help in obtaining photographs, I am grateful to Mr and Mrs Edward Carter, Jeroen Giltay, James Golob, the late Yurig Kouznetsov, Dr Ir F.J. Philips, Seymour Slive, the Earl of Wemyss, Luigi Zangheri and a number of anonymous private collectors. I am also grateful to many dealers in Dutch paintings for information and photographs provided over several years, in particular to Thos Agnew & Sons Ltd, London, The Brod Gallery, London, P. & D. Colnaghi, London, H.M. Cramer, The Hague, Alan Jacobs Gallery, London, Galerie Hoogsteder, The Hague, Newhouse Galleries, New York, Robert Noortman, London, Gallery Sanct Lucas, Vienna, Victor Spark Gallery, New York, and Edward Speelman Ltd, London. I am likewise grateful to Christie's, London , Sotheby's London, and Sotheby's—Mak van Waay, Amsterdam, for the gift of photographs. To those museums who provided photographs free of charge, my grateful thanks. I am particularly grateful to all those private individuals who generously gave me access to study works in their collections, and especially to Sir Oliver Millar for arranging access to the Royal Collection, London.

My thanks also to those many other individuals and institutions who provided help in other practical ways, to Jannie Zijlstra for proof reading an earlier draft and correcting my translations from the Dutch, to Anne Froelich for further proof reading, to Heather Fong, for assistance with obtaining photographs, to Judy Lowe, and Fran Price, for typing successive drafts, and to Dean Patricia Ward and Wheaton College for providing time, space and other practical support to complete this project. In John Nicoll I have enjoyed an editor without peer, with a rare mix of patience, speed, and good judgment. To him, to Sally Salvesen for astute copy editing, and to all the staff at Yale University Press, my thanks and my admiration. Finally, to my mother for all kinds of support, to my sister, Belinda McCorquodale, for generously providing a London base, and most of all to my wife, Maria, who has sustained and encouraged me throughout, and to my three children, who have never outwardly protested at all the time and attention this project has taken from them, my gratitude to them all.

Wheaton, Illinois, January 1991.

List of Illustrations

All works illustrated are by Jacob van Ruisdael unless otherwise indicated.

Measurements are given in centimetres for paintings, and in millimetres for drawings and prints; height precedes width in all cases.

1. Jan Brueghel: *Paradise with the Creation of Eve*. Copperplate, 29 × 38. Frankfurt, Städelsches Kunstinstitut.

2. Claes Jansz. Visscher: *Title Print of 'Plaisante Plaetsen' (Pleasant Spots)*. *c*. 1611. Etching.

3. Claes Jansz. Visscher: *The Lepers' Asylum of Haarlem*, No. 9 in the series 'Plaisante Plaetsen'. *c*. 1611. Etching.

4. Esaias van de Velde: *Ferry Boat*. 1622. Panel, 75.5 × 113. Amsterdam, Rijksmuseum.

5. J. Mathem, after Karel van Mander: *Allegory of the Life of Man*. 1599. Engraving.

6. Cornelis Cort, after Girolamo Muziano: *St. Onuphrius in a Landscape*. 1574. Engraving.

7. Hendrick Goltzius: *Couple Viewing a Waterfall*. Drawing. Stockholm, Nationalmuseum.

8. Hendrick Goltzius: *Fisherman by a Waterfall*. Woodcut.

9. Roelant Savery: *Landscape with a Ruined Church by a Waterfall*. Panel, 52.2 × 104. Munich, Bayerische Staatsgemäldesammlungen.

10. Jacques de Gheyn: *Milking Scene before a Farmhouse*. Etching.

11. Anon., after Pieter Bruegel the Elder: *The Triumph of Time*. Engraving.

12. Salomon van Ruysdael: *Farm in the Dunes*. 1626 ('28?). Panel, 30.2 × 47. Cambridge, Fitzwilliam Museum.

13. Jan van Goyen.: *Country Road*. 1633. Panel, 51.6 × 59.3. Sheffield, City Art Galleries.

14. Rembrandt: *Baptism of the Eunuch*. 1636. Canvas, 85.5 × 108. Hannover, Niedersächsisches Landesmuseum (loan Pelikanwerke, Hannover).

15. Rembrandt: *The Stone Bridge*. Panel, 29.5 × 42.5. Amsterdam, Rijksmuseum.

16. Roelant Savery: *Elijah fed by Ravens*. 1634. Copperplate, 40 × 49. Amsterdam, Rijksmuseum.

17. Hendrick Goltzius: *Cliff on Seashore*. Woodcut.

18. Jan Porcellis: *Beachscene with Shipwreck*. 1631. Panel, 36.5 × 66.5. The Hague, Mauritshuis.

19. Cornelis de Man: *Family Meal*. Canvas, 59.5 × 73.5. Malibu, California, J. Paul Getty Museum.

20. Joos de Momper II: *Spring*. Panel, 55.5 × 97. Brunswick, Herzog Anton Ulrich–Museum.

21. Pieter van Santvoort: *Sandy Road*. 1625. Panel, 30 × 37. Berlin-Dahlem, Staatliche Museen.

22. *Landscape with Blasted Tree by a Cottage*. 164–(7?). Panel, 52.7 × 67.6. Cambridge, Fitzwilliam Museum.

23. *Country Road with Cornfield*. 1645 ('46?). Panel, 68.8 × 87.5. Paramaribo, Surinam Government Building.

24. Jan van Goyen: *Country Road*. 1629. Panel, 41.4 × 66.6. Munich, Bayerische Staatsgemäldesammlungen.

25. Isaack van Ruysdael: *Country Road*. Panel, 47 × 64. Stockholm, Nationalmuseum.

26. *Country Road with Farmhouses and Leaning Willow*. 1646. Drawing. Black chalk, grey pen and pencil, 140 × 200. Private Collection.

27. *Woodland Road*. 164–(6?). Panel, 35.5 × 30. Formerly Leonard Koetser Gallery, London.

28. Isaack van Ruysdael: *Wooded Road*. Panel, 30 × 28. Munich, Wittelsbacher Ausgleichsfonds.

29. *View of Egmond aan Zee*. 1646. Canvas, 96 × 132. Eindhoven, The Heirs of Mr. and Mrs. Philips-de Jongh.

30. Isaack van Ruysdael: *View of Egmond*. Canvas, 87 × 130.5. Eindhoven, The Heirs of Mr and Mrs Philips-de Jongh.

31. Isaack van Ruysdael: *Courtyard with a Woman laying out Linen*. 1646. Canvas, 100.8 × 139.8. Mr & Mrs Seymour Slive, Cambridge, Mass.

32. *Cottages and Trees on a Dike*. 1646. Etching, 204 × 281.

33. *Farm in the Dunes*. 1646. Etching, 150 × 213.

34. *Windmill by a Country Road*. 1646. Panel, 49.5 × 68.5. The Cleveland Museum of Art, Mr and Mrs William H. Marlatt Fund.

35. *Windmill at the Edge of a Village*. Drawing. Black chalk, 147 × 198. Dresden, Staatliche Kunstsammlungen, Kupferstichkabinett.

36. *Landscape with a Cottage and a Windmill*. 1646. Panel, 34 × 46.5. Private collection.

37. *A Huntsman in a Wood with Three Dogs*. 1646. Drawing. Black chalk, grey pencil, grey wash, black pen, 284 × 385. Berlin-Dahlem, Kupferstichkabinett.

38. *Woodland Path with Hunter*. Panel, 57 × 47. Vienna, Gemäldegalerie der Akademie der bildenden Künste.

39. Salomon van Ruysdael: *Tree on a River Bank*. 1646. Panel, 62.5 × 89. Rotterdam, Museum Boymans-van Beuningen.

40. *Cottage under Trees*. 1646. Panel, 71.8 × 101. Hamburg, Kunsthalle.

41. Isaack van Ruysdael: *Dune Landscape with Wooden Fence*. Panel, 40 × 60. Formerly S. Nijstad, The Hague.

42. *Dune Landscape with Wooden Fence*. 1647. Panel, 32 × 44. Formerly Henle Coll., Duisberg.

Introduction

One of the most lively topics of debate among those concerned with seventeenth-century Dutch painting has been the issue of representation and meaning. Recently this discussion has spilled over into the area of landscape painting. It has been recognised that a painted landscape, however realistic, and from whatever period or place of origin, is never a pure copy of nature and therefore can never be rendered value free. This in turn has raised a host of questions concerning how meaning is embodied in landscapes. For example, did Dutch landscapes contain narrative, symbols, isolatable meaning, or were they intended solely as objects of aesthetic delight? Even if aesthetic pleasure was their primary function, this does not necessarily imply that they neither carried, nor were intended to arouse, any further significance or associations.

Given that the character of a painted landscape will inevitably be influenced by the historical context, the mind, temperament and eye of the painter, further questions arise about what factors influenced artists' perceptions of nature, how deliberately and by what means such perceptions were included in their paintings, and to what extent the contemporary beholder was aware of them. For a student, recovering such meanings, rather than seeing these works exclusively in terms of our contemporary values and perceptions, is an important task.

Ruisdael has long been acknowledged as perhaps the greatest of all Dutch landscapists: an outstanding representative of his time and a significant influence on many later artists. His work merits exploration not only for its exceptional pictorial interest and quality, but also because it provides an illuminating case-study for considering issues of representation and significance in Dutch landscape painting.

Ruisdael is known for his truth to nature, his poetic mood, and the strength of his compositions. This study reviews these characteristics, and attempts to clarify their significance. Particular attention is given to historical context and to the relationship between artistic form and expression in an attempt to clarify issues of representation and meaning.

The critical responses of later generations have clouded our view of Ruisdael, influencing our reaction to his form of realism, poetic mood and compositional structures. Nineteenth-century perceptions of realism have been insufficiently differentiated from those of Dutch painters such as Ruisdael. Captured by his truth to nature, it is easy to overlook the conceptual framework and modes of interpretation that determine the relationship between his art and reality.

Appreciation for Ruisdael is also clouded by a romantic conception of his poetic mood. Notions of his supposed melancholy temperament, and its projection into his landscapes have been developed from unreliable and probably unfounded evidence, without regard for the outlook of the Dutch in the seventeenth century and its relevance to Ruisdael's works. Recent studies of Dutch still-life, genre and portraiture have made us more aware of the conceptual framework shared by Dutch artists and their public. These also enhance our understanding of the way in which landscape paintings were conceived and enjoyed.

Ruisdael's compositional structures formed the main focus of the monographs of Simon and Rosenberg. Of the two, Rosenberg's analysis of stylistic development has proved of lasting value, although his chronology requires some modification in the light of recent discoveries. His view has influenced all subsequent studies, including the 1981–82 Ruisdael exhibition which demonstrated the range and power of Ruisdael's art, but did little to clarify the interpretive issues to which this study is devoted.

In order to clarify Ruisdael's working context, the significance of Dutch landscape painters' selection of motifs and manner of expression are considered, paying particular attention to the influence of religion on artists' conception of nature – an influence equally perceptible in Dutch poetry. The beauty, fragility, and abundance of creation was seen as a form of divine revelation, encouraging contemplation. This is considered as an influence on the way in which some poets and painters perceived and represented the world. Ruisdael's stylistic and thematic development is explored with reference to significant works from the categories of landscape produced at each stage of his life. Since a major portion of the book is devoted to an assessment of the process by which Ruisdael formulated, refined and expanded on his selected motifs, further works are included to support the chronological framework, which is obscured by the dearth of dated works after 1653. In studying the development of his themes, attention is given to the selection, rejection, and combination of elements; the accentuation of particular facets of nature; and Ruisdael's varying response to nature and to his cultural environment.

Various formative influences on Ruisdael's development can be identified, including that of his father Isaack, his uncle Salomon van Ruysdael, and Cornelis Vroom. His friendship with Berchem, his travelling companion to the German/Dutch borders, may have alerted Ruisdael to the fine detailing and denser execution of the Italianate mode, lacking in the earlier Haarlem tradition, but its subject matter and mood evidently had no appeal to him. By contrast, in Amsterdam, Ruisdael's style matured in response to the subject matter and mood of the earlier mannerist landscapes of Savery and Gillis van Coninxloo, as well as those of Van Everdingen. His influence stimulated Ruisdael to produce not only waterfalls, but also marines and mountainous landscapes. The evidence of drawings and paintings suggests that Ruisdael revisited the German/Dutch borders around 1660 or 1661, this time accompanied by Hobbema. Thereafter Ruisdael produced many of his most admired masterpieces. Hobbema, Jan van Kessel, and Jan Vermeer van Haarlem imitated his motifs, suggesting possible dates for some of Ruisdael's works. In the final phase of his career, from 1670 to 1682, Ruisdael reduced the scale of his works, which became tighter and dryer in execution, emphasising delicacy of effect more than the earlier force and grandeur, perhaps in response to the changing taste of the period.

The close relationship between Ruisdael's artistic forms and expressive intentions is not to be taken as a projection of personal melancholy. The strength of his vision lies in evoking well-being in the context of the fragility of life, and without escape into the type of idealised fantasy favoured by the Italianate landscapists. His conception of landscape conforms to aspects of the religious outlook of the period, and reflects recurrent elements in the intellectual and artistic environment. The pictorial strength of his images lies not so much in the form of a series of encoded images, as some have asserted, but rather in his capacity to invent endless variations on a series of similar landscape themes that are in themselves inherently meaningful. Building on characteristics found in both the mannerist and realist

landscape traditions, Ruisdael imaginatively expanded the artistic resources available to him first in Haarlem and later in Amsterdam. He developed thereby a body of uniquely expressive works in which pictorial motifs popular with the mannerists are refreshed and expanded by the example of the sensitive observations of the Dutch realists. Possessed of even more acute powers of observation and invention, Ruisdael went on to develop his own more forceful pictorial mode. Through his chosen themes, he conveyed conventional ideas about man and nature with great originality. He created memorable images of well-being in a mutable world, the study of which illuminates the relationship between representation and meaning in Dutch landscape painting.

While some will regret that a wider range of sociological and economic contexts are not explored, these have been ably addressed by others. The attempt to discover how the religious thought of the period influenced the representation of nature in the landscapes of Ruisdael and others is an issue of sufficient complexity in itself. An understanding of Ruisdael's work is more elusive than the current tendency of criticism to polarise between a highly spiritualised emphasis on narrative and encoded symbol, and a more materialistic approach, stressing pure aesthetic delight or economic and patriotic associations, often to the exclusion of other concerns. Ruisdael's work is distinctive for the range of his interests and the resulting variety of pictorial motifs. Thus no attempt will be made to relate all his works to a contemplative mode of perception. The aim, rather, is to identify a certain outlook and frame of mind, which, while not endlessly and specifically alluded to in the paintings subsequently discussed, serves, nevertheless, to determine their fundamental orientation and give them their specific character, influencing the selection of themes and motifs and their formal and expressive qualities.

CHAPTER I

Ruisdael's Life

Arnold Houbraken published the earliest life of Jacob van Ruisdael in *De Groot Schouburgh der Nederlantsche Konstschilders en Schilderessen,* published in 1721, some forty years after Ruisdael's death:

> Jakob Ruisdaal [sic], a great friend of N. Berchem, was a Haarlemer by birth, but spent most of his life in Amsterdam. His father, who was an ebony-frame-maker, had him taught Latin in his youth, and further had him trained in the science of medicine, in which he came so far as to perform several operations in Amsterdam, for which he received great fame. However he died in Haarlem in 1681 and was buried on 16th November, as appears from burial notices. He painted both local and foreign landscapes, but especially those in which one sees water crashing down from one rock onto another, finally to spread out in a roar [*geruis*] (to which his name appeared to allude) into dales [*dalen*] and through valleys: and he could depict the spray, or the water foamy from dashing on the rocks, so naturally clear and translucent, that it appeared to be just like real water. Likewise he could also depict the sea-water, when he chose to bring onto his panel a turbulent sea, which, with the force of rising waves, roared against rocks and dunes. Thus he was in this manner of painting one of the best. However I cannot say that he had luck as his friend. He remained unmarried to the end of his life; it is said: in order to be of that much more service to his old father.[1]

Houbraken's comment about misfortune, which so captured the imagination of later generations, results from mistaken identity. It was Jacob's cousin, Jacob Salomonsz. van Ruysdael, also a painter, who died a pauper in November 1681. If Houbraken believed that Ruisdael's art was ill-rewarded, he was in no doubt as to its quality. In his biography of Jan Griffier (Amsterdam 1652 or 56–1718 London) he tells us that Griffier was beloved by everyone for his zeal and industry, 'so that he had entry to see the works of the finest masters of the time, Lingelbach, Adriaen van de Velde, Ruisdael and Rembrandt' and further on he says that Griffier could so adapt his style as to imitate 'sometimes Rembrandt, sometimes Van Poelenburgh, sometimes Ruisdael, and others, so that his works were frequently sold as genuine works of these masters'.[2] Estimation for Ruisdael in the late seventeenth and early eighteenth century thus prompted Griffier to copy him and Houbraken to consider him one of 'the finest masters of the time'.

Jacob van Ruisdael was born into a family of craftsmen and painters. The family came originally from Gooiland and their forefathers possibly lived at the little castle of Ruisdael, or Ruisschendaal, near Blaricum, in the Gooi. Jacob's grandfather, Jacob Jansz. de Goyer (*c.* 1560–1616), moved from Blaricum to nearby Naarden in the 1590s. His name means simply 'from the Gooi'; he is also named in deeds as Jacob Jansz. van Blarenco(m), even Jacob Jan Jacobsz.; Jacob de Goyer was a carpenter and a Mennonite. He had four sons, three of whom, Jacob, Isaack and Salomon assumed the name 'Van Ruysdael' or 'Van Ruisdael', probably in commemoration of their family origins. The eldest, Jacob (*c.* 1594 –

Naarden – 1656), continued his father's trade and from 1620 onwards appears as alderman and councillor of Naarden.[3] The second son, Pieter (c. 1596–1644), who retained the name 'De Goyer', moved to Alkmaar, where he prospered as a linen merchant. The third son, Isaack (1599–1677), was father of the landscape painter Jacob van Ruisdael. Isaack and his younger brother Salomon (1600/3[?] – 1670) moved to Haarlem at some date after their father's death. Salomon was inscribed in the painters' guild at Haarlem in 1623 (as 'Salomon de Gooyer') and is praised as a landscape painter in Samuel Ampzing's *Beschryvinge ende lof der stad Haerlem* (1628). This testifies to the early recognition of his talents. He is recorded in 1669 as a member of the United Flemish, High German and Friesian Mennonite Community which did not exclude him from holding various offices within the St Lucas Guild of Painters, including that of Dean in 1648.[4]

Contact between the brothers and their respective families was maintained, as is evident from matrimonial and testamentory records.[5] In the midst of the family circle Isaack is found unable to manage his affairs. He was constantly in debt during the years 1628 to 1646.[6] He was a frame-maker, using skills probably learnt in his father's workshop. He is also mentioned as an art-dealer and painter. On leaving Naarden, it is striking that Isaack and his brother Salomon chose Haarlem rather than Amsterdam, which was closer to home. At the time they moved, which must have been after their father's death in 1616 and before 1623, when Salomon entered the guild, Haarlem could boast a lively artistic community and a prestigious tradition. We can imagine the allure of Haarlem for these young men from a contemporary eulogy to Haarlem painters past and present in Samuel Ampzing's *Het Lof der Stadt Haerlem in Hollandt* (1621).[7]

If such artistic activity offered Isaack van Ruysdael a plentiful supply of business, for both brothers Haarlem represented a promising artistic centre. Besides, there may have been another factor that attracted them. It is noteworthy that among those Ampzing praises are not only history and figure painters, but also those who were specialists in landscape and seascape. Just at this time the new trends of 'realistic' landscape painting that Huygens esteemed were being explored there, and this may have been of interest, especially to Salomon. Esaias van de Velde had moved to Haarlem in 1612, staying until 1618, during which time, together with his cousin the engraver Jan van de Velde, he had played a seminal rôle in the rise of this 'realistic' landscape school.[8] These experiments were extended in the 1620s by Pieter Molijn, Cornelis Vroom, Jan Porcellis and others, and were a formative influence on Salomon van Ruysdael's style.

There is no record of Isaack as a painter at this stage, but besides his activity as a frame-maker, we find him at least by 1626 acting as an art-dealer. Due to unsatisfactory transactions with Jan Porcellis in that year he was sued by the latter's widow in 1632.[9] Meanwhile, in August and September of 1628 his occupation is given as '*Patroonmaker*' (a designer of tapestry cartoons). At this time he was living in Smedestraat, Haarlem, opposite the inn 'de Bastaertpijp', unable to pay his house rent of fourteen guilders a year. On 12 November 1628, a widower just twenty-nine years old, he married Maycken Cornelisdr. of Haarlem.[10] The exact date of birth of his son, Jacob van Ruisdael, is unknown, but on 9 June 1661 Jacob declared himself to be thirty-two years old, which if accurate would mean that he was born between June of 1628 and 1629.[11] This leaves open the possibility that he was the child of Isaack's first wife, who perhaps died in childbirth, or that he was the cause of this new union. There were no further children by this marriage, and it is more likely that Jacob was born in 1628 since he was enrolled as a master in the St Lucas Guild in 1648, and under the

Ordinances of the Guild a painter could become a master at the age of twenty.[12]

Painting was an integral part of Jacob's childhood environment. In 1634, when Jacob was six, Jan van Goyen was staying in Haarlem, at work in Isaack's house.[13] Although Isaack was not recognised as a master painter, by the mid-thirties he was producing landscape paintings as well as frames and tapestry cartoons, for paintings by him are recorded in inventories of that time.[14] It is apparent, when examining the few works by Isaack known today, that a group of them reflect the marked influence of Jan van Goyen and so may derive from the time when Van Goyen was working in his house.[15] It is also probable that Isaack as a dealer was familiar with pictures by Van Goyen even before the latter came to his house.

In the early forties Salomon and Isaack were active together in the affairs of the guild. In 1640 the brothers held a sale 'for the benefit of the guild' and in 1642, when the master-painters and art-dealers assembled to discuss a petition to prohibit art auctions, Adriaen van Ostade, Salomon and Isaack van Ruysdael refused to sign the document.[16] This suggests that Salomon and Isaack had a common interest in this issue, such as their earlier cooperation of 1640.

At this time Isaack was once more a widower. In 1642 he married Barbertgen Hoevenaels of Haarlem. She gave birth the following year to a daughter, Maria. Isaack's new wife had a sister, Anneken, who was married to the still-life painter Cornelis Cruys, who painted in the monochrome style of the Haarlem painters Pieter Claesz. and Willem Claesz.Heda.[17]

Isaack's son Jacob was by now fourteen years old. Houbraken says that 'his father had him taught Latin in his youth, and further had him trained in the science of medicine'. While the former statement is possibly true, the latter is perhaps an assumption based on his subsequent reputation as a surgeon. It is most unlikely that he received medical training at this stage of his life, given both the precarious financial position of his father and his own precocity as a painter. Furthermore, he was admitted to the guild as a master in 1648. Under guild regulations he would have served already three years as an apprentice, during which time he could not sign or sell his works, and he had to work a further year or more as a *vrije gast* (a 'free mate' or assistant) in a master's studio or for himself, during which time he could sign his works and sell them.[18] There are a number of signed and dated works from 1646 onwards. This suggests that his three-year apprenticeship fell in the years 1643 to 1646, that he remained a *vrije gast*, a painter but not a master, during 1646 and 1647, and became a master in 1648, the year that his uncle Salomon was Dean of the Guild. The entry in the book of the guild handed down by Van der Vinne reads: 'Jacob Ruysdael, eldest son, the father was a frame-maker'.[19] It has been pointed out that the phrase 'eldest son' refers to the fact that the first incoming son of a master, who wanted to become a master, had only to pay three guilders, the usual fee being fifteen guilders. As this only applied to the sons of masters of the 'arts', namely the painters and associate artists, engravers and sculptors, Isaack, though described as a frame-maker, must also have belonged to this category.[20]

Hence, by the time Jacob van Ruisdael began his apprenticeship, he had already enjoyed considerable exposure to the art of painting. The nature of his father's profession would have brought a constant flow of paintings to their house, and doubtless he was familiar with the style of the older generation of landscape and seascape painters. He would also have seen his father painting landscapes, and perhaps remembered seeing Jan van Goyen at work. The genre painter, Jan Miense Molenaer, may have been a family friend, since he owned one of Isaack's

landscapes. In his family circle he could profit from the example of his uncle Salomon, and, since 1642, from the still-life painter Cornelis Cruys. This influence doubtless stimulated his choice of profession and contributed to his precosity as a painter.

It is not recorded with whom he served his apprenticeship. The possibility that it was with his uncle Salomon cannot be excluded. No known works by Jacob can be attributed to his years of apprenticeship, but some of his earliest works, from 1646 and 1647, reveal traces of his uncle's subject matter, style, and manner of execution. A closer relationship, however, exists between the early works of Jacob and the paintings of his own father, in subject, composition, limited range of colour, subdued tone, and manner of execution.[21] It is doubtful whether Isaack was entitled under guild regulations to take apprentices; but Houbraken mentions the landscape painter Isaack Koene as a disciple of Isaack van Ruysdael, which is perhaps no mere confusion of names.[22] Even if Jacob did not serve an apprenticeship with his father, the possibility remains that after serving with his uncle or some other master, he painted with his father during 1646 and 1647 as a *vrije gast*, which would account for the similarity of their works at this time. Furthermore, during these same years Isaack sometimes contributed the staffage to his son's paintings.[23]

In 1646 Jacob and his father visited Egmond aan Zee, near Alkmaar, where Isaack's brother Pieter had settled. Both Isaack and Jacob made paintings of Egmond (Figs. 29 & 30). The following year, Jacob may have visited other relatives in Naarden, as several drawings and paintings from this area testify. This visit to Naarden would have taken him past Amsterdam, his first glimpse of the city in which he was later to settle.[24]

In or before 1649 Ruisdael went a little further afield, to Rhenen on the Neder Rijn, the subject of two drawings (Figs. 60 and 61), and a magnificent painting, dated 1649, now in Edinburgh (Fig. 59), which depicts the surroundings of Rhenen, adapting features from these drawings.[25] This painting must have been produced in the studio before his trip to Bentheim, which we suppose was made in the following year and took him on a more northerly route.

Houbraken tells us that Ruisdael was 'a great friend of N. Berchem', the son of the Haarlem still-life painter, Pieter Claesz.[26] Berchem, who became one of the most eminent Italianate landscape painters, and was known for his lively groups of shepherds and animals, would frequently enliven the landscapes of others with his figures. He did so for Ruisdael on a number of occasions, for instance in Ruisdael's *Wooded Country Road* of 1652 (Fig. 70). Berchem's provision of staffage for Ruisdael ceased in 1653, presumably due to Berchem's departure for Italy. It was probably in 1650 that they made a trip together to Bentheim in the German-Dutch border country a little to the northeast of Enschede.[27]

One of Berchem's drawings of *Bentheim Castle* (Frankfurt, No. 3842), made from the same viewpoint as one of Ruisdael's paintings, bears the date 1650; lack of dated paintings by Ruisdael in that year also suggests his absence from the studio.

In the early fifties, after his return from the German border country, Ruisdael perhaps revisited his relatives in Alkmaar. An undated drawing of *The Gasthuisstraat behind the Grote Kerk, Alkmaar* (London, British Museum; Fig. 87) is datable to this period. It was probably on this same trip that he made a number of drawings of the nearby ruins of Egmond Castle, including *The Ruined Castle of Egmond* (Stuttgart, No. C 64/1329; Fig. 88), which he used as the basis for the building in the background of the Dresden version of *The Jewish Cemetery* (Fig.

94). This trip would have been before 1653/4, the period of the two paintings of *The Jewish Cemetery* (Figs. 89 & 94).[28]

The earliest surviving record of paintings by Ruisdael in Amsterdam is in the effects of the art-dealer Pieter van Meldert, who died on 1 October 1653. His estate included 'a landscape by the young Ruysdael with a tree trunk in the foreground' and, 'a small-size little landscape by the same Ruysdael with an ebony frame'.[29] Although Jacob wrote his family name with an 'i', not a 'y', his name was almost invariably written by contemporaries in the latter form. It is striking that a tree trunk in the foreground was taken as a distinctive feature of one of these paintings, since it continues to strike us as a feature of his art. Perhaps the little ebony frame on the other picture was made by his father, a specialist in this type. While the inclusion of works by Ruisdael in the effects of an Amsterdam art-dealer gives no grounds to suppose that he had already moved there, it does show that his pictures were circulating beyond Haarlem.

It has been supposed that Ruisdael moved to Amsterdam around 1656. He was certainly there by the following year, and conceivably he moved there a few years earlier, around 1653. There is no documentary evidence of his being in either Haarlem or Amsterdam at that time, but some indications from his paintings and drawings support the view that he was in Amsterdam by 1653/4, as will be considered in discussing his works.[30]

Documentary evidence relating to Ruisdael's life is scarce. The first record of him in Amsterdam is in 1657. On 14 June he applied to the Church Council of the Calvinist Reformed Church in Amsterdam to be baptised on giving his profession of faith.[31] His residence is given as '*in de Beursstraet inde Silvere Trompet*', that is in the present day Rokin, by the Dam. He was presumably brought up a Mennonite, and so had not been baptised as an infant, as he would have been in the Calvinist Church. The age of twenty-nine was unusually late to make a profession of faith, except among the Mennonite community. The baptism took place a week later in Ankeveen, a village near Naarden, where he had relatives. While this baptism could conceivably refer to some other family member from Naarden, the available evidence suggests that it was the landscape painter who joined the Reformed Church in 1657.[32] Whatever personal significance this may have had, its consequences for his art seem negligible. It was certainly not a necessary step towards participation in the establishment and the procurement of commissions, as is evident from his Mennonite uncle, Salomon van Ruysdael's service as Dean of the Painters's Guild. Indeed the many Catholic painters fared no differently to their Protestant colleagues. Amsterdam was renowned for its toleration and its ability to absorb sects of all kinds. James Howell wrote to his father in May 1619, 'in this street, where I lodge, there be well near as many Religions as there be Houses, for one Neighbour knows not, nor cares not much what Religion the other is of'. This did not change much during the century, for Owen Feltham observed in 1670 of the religious life of Amsterdam, 'if you be unsettled in your Religion, you may here try all, and take at last what you like best'.[33]

Ruisdael purchased citizenship of Amsterdam on 15 January 1659, reflecting a decision to settle. This was not necessarily the act of a new arrival. Allart van Everdingen became a citizen of Amsterdam in 1657, after five years residency.[34] By this time Ruisdael was an established master with a pupil in his service.

On 8 July 1660 Ruisdael declared before an Amsterdam notary that Meyndert Lubbertsz. (who adopted the surname Hobbema) had served and studied with him for some years ('*eenighe jaren gedient en geleert*'). Hobbema (1638–1709) became his most talented follower and their friendship lasted longer than these

years of pupilage, for Ruisdael acted as a witness at Hobbema's marriage on 2 October 1668.[35] Hobbema had left an orphanage in 1655, aged seventeen. Perhaps he had come to Ruisdael soon after that, since the purpose of the abovementioned declaration was to give an account of Hobbema's conduct to his guardian.

It is likely that around 1660/1 Ruisdael made a second trip to the German border country, this time accompanied by Hobbema. Both artists depicted the same motifs, or different motifs but from the same village, indicating a route through the Veluwe to Deventer, and on to Ootmarsum, on the border, northeast of Almelo. While the outcome of this trip was of less consequence for the now mature Ruisdael, it was a decisive turning point for Hobbema, especially in the selection of his subject matter. Henceforth wooded country roads and watermills were constant features of his pictures, and it was clearly Ruisdael who pointed him in this direction.

During the sixties we find several incidences of Ruisdael's activities in the art world of Amsterdam reflecting his position as an established artist. Besides Hobbema, the slightly younger Jan van Kessel (1641/2–1680) appears at this time as a close imitator of Ruisdael. He was a friend of Hobbema (who was godfather of his second son in 1675) and, like him, was probably a pupil of Ruisdael, though considerably less gifted.[36] We also find Ruisdael called upon to give his opinion as an expert on the authenticity of a work attributed to the marine painter Jan Porcellis on 9 June 1661. Ruisdael declared that in his view Porcellis had begun the painting, but that in its present condition it could not be sold as such. Two of the other experts were Allart van Everdingen, a painter of waterfalls, who influenced Ruisdael, and the still-life painter Willem Kalf. Hobbema was one of the witnesses, and so evidently still close to Ruisdael.[37] This deed is one small indication of Ruisdael's artistic contacts in the early sixties. We may gain a further idea of his contacts and standing from a deed of 28 March 1664 in which Jacob van Ruisdael, Adriaen van de Velde, Jan van de Heyden and others authorised Jan Jansz. Alebrant to receive on their behalf the proceeds of sale from paintings belonging to the said Alebrant and sold by E. Frans Uytenbogaert, concierge of the city, under an order of execution. These paintings included works by Ruisdael, Jan van de Heyden, Jan Wijnants, Willem van de Velde, Hobbema, Abraham Beerstraaten, and others. When sold, a picture of Ruisdael's fetched the highest price.[38]

There are other indications that Ruisdael enjoyed considerable prestige in Amsterdam in the sixties as a landscape painter. This coincides with the most mature phase of his development. Cornelis de Graeff, related by marriage to the Bicker family, the most powerful of the Amsterdam regents, became the leading burgomaster of Amsterdam in 1651. He continued the régime of the Bickers until his own death in 1664, becoming one of the most influential men in Holland. When De Graeff called on Thomas de Keyser (1596/7–1667), long a favourite with the regent classes, to depict himself and his family with horses and carriage in a landscape setting, it was to Jacob van Ruisdael that they turned for the landscape. Whether this was at the request of De Keyser or De Graeff is unknown, and the date of this commission is uncertain, but was most probably between 1660 and 1664. The picture is now in the National Gallery of Ireland.[39] In any event, the De Graeff family were clearly satisfied, for they looked to Ruisdael on another occasion to make paintings of their country estates, Zuid-Polsbroek and Soestdijk, which lie about twenty-five miles downstream from Wijk bij Duurstede, also painted by Ruisdael. His pictures are mentioned in 1709 among

the effects of Pieter de Graeff, Lord of the Manor of Zuid-Polsbroek, and son of Cornelis de Graeff.[40]

These scanty references to Ruisdael offer but a glimpse of his standing and of his intercourse with other members of his profession. We catch sight of him again in 1671 acting as godfather to the twin sons of his friend Cornelis Kick, a flower and still-life painter.[41] Houbraken gives a detailed and colourful account of Cornelis Kick, the source for which was probably Kick's pupil, Jacob van Walscappelle (1644–1727), whom Houbraken describes as still living in Amsterdam.[42] Since Van Walscappelle, as a pupil of Kick, is likely to have known Ruisdael personally, he could have been a source of information on Ruisdael's life for Houbraken as well.

In 1667 aged about thirty-nine Ruisdael saw fit to make his Will. In fact he made two, one on 23 May, a second four days later.[43] He is described as '*Sr Jacob van Ruysdael, jongeman, wonende in de Calverstraet over het Hoff van Holland*'. He was living unmarried on the east side of present-day Kalverstraat, near the Dam. His condition is described as '*sieckelijken van lichaem doch gaende en staende*' (sick in body but alert and in order). Perhaps an indication that he was seriously ill at this time, it may only be a legal formality declaring that he was fit to execute a Will. In any event he lived on. From these Wills we learn that Ruisdael was concerned to provide for his father and was in a position to do so. By the first Will he designated his half-sister Maria his universal heir, with the obligation to support their father, who was to have the income from the estate. Not satisfied with this arrangement, in the second Will he made his father his universal heir, the estate to be tied to a mortgage, the rent from which would be paid to his father. There is a further stipulation that if his father became incapacitated, his executors were to place him in a decent place (*civiele plaetsen*) and to provide for him for the rest of his life. The executors appointed were his uncle Salomon van Ruysdael, and Salomon's son Jacob. Provision for his father evidently went beyond this testamentary arrangement, for in a deed of 1668 Isaack made over to his son all his possessions in return for loans he had received from him.[44] Isaack lived on nine years and died in Haarlem in 1677. We may wonder for how long his son had supported him and note that Isaack had ceased to appear in the debtor's court after 1646, the time his son began to paint. Houbraken's report of Jacob's care for his father was well-founded, which adds credibility to his account as a whole.

After a period of unprecedented economic expansion in the fifties and sixties, the bubble burst in the seventies and many artists and art dealers fell on hard times before the market recovered. It is in this context that Houbraken's statement that Ruisdael became a surgeon must be considered. An over-abundant supply throughout the century had rendered paintings a cheap commodity, except in the case of important commissions. Hence the economic position of Dutch artists had often been precarious. But in the seventies economic hardship among painters became widespread, aggravated by the financial crisis that followed the French occupation of Holland in 1672. It was described by Houbraken as, 'that fatal year . . . that brought everything to a halt.'[45] In Amsterdam alone the situation was reflected in the bankruptcy or near bankruptcy of two prominent art-dealers, Gerrit van Uylenburgh and Jacob van Neck, and of the popular portrait painter, Bartholomeus van der Helst.[46] Willem van de Velde, Elder and Younger, both moved to England in 1672 in search of employment and subsequently found shelter under the patronage of Charles II. Other painters resorted to support from alternative employment, already a common practice. Among Ruisdael's Amsterdam colleagues, Hobbema had taken in 1668 a post as wine-gauger to the

Amsterdam customs, a post he held for the rest of his life. Jacob Salomonsz. van Ruysdael is described in the seventies as a hosier, and Cornelis Kick, who had earlier married a rich woman, nevertheless found it necessary to keep a shop. Aert van der Neer, who kept an inn in Amsterdam from 1659 to 1662, had already gone bankrupt in the latter year. Philips Koninck seems to have painted little in the last decade of his life and probably derived his income from ownership of a hostel and shipping line. Jan van de Cappelle, whose father owned a dye works, is described in 1666 as a dyer, and the absence of dated works after 1663 suggests he may have painted less in the late sixties and seventies.

Ruisdael's production during this period, though difficult to gauge accurately through lack of securely dated works, appears reduced both in scale and in extent. Did Ruisdael then become a surgeon and perform several operations in Amsterdam, bringing him 'great fame', as Houbraken reports? Compared with the secondary occupations of his colleagues, it seems remarkable that in his late forties Ruisdael should have become a surgeon. It has been argued that the continuity of his development and the extent of his production make the time necessary for a second profession hard to imagine, yet others achieved it. Houbraken's life of Ruisdael contained one major error: the belief that he had died in the poorhouse at Haarlem. In all other respects the account is confirmed by other sources. Furthermore, the surviving shreds of evidence tend to support rather than refute Houbraken's report. In 1676 Jacobus Ruÿsdael (sic) was enrolled in the register of Amsterdam doctors, the *Series Nominum Doctorum*, having received a medical degree at the University of Caen on 15 October 1676.[47] Some went to foreign universities, such as Caen, to avoid the rigorous demands of Leiden University. Ruisdael may have chosen this course. As well as this entry, the 1720 sale catalogue of Johann van der Hulk's collection lists a *Waterfall* by Doctor Jacob Ruisdael.

While this evidence is inconclusive, especially since the entry in the *Series Nominum Doctorum* was subsequently deleted, there are nevertheless grounds for identifying the surgeon with the painter of *Waterfalls* called Doctor Jacob Ruisdael in the sale catalogue. The Van der Hulk collection in Dordrecht was built up in Ruisdael's lifetime and it is likely that Houbraken, who lived in Dordrecht for more than twenty years, knew Van der Hulk personally. Furthermore, as has been noted by others, only three years after Ruisdael's death, in 1685, Houbraken married at Dordrecht the daughter of the town surgeon, Jacob Sasbout Souburg, so giving him a link with the medical profession. On moving to Amsterdam, Houbraken appears to have obtained information for his lives of artists from Jacob van Walscappelle, a pupil of Ruisdael's friend Cornelis Kick.[48] This offers three possible sources for Houbraken's account of Ruisdael's 'great fame' as a surgeon. Besides this, in a period when many painters in Ruisdael's milieu had resorted to alternative employment, the name 'Jacob Ruÿsdael' is found inscribed on the register of Amsterdam doctors, his practice attracting great fame. Why then should we doubt Houbraken? At least, as a painter, Ruisdael had the advantage of a keen eye and a steady hand, even if his medical training was not from prestigious Leiden University!

Shortly after Ruisdael's enrollment as a surgeon, he is also found lending financial assistance to an Amsterdam surgeon. In 1677/8 Dr Jan Baptist van Lamsweerde, physician of the R.C. Maagdenhuis, in the Spui, Amsterdam, became involved in a dispute over medical practices which tarnished his reputation and put him in financial difficulties. In these circumstances Ruisdael made him a loan of four hundred guilders, secured by a bond dated 9 July 1678. Van

Lamsweerde failed to repay his debt and left Amsterdam, subsequently taking up an appointment as Professor in Cologne.[49] On 21 January 1682 Ruisdael set proceedings in motion to recover the debt, but died shortly thereafter, before the matter was settled. Whatever significance this affair may have, it proves at least that his father was not the only one to benefit from his generosity, and that Jacob was not without the means to extend loans.

On or about 10 March 1682 Ruisdael died, probably in Amsterdam, where he had been recorded in late January. He was buried on 14 March in the South Transept of the Church of St Bavo, Haarlem, the church whose form dominates the skyline of his many *Views of Haarlem*. No records survive of the settlement of his estate other than a deed of 5 October 1682 by which partial repayment in settlement of Lamsweerde's debt is accepted by Joost van der Hulst on behalf of his wife Maria, Jacob's half-sister and universal heir.[50]

Knowledge of the Dutch art market is relatively limited and contemporary comment on matters of taste is likewise extremely sporadic. Beyond what has been noted above, one can but glimpse Ruisdael's standing among his contemporaries in occasional sale catalogues and inventories.[51]

Ruisdael's reputation soon spread beyond the confines of his home town. By 1653 his works had passed into collections in both Leiden and Amsterdam.[52] We saw that in a picture sale of 1664 a painting by Ruisdael fetched the highest price. A few years earlier, on 31 August 1660 at a sale of the large collection of Adriaen Banck, two large landscapes by Ruisdael fetched one hundred and thirty guilders, compared to a portrait of Adriaen Banck by Rembrandt one hundred and fifty guilders, and a history piece by the same artist of *Susanna and the Elders* five hundred and sixty guilders.[53] We saw that Ruisdael was patronised by the prominent De Graeff family, and that the large Van der Hulk collection in Dordrecht contained a fine *Waterfall* by him. The father-in-law of Ruisdael's friend Cornelis Kick, Harmen Claesz. Spaaroogh, 'concièrge' of the Amsterdam city lending bank, was a collector, in whose collection there were doubtless works by Ruisdael. In the riots of 1696 the Amsterdam house of his son Captain Martinus Spaaroogh was plundered by the mob and the city had to compensate him ninety guilders for the loss of a 'capital landscape by Jacobus Ruijsdaal', and a further one hundred and forty guilders for the loss of three more paintings by Ruisdael. Ruisdael was also well represented in the collection of Herman Becker, a wealthy Amsterdam merchant with a significant collection that included a range of landscapes, in the large Douci collection, and in 1662 three paintings by Ruisdael were included in the effects of Mathijs Hals, probably a member of the Haarlem family of painters.[54] In 1667 four paintings by Ruisdael were owned by Thomas Asselijn, poet and brother of the Italianate landscape painter Jan Asselijn. In 1684 paintings by Ruisdael are found in the effects of Jan Post, a painter, later a clerk, and a member of the Post family of painters and architects, and also in the effects of a baker, who died in 1660, are found paintings by Ruisdael, Van Everdingen and Van der Neer. This reflects the range of the market he reached, and confirms Peter Mundy's well known observation of Amsterdam in 1640, 'All in general striving to adorn their houses, especially the outer or street room, with costly pieces, butchers and bakers not much inferior in their shops, which are fairly set forth . . .'.[55]

An idea of the comparative value of a Ruisdael in the seventeenth century is more difficult to obtain, especially since size was an important factor in probate valuations, but Chong's survey of the market for landscapes in seventeenth-century Holland provides some valuable guidance.[56] It is evident that during his

lifetime Ruisdael's works were valued on a par with those of De Vlieger, Adriaen van de Velde, and Allart van Everdingen, above those of other painters of the local landscape, such as Van Goyen, Pieter Molijn, and Aert van der Neer, but generally lower than the preferred Italianate landscapists. No landscapes could rival the popular appeal of Gerrit Dou and Frans van Mieris the Elder's highly finished genre pieces, let alone match the prestige of Rembrandt's histories.[57] That Ruisdael fared better than many may also have been because, as Houbraken remarked, 'he painted both local *and* foreign landscapes'. There were certainly those who shared Vondel's taste among the regent classes, retaining a preference for the multi-coloured, composite landscapes of the late sixteenth and early seventeenth century.[58] But there evidently was a market for Ruisdael and other painters of the Dutch landscape as well. Ruisdael fared better than most, and, by the late 1660s, he was ranked by the successful portrait painter, Ferdinand Bol, and the prominent art dealer, Gerrit van Uylenburgh, among the foremost landscape or seascape painters of his day. By Houbraken's time, his reputation far surpassed that of his uncle Salomon.

The type of picture produced by Ruisdael, though less decorative and idyllic than those of the Italianate masters, was by no means unusual. Many of his subjects correspond closely to those being produced by his contemporaries. His country roads, panoramas, seascapes, beachscenes, canals, winters, and town views, while all marked by his own distinctive flavour and masterly handling, nevertheless are built on concurrent models. They are likely, therefore, to have impressed his public more for their particular distinction than for their unusual features. Some of his other works depart more noticeably from contemporary models. Among the small body of etchings produced early in his career, some have a reactionary quality, recalling the style of mannerists such as Roelant Savery and Gillis van Coninxloo. His woodlands also have this reactionary, mannerist quality, though they are analogous to the late works of Cornelis Vroom, and were emulated by Hobbema, Jan Looten, Joris van der Haagen, Jan van Kessel and others, which is evidence that a market could be found for them. His waterfalls, which have seemed uninspired to modern taste, were particularly esteemed by his contemporaries. They were a favoured subject, recommended by Van Mander, depicted by many seventeenth-century landscapists, and noted for their popularity by Vondel.

It comes therefore as no surprise to find that Ruisdael's waterfalls are singled out for praise by his earliest critics. Houbraken takes the subject of Ruisdael's waterfalls for granted and praises the manner in which they are handled. In a period when painters regularly and unashamedly employed similar schema to render conventional subjects, estimation depended on the relative skill and handling of the subject. Contemporary comments often refer to the manner in which a painter has emulated and surpassed his predecessors and can rival his contemporaries.[59] For Houbraken, Ruisdael's waterfalls stood out for the lively rendering of tumbling water. They were rivalled only by those of Van Everdingen, which he also praised. No wonder, since compared to the stylised productions of their predecessors, their works display this merit, which contemporary collectors did not miss. When Jan Luyken, only twenty years Ruisdael's junior, came to write of waterfalls in his *Beschouwing der Wereld*, he surely alluded to the painter in coining the word 'Ruis-dal' when writing of the vanity of life in this 'rushing dale' of existence and the need to wait patiently for the salvation of the Lord.[60] Not only does this reflect on the fame of Ruisdael, and the particular estimation for his waterfalls, but it also gives a clue to their meaning.

Looking back on the life of Ruisdael, as far as we can know it, there are no grounds for an association of his art with a melancholy disposition, misfortune, ill-health or solitude. He was not prominent in public affairs, but neither was he found neglectful. He seems to have been not lacking in means and of a generous disposition. He cooperated with other painters in their mutual affairs, and we think of his friendship with Berchem, Hobbema, and Kick, to mention only the names of those whom surviving records reveal as his friends. Ruisdael was an esteemed landscape painter whose works ranked favourably in a period of vast production.

Although Ruisdael's art lacks the bustle of daily life found in the landscapes of Jan van Goyen or Salomon van Ruysdael, it is a misconception to imagine that his landscapes reveal a melancholy disposition. There is a depth of reflection underlying his paintings that commands our respect, prompting Fromentin to remark, 'there is in the painter a man who thinks'.[61] The reflective tone of his paintings expresses not so much his personal feelings and moods as an understanding of the world common to his generation, to which he gave uncommon expression. There are no grounds for supposing that he was some 'rara avis', working in isolation from current trends.[62] This very misconception turns Ruisdael into an isolated figure so that Brom has commented in a study of sixteenth- and seventeenth-century art and literature, 'no poem of the seventeenth century reproduces his deep melancholy'.[63] No wonder, for this is not the spirit of Ruisdael. To suggest that the landscape was seen purely through the artist's temperament is too modern and romantic. Such notions misrepresent seventeenth-century taste, artistic practices, and perceptions of landscape.

Although each artist's work is coloured by his individual personality, interests and preferences, the seventeenth-century Dutch painter was more concerned with current schema, values and standards of craftsmanship, than with personal confession. An analysis of Ruisdael's work in the light of contemporary practices and perceptions of landscape will demonstrate that he was no exception.

CHAPTER II

The Perception of Landscape

The freshness and so-called realism of Dutch landscape paintings, in contrast to the evident artifice of landscapes produced elsewhere in seventeenth-century Europe, have generated not only a diversity of reaction from scorn to praise, but also no little disagreement as to their character and intent. The more closely an image approximates to natural appearances, the more easily one can overlook the modes of perception that inevitably influence the transformation of landscape into art. Hence one is wary of accepting the freshness and apparent realism of Dutch landscapes as mere mindless transcription. The diversity of responses to Ruisdael's paintings, reviewed in Chapter X, reflects broader discussion of the character and essence of seventeenth-century Dutch landscape paintings. In this chapter we shall explore notions of realism in Dutch art, with particular attention given to the concept of selective naturalness, and more specifically how contemporary attitudes towards nature as a form of divine revelation influenced what was perceived and presented as a natural and representative image of the visible world.

In the eyes of Félibien, De Piles, and Reynolds, Dutch painters of the seventeenth century were servile copyists of the everyday world, who had represented lowly subject matter, unedifying to the soul. Félibien's objection to painters of the native scene was that they 'imitated (Nature) without choice', so conveying, 'an idea of Nature as it is ordinarily seen with its defaults, and not as it can be in its purity'.[1] In Reynolds's Fourth Discourse to the Royal Academy he observed similar deficiencies in the Dutch school. He spoke of 'a partial view of nature', considering their landscapes 'always a representation of an individual spot, and each in its kind a very faithful but very confined portrait'.[2]

This deficiency, by the standards of humanistic art theory, was acclaimed as a virtue by nineteenth-century critics. In 1850 Dumesnil pronounced that the modern soul must seek its 'raison d'être' not in the world of illusions evoked by Claude Lorrain but in reality, in the world of sand and mud of Ruisdael.[3] Thoré-Bürger, writing in 1858, conceived of Dutch art as 'a sort of photography of their great seventeenth century', in which everything was 'fixed, in exact and luminous images'.[4] This response to the realistic quality of Dutch art was echoed by Eugène Fromentin in his widely read Les Maîtres d'autrefois: 'Dutch painting', he wrote, 'was not and could not be anything but the portrait of Holland, its external image, faithful, exact, complete, life-like, without any adornment'. The Dutch school 'was content to look around her and to dispense with imagination'.[5] The idea has come down into our own century that Dutch landscapists mirrored the everyday world with spontaneous naïveté, faithfully recording outward appearances, free from preconceived notions, and bereft of ideals. This 'recording of appearances' has been compared by Bengtsson, Alpers, and others both to the new scientific spirit with its 'unprejudiced method', based on observation rather than precedent, and to bourgeoise desire for the portrayal of 'recognisable experiences'. Bengtsson saw in the landscapes of Esaias van de Velde an 'unprejudiced description of reality', reproduced 'without squeezing it into preconceived patterns of form'. He saw this as part of a new humanistic trend in Dutch culture, Erasmian,

rationalistic, and denying revelation. The glimpses of everyday life in Bredero's poetry are for Bengtsson its literary parallel. For Alpers, it is most closely analogous to mapmaking and an emerging rationalistic spirit associated with figures such as Huygens.[6]

Others have attempted to rescue Dutch landscape painting from the accusation that it is no more than a mirror of the everyday world, stressing the artistic sensitivity of the landscapists. Slive drew attention to a process of selection and composition based on preliminary studies, and to the pure aesthetic sensations aroused by their 'unprecedented pleasure in perceiving and painting the harmony of colours, the sparkling play of light, the mystery of shadow, and intangible space'.[7] Four years later, writing in collaboration with Rosenberg, he went further in accentuating the significance of transforming 'a mean motif into a masterpiece', regardless of subject or meaning.[8] This, he argued, led to a break with the anthropocentric tradition of Netherlandish landscape painting, to the dominance of nature over the human figure, and to the development of qualities of formal organisation expressive of 'atmospheric life and impressive spaciousness'. Yet he considered that, 'the power of expressive organisation, the depth of feeling before nature and the pictorial beauty' raised landscapes of the mature period (from around 1650) above classification as 'realistic, imitative, lacking in ideal content'.[9] Into the significance of this ideal content he did not further venture.

Stechow likewise recognised the new freedom with which Dutch artists discovered 'many new facets of nature' which 'was now for the first time represented entirely for its own sake'. In this respect he considered it more secular than still-life or genre, which, he recognised, retained more symbolism and allegorical significance 'than Bode or Hofstede de Groot would ever have admitted'. But he also cautioned against attributing its truly novel realism to 'wide-eyed innocence and narrow-minded neglect of artistic traditions'. The new generation of artists, when they began to paint rather than draw landscapes, 'needed compositional crutches provided by the older generation'. The essence of Dutch landscape painting for Stechow was to be found in the combination of these two elements, composition and naturalness, summed up by Samuel van Hoogstraeten's term *keurlijke natuurlijkheid* – selective naturalness. Stechow concluded: 'They all selected from nature; but what counts in their selection is nature'.[10] The assumption thus persists that nature was perceived naïvely and without preconceptions, other than compositional ones.

But, it is widely recognised today that a painted landscape, however realistic in appearance, is never a pure copy of nature and therefore can never be rendered value free. Implied in the artist's choice of motifs and his pictorial representation is a certain view of reality. This is conditioned by the many factors that make up his working context, including the artist's personal temperament, prevailing artistic conventions, and other cultural values. Together these provide a conceptual framework that shapes the artist's perception and representation of nature. Earlier criticism of Dutch landscape painting has taken insufficient account of such matters, both overlooking factors that influenced the artist's perceptions of nature, and ignoring the attitudes and assumptions of the seventeenth-century beholder.

The tendency in current criticism is to accentuate one of two extremes: while some writers still see Dutch landscape painting in terms of pure description and aesthetic delight, others have confronted this with an iconological approach, in an attempt to retrieve whatever meaning or associations may be embedded within

Dutch landscapes. However, it may be that a concern with aesthetic delight and the presence of meaning, or of a particular attitude towards nature, may well prove not so much mutually exclusive as intimately related. It is certainly fitting to ask how deliberately and by what means such attitudes were embodied in paintings, and the problem also remains of how to identify them.[11]

The present study attempts to pay attention to artistry as well as iconography, examining recurrent motifs and their pictorial presentation. Attention is also paid to historical context as a control of our reading, identifying artistic and cultural conventions, and attempting to grasp, where possible, how such pictures were perceived in their own time. The generally-held view that Dutch landscapes are dependent on a process of selective naturalness is plausible. Nevertheless insufficient attention has been paid to the implications of this process. We too readily understand it on our own terms, attributing selection too exclusively to purely formal concerns, and working with our own modern assumptions as to what is natural.

In the seventeenth century, naturalness in landscape painting was praised. It was a quality Van Mander esteemed in the landscapes of Pieter Bruegel; it is implied by Huygens's preference for Porcellis over the older and respected Hendrick Vroom, and explicit in his praise for the new generation of landscape painters: 'As far as naturalness is concerned', he said, 'nothing is lacking in the works of these clever men besides the warmth of the sun and the movement caused by cool breezes'. The poet Anslo, too, praised the paintings of Adriaan van der Kabel for their lively, realistic representation; and naturalness is one of the qualities to which Houbraken most frequently refers in his *Lives of the Painters*.[12]

The mimetic quality of art was of evident significance for Dutch artists. In Van Mander's eyes the art of imitation and the display of skill applied no less to the painting of landscape than to the figure. He argued that since Apelles, with so few colours, had been able to represent thunder, lightning and the like, the present-day artist, with a greater range of colour, should be able to represent all manner of natural phenomena: raging seas, snow, rain, hail, ice, and mist. If the challenge was to represent all that the eye of man could understand by means of sight, real distinction could be won by capturing the invisible; hence Van Mander's challenge to the painter to conjure up the sound of waterfalls (*Word hier Echo*), an idea that is picked up by Houbraken in his praise for Ruisdael's evocation of the roar of waterfalls.[13] The ideal of imitation continued to be upheld after Van Mander's time. In an address to the Leiden St Lucas Guild in 1641, Philip Angel made a plea to his colleagues for faithful representation of visible reality. He said that we are *na-bootsers van 't leven* (imitators of life), and so 'we should spare ourselves no efforts if we can thereby approximate natural things more closely'. Indeed, the poet Oudaen wrote in praise of a painting of a storm by Jan Porcellis that the artist did not flinch from experiencing the reality of 'this raging element' in order to paint it true to life (*om levend na te gaen*).[14] Some decades later Samuel Van Hoogstraeten wrote that, ' . . . a perfect painting is like a mirror of Nature, that makes things which are not there appear to be so, and deceives in an acceptably delightful and praiseworthy way'. His own peepshows and *trompe l'oeil* still-life carry imitation to the point of illusion.[15]

While acknowledging this concern for naturalness of effect, it is soon evident that even the most informal representation of a scrubby sand dune belongs to a family of such images, so making us aware that in the interplay between art and reality, artistic conventions and a process of selective naturalness played mediating rôles. Furthermore, scrutiny of the paintings, these written commentaries,

and other sources suggest that the process of selection was not limited to formal concerns and that seventeenth-century conceptions of naturalness went beyond our own. In this respect, Karel van Mander considered 'study from life' an essential basis for good art, but insufficient in itself, as an artist must also learn to work from the mind (*uyt zijn selven doen*).[16] This applied primarily to the representation of the human figure, but the principle was also relevant to the representation of landscape. Van Mander distinguished the visible world (life) from Nature so that while he considered empirical observation of the visible world essential, it is insufficient as a means to know the essence of Nature. This is invisible and know only to God. Man can but observe it as reflected in earthly things. He understands it only through instruction. In order to represent things in a natural and characteristic way, the artist must therefore learn to discern and select from life. He must combine observation and understanding in order to be true to the essence and not just the appearance of things.[17]

The rôle of imagination and Van Mander's distinction between the visible world (life) and its essential characteristics (Nature) continued to be of significance, even for so-called realist painters. This is evident from the above-mentioned quality Samuel van Hoogstraeten praised in the work of the marine painter Jan Porcellis – *keurlijke natuurlijkheid*.[18] Selective naturalness is fundamental to Van Mander's evaluation of the Alpine Landscapes of Pieter Bruegel the Elder; it is also reflected in Houbraken's remark a hundred years later that, 'those artists, who knew how to depict animals the most naturally and appropriately, received the greatest fame'.[19] Selective naturalness is implicit in a Dutch seventeenth-century painter's conception of 'painting from life'. We may say that it implied capturing the essential character of things, including their meaning and significance. Selective naturalism may thus embody a religious and contemplative attitude towards observed reality. As a method of thinking and working it could also lend itself to the embodiment and expression of other contemporary interests and concerns. This intertwining of material and spiritual levels of reality is typical in Dutch seventeenth-century thought and in contemporary artistic practice.

This is evident in even the most imitative of still-life paintings. Pieter Claesz., for instance, in his *Vanitas Still-life* (Malibu, J. Paul Getty Museum) asserts his fidelity to life by including a reflection of himself at his easel, visible in a glass ball on the table. The skill in differentiating a variety of surface textures is captivating, and delights the eye, yet the artist has also organised his objects into meaningful coherence so as to stimulate contemplation of both the joys, beauty and transience of life. As Van Mander advocated, he has combined observation and understanding, in order to represent things in a natural and characteristic way, that goes beyond mere appearances.

Imitation of life, or naturalness, as applied to paintings, almost never implied the kind of 'unprejudiced description of reality', inspired by modern scientific methods, that Bengtsson and more recently Svetlana Alpers imagine it to be. This is not to deny that some artists showed a keen interest in the methods and discoveries of the new science, and used their skills as draughtsmen in its service, as Alpers has ably demonstrated. But while she sheds light on a limited number of artists who at times showed interest in recording or transcribing what can be seen, to claim that this is relevant to our understanding of the broad spectrum of Dutch art is misleading. Even in the case of Vermeer's *View of Delft*, Gombrich observed that the work of art begins where topography leaves off, description is supplanted by poetic description. In the case of an artist such as Jacques de Gheyn, his works suggest that it was clear to him when he was using his skills in the

service of scientific knowledge and when in the service of art – a distinction Alpers chooses not to preserve.[20]

As Gombrich has pointed out, even 'fidelity to natural appearances is never a simple matter of "transcribing" reality', it must be 're-created, even reinvented'.[21] In the case of Dutch seventeenth-century art, we must be aware that in landscape painting, as much as still-life and genre, naturalness of effect implied far more than fidelity to external appearances.

Ideally Dutch landscapists were concerned with combining their observations of landscape with an understanding of its essence. Thereafter with its recreation through the artistic imagination. In practice they would most likely resort to reworking existing conventions which had themselves come into being through this process, modifying them as they saw fit and introducing fresh observations of their own. In either case their pictures were thus based on reflective selection from the storehouse of nature and art. Such a process of selective naturalness inevitably engages the mind and preconceptions of the artist, as well as his temperament and eye. Therefore any attempt to discover the attitudes and interests that inspired Dutch landscapes, to penetrate their significance, must attend to both the process of selection and the manner of representation.

The inspiration for Dutch landscape and marine paintings was patently buoyed by a rich diversity of interests and taste, perhaps most of all by sheer relish in the visible world itself, to which the range of pictorial exploration testifies. At the same time the volume and repetition of imagery also indicates that many allowed prevailing taste and market conditions to guide the production of works that simply conformed to popular prototypes. Besides the evident pleasure taken in all manner of visual sensations, local attachment and civic pride are manifest in river scenes, sandy roads, panoramas and townscapes; historical consciousness may have prompted inclusion of motifs such as Brederode Castle; pride in the prosperity of the new-born nation, closely linked with the sea, in paintings of its shipping; and curiosity for travel, both at home and abroad, in paintings and drawings of Brazil, Scandinavia, Italy and the Rhineland; in views of Arnhem, Nijmegen, Kleef, and in Ruisdael's paintings of the castles of Bentheim and Steinfurt. In literature the restful life of the land, in contrast to the noisy city, is conceived as inducing reflection, well-being, and content. Furthermore, landscape paintings brought the country into the town, much as flowers could be enjoyed in paintings, as Houbraken suggested, when pleasure gardens were covered by snow and ice. The many Italianate landscape paintings, like pastoral poetry, evoked an idyllic world, timeless and immutable, quite foreign in inspiration to the images of transience and decay produced by Ruisdael and others. Saenredam's precise scrutiny of local churches and Vermeer's *View of Delft* are different again. While some looked at the world with fresh eyes, others were content to rely on well-worn conventions.[22] Without discounting the many other factors that influenced the character of Dutch landscapes, our aim is to explore the degree to which their visual sensitivity, choice of motifs and use of artistic conventions was grounded in a sense of contemplative delight in the visible world, inspired by the widely-held perception of the world as 'God's second book of revelation', as Spiegel, Huygens, and others called it.

Contemplation of the creation as divine revelation was of paramount importance in the seventeenth century, as De Jongh, Fuchs, and others have recognised. The influence of religion on contemporary genre painting, still-lifes, emblems and some literature is widely acknowledged, yet its impact on the character of Dutch landscape painting has until recently hardly been explored.[23] It has been

assumed that such an outlook would be manifest either in religious subject matter or in symbols, but it is actually more evident in the way that artists and public perceived the world, in what was esteemed and selected for representation. Nature was seen within a certain mental framework as having a given structure and value, and as revealing certain general truths about life.

The type of realism found in Dutch genre, still-life and landscape painting is founded on the conviction that general truth is evident in the particular. As Roemer Visscher proclaimed in his emblem book *Sinne poppen*: 'Daer is niet ledighs of ydels in de dinghen' – There is nothing empty or idle in things. This view of an Amsterdam businessman and writer can be taken as representative of an outlook that reached far beyond the genre of emblematic literature. It reveals where the seventeenth-century world of ideas differs most sharply from our own. As De Jongh has pointed out, this is something of which we must always take account when considering the art of that time. Dutch landscape, still-life, and genre painting is, as he put it, a form of 'apparent realism', namely a representation which with respect to form imitates reality, and which is at the same time a realised abstraction.[24] Besides giving aesthetic delight it also invites contemplation of the meaning of things.

With respect to landscape painting, this contemplative mode of perception is not a matter of literary or emblematic allusion, as in genre painting, but of creating a characteristic image of nature according to prevailing notions of its essence and significance. One notices in Dutch landscapes expression of certain preferences, a consistency with which some elements are accentuated, others suppressed; there is a sense of order, of well-being, and of everyday activity, and, in the landscapes of Ruisdael and others, a peaceful harmony between man and his environment despite a prevailing consciousness of the ultimate transience of life. The Dutch landscapist, in selecting his motifs according to his preconceptions, created a representative image of Nature, rather than a direct imitation of life.

The underlying inspiration for this aspect of Dutch painting is found in the Bible. The Book of Proverbs, some of the Psalms and God's dialogue with Job, for example, provided a model of contemplative observation of the visible world, which came to be known as God's 'second book' of revelation. This outlook is specifically defined in the Netherlands Confession of Faith, it is echoed in Dutch literature, marginally influenced art theory and is observable in some of the paintings of the period.

Exhortation to contemplative delight in the visible world was instilled by the influential Confession of Faith and Catechism of the Netherlands Reformed Churches. They were the subject of weekly evening sermons and were taught in all schools, so penetrating the entire society. The Netherlands Confession states that God may be known first through the creation, sustenance and government of the whole world; secondly and more completely through His Holy Word. Observation and contemplation of the visible world was of paramount importance since, in the words of the Confession: '(the world) is before our eyes as a beautiful book, in which all created things, great and small, are like letters, which give us the invisible things of God to behold, namely His eternal power and divinity'. The Confession also emphasises the doctrine of the Fall of Man, with the consequent corruption of all earthly matter. The sustaining providence of God may be seen, as the Catechism puts it, in such things as 'foliage and grass, rain and drought, fruitful and unfruitful years'.[25]

While this represents the official position of the Reformed Church, the differences that separated Catholics, Calvinists and Mennonites were in matters other

than their conception of nature. Among the different streams in Dutch art and literature there are no apparent divisions on confessional grounds, though perhaps there was some slight preference among Catholic landscape painters for the idealised, Italianate landscape (Van Goyen being an obvious exception), and among Pietistic writers, such as Van Lodensteyn and later Jan Luyken, to accentuate the corruption of earthly matter and the transience of life. While the Bible itself served as a guide to contemplative observation of the visible world, Reformed thinking in Holland appears generally to have steered men away from the ideal, and to have fostered estimation for the everyday world, beautiful as God's creation even in its imperfect, fallen state. This underlying consensus stimulated observation of the visible world and at the same time led men to submit it to a conceptual framework. Thus, with respect to landscape painting, aesthetic delight in the visible world conveyed inherent spiritual significance.

As demonstrated by Pamela Jones in discussing Federico Borromeo's patronage of the still-lifes and landscapes of Jan Brueghel the Elder and Paul Bril, such perceptions of nature are also found among Italian Counter-Reformers, who acknowledged its depiction in art as a speciality of Netherlandish artists such as Jan Brueghel and Bril.[26] This was in measure because of the degree of naturalism, variety of detail, and precision of execution found in these artists. For Borromeo, the closer a painting of landscape or flowers approximated reality, the more effectively it could serve, either in winter or for the city dweller, as a surrogate for contemplation of the actual landscape or flowers. Jan Brueghel shows that he understands this in a letter of 14th April 1606 to Borromeo. What Pamela Jones also shows us is that for Borromeo, as for several Dutch poets, and later for Houbraken, such a contemplative approach to landscapes and still-lifes is not typically a matter of narrative content, but rather it is the sensory appeal of landscapes and still-lifes that is a source of religious contemplation. All that is given to the eye, whether in the actual landscape, or its pictorial approximation, arouses in the contemplative viewer a sense of marvel at the abundance, variety and curiosities of and within God's creation. This may be beheld, winter and summer, in city or country, in its naturalistically painted representation.

Reference to this same attitude is found in contemporary Dutch literature. Beening's study of landscape motifs in Dutch literature shows that Dutch authors mostly came from a class which had received a Classical education and were orientated towards Classical models. Hence, three-quarters of the written landscapes of the period are idealised fantasies coloured by the golden light of Virgilian pastoral. Italianate landscapes are the nearest equivalent in Dutch painting. Nevertheless, the everyday landscape does occur as a source of religious inspiration and one finds in the writings of Spiegel, Huygens and Luyken direct echoes of the Confession of Faith, each referring to their reading out of the book of creation.[27] For these and many other writers the beauty and transiency of the visible world is seen as opening windows for the beholder on the invisible, and sunlight, storm and harvest are perceived as revealing the providence of God. It is apparent that for these writers aesthetic sensations aroused by the landscape were a source not only of delight but also of deeper contemplation. As Jacob Cats, the most moralistic of these writers, put it in *Ouderdom en Buytenleven* 'Wherever vegetation grows, one can honour the great Creator . . . Who in the fields combines his vision with reason, will find many a thing to edify his morals'.[28] This recommendation is striking for its similarity to Van Mander's advice to painters to combine observation with understanding.

The belief that the beauty of the visible world opens a window for the beholder

on the invisible, a notion applied to painting by Van Mander and Houbraken, was expressed equally by poets throughout the seventeenth century and into the eighteenth century. The idea was often expressed that through the five senses man nourishes his inner being, perception acting as a source of delight and as a prelude to contemplation.[29] Spiegel, for instance, in his *Hertspieghel* describes the effects of a morning walk to 'delight the senses' that takes him through the dunes and polders: It relaxes the body, it lightens the heart. His cares slip away, and finally he can learn from the 'book of creation'. He describes a similar progression from sensation to contemplation aroused by his garden at Meerhuizen on a summer morning. It is a 'beautiful sight', a 'show-place of nature' that stimulates all the senses, teaches 'most lively virtue', and 'provides the thankful heart with constant grateful joy'.[30]

Thus poets from Spiegel early in the seventeenth century to Poot, one hundred years later, describe their responses to landscape as a progression from visual sensation to deeper contemplation, nature providing a ladder by which our thoughts climb to God. Indeed Anna Bijns, Spiegel, Van Lodensteyn, Luyken and Poot all condemn the folly of those who do not contemplate the beauty of nature with a spiritual eye, or see God in and through His creation. Spiegel, for instance, full of the edification to be derived from nature, condemns the man who is willfully blind to its deeper significance, and Poot, thankful to God for opening his eyes to the beauties of nature, like Spiegel, condemns the folly of men who do not see God in it.[31] This concern that response to the visible world should ideally entail a progression from visual sensation to deeper contemplation was evidently shared not only by genre and still-life painters but also by some landscapists. As we shall see, in a few cases they even included a contemplative couple in the foreground of the picture. But even in the absence of such figures, a study of their works suggests that the contemporary beholder could approach them on these progressive levels, and that he or she would be missing out if aesthetic delight did not arouse deeper contemplation. Something further of the attitude of the contemporary beholder and of the elements of landscape that aroused contemplation can be found in Dutch literature.

Given the differences in the educational orientation, artistic traditions, and modes of expression of the poets and painters, it would be a mistake to look for any direct analogy between the actual form in which landscape appears in literature and painting. Hindered by their classical orientation, evocation of the atmosphere and beauty of the ordinary Dutch landscape in literature grew but slowly, as Beening noted, to reach its best early in the eighteenth century in the works of Poot. The everyday landscape does however occur in Dutch literature in the context of the country-house poem, in response to travel, both at home and abroad, and as a source of religious inspiration.[32] Landscape painters, on the other hand, had generally not had a humanist education, and, in contrast to writers, did have a strong native tradition of painting inspired in part by the local landscape.

Despite these differences, both artists and writers gave expression to certain concepts of nature which were based on shared religious convictions. As Price noted, the literary culture of Holland, though largely a foreign import, 'was given a typically Dutch stamp through the religious inspiration and moral seriousness of nearly all Dutch writers'.[33] It is therefore worth considering what elements of the landscape aroused religious reflection in the poets and what was the character of such reflection. Their responses took various forms which may be likened to notions expressed in the Netherlands Confession of Faith. They responded par-

ticularly to the beauty and order of the landscape, at times observed its transience, and also perceived in it the provident hand of God. These qualities prompted them in turn to marvel at its beauties, to ponder the fragility of life, and to find assurance of well-being in the signs of divine providence.

By far the most common tendency was to see in the beauty and order of nature a reflection of the absolute beauty and wisdom of God. This is found from the late sixteenth century, in the works of Anna Bijns, throughout the seventeenth century, in Spiegel, Bredero, Van Borsselen, Huygens, Cats, Vondel and many others, and continues in the early eighteenth century in the works of Claas Bruin and Poot.[34] We have caught glimpses of this already in considering the function of the five senses, noting how Spiegel and others wrote of nature as providing a ladder by which our thoughts climb to God. For Spiegel, this was aroused by his walks in the Dutch countryside, along the Amstel, the IJ, and the Spaarne, and over the dunes of Overveen, as well as in his garden at Meerhuizen. Walking along the Amstel in early spring he describes a typical polder landscape, and is struck by the wonderful change that takes place in things, buds bursting out of hard branches, new grass springing up where there was ice, cattle full of milk in fields so recently under water; and, like the painters, he delights in the wide panoramas to be seen from his look-out tower. His eye was directed to the ordinary Dutch landscape, and there he sought to learn from the great 'book of contemplation of the world'.[35] A precious collection of seashells inspired Van Borsselen in his poem Strande to muse on the wonders that lie hidden in the sea, which, he prays, might turn our thoughts on high. In Den Binckhorst edification is to be found in the garden and surrounding fertile fields of the country house, seen in the varying conditions of the seasons.[36] Poot's ladder springs from reflection on the constant, provident care of God, seen likewise in the beauty of the changing seasons, especially in the summer with its crops and harvest. Like Spiegel more than one hundred years earlier, he marvels at the countryside in springtime with cows ('living tubs of butter') grazing in recently waterlogged fields, and in summer at the pastures and clover meadows with cows being milked in the long grass. He urges his reader to go out and let the eye wander happily through 'God's landscape painting'. This term is of interest not only for the comparison between the actual and the painted landscape, but also because Huygens, as Haak has noted, as a strong Calvinist had much earlier protested against calling a landscape 'picturesque', a term he considered a distortion of the truth, as if God were copying the work of painters, when in fact the reverse was true.[37]

Huygens and Cats tended to look for details in the landscape that were instructive or pointed to God. For Huygens this was in his garden, or when alone among the dunes, where in the quietness he could study the flowers, flies, or insects, objects all drawn by his friend Jacques de Gheyn II. Even the sand dunes themselves caught his imagination. Marvelling at the way in which these dunes, piled up by storm and water, formed a barrier to the sea, he exclaimed: 'The Lord's goodness is manifest on the top of every dune . . .'. This capacity to respond to such simple elements of the landscape must have contributed to the appreciation expressed in his Autobiography for landscape painters such as Esaias van de Velde and Jan van Goyen, artists who often depicted the dunes. It also suggests that De Gheyn, like Huygens, may have approached the miniscule objects he so carefully depicted with both a scientific and contemplative frame of mind.[38] For Cats, as for Huygens, nature was God's second book. Whether in the woods, the fields, in the surroundings of his country house 'Sorgh-Vliet', or looking out over the land from his little belvédère hill, Cats writes that when alone he tries to nourish

his spirit through the eye, and elsewhere he says that whatever he sees, it speakes of the Creator.[39]

In the work of Vondel and Luyken contemplation of nature's beauty bore little relation to the actual landscape.[40] But Claas Bruin, on the other hand, was inspired to religious contemplation by the apple orchards of the fertile Betuwe and the cornfields around Zeist. Describing a fourteen-day trip through the Netherlands in *Kleefsche en Zuid-Hollandsche Arkadia . . .* (1716), he wrote that you do not have to make foreign journeys in order to 'contemplate and praise the Creator in His creation'; wherever one looks one finds 'a thousand pleasing things, which the great creator of nature has made for the joy and refreshment of man'.[41]

If it was much more common for these writers to concentrate on the beauty, variety, and order of nature, the transitory quality of earthly existence did not escape them. Bredero in the *Stommen Ridder* observed that there is nothing so slight, so frail that we cannot learn from it, and further on compares the beauty and transience of flowers to the life of man:

> Gheen dinghetjes zoo slecht zoo teer,
> Of sy gheven ons een leer . . .
> . . . aenschout de schoone bloemen,
> Voorbeelden vanden mensch, hoe lustich datse staen,
> Hoe onseker, hoe kort sy weer ter aerden gaen.[42]

Van Lodensteyn, living in his country house 'Het Park', on the outskirts of Utrecht, reflected on the vanity of all around him, not only the flowers, but the trees, and the house itself. In *Niet en Al, dat is, Des werelds ydelheyd, en Gods Algenoegsaamheyd* he returns sixty-eight times to the refrain: 'Siet! siet! wereld en al is niet', considering the transitoriness of all worldly things against the backcloth of God's all-sufficiency.[43] He expresses a similar concept succinctly in the title of another poem: *Stantvastige Onstantvastigheyd der onder-Hemelsche dingen* (Constant inconstancy of all things under heaven). Van Lodensteyn represents an extreme pietistic end of the Dutch religious spectrum, but his sense of constant inconstancy reverberates more widely in Dutch culture, witness the many *Vanitas* motifs in still-life and genre paintings, a sensibility that flows into landscape painting as well.

If Van Lodensteyn's pietism led to a preoccupation with the mutability of the world, for Claas Bruin and Poot, writing in the early eighteenth century, regard for the beauty and variety of creation did not exclude such considerations. Bruin took the example of the ruined castle at Wijk bij Duurstede to observe that the finest splendour of buildings will be deadened by time, for 'Nature loathes things that always stand before her, she loves change'.[44] In Bruin's comments we hear the echo of Van Lodensteyn's expression of the constant inconstancy of all things under heaven. Likewise Poot, in his poem *Herfst* surveys the delights of the autumn season, the fruits and crops from orchard, pasture, hill and dale. Then, in his last lines, he turns from considering the plough cutting furrows for the following year, to reflect on the constant changing of the seasons, and the transitoriness of life, concluding: Let us, while we are here, be virtuous, enjoy God's blessing, and praise Him.[45]

Poot's lines reflect a sense not only of the transience of life, but also of the provident hand of God as seen in the landscape. This forms a recurrent theme of his poetry. In *Herfst* he observes how 'the bountiful God . . . still drops his favour on paltry matter, cleft in sin' as 'autumn pours forth a lavish abundance of ripe crops for man's incessant desire'.[46] Songs on spring and summer, in which divine

providence was seen especially in the beauty and bounty of the earth, were followed by a poem *Zomerönweer* in which Poot creates an image of the elements breaking forth in full force. For all the destruction it brings and the fear it arouses, nevertheless, herein speaks the might of God:

> De donder, blixem, wint, en weerlicht loopen mis,
> Of treffen zachtst en minst 't geen laeg en buigzaem is.
> Maer gy, die oit zult lyden;
> Houdt moet in droeve tyden.
> 't Is Godt, Godt is 't alleen, die onweer doet ontstaen.
> Hy is het, hy alleen, die 't ook doet overgaen.
> Beseft voorts onverdroten,
> Dat door die grove nooten,
> En met zoo oversterk en vreesselyk een tong
> Het luchtruim tot Godts lof, en van zyne almagt zong.[47]

As the Dutch Catechism says of providence: 'All things come to us, not by chance, but from his fatherly hand'.[48]

The idea of providence is evident in all those poets who wrote of nature as divine revelation. With Vondel, and Anslo imitating him, it is reflected in their praise of God the great ordainer. For Spiegel, providence was to be seen in the meadows, dunes, woods and sky of his immediate surroundings. In *Hertspieghel* he specifically rejected the classical idiom and its goddesses of fields and streams in favour of representing his own land, which manifested to him, 'the ineffable God, all-wise and good, who is the father and keeper of all things'. It is perhaps significant that representation of the ordinary Dutch landscape is given an ideological value just at a time when it was receiving greater attention from landscape painters.[49]

For many poets, the fertility of the land was a continual reminder of providence. Sight of the fruitful earth and domestic animals inspired Bredero with thankfulness to God, and Hondius was struck by nature's utility in glorifying God's name and meeting the needs of man.[50] Sluyter, the country parson, viewed the fertile Achterhoek landscape, with its pastures, crops and cattle, as a source of joy, free from the constraints of the city, and full of the glory of God.[51] Claas Bruin, on his tour of South Holland, at one point pauses to marvel at the variety that God in His wisdom has given to different areas, that men and animals may be provided for according to their several needs, concluding:

> Dus is deeze aarde vol verandering geschapen,
> Ten dienst van mensch en vee, die hier hun voedzel raapen
> Naar ieders stand en staat . . .[52]

Perhaps the most symbolic manifestation of providence for the Dutch poets was sunlight, returning daily to dispel darkness and quicken the earth. Huygens, Van Borsselen, Van Lodensteyn, Sluyter, and Luyken all wrote of daybreak, taking their lead from Psalm 19 where the sun at dawn is compared to a bridegroom coming forth from his chamber. For Van Lodensteyn and Luyken, as for Spiegel earlier in the century, this morning light is allegorised into an image of 'The Light of the World' dispelling darkness from the soul. But Huygens describes the sun in many other ways, as 'light of the heavens', 'cloud driver', 'bringer of summer', and for Sluyter, one of the great joys of the country life is how the birds begin to sing, and man, the animals, and the countryside itself bursts joyfully into life as the bridegroom comes forth from his chamber.[53] Poot, in his poem *Een schoone*

dagh . . . , likewise responds to the actual sunlight, here breaking through a cloudy sky onto the land below; it soothes all the senses, delights the eyes and is conceived as a gift of God, bringing down from heaven delight and jubilation; and life, growth, fire and dissolution:

> Hoe speelt haer glans, door wolken, wit van zoomen,
> In 't ruim, dat nergens stuit! . . .
> Gewiekte Dagh, klaerglinsterend van leden,
> En wonderheuchelyk,
> Gy brengt den lust en 't juichen naer beneden,
> Uit Godts gelukkigh ryk.
> Gy koestert, streelt, en zegent lant en water.
> Door u is 't overal
> Vol levens, vol bewegens, en geschater,
> En tier, en vier, en val.[54]

Although Poot's poetry is more vivid in detail drawn from the actual landscape, its inspiration reflects ideas that had continued, little changed, throughout the seventeenth century and into the early eighteenth.

If these classically orientated poets gave expression to contemporary religious values in their response to nature, how much more would we expect this of the landscape painters who were formed less by the classics and more by the popular values of their own culture. It would be surprising if landscape painters were totally insensitive to such ideas of nature and all lacked an analogous capacity for contemplation. Its expression may not be immediately apparent to the modern eye, but the religious perceptions of the Dutch poets may serve to alert us to ways in which the painters perceived the landscape, taking due account of differences in their modes of expression. In a poem dedicated by the Amsterdam poet Reyer Anslo to the landscape painter Adriaan van der Kabel, the poet says that paintings 'sharpen us with profitable lessons through the eye', for while 'the painter depicts what is visible, the spirit will be engaged by it, since Nature, God's daughter, is rich in meaning'.[55]

This typifies an outlook shared by writers, scientists and painters alike. The conception of nature as 'God's second book' is also found in the writings of both Kepler and Bacon, and, within the Netherlands, this perspective is reflected in the words of the entomologist Jan Swammerdam (1637–80): 'The Omnipotent Finger of God is here presented in the anatomy of the Louse, in which you will find wonder heaped upon wonder, and will be amazed at the Wisdom of God manifest in a most minute matter'. Some of his papers were published after his death under the appropriate title *Bible of Nature*.[56] This title would be equally appropriate for Jacques de Gheyn's studies of nature's minutiae, or for Jan Brueghel and Roelant Savery's painted studies of animals and flowers displayed in great variety and sometimes even set in the context of creation. Vondel's praise of the order and variety in the landscape, expressed in his *Bespiegelingen van Godt en Godtsdienst*, strikes a similar note.[57] Did this conception of nature have no influence on landscape painters, or on the images they created of the visible world, or is it that we ourselves, looking with the eyes of a later generation, do not recognise it? Has not our own sense of perception been influenced by the intellectual revolution brought about by the Enlightenment? Indeed, Fromentin noted one hundred years ago that photography alone has changed our whole manner of seeing, perceiving, and painting.

Dutch art theory is based on Italian models and bears only limited relationship

to actual practice, but some comments of Van Mander and Houbraken are worth noting. Van Mander's advice on painting landscape constitutes one of the most original sections of his *Grondt der Schilderkonst*, even though landscape is treated not as a genre in its own right, but as playing a supportive rôle to figure painting. His comments on landscape are rooted in his overall aesthetic theory in which a form of Renaissance Neo-Platonism is modified in part by the ideas of natural revelation considered above. His theory is founded on the idea that, '(God from) Heaven . . . has furnished precious nature . . . with the virtue of beauty, both fitting and artistic, which gives the eye complete satisfaction'. Absolute beauty is not perceptible, but the great variety of phenomena in the visible world gives us an imperfect reflection of it.[58] Since God has endowed nature with these qualities, the artist must strive to reflect them by depicting the variety of creation. While the human body expresses this most perfectly, it is also apparent in elements of landscape and still-life. Observing that 'nature is beautiful in its variety', Van Mander cites as examples 'when the earth displays its thousand colours in full bloom', and even 'a table well spread with food and drink'.[59]

In recommending the painter of landscape to capture its characteristic variety, Van Mander's idea of it is coloured by his admiration for Pieter Bruegel the Elder, and also includes detail drawn from the local landscape. He recommends depiction of fields filled with corn, some ripe some unripe, through which the wind blows, and ploughed fields, cut by furrows, here and there fields on which crops stand harvested, and grassland and meadows, just as it is, with canals, hedges and winding roads.[60] To this image of variety is added a sense of order in the world, with each element fitted to its purpose and man accomplishing his alloted tasks. With regard to staffage of the landscape he wrote: 'But above all do not forget to put small figures under tall trees. Create a small world (a microcosm) with figures here ploughing, there mowing; over there let them load up wagons, and elsewhere let them fish, sail, catch birds or hunt . . . Make the countryside, the town, and the water full of activity, the houses inhabited, and the roads travelled'.[61] Taken in the light of his theory of aesthetics, we can understand that these qualities of variety, beauty, and order are intended not only to show off the skill of the artist and to 'give the eye complete satisfaction', but also to reflect creation's manifestation of the absolute beauty and goodness of the unseen God.[62]

Although the next generation developed new ways of representing the visible world, there was no concurrent change in man's world view capable of displacing these fundamental assumptions. The outlook expressed by Van Mander, and common to his time, offered a theoretical basis for representing the great variety of things visible to the eye of man. If this deeper level of meaning is rarely explicit in Dutch seventeenth-century art, it is certainly implicit to a degree greater than is generally acknowledged, in the sense of order and well-being found in these paintings, in the love for everyday detail, and in the common allusion to the transitory quality of life. That this perspective was not entirely forgotten is testified by Houbraken's comments in *De Groot Schouburgh der Nederlantsche Konstschilders en Schilderessen*. He too drew attention to the variety of creation, recognised its capacity to delight the eyes and induce religious contemplation, and commented that: 'Just as Nature strives for the completeness which makes for beauty, so artists, from of old, *and still today*, attempt to imitate nature (*zo na te komen*) as best they can, so much the better to show forth its wonder for the viewer'. He mentions artists who have achieved this even in the representation of animals and flowers,[63] and, looking back over the painters of the seventeenth century, writes that it is no wonder painters have imitated various aspects of

nature, since the Psalmist thought it worthy of his attention in Psalm 104, seeing the providence of the Almighty therein reflected. He continued, in words that remind us of Huygens, 'it is the same in the representation of still waters and rough seas, even at its wildest, when wave after wave lashes on rocks and sand dunes . . . in such depictions one can contemplate far more than the mere art of the painted panel'. As he said earlier in the same passage, nature is always changing; art, by capturing elements of it, preserves the transitory, so that nothing is lost in the contemplation of the Creator in the creation as in a mirror.[64]

One of the reasons for the widespread and sensitive imitation of nature in seventeenth-century Dutch landscape painting was that the visible world was perceived as being inherently meaningful. The fascination with pictorial allusion and the desire to draw attention to this meaning are implied in the ideal of creating a natural image of the world. We have emphasised the influence of religion on the outlook of some Dutch poets. They responded to the beauty, fragility, and abundance of creation as a form of divine revelation, encouraging contemplation which reflected a tendency more widely present in seventeenth-century Dutch culture. We have also suggested that selective naturalness, as a recognised artistic practice, implied creating a characteristic and representative image of nature, which could also embody this significance. Landscapes intended both to delight the eye and to arouse the contemplative mind did not necessarily have to contain narrative or emblematic meanings. A natural image could embody this outlook without being explicitly symbolic. The process of selective naturalness is not however limited to the embodiment of such a sensibility. It serves also as a means to give form to a multitude of pictorial concerns and historic, economic and civic associations. Discussion of selective naturalness in relation to a religious and contemplative mode of perception serves to clarify the impact of such an outlook on Dutch landscape painting. It does not exclude the validity of the many other concerns and interests manifest in such paintings. This is a further influence on the way in which some poets and painters perceived and represented the world. A tradition of painting landscape from this perspective is identified in the following chapter.

CHAPTER III

Landscapes for Contemplative Delight

The previous chapter explored the implications of painting a landscape following a process of selective naturalness, considering criteria that influenced the process of selection, and contemporary views of what constituted a natural and representative image of the visible world. Inasmuch as the landscape was perceived as a source of religious contemplation, let us examine how such an attitude manifests itself in the actual paintings of the period, giving specific attention to those that formed the context for the development of Ruisdael's own pictorial style.

Houbraken, writing about seventeenth-century Dutch paintings, commented that, 'ordinary people look at things only to delight their eyes: but the wise look beyond the same, in order to know what is concealed behind'.[1] Clearly not all painters or printmakers exploited this contemplative potential, nor did all people consider their works in this way. Indeed, the range and character of Dutch landscapes provide substantial evidence to the contrary. Their sheer visual delight should not be underestimated, neither should the many other factors which influenced their character be discounted. However, this contemplative mode should be explored to assist our understanding of some of the paintings and prints of Ruisdael and his contemporaries.

In seeking to identify which elements of the landscape aroused religious reflection and how this is manifest in art, the basic premise is that selective naturalness implied a depiction of the essence of nature as then understood. Dutch landscapes are therefore best approached not so much as bearers of narrative or emblematic meanings, but rather as images reflecting the fact that the visible world was essentially perceived as manifesting inherent spiritual significance. Concern with aesthetic delight and the presence of meaning are not therefore seen as mutually exclusive but rather as intimately related. If the landscape painter was concerned that his viewer should be inspired by visual sensation to deeper contemplation, we may expect that this would be directed by certain stimuli. These would derive both from the sheer beauty and order within the image itself and also from elements which emphasise the essential character and significance of the visible world.

In the absence of any other records, one can imagine that the contemporary viewer, transcending mere aesthetic delight, would be prompted to deeper contemplation by much the same stimuli as the poets used, or figures like Van Mander and Houbraken, who took their lead from religious sources such as the Bible and the widely-taught Confession of Faith. As with Dutch poetry, the ethos of the Confession provides a useful perspective from which to approach the paintings, without suggesting that its attitudes were in any way exclusive to the Reformed tradition. In ways adapted to their own artistic traditions, landscape painters and printmakers celebrated the beauty, variety and order of the world. They were sensitive to its corruption and mutability, and yet created an overall image of peaceful well-being. As with the poets, this may be attributed in part to the assurance of divine providence which the Bible and the Confession underscore.

A sense of the beauty and variety of the world as a reflection of the wisdom of the Creator is explicit in Jan Brueghel's *Paradise with the Creation of Eve* (Frankfurt, No. 1097; Fig. 1) of about 1615. It shows the presence of a creating God in the midst of His creation. The specific elements of the visible world, represented with the studied attention of a natural scientist, are thereby set within a wider context of meaning. Brueghel made several landscapes of this type and others in which a whole zoo of animals and birds gather around Noah's ark. Roelant Savery likewise filled landscapes with all manner of animals and birds, which show off the abundance of creation.[2] These pictures are analogous in spirit to the later paradise landscapes of Vondel and Luyken and to the multi-coloured, aromatic flower gardens that inspired contemporary poets such as Spiegel, Van Borsselen, and Huygens. They are also comparable to the richly-coloured flower paintings of Ambrosius Bosschaert the Elder, of Jacques de Gheyn, the friend of Huygens, and to those of Savery and Brueghel themselves, which reflect Van Mander's comment that nature is beautiful in its variety, as 'when the earth displays its thousand colours in full bloom'. Such variety, Van Mander had pointed out, was equally to be seen in a 'table well spread with food and drink'. This latter possibility was fully exploited as much by his contemporary Floris van Dyck, in his abundant displays of fruits, nuts, and cheeses, as by a host of subsequent still-life painters.[3] Delight in the marvels of creation is reflected equally in Balthasar van der Ast's paintings of sea shells. As the poet Van Borsselen had meditated on a collection of sea shells, so the beholder of Van der Ast's pictures might both contemplate the skill of imitation of such rare specimens and equally be moved by the ingenuity of their Maker, as Houbraken wrote.[4] While Samuel van Hoogstraeten, following classical art theory, had a low estimation of still-life painters, calling them the 'common footmen in the Army of Art', Houbraken was in no doubt as to their value, citing the example of the Psalms, just as he did with landscapes.[5]

This display of variety and delight in the manifold beauties of creation is equally apparent in such still-life and animal paintings as it is in the landscapes of painters such as Pieter Bruegel the Elder, Hans Bol, Gillis van Coninxloo, Joos de Momper, and the early works of Jan Brueghel. They employ an imaginary, high viewpoint so as to accumulate within one image various facets of the visible world, so giving a composite, overall view of its beauty and variety. These still-lifes and landscapes manifest the ideals Van Mander describes in his treatise. While the practice of representing such massed variety discontinued, the inspiration evident in these paintings of landscapes, animals, and still-life objects provided in Houbraken's view a foundation for the subsequent development of these different genres in seventeenth-century art. Animal painters such as Gillis d'Hondecoeter, his son Gijsbert and grandson Melchior, Paulus Potter, Cuyp, Wouwerman, and Adriaen van de Velde concentrated on representing individual specimens or small groups of animals or birds in more natural settings; still-life painters, such as Pieter Claesz. and Willem Claesz. Heda, concentrated on fewer objects; and likewise landscapists abandoned panoramic surveys in favour of a more localised and specific image. This is comparable to the early seventeenth-century trend in genre painting to express general values by the specific, everyday example rather than by biblical or mythological allegory as was done previously. As De Jongh wrote, they are representations, which with respect to form, imitate reality and which are at the same time a realised abstraction.

In landscape, this transition is manifest in novel representation of the indigenous rural landscape, in which the dunes, country roads and frozen canals of the

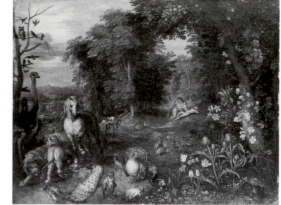

1. Jan Brueghel: *Paradise with the Creation of Eve.* Copperplate, 29 × 38. Frankfurt/M, Städelsches Kunstinstitut. Photo: Museum (Ursula Edelmann).

Dutch countryside feature prominently. As is widely recognised, this new vision of nature was triggered in part by a 1601 re-edition of a series of prints of *Small Landscapes*, showing local village and countryside views, first published by Hieronymus Cock in 1559 and 1561. This vision of the local landscape made its first appearance in Holland in the graphic art of two significant printmakers, Hendrick Goltzius in Haarlem and Claes Jansz. Visscher in Amsterdam, the latter making numerous series of landscape prints. Their widespread dissemination attracted others, such as Esaias and Jan van de Velde, and so established a new mode of landscape.[6] Their vision of the indigenous rural landscape was transferred into paintings by Esaias Van de Velde around 1614 and was thereafter developed by a host of others, among them Jan van Goyen, Pieter van Santvoort and Salomon van Ruysdael, artists whose work in turn provided the initial stimulus for Jacob van Ruisdael. The main centre for their activities was Haarlem, the home of one of the leading figures in this movement, Hendrick Goltzius. Besides producing Arcadian pastoral landscapes, Goltzius also conceived of landscape as a stimulus to religious contemplation, being also in the vanguard of those who turned their attention to the marvels of the local landscape.

2. Claes Jansz. Visscher: Title Print of *Plaisante Plaetsen (Pleasant Spots)*. *c*. 1611. Etching. Photo: Amsterdam, Rijksmuseum.

The inspiration for depiction of the indigenous landscape is hinted at in the title pages of various series of these landscape prints. They are offered as *Delightful views . . .* , *Very pleasant views to delight the eyes*, or, as C.J. Visscher inscribed in Dutch on the title page of a series drawn around 1607, and probably published in 1611 (Fig. 2): 'The *Pleasant Spots* here you can contemplate with ease, devotees who have no time to travel far. Situated outside the agreeable city of Haarlem or thereabouts. Buy without thinking for long'. The accompanying Latin text links these new visual experiences of the modest Dutch landscape with a much older and more prestigious tradition. It reads, in translation: 'You who enjoy the varied view of country houses and the surprising turns in ever delightful roads: come, let your eager eye roam these open vistas offered by the sylvan surroundings of Haarlem'. The intention is clear. Visscher wants to extend his public's response to landscape beyond the literary conventions of the traditional country-house poem and its pictorial equivalents to embrace the indigenous landscape, and, symbolically, he writes of the older perception in Latin and of the new in Dutch. The success of his venture may be gauged by the fact that his prints not only spawned a profuse flourishing of landscape in prints and paintings, but even the most cultivated literary figures, such as Constantijn Huygens, started enthusing not only about life in their country houses, but about the marvels of the Dutch countryside with its sand dunes, dikes and winding country roads. We have also already noted how Huygens responded with such enthusiasm to the very painters who were developing this new type of landscape with their dunes and country roads. An aristocratic literary mode of enjoying the pleasures of the country house life was being extended into new and fresh perceptions of the actual environment.[7]

Visscher's initiative in landscape prints corresponds to the direction already taken by Spiegel in his ode to his country house, *Hertspieghel* of 1599, in which, while still using the traditional country-house format, he had expressed a preference for the Dutch landscape over classical Arcadia on the grounds that it is precisely there that God's provident hand is in evidence. Both poet and printmaker invite their public to join them on a walk through the pleasant countryside, which, in Spiegel's case, was to be experienced as a progression from visual delight to deeper contemplation. Spiegel's walk through the dunes and polders, we recall, served to relax the body, lighten the heart, ease one's cares, and free the

spirit to contemplate from the 'book of creation', and so provide the heart with 'constant grateful joy'. Could it be that Visscher also had something similar in mind? He does not say as much in words, but his cogent imagery suggests it. His title page (Fig. 2) includes, besides the above mentioned inscriptions and other elements, the radiant presence of God, symbolised by the aureoled Hebrew letters ΥΗWΗ (Yahweh/Jehovah) top left, and surmounting the centre of the composition, a dead tree, symbolically grasped by the figure of time. Why else would he include in his title presentation an image of the presence of God and signs of mortality in conjunction with an invitation to view the delights and beauties of the countryside around Haarlem? The contemporary beholder was expected to find in the beauty and well-being of the everyday world shown in the prints delight for the eyes and a reflection of the beauty and wisdom of the Creator. He offers them, after all, as delights to be contemplated and actually captioned another series of landscape prints he published in 1615 with the words: 'Seeing leads to reflection'. Visscher also claims that the landscape prints are sold with honourable intent since, as he says in the inscription, reflective viewing of them 'teaches the truth'.[8]

3. Claes Jansz. Visscher: *The Lepers' Asylum of Haarlem*, no. 9 in the series *Plaisante Plaetsen*. c. 1611. Etching. Photo: Amsterdam, Rijksmuseum.

The prints themselves, for example figure 3, from the series *Pleasant Spots*, show the beauty, bounty and serenity of nature, at times illuminated by light-beams bursting forth from clouds. They also include the visible benefits of divine providence in such typical local, sun-dependent activities as bleaching linen, and the hand of time in dead trees and ruins. These prints, then, have their background in a sense for the traditional delights of the country life, celebrated alike by poets, but now attention is turned away from the aristocratic milieu and its artifice, and towards the immediate environment, embraced, at least for Spiegel, and seemingly also for Visscher, as equally marvellous parts of God's creation. Fittingly, as the scenery becomes less artificial and more localised, so the figures within them are changed from elegant courtiers to plain country folk, a shift that has parallels in the market for such works.[9]

In landscape paintings, as opposed to prints, the transition from the old to the new mode of landscape is first noticeable in Holland in the works of Esaias van de Velde. It is also seen, somewhat earlier, in those of the Fleming Jan Brueghel. Their paintings echo the trends set by the printmakers, yet they continue to reflect Van Mander's ideal of creating a small, ordered world, full of variety and characteristic activity, only now in a more natural manner. In the case of Jan Brueghel, a painter who so patently celebrated the beauties of God's creation, the influence of the new outlook can be seen, for example, in his *Village Road* (Vienna, Kunsthistorisches Museum, No. 6329) of 1603, painted just two years after the re-publication of the *Small Landscapes*. In a rich gamut of colour Jan Brueghel represents the salient features of a village with its inn, mill, cottages and church, and a cross-section of social types. But he lowers the viewpoint, restricts the space, and localises the scene, giving it a distinctly Flemish tone, with no exotic intrusions.[10] Esaias van de Velde makes similar adjustments in his paintings and prints. In his *Ferry Boat* (Amsterdam, No. A 1293; Fig. 4) of 1622, he goes even further than Jan Brueghel in using tone in place of Brueghel's multi-colour to convey a more natural impression of objects seen in recession through moisture-laden atmosphere. As with Jan Brueghel the scene is localised, yet it contains a representative selection of elements of the river landscape. On the left bank is an inn, beyond a church, some cottages, and a mill, interspersed with trees. On the right bank is a farm, and beyond, a boatyard. These elements are unified by the central feature of a ferry conveying men and animals over the river, so creating a

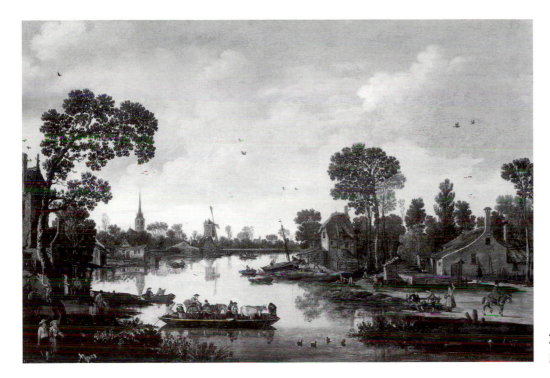

4. Esaias van de Velde: *Ferry Boat*. 1622. Panel, 75.5 × 113. Amsterdam, Rijksmuseum. Photo: Museum.

composite image of river life. The picture represents this little world full of activity on land, water, and in the air. Travellers populate the roads, a beggar entering on the left, others strolling through, and a gentleman on horseback departing on the right; others fish, repair a boat, and converse by the inn and the landing-stage; birds enliven the water, the roof-tops and the sky. These elements, perhaps observed at different times and places, have been combined and imaginatively recreated to show the river landscape complete, with everything in its proper place. Such village scenes and river landscapes were refined by other painters, such as Jan van Goyen and Salomon van Ruysdael, and became a popular theme taken up also by Jacob van Ruisdael and his pupil Hobbema.

Landscapes such as these reflect Dutch artists' selection of significant representative elements of their surroundings, the rivers, dunes, country roads, villages, beaches, and the sea, invariably enlivened by the activity of man. By comparison to earlier landscapes they are more natural in appearance. But naturalness of effect, so highly esteemed, did not imply imitation without choice, or concern solely for aesthetic sensations. They created an image of the world that is beautiful, orderly and full of well-being conforming to ideals expressed by Van Mander, and much later by Houbraken, and paralleled in contemporary literature. Spiegel rejected the classical idiom, as bypassing attention to his immediate surroundings, significant to him as God's creation. In the same way Dutch landscapists were looking more closely at their surroundings. It would seem that in this respect they shared an outlook that found in the beauty of the everyday world delight for the eyes and a reflection of the beauty and wisdom of the Creator.

Another aspect of the religious conception of nature concerned the decay of earthly matter. A recurrent preoccupation of seventeenth-century thought and experience was the uncertainty and brevity of life. Reminders of it recur endlessly in moralistic literature, in genre and still-life paintings, in the contemplation of landscape in literature, and in some Dutch landscape paintings and prints.[11] While today we may take this as a melancholy image of futility, and a depressing reminder of death, contemporary sources give a different emphasis, one of

exhortation and perspective: reminders of the brevity of life were to encourage virtue in the present. Its intent thus was to turn one back to life a little wiser.[12]

In the Old and New Testament, and in the Dutch Confession of Faith the corruption of all earthly matter is directly associated with the fallen state of man and our dependence on the eternal and unchanging providence of God. The realm of nature was to serve as a constant reminder of the Fall and of the consequent uncertainty and short duration of life. When Job lamented that 'Man that is born of a woman is of few days and full of trouble', he compared man's life to the flowers of the field, to trees, to water draining away, to stones, and 'things which grow out of the dust of the earth', that are eroded and washed away by water.[13] In seventeenth-century Holland, such imagery was exploited not only by still-life and genre painters, but also by some landscapists as showing one of the essential, significant characteristics of the visible world. Furthermore, given the biblical context, such elements were particularly conducive to contemplation.

An elaborate *Allegory of the Life of Man* designed by Van Mander and engraved by J. Mathem in 1599 (Holl. 344; Fig. 5) provides an illuminating addendum to Van Mander's written comments on the depiction of still-life and landscape. While his writings focused on the variety of nature's beauties, here he emphasises the brevity of their existence, as matter for contemplation. The theme is centred on a vase of flowers and developed with other elements associated with *Vanitas*: an hour-glass, skull, other objects, and smoke. But it is also illuminated by two vistas opening onto landscape. A tree in leaf, on the left is contrasted to a tree on the right from which the leaves are falling. On the left a fisherman, idling, is contrasted with a man, staff in hand, a pilgrim on the path of life who does not turn to the right or left. On the right is a waterfall in a mountainous landscape under a brighter sky. All these elements are clarified by elaborate biblical texts which remind man that he is but a sojourner here on earth, like the leaf that grows and falls, the flower that fades, and the water that flows away. These things, it says, should teach us to number our days that we may gain a heart of wisdom, for , as it concludes, 'it would be better for him never to have received life, who will not wake up when the Lord returns'. As an exhortation to wisdom and virtue, such sentiments recur frequently in Dutch literature and art. Their association not only with genre and still-life, but also with landscape painting, results from contemporary reflection on the realm of nature, and derives from a much older tradition.[14]

In sixteenth-century North Italian and Netherlandish art various landscape types had developed in which remote mountainous or woodland landscape were associated with contemplation.[15] In these works the wilderness, as a place of prayer and contemplation on human mortality, was typically associated with St Jerome and other hermit saints. A number of North Italian examples were introduced to the Netherlands by means of engravings such as Cornelis Cort's engraving *St Onuphrius in a Landscape* (Holl. 119; Fig. 6) of 1574, which is one of a series designed by Muziano. The wilderness is characterised by a remote mountainous landscape in which a waterfall, boulders and a shattered tree stump are prominent as elements that recall the transiency of all earthly existence and man's dependence on God. The subject attracted a number of Netherlandish artists, including Jan Brueghel and Paul Bril, both of whom were also working for North Italian patrons.[16] The motif enjoyed a certain vogue in the late sixteenth and early seventeenth century. Thereafter, in the Northern Netherlands, it was modified as a landscape type, with the hermit saint discarded in deference to Protestant sensibility, and marshy woodland preferred to mountains in response to new

5. J. Mathem, after Karel van Mander: *Allegory of the Life of Man.* 1599. Engraving. Photo: London, British Museum.

6. Cornelis Cort, after Girolamo Muziano: *St. Onuphrius in a Landscape.* 1574. Engraving. Photo: Amsterdam Rijksmuseum.

artistic trends. Its continued influence, however, is attributable to ongoing reflection on mortality as embodied in landscape motifs.[17]

An interesting transitional example of this landscape type is Goltzius's drawing of *A Couple Viewing a Waterfall* (Stockholm, Nationalmuseum; Fig. 7), in which we are invited to look over the shoulders of a well-dressed couple, prominent in the foreground, and participate in their act of contemplation. The object of their contemplation, a waterfall, is familiar from earlier hermit landscapes as well as from Van Mander's 1599 allegory (Figs. 5 & 6). The artist draws attention to their contemplative attitude – assumed in the hermit pictures – by their posture, gaze, and elegant costume. The contemporary beholder would have been familiar with the recurrent image of an elegant couple in a landscape stalked by the figure of death.[18] In rejecting allegory for a more realistic image, Goltzius has replaced the the figure of death with landscape elements carrying similar associations, a process taken further by the next generation.

Landscape motifs treated as matter for contemplation are also the inspiration for Goltzius's woodcut *Fisherman by a Waterfall* (Holl. 378; Fig. 8). While there is no hermit saint nor foreground couple to guide the viewer's response, the landscape elements themselves are organised to evoke contemplation. The fisherman on the left is set beside a waterfall. Opposite him a tree stands before a watermill, with smoke emitting from its chimney. In the right foreground is a tree stump. The picture suggests a similar theme to his colleague Van Mander's print of 1599, where a fisherman featured as an image of idleness, and smoke, waterfall and trees were reminders of the brevity of life. The revolution of the water-wheel, like the hour-glass in Van Mander's print, may also be intended to allude to the constant passage of time.[19]

Roelant Savery's *Landscape with a Ruined Church by a Waterfall* (Munich, No. 2199; Fig. 9) includes a small figure of a meditative hermit. The beauty of the world, its variety of plants and animals, is contrasted to life's mutability as suggested by the waterfall, fallen boulders and trees, and, prominent in the design, a ruined church. While ruins have diverse associations, their significance to the contemporary viewer in this type of landscape is parallel to all the other mutable elements represented. They are yet further evidence of what Van Lodensteyn called the constant inconstancy of all things under heaven. As Claas Bruin wrote later of the ruined castle of Wijk bij Duurstede, the finest splendour of buildings will be deadened by time, for 'Nature loathes things that always stand before her',

7. Hendrick Goltzius: *Couple Viewing a Waterfall*. Drawing. Stockholm, Nationalmuseum. Photo: Museum.

8. Hendrick Goltzius: *Fisherman by a Waterfall*. Woodcut. Photo: Amsterdam, Rijksmuseum.

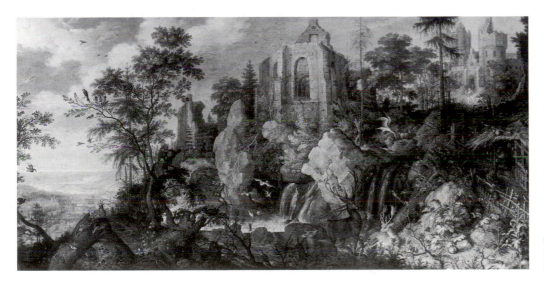

9. Roelant Savery: *Landscape with a Ruined Church by a Waterfall*. Panel, 52.2 × 104. Munich, Bayerische Staatsgemäldesammlungen. Photo: Museum.

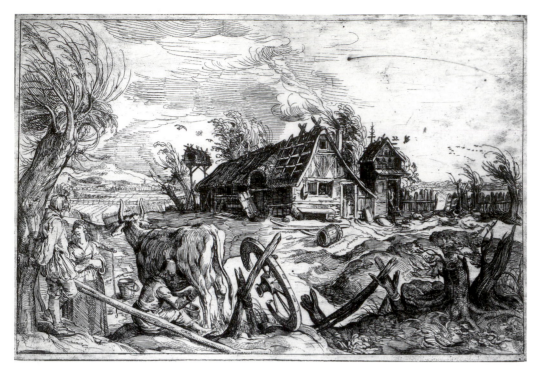

10. Jacques de Gheyn: *Milking Scene before a Farmhouse*. Etching. Photo: Amsterdam, Rijksmuseum.

a conception that is of particular relevance in considering Jacob van Ruisdael's use of motifs similar to many of those in Savery's painting, including ruins.[20]

One of the first to depict the theme of the constant inconstancy of all things under heaven in terms of the more immediate environment was Jacques de Gheyn. His etching *Milking Scene before a Farmhouse* (Holl. 293, from his drawing of 1603; Fig. 10) contains motifs that have obvious allegorical intention and which subsequently recur in many Dutch landscapes as indicative of the artist's perception of the essential structure of reality. Rather like Goltzius, De Gheyn has transposed the familiar allegory of a young couple threatened by death into a setting even more localised than Goltzius's *Waterfall* (Fig. 7). If the elegant young man on the extreme left has amorous intentions towards the milkmaid, the scene before him is an admonition to virtue in the spirit of Van Mander's 1599 *Allegory of the Life of Man* (Fig. 5). The landscape relates to the young couple as the waterfall to the couple or the fisherman in Goltzius's versions of the theme, but this time the elements are drawn from the local landscape.

De Gheyn's print does not present the idyllic setting of pastoral love, for the farmhouse shows signs of decay, a door has swung loose from its hinges, a window shutter is broken, smoke billows from the chimney (as in Goltzius's print), and a storm whips across the scene suggesting inconstancy. A novel element is the broken cartwheel, set prominently in the foreground to catch our attention and guide our reading of the other landscape elements. Its deliberate positioning alerts us to its significance as yet another manifestation of the corruption of earthly matter, this time taken from the rural landscape to which it belongs. Its usage, found elsewhere in Dutch landscapes, is entirely consistent with contemporary practice. It may be compared to a dead flower or a burnt-out candle in a still-life, or a dead tree in a woodland, or a waterfall in a mountain landscape. Ultimately it may have derived from Pieter Bruegel's print *The Triumph of Time* (published by Philippe Galle, 1574; Fig. 11) which includes a broken wheel among the artefacts of man that are strewn in the path of all-consuming time.[21]

11. Anon, after Pieter Bruegel the Elder: *The Triumph of Time*. Engraving. Photo: Amsterdam, Rijksmuseum.

De Gheyn's print reflects a significant attempt to transpose allegory into more realistic dress, much as was being done by contemporary painters of genre. In some ways his print is a hybrid of genre and landscape. His innovation was to identify and exploit the expressive potential of the local landscape in ways that were carried further by artists such as Jan van Goyen, Salomon van Ruysdael, and, later on, his nephew, Jacob van Ruisdael.

In his *Farm in the Dunes* (Cambridge, Fitzwilliam Museum, no. 1049; Fig. 12) of 1626, or possibly 1628, Salomon van Ruysdael has dispensed with the narrative incident of Jacques de Gheyn's etching, but the landscape is conceived in a comparable spirit. The composition in based on two acute diagonal axes which create a sense of instability and evoke the force of wind sweeping across the landscape. As in De Gheyn's print, smoke emitting from the cottage chimney is at once caught up in a gust of wind. The barn and gate are also subjected to this diagonal emphasis and a sense of impermanence is reinforced by the decadent state of the thatch. In the left background a cartwheel is silhouetted and beyond a man sets out into the windswept landscape. Into this bleak image sunbeams fall on the cottage, railings, roadway, and figure in the right foreground, so creating a welcome contrast.[22]

Likewise, examination of Jan van Goyen's life-like *Country Road* (Sheffield, No. 3100; Fig. 13), dated 1633, shows that the artist was not merely concerned to record a specific view, but to bring out the significant structure of the land-

12. Salomon van Ruysdael: *Farm in the Dunes*. 1626 ('28?). Panel, 30.2 × 47. Cambridge, Fitzwilliam Museum. Photo: Museum.

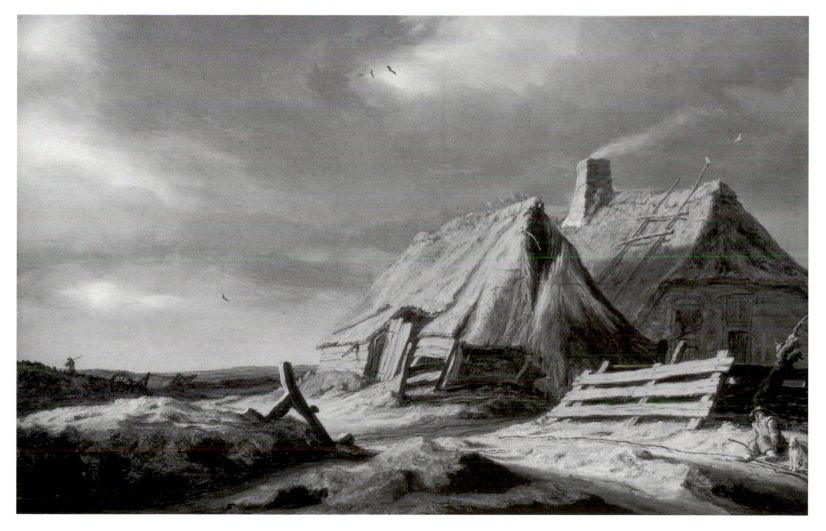

scape. It has been recognised as one of the artist's most ambitious compositions from this date. Beside trees rich in foliage, a dead tree looms up against the sky, and, prominent in the right foreground, detached from the other elements in the picture, a broken cartwheel and a wicker basket (fishing pot?) lie by the roadside in a pool of water. If it is tempting to suppose that the artist just recorded what he happened to see, their prominence surely implies more deliberate inclusion, as is also the case in works of Salomon van Ruysdael, Jacques de Gheyn, and several other contemporary landscapists who included a broken cartwheel, or at times a skeleton, in prominent locations, often the immediate foreground.[23]

Van Goyen's landscape is a classic example of selective naturalness, and is comparable in both subject and mood to other works produced in the late 1620s and early 1630s by artists such as Salomon van Ruysdael, Pieter Molijn and Pieter van Santvoort. These painters, like Van Goyen, represent the everyday world, but they represent not only what they see, but what they know of the essential structure of reality. Their works are typically composed as a combination of opposites, with sunlight breaking into a landscape menaced by wind and storm, suggesting both the well-being and mutability of life.[24] Like Dutch flower paintings, these landscapes reflect the beauty and frailty of existence, providing both delight for the eye and matter for contemplation.

Dutch poets, reflecting, as noted, ideas expressed in the Confession of Faith, contemplated not only the beauty and transitoriness of nature, but also wrote of sunbeams and storms, spring time and harvest as revealing the sustaining providence of God. In many ways this outlook harmonises the otherwise conflicting sense of beauty and mutability into an overall consciousness of peaceful well-

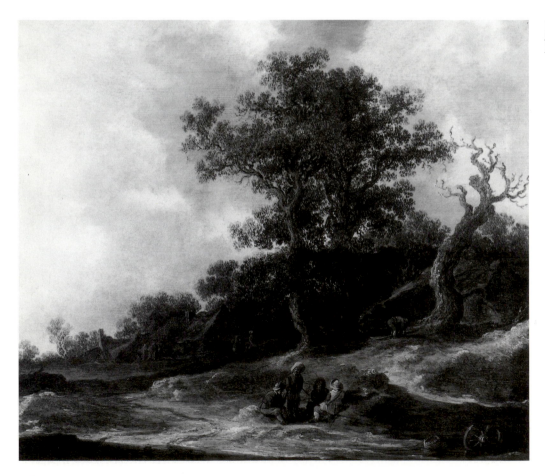

13. Jan van Goyen: *Country Road*. 1633. Panel, 51.6 × 59.3. Sheffield, City Art Galleries. Photo: Museum.

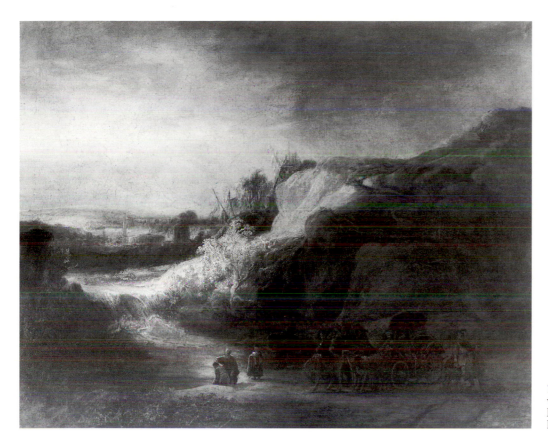

14. Rembrandt: *Baptism of the Eunuch*. 1636. Canvas, 85.5 × 108. Hannover, Niedersächsisches Landesmuseum (loan Pelikanwerke, Hannover). Photo: Museum.

being in a mutable world. Without a belief in sustaining providence, the preoccupation with corruption would be unbearable and pictorially depressing. The poetic expression of providence in the form of praise for the fertility of the land, the abundance of crops and cattle, finds almost no pictorial equivalent, and neither does the poet's praise for the light of dawn dispelling darkness and quickening the earth.[25] As for depictions of the seasons, while found at the turn of the century, they were soon outmoded.

Nevertheless, this sustaining conception of reality perhaps accounts for the repeated depiction in Dutch landscapes of sunbeams breaking out of storm-clouds that are blown across beaches, dunes, corn fields and winding roads, evoking a mood of well-being in an otherwise mutable world. This too aroused poets to reflect on divine providence.

Light-beams, as an image of divine providence breaking into a darkened world, are a commonplace of seventeenth-century religious art, not least that of Rembrandt. It is not surprising therefore that when religious subjects were given a landscape setting, it is with such light-beams that the idea of grace is conveyed. In Rembrandt's *Baptism of the Eunuch* (Hannover, No. 319; Fig. 14), painted in 1636, human mortality is evoked by familiar elements, a waterfall and shattered fir trees, here set in a darkened landscape which is pierced by a shaft of light illuminating the scene of baptism.[26] The effect is comparable to that in his famous etching *The Three Crosses* (Bartsch, 78). Rembrandt also used similar lighting effects in his little landscape painting, *The Stone Bridge* (Amsterdam, No. A 1935; Fig. 15) in which once again a dramatic contrast of sunbeam and storm-cloud evokes the sensation of light and well-being breaking into a world vulnerable to storm and change.[27]

Man's need met by divine providence is also underscored by a contrast of dark

15. Rembrandt: *The Stone Bridge*. Amsterdam, Rijksmuseum. Photo: Museum.

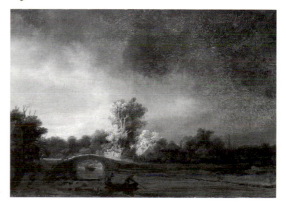

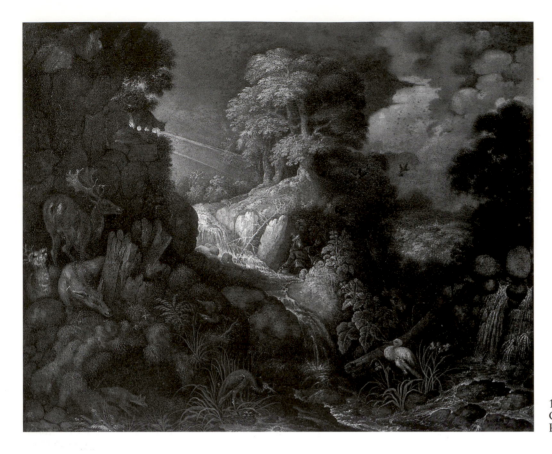

16. Roelant Savery: *Elijah Fed by the Ravens*. 1634. Copperplate, 40 × 49. Amsterdam, Rijksmuseum. Photo: Museum.

and light in Roelant Savery's *Elijah fed by Ravens* (Amsterdam, No. A 1297; Fig. 16), painted in 1634, two years before Rembrandt's *Baptism of the Eunuch*. Elijah is set in the familiar wilderness setting, three ravens descend on the right, bringing him food, while a shaft of light breaks into a predominantly dark landscape.[28]

The manner in which the landscape is represented in these paintings contributes to their meaning. The significance of the lighting in them is made explicit by their religious subject matter. But this expressive potential was also exploited in landscapes that contain no religious subject, yet, as landscapes, are probably intended both for aesthetic delight and religious contemplation. As with other types of landscapes such pictures are first found as mannerist fantasies that are subsequently recast in a more realistic, life-like mode, which in turn influenced Jacob van Ruisdael's conception of the visible world.

Among mannerist examples Goltzius's woodcut *Cliff on a Seashore* (Holl. 381; Fig. 17) would have been familiar to his contemporaries as an image of peril and salvation. It is constructed according to a traditional scheme found in paintings, prints and emblems of both earlier and later date, of which an earlier example is the *Sea Storm* in Vienna of around 1568/9 formerly attributed to Pieter Bruegel.[29] The essence of this scheme is conveyed by a binary composition, one side representing peril and the other safety, the division in Goltzius's woodcut being emphasised by the prominent rock in the centre. On the right under a dark, stormy sky a ship is tossed in heavy seas perilously close to rocks. It sails towards the left, where a church spire points to a clear sky, accentuated by darker shading on the water. In the centre foreground a monk prays by a crucifix, the scene before him playing an analogous rôle to the waterfall in the wilderness theme. The sentiment behind this image, and others like it, is illustrated by the epigram under Whitney's emblem (Leiden, 1586) of a ship at sea passing under a dark to a

17. Hendrick Goltzius: *Cliff on Seashore*. Woodcut. Photo: Amsterdam, Rijksmuseum.

light sky. The ship that survives the perilous seas is compared to man attaining salvation: '. . . And if he keepe his course directe, he winnes/That wished porte, where lastinge joye beginnes'. A Dutch emblemist, B. Hulsius used the same image to emphasise divine providence by reference to Psalm 107. 23–8, which says that those who sail the seas behold the wonders of the Lord who both raises up the stormy wind and waves, and brings calm and deliverance. In both the painting formerly attributed to Bruegel and Goltzius's woodcut the relation of church spire to clear sky underscores that deliverance comes from the hand of God.[30] This association of storm and calm with divine providence parallels the sentiments expressed by Huygens, and later Poot in his poem *Summer Storm*, reflecting the persistence of such religious reflection on natural phenomena.

A *Beachscene with Shipwreck* (The Hague, No. 969; Fig. 18) was painted by Jan Porcellis in 1631, the same year that Hulsius published his ship emblem. While Porcellis may not have seen the emblem, he certainly knew the theme, and was perhaps familiar with Goltzius's woodcut. Following current practice, Porcellis transformed this theme into a more realistic idiom, representing peril by a ship sinking off the coast of Holland, and safety by a rescue party setting off from the shore. Menacing storm-clouds hang over the sea, while light shines down on the safety of the land. There is no praying monk in the foreground, but a more fitting substitute, a couple whose distinct costume and location differentiates them from the others as spectators not participants.[31] The couple are faced by an everyday example of the uncertainty of life, which is more immediate and compelling than the remote waterfall in Goltzius's drawing (Fig. 7), or the ship in his wood-cut (Fig. 17). We recall that the poet Oudaen wrote in praise of a painting of a *Storm* by Porcellis that the artist did not flinch from experiencing the reality of

18. Jan Porcellis: *Beachscene with Shipwreck*. 1631. Panel, 36.5 × 66.5. The Hague, Mauritshuis. Photo: Museum.

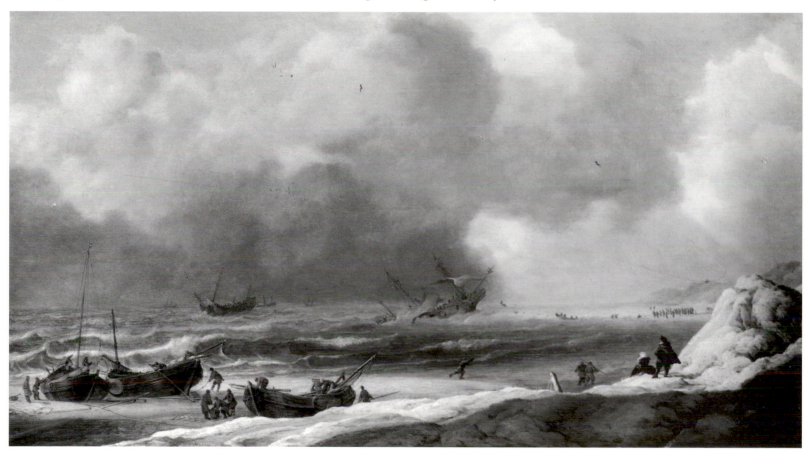

'this raging element' in order to paint it true to life ('*om levend na te gaen*'). But such lively imitation was subordinated to understanding. As we look over the shoulders of the spectator couple, we discover in the sunbeams breaking out of cloud more than a fortuitous incidence of light, and appreciate that the artist has articulated elements of the visible world to create a sense of providence amidst life's uncertainty. The way in which the seventeenth-century spectator contemplated such a subject is shown by the prominence given to a comparable painting in Cornelis de Man's *Family Meal* (Malibu, J. Paul Getty Museum; Fig. 19), executed some twenty years after Porcellis's picture. As the domestic virtues are displayed by members of the family, above them, in the painting within the painting, a couple by a beacon gaze at a ship at sea under a dark sky, illuminated by a shaft of light, a reminder to the family to look to the light as they continue on life's uncertain voyage. After the 1630s seascapes as allegories of faith are rare, but artists continued to exploit this combination of opposites, depicting man on the seas as vulnerable to the elements, yet secure.[32]

19. Cornelis de Man: *Family Meal*. Canvas, 59.5 × 73.5. Malibu, California, Collection of the J. Paul Getty Museum. Photo: Museum.

Even when there is no contemplating couple and no specific allegorical allusions are intended, such perceptions of nature continued to influence the representation of landscape in art as images for delight and contemplation. Painters such as Jan van Goyen, Aert van der Neer, Salomon van Ruysdael, and his nephew Jacob selected their motifs and structured their pictures not merely to represent what could be seen, but rather to characterise the essence of Nature, evoking both the well-being and mutability of life, while at the same time providing a feast for the eyes.

A typical dimension of their image of Nature is an interplay of storm-clouds and light-beams, as seen in Porcellis's *Beach Scene*. While its roots lie, as we have seen, in religious art and allegorical landscape, it became established as part of the Dutch landscapists' characterisation of the world. An early example is Joos de Momper II's *Spring* (Brunswick, No. 64; Fig. 20), from a series of *The Four Seasons*. He creates a microcosm much as Esaias van de Velde's *Ferry* (Fig. 4) does, and as Van Mander advocated in his *Grondt der Schilderkonst*. People are busy with their different activities, the roads are travelled, and the houses inhabited; they are loading wagons, pruning trees, and laying out the linen; birds grace the water and enliven the sky; and animals are in the fields. A characteristic feature of this little

20. Joos de Momper II: *Spring*. Panel, 55.5 × 97. Brunswick, Herzog Anton Ulrich-Museum. Photo: Museum (B.P. Keiser).

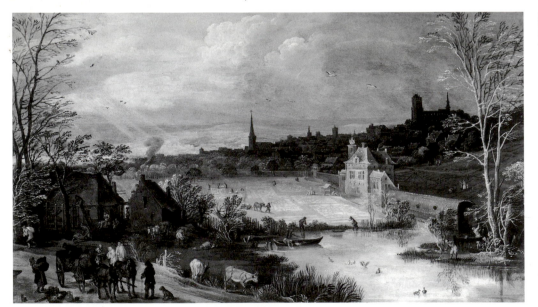

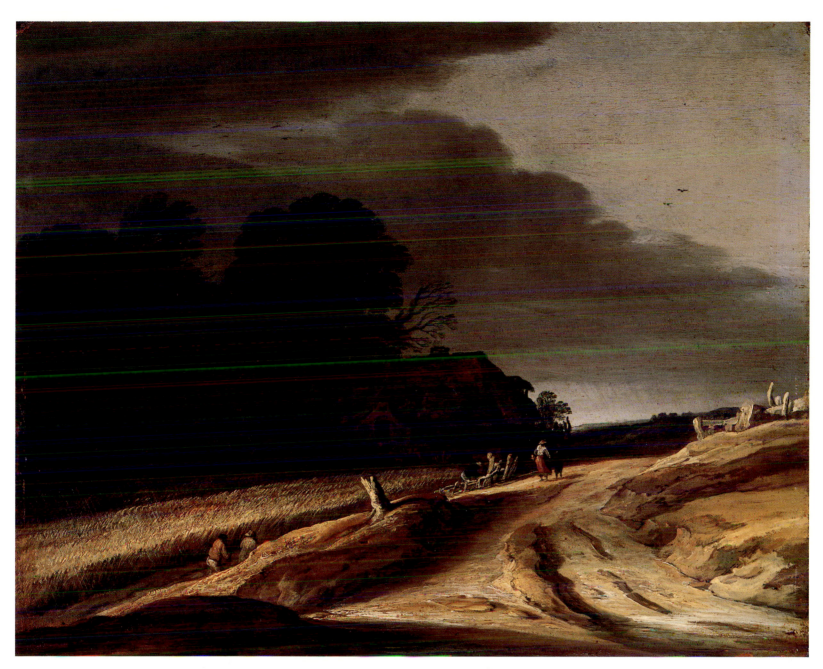

21. Pieter van Santvoort: *Sandy Road*. 1625. Panel, 30 × 37. Berlin-Dahlem, Staatliche Museen, Gemäldegalerie. Photo: BPK (Jörg P. Anders).

world is its lighting. The landscape is set under a dark, stormy sky in which a rainbow is visible on the right, and a shaft of sunlight illuminates the bleaching fields from the left. The presence of a rainbow in a painting of spring within a series of the seasons must be an allusion to the Covenant in Genesis 8.22 that while the earth remains, seed time and harvest shall not cease. Rays of sunlight bleaching linen, found in literature as an allegory of man's dependence on God, here suggest daily activity sustained by providence.[33]

As we have seen, the next generation of landscapists replaced such additive compositions with more selective representations, but such oppositions of storm–cloud and sunlight continued to attract landscapists, culminating in Jacob van Ruisdael's *Haarlempjes*, with their bleaching fields illuminated by a grandiose play of sunlight and shadow. Preceding him, we find that the structure of Pieter van Santvoort's *Sandy Road* of 1625 (Berlin-Dahlem, No. 1985; Fig. 21) is built on this same opposition of storm–cloud and sunlight. It is an early example of this

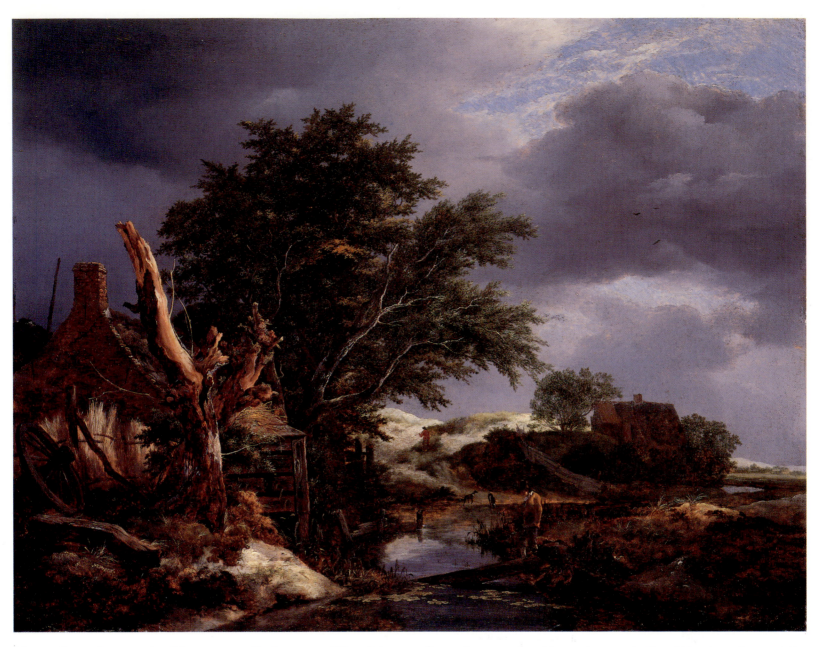

22. *Landscape with Blasted Tree by a Cottage*. 164–(7?). Panel, 52.7 × 67.6. Cambridge, Fitzwilliam Museum. Photo: Museum.

binary formula conceived in more realistic terms. The element of transience and man's vulnerability is conveyed by wind blowing the trees and the figures on the path, rain falling on the cornfield on the left and low in the sky in the background, and by storm-clouds overhead; it is also seen in the dead tree leaning over the cottage, and the prominent tree stump in the centre foreground, a motif that can be traced back to Pieter Bruegel, and even earlier examples.[34] Into this unsteady world, light falls on the figures and on the cornfield, as on the bleaching field in De Momper's painting, and counter-balances the other elements with a sense of well-being. Van Mander wrote in his *Grondt*, 'We are reproached by some people that we never represent fine weather, but always show the sky showery and full of clouds, and only allow Apollo a small aperture through which he can cast his rays (on the land) below'.[35] It is evident that such traditions did not die with Van Mander for sunlight breaking into a stormy landscape, as a typical characterisation of the world, is found in many paintings of the 1620s and 1630s by artists such as Jan van Goyen, Salomon van Ruysdael, Pieter Molijn, Jan

Porcellis, Simon de Vlieger, Rembrandt, Adriaen and Isaack van Ostade.[36] Some modern viewers may be skeptical of seeing such light effects as anything more than a pictorial device and a faithful rendering of Dutch weather conditions – which they are. But taken in context one may deduce that a contemporary viewer would also have been aware of the conventionality of such imagery and aroused to reflect on its deeper spiritual significance. The above-mentioned painters employed more realistic stylistic means than were used by De Momper and the earlier generation. But, like them, they represented the world as they perceived its essence, mutable yet irradiated by light.

Jacob van Ruisdael turned to this trend of landscape painting as he began to develop the means with which to characterise the visible world. Indeed, he became its finest exponent. In his *Landscape with Blasted Tree by a Cottage* (Cambridge, Fitzwilliam Museum, No. 84; Fig. 22) of 164–(7?) one can recognise his youthful attempt to exploit some of the resources available to him as a painter in Haarlem. He articulates the familiar elements of cottage, living and dead trees, prominent cartwheel, dark blustery sky, and shafts of light in a dune landscape with new force and weight. In comparison to Pieter van Santvoort's *Sandy Road*, his painting appears detailed and heavy, the gaunt silhouette of the shattered tree over dramatic, but the whole is worked up with a substance and strength that suggests both in its style and its subject matter the future direction of his art.

If landscapes of the Dutch school are conceived as a mirror of nature, it is evident that prevailing conceptions of the world influenced the reflection of nature in art. Just as seventeenth-century science is less purely rationalistic than has been presumed, and the literature of Bredero and his contemporaries has little 'unprejudiced description', so the naïve realism of the landscape painters is more apparent than real. In stressing the influence of religion on man's understanding of nature in seventeenth-century Holland, this is to be taken as one significant influence among others on the manner in which Dutch painters represented landscape. Furthermore, such religious thinking did not so much lead artists to create landscapes that are emblematic or explicitly symbolic, but rather it influenced what was perceived as contributing to a natural and representative image of nature. In the works of Jacob van Ruisdael the thoughtful selection and the powerful expression give particularly distinct form to what may be loosely described as a typically Dutch Protestant view of nature. The characteristically Dutch perception of the world, influenced by contemporary religious thought is reflected in the lack of idealisation in Dutch landscape painting, where nature is shown with its faults, as humanistic art theorists objected. Although it appeared to be an art of imitation without choice, in fact the Dutch landscapists did exercise selection, but according to a different set of values. The everyday world had innate worth without being idealised; indeed, its mutability was itself of significance.

Dutch paintings of landscape can be enjoyed on different levels, for their associations with the actual landscape, delighting the eyes, refreshing the mind, and inviting deeper contemplation. If there was something unique in the outlook of the Dutch landscapists, it was that they were raised to believe that the world around them was worthy of scrutiny and depiction. As Houbraken wrote, they attempted to imitate nature as best they could, so much the better to show forth its wonder for the viewer. Such an outlook certainly contributed both to the naturalness of the images and to the process of selection.

In the case of Ruisdael, we find that he drew on many trends within contemporary art and culture, appealing to various levels of response, but perhaps more

intensely than other landscapists of the period he articulated the contemplative mode inspired by religion. There was an established framework for perceiving and depicting landscape from which Ruisdael took his early inspiration and onto which he built further.

While the contemporary viewer would have been aware of the contemplative mode and understood the outlook that sustained it, this is not always the case for the modern viewer. How then is the modern viewer to ascertain such an intention? First, by paying attention to the original context of such landscapes, including the contemporary view of nature as God's 'second book' and the response of poets to particular facets of landscape. Second, in noting the recurrence of selected features of nature, the viewer will become aware of the mediating conventions, both artistic and associative, that influenced the representation of nature in art. One will also recognise that since Dutch landscape paintings resulted from a process of selective naturalness, something of the inherent meaning and structure of nature, as then understood is revealed. Thus while contrasted living and dead trees, ruins, flowing water or waterfalls, opposing storm-cloud and light-beams, and other such elements have a symbolic quality and may be taken as what De Jongh has called 'tone-setting devices', it is nevertheless important to bear in mind, as Kouznetsov has pointed out, that the symbolic content of Dutch landscapes is found in the vital and essential phenomena of nature itself. An artist such as Ruisdael draws attention to these through his selection of motifs and the formal structure and emphases of his compositions. His pictures thus invite contemplation of the inescapable process of growth, change and eventual decay, as well as the inherent tension between corrosive and nurturing forces, as essential characteristics of our natural environment. An awareness of the recurrence and conventional associations of such elements of landscape should help to alert the modern viewer to the presence of imagery the conventionality of which would have triggered a set of associations shared by both artist and contemporary viewer.

In studying Ruisdael's oeuvre we will also consider his manipulation and refinement of such conventions as seen in both his selection of motifs and varying manner of representing them. It should thus become apparent that his landscapes are not merely dramatic renderings of the local scene nor are they just a series of encoded symbolic messages embodied in landscape, but rather he presents us with images of great range and variety which at the same time express a unified underlying vision of reality.

CHAPTER IV

Ruisdael's Works: The 1640s

By the time Ruisdael began painting, Dutch painters and printmakers had developed a variety of landscape types. These included dunes and country roads, panoramas, river scenes, woodlands, beachscenes, marines, winters, and town views; also paintings of foreign scenes: alpine, Italianate and exotic. Despite a general tendency to specialisation in one or more of these categories, Ruisdael was to master all but the Italianate.

Ruisdael dated many early works, but after 1653 the incidence of surviving dated works is too sporadic to give any indication of his development.[1] It is therefore difficult to establish an accurate chronology of Ruisdael's paintings, given also his range and flexibility. Variations in scale, conception, and execution result in totally different works of similar date, for example the intimate *Wooded Road* in Amsterdam (Fig. 84) and the monumental *Bentheim Castle* in the Beit Collection (Fig. 78), both of 1653. Rosenberg's study has proved an indispensible guide to Ruisdael's development and remains valid, subject to some modifications. Analysis of composition, colour and manner of execution, in conjunction with his changing tree types, lighting, space, and cloud structures, remain the most satisfactory guide to Ruisdael's development. Dated works by his imitators are an additional guide, and costume is an indication for some of the later works.

Ruisdael emerges in 1646, a young man aged seventeen or eighteen who demonstrates exceptional technical and pictorial precosity. Today there remain about seven hundred oil paintings, a little over one hundred drawings, and thirteen etchings that are attributed to him. His oil paintings, following contemporary practice, are either on a wood panel or canvas support, with the former more common in his earlier works, and almost all works executed after about 1653 being on canvas. This tendency for canvas to replace panel around the midcentury is widespread in Dutch landscape painting. Ruisdael, more than his immediate predecessors, takes advantage of the oil painting's potential to superimpose one layer of paint over another. He builds up his surface into a dense, rich and at times quite thick application of paint. This heavy impasto contrasts with the technique of landscapists such as his uncle Salomon van Ruysdael and Jan van Goyen, whose thinner, more fluid films of oil paint leave the underlying ground paint partially visible especially in the sky. Such fluidity is seen in some of Ruisdael's earliest works, while in his late works his typically heavy impasto is less evident, and the execution often rather tight, thin, but retaining a crisp definition of detail.

Ruisdael's extant drawings rarely relate to the exact composition of existing paintings, although a number of paintings include architectural details that derive from surviving drawings. A large number of the surviving drawings are formal compositions, like his paintings. They are executed in black chalk and have been worked up with pen and ink detailing, grey ink washes and occasional touches of colour. Some of these are also signed and dated, suggesting their status as works of art prepared for sale in their own right. A few of his surviving drawings appear to be sheets from a sketchbook used out of doors. Many, like the paintings, appear to be studio products. While the artist certainly did draw out of doors,

most of the drawings that survive appear to have been, at the very least, completed in the studio. The way in which certain motifs reappear in a number of Ruisdael's paintings, often years apart, but given different settings, suggests that he kept a number of other working drawings in his studio, beyond those that have survived. It is also likely, to judge from the evidence of surviving paintings, that his pupil Hobbema, and Jan van Kessel, another artist in his circle, made use of these in their formative years. Ruisdael's few etchings are technically quite experimental, having a density of line that parallels the richness of his paint surfaces. In composition and subject matter a number of them are similar to his paintings, suggesting reliance of both on drawings in his studio.

His early works are limited in the range of motifs, but at once reveal fresh and vigorous solutions to old pictorial schema. His range of invention and compositional strength profits from his trip to the German border country in 1650 and his subsequent move to Amsterdam around 1653. The achievement of the fifties is refined in the sixties, yielding his most mature output. From the early seventies onwards his motifs become reduced in scale, quieter in expression, and some show a marked deterioration in quality. His refinement of various themes can be observed by studying their development. They reveal something of his aims and working methods: the selection, rejection, and combination of elements; the accentuation of particular facets of nature; the attempt to give more effective expression to his conception of the subject; and his varying response to nature and to his cultural environment.

The subject matter of Ruisdael's early paintings was derived from three areas where members of his family were settled: the surroundings of his native Haarlem; Egmond aan Zee, to the north, near Alkmaar; and the coastal region near Naarden, southeast of Amsterdam. His pictures are unpretentious representations of the trees, bushes, dunes, cottages, churches and mills of these localities, executed with scrupulous attention to detail. He painted dunes and country roads with cornfields, woodlands, coastal scenes, and panoramas. His approach to these motifs resembles the type of dune landscapes with travellers on country roads established by Jan van Goyen, Salomon van Ruysdael and Pieter van Santvoort in the mid-to-late 1620s (see Figs. 12, 21 and 24), and ultimately derives from earlier print series, such as C.J. Visscher's 'Plaisante plaetsen', published around 1611. These dune landscapes belong to the type that Schama has characterised as expressing 'the modest virtues of the homeland' and 'the emergence of a native aesthetic, poetically expressed', a poetry of 'aggressive localism', being a 'highly selective and value-laden presentation of a particular kind of native habitat'.[2] The landscape in Ruisdael's works is typically seen under cloudy skies illuminated by a burst of sunlight, as it had been in works of the older generation. Ruisdael departs from them in giving less prominence to figures and buildings, and in showing a keener interest in rendering the specific characteristics of the indigenous vegetation, perhaps, as Houbraken later commented, so much the better to show forth its wonder to the viewer.

A remarkable group of paintings, drawings and etchings, handled with verve and assurance, are dated 1646, two years before the artist's recorded admission to the guild as a master in 1648. If his training proceeded according to the strict guild regulations, then his three-year apprenticeship would have fallen in the years 1643–1646, aged about fifteen to eighteen, or fourteen to seventeen, according to his actual birthdate. Thereafter, as a *vrije gast* but not a master in 1646 and 1647, he could both sign and sell his works. What preceded his precocious achievements of 1646 is difficult to determine. It has been suggested that his three

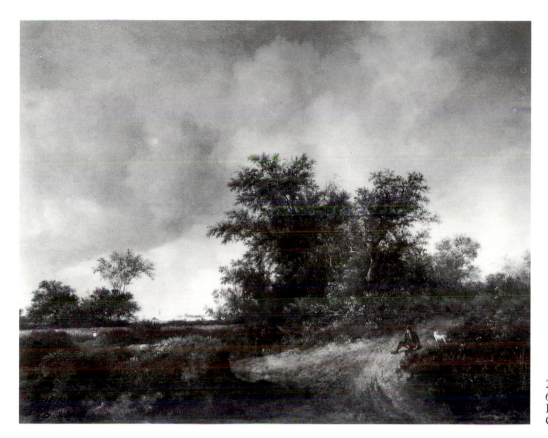

23. *Country Road with Cornfield.* 1645 ('46?). Panel, 68.8 × 87.5. Paramaribo, Surinam Government Building. Photo: Frequin (courtesy of H.M. Cramer, The Hague).

24. Jan van Goyen: *Country Road.* 1629. Panel, 41.4 × 66.6. Munich, Bayerische Staatsgemäldesammlungen. Photo: Museum.

25. Isaack van Ruysdael: *Country Road.* Panel, 47 × 64. Stockholm, Nationalmuseum (as Gerrit van Hees). Photo: Museum.

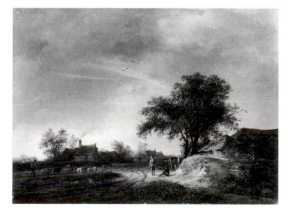

tiny oval etchings (Keyes 11,12,13) and perhaps some of the drawings in the 'Dresden sketchbook' (see Fig. 35) may be earlier.[3] There is also one surviving painting that bears his signature and the clearly legible date of 1645, his *Country Road and Cornfield* (Paramaribo, Surinam Government Building; Ros. 534; Fig. 23). It is perhaps a prototype of the much larger and more refined version of the same subject, the *Dune Landscape* in Leningrad (No. 939), which is dated 1646.[4] Their subject matter, type of vegetation, composition and handling of paint are typical of his early works. In the Paramaribo version of 1645 a clump of trees on a dune under a cloudy sky divides the scene into two parts, comprising a wooded, upright, near-view and an open, horizontal far-view. On the right, illuminated in a patch of sunlight, a man accompanied by two dogs rests on a sandy bank beside a country road, flanked by trees and scrub. He looks out on the scene to the left, where a cornfield is screened by dunes and a hedge, with a church spire seen in the distance beyond. A man and a boy make their way along a central path, leading our eye towards the distant village. In the Leningrad version of the following year, 1646, the trees are much larger, sheltering a little cottage, and the artist has added a felled tree trunk in the immediate foreground, adding to the sense of peace and well-being the dimension of time and its passage.

The figures animate the scene with a human presence but also serve to lead our eye into and through the landscape itself. They induce us into a vicarious experience of the landscape, which becomes a substitute for an actual walk through the countryside, so cherished by some of the Dutch poets.

Dunes and country roads of the indigenous Dutch landscape were recurrent themes for Dutch landscapists of the generation immediately preceding Jacob van Ruisdael, (Figs. 24 and 25). In Ruisdael's hands less emphasis is given to buildings and more to trees and other vegetation. While the effect is therefore of passing through an environment more remote from the village, it remains a humanised

landscape, enlivened by an occasional cottage, a church spire and human figures. By contrast to the busy activity of Van Goyen and Ruisdael's uncle Salomon, Jacob's pictures offer the beholder a peaceful environment for quiet reflection.

The identity of Ruisdael's first master is unrecorded.[5] The novice emerges among a group of minor Haarlem landscapists, Guilliam Dubois, Jan Vermeer van Haarlem, Jacob van Mosscher, Gerrit van Hees, Klaas Molenaer, Claes van Beresteyn, and his own father, Isaack van Ruysdael. Their subject matter: wooded dunes and country roads, was derived from the same sources as Ruisdael's, while their denser tonality and more detailed handling, like Ruisdael's, owes a debt to another Haarlem artist of the older generation, Cornelis Vroom.

Ruisdael's early compositions, in both paintings and etchings, bear most resemblance to a small group of works which can be attributed to his father, Isaack van Ruysdael. This may only indicate that they worked together for a while, but it may also be that the son's compositions, limited range of colour, subdued tones, and stippling of tree foliage in his earliest works reflects lessons learned from the father. While these may have been formative elements of his taste, they were something that in technical and imaginative accomplishment he soon outgrew.

Isaack was active as a landscapist by the mid-thirties. The *Country Road* (Stockholm, No. NM 1173; Fig. 25) attributed by Simon to Isaack is catalogued as Hees. Stylistically, though, it accords closely with other works by or attributed to Isaack and differs significantly from those of Hees.[6] Simon thought Isaack's Stockholm *Country Road* probably derived from the time when Van Goyen was staying in his house, 1634, citing its similarities of subject and style to, for example, Van Goyen's *Country Road* of 1629 (Munich, No. 6398; Fig. 24).

Isaack's binary composition, derived from Van Goyen, and seen in the *Country Road*, could have provided the model for Jacob's early works. Its upright near-view and horizontal far-view, with a winding road leading down the centre, linking the parts, was seen in Jacob van Ruisdael's *Country Road and Cornfield* of

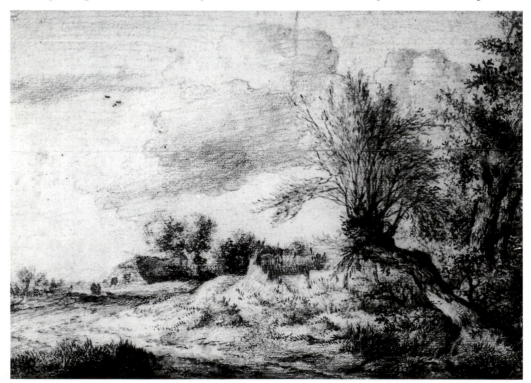

26. *Country Road with Farmhouses and Leaning Willow*. 1646. Drawing. Black chalk, grey pen and pencil, 140 × 200. Private Collection. Photo: Courtesy of Jeroen Giltaij, Rotterdam.

1645 (Fig. 23). It also provides the structure for some of his earliest preserved drawings, such as the 1646 dated *Country Road with Farmhouses and leaning Willow* (private collection; Giltay 105; Fig. 26). This drawing is not a quick sketch, direct from nature. It is carefully composed to combine elements of woodland, dunes, farmland and a large expanse of clouds and sky. It is delicately drawn in black chalk worked up with fine pen lines, like other early drawings. It reflects the same careful attention to the detailed characteristics of vegetation seen in his early paintings and etchings. While the composition recalls those of his father, and of Van Goyen, the attention to detail is closer to works attributed to his father than to those of his uncle or other older masters of the Haarlem School, apart from Cornelis Vroom.

The similarity of works by father and son is most evident in the case of Jacob van Ruisdael's *Woodland Road* (formerly Leonard Koetser Gallery, London; Fig. 27) of 164–(6?). It may be compared in conception, pictorial structure and even mood to his father's *Wooded Road* (Munich, WAF, No. 913; Fig. 28), which is monogrammed, lower right, IVR, and was first attributed to Isaack by K.E. Simon in 1935. Isaack's stippling of the foliage, apparent here, as in the Stockholm picture, is adopted by Jacob in his painting, and the scale and position of the figures is very similar. They may in fact be by Isaack, who, in Simon's view, not infrequently contributed the staffage to Jacob's early works. Whether this is in fact the case is debatable, but certainly there are distinct types of figures and dogs that occur in a number of Jacob's early works that are very similar to those of his father and that do not recur in Jacob's later pictures.[7] They are more detailed in execution and more precise in draughtsmanship, qualities also found in Isaack's paintings that are not surprising in one who also designed tapestry cartoons. By contrast, Jacob's figures are usually executed in a manner that is swifter, freer, and suggestive rather than descriptive.

From the evidence of paintings it would appear that Isaack and Jacob journeyed together to Egmond aan Zee in or before 1646, the date on Jacob's *View of Egmond* (Eindhoven, Philips collection; Ros. 29; Fig. 29). A second *View of Egmond* in the Philips Collection (Ros. 28; Fig. 30) attributed by Rosenberg and Slive to Jacob, is monogrammed IVR identically to the Munich *Wooded Road*, as Simon discovered.[8] The highlights on the figures and the rush-covered boxes are similar to those on the figures and bound-rush fence in Isaack's Stockholm *Country Road*. Reluctance to attribute these paintings to Isaack is no longer valid, in view of the appearance on the London art market in the late 1960s of a painting of a *Courtyard with a Woman laying out Linen* (Mr & Mrs Seymour Slive, Cambridge, Mass.; Fig. 31). It is identical in execution, signed lower right IVRUISDAEL and dated 1646, the initials being formed just like the monograms on the other two paintings.[9] Besides the IVR monogram, the precise detailing of the tower and cottage windows, graphic rather than painterly, the speckled foliage, and the more old-fashioned conception of the subject, support the attribution of these pictures to Isaack.

His son's *View of Egmond*, taken from the land side, like C.J. Visscher's 1615 lottery print, *Egmondt-op-zee*, offers the first foretaste of his later and much finer panoramas. Despite its bold conception, with dominant church tower looming up against the sky, it has a somewhat naïve air. The sea is rather lifeless, the forms of the dunes are harshly delineated, and the monochromatic colouring, derived from tonal paintings of the 1640s, is heavy, dark and foreboding. The cottages in the centre, bathed in sunlight, stand out as the most animated passage in the picture, both in execution and effect. The Glasgow version (No. 34), painted

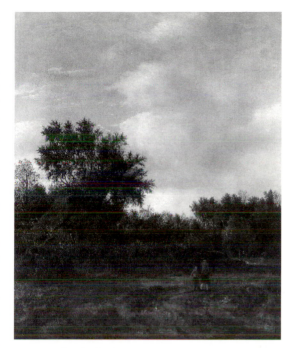

27. *Woodland Road*. 164–(6?). Panel, 35.5 × 30. Formerly Leonard Koetser Gallery, London. Photo: A.C. Cooper (courtesy of Edward Speelman Ltd., London).

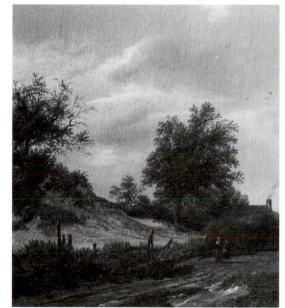

28. Isaack van Ruysdael: *Wooded Road*. Panel, 30 × 28. Munich, Wittelsbacher Ausgleichsfonds. Photo: Courtesy WAF, Munich.

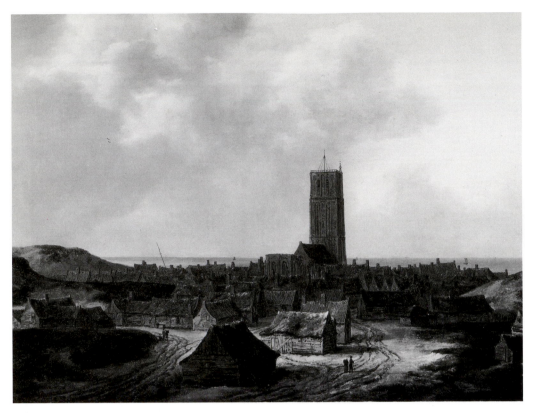

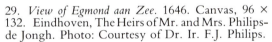

29. *View of Egmond aan Zee*. 1646. Canvas, 96 × 132. Eindhoven, The Heirs of Mr. and Mrs. Philips-de Jongh. Photo: Courtesy of Dr. Ir. F.J. Philips.

perhaps a year or two later or even in the early 1650s, is much more confident in the handling of space and lighting; there is more contrast between land and sea, and the supple handling of houses and dunes adds vitality to the picture.[10] However, as possibly one of his earliest works, the picture of 1646 is nevertheless remarkable as a first essay in panoramic town views. In comparison to earlier representations of such fishing villages, it is less topographic and more atmospheric than Visscher's print, and it also omits the fishermen and nets depicted by Van

30. Isaack van Ruysdael: *View of Egmond*. Canvas, 87 × 130.5. Eindhoven, The Heirs of Mr. and Mrs. Philips-de Jongh. Photo: Courtesy of Dr. Ir. F.J. Philips.

Goyen, Salomon van Ruysdael and others in the 1630s. While capturing the atmosphere of such a Dutch of fishing village, poised on the dunes before the expanse of sea and sky, Ruisdael shows less concern to underscore the patriotic associations of such fishing villages Schama has attributed to such pictures by the older generation, and which Isaack, as a member of that generation, was still interested in evoking (Fig. 30).[11]

Ruisdael's 1646 etchings show marked originality and form a significant feature of his early development.[12] His activity as an etcher is however limited to thirteen known prints, all produced in the first decade of his career and five of which exist only in unique impressions, suggesting their experimental nature. His first essays in the media were probably the three tiny undated prints in oval format (Keyes 11,12,13), the compositions of which K.E. Simon related to works which he attributed to Jacob's father Isaack.[13]

Two much larger etchings are dated 1646, his *Cottages and Trees on a Dike* (Amsterdam, Rijksprentenkabinet; Keyes 1, II; Fig. 32) and the *Farm in the Dunes* (Amsterdam, Rijksprentenkabinet; unique proof; Keyes 2; Fig. 33). The former reveals Ruisdael's early mastery of the technique: the foliage is delicate in touch, and the intensity of shading carefully controlled. The wind-blown trees, leaning from the top of the dike, are similar to Isaack's trees, and the subject and composition is virtually identical to that of a painting attributed by Simon to Isaack: *The Dike* (private collection, USA; Simon, 1935, pl. I, C). Spatial recession is suggested by a double diagonal scheme favoured by Dutch landscapists, and here incorporated in a composition subsequently revised in the 164−(7?) *Landscape with Blasted Tree by a Cottage* (Cambridge, Fitzwilliam Museum, No. 84; Fig. 22).[14] His other etching of 1646, the *Farm in the Dunes* (Fig. 33) is more vigorous. As a bold experiment in powerfully contrasted lighting, it recalls the storm landscapes by Pieter van Santvoort (Fig. 21), Pieter Molijn, and his uncle Salomon from the twenties and thirties more than subsequent developments in landscape. It is

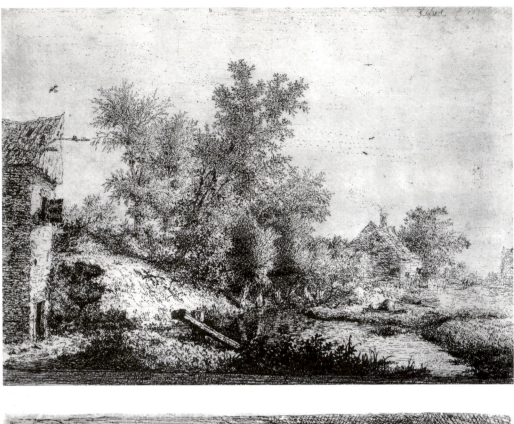

32. *Cottages and Trees on a Dike*. 1646. Etching, 204 × 281. Photo: Amsterdam, Rijksmuseum.

33. *Farm in the Dunes*. 1646. Etching, 150 × 213. Photo: Amsterdam, Rijksmuseum.

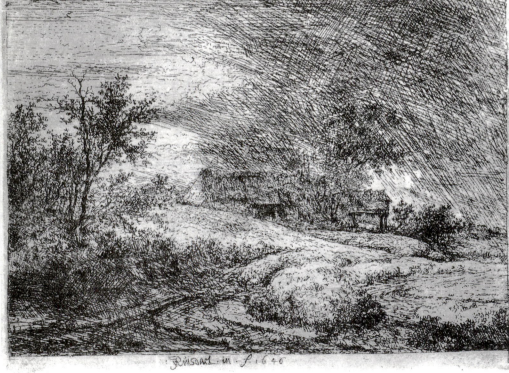

however no match for Rembrandt's majestic use of chiaroscuro in his *Three Trees* etching of 1643, the composition of which inspired a painting of Jacob's dated 1648 (Fig. 50). The composition of Ruisdael's 1646 etching uses similar elements and spatial manipulation to his drawing of a *Country Road with Farmhouses* . . . of the same year (Fig. 26). The composition is reversed in a painting of 1648 (Fig.

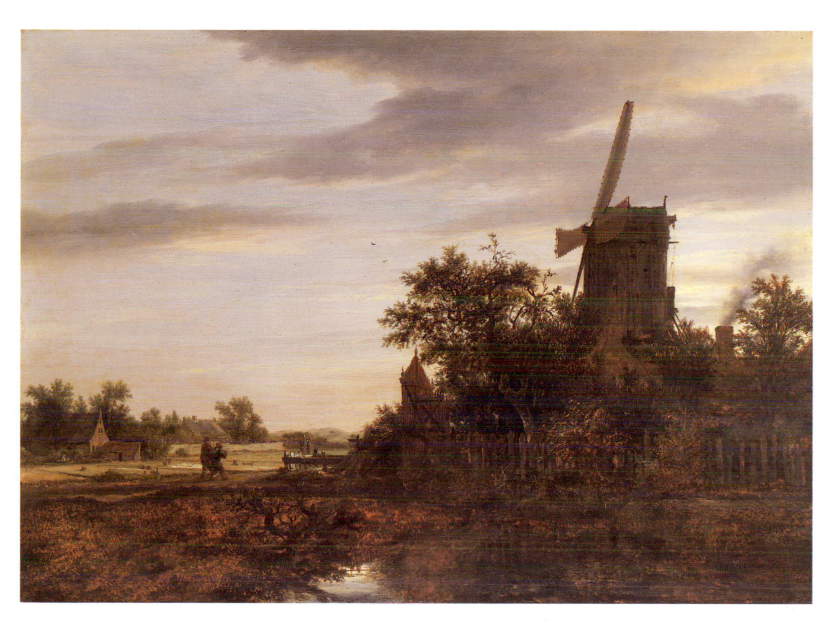

52), which perhaps, like the etching, was dependent on a lost sketch. The inter-relations between his compositions and imagery in different media reflect the experimental nature of these early works. The effect of the dark thunderous sky in the etching was pushed even further in another smaller etching, *Trees by a Pond* (Keyes 10), in which the variegated texture of diverse vegetation barely emerges from the overall mass of dense, dark lines. The composition of this etching is itself mirrored in the equally dark painting of a dense *Woodland Pond* in Budapest (No. 263).[15] Like the Cambridge picture of 164–(7?) (Fig. 22) it features a brilliantly illuminated blasted tree set against a stormy sky. Such works reflect the young Ruisdael's early efforts to accentuate the drama in nature between storm clouds and light-beams, which was a feature of the landscapes of the older gen-eration. His early attempts are prone to an exaggeration which is moderated successfully in his subsequent work. The underlying theme continued to interest him for many years, reaching its finest and most subtle expression in works such as his *Mill at Wijk bij Duurstede* (Fig. 156).

Another aspect of that masterpiece is anticipated in one of Jacob's most striking paintings from 1646, the *Windmill by a Country Road* (Cleveland, No. 67.19; Fig.

34. *Windmill by a Country Road.* 1646. Panel, 49.5 × 68.5. The Cleveland Museum of Art, Mr. and Mrs. William H. Marlatt Fund, 67.19. Photo: Museum.

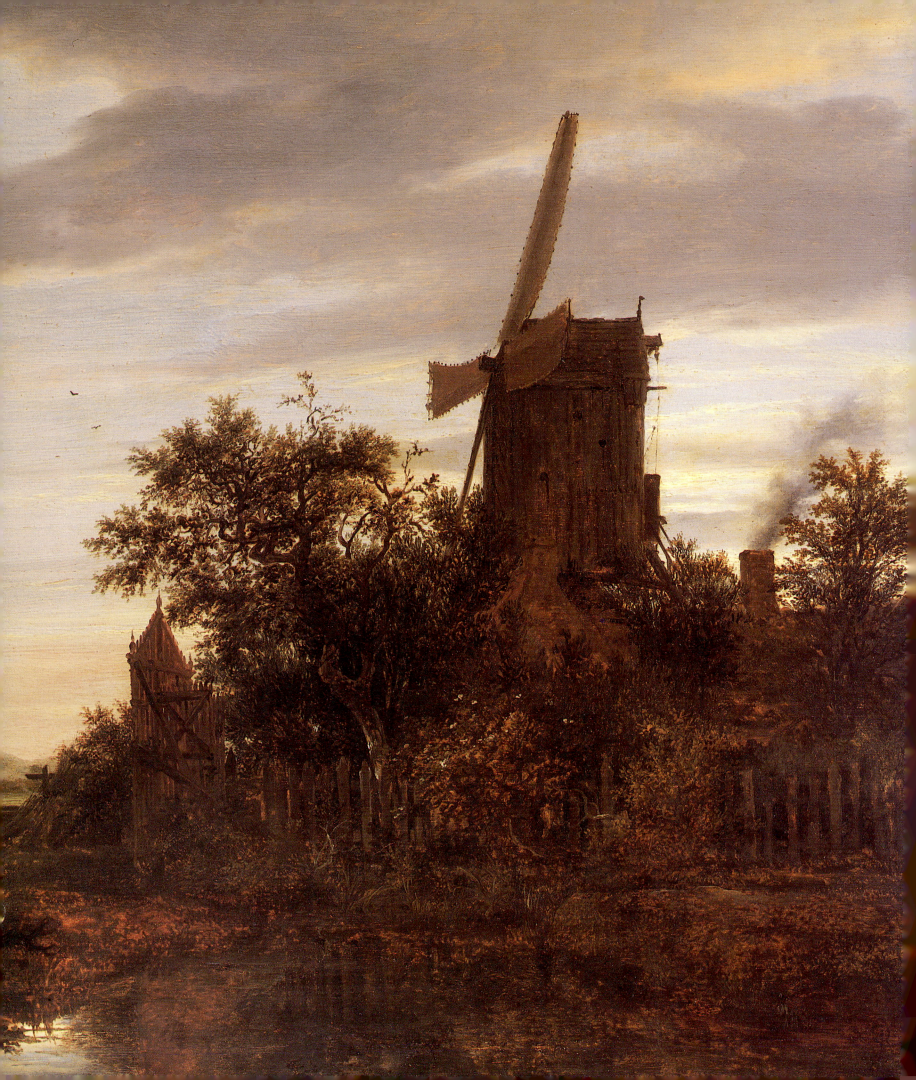

34). It owes more than any other work of his to the style of his uncle Salomon, especially in the handling of the sky. Yet it reveals his precocious individuality. The dark brown tones and opaque forms of the mill, fence, cottage, and bushes are boldly opposed to the warm light from the setting sun which spreads over the powdery, blue sky, lining the streaky, grey cloud with touches of pink and yellow. As Stechow observed, it is more monumental than anything by Salomon of that date.[16] Even where Salomon places a prominent tree to one side, as in his *Tree on a River Bank* (Rotterdam, No. 2623; Fig. 39) of 1646, the foreground structure remains diaphanous. In his nephew's picture the dense mass created by the windmill and surrounding vegetation is more solid and imposing.

Windmills occur frequently in Dutch art as visual accents on the distant horizon, but are surprisingly rare as a primary motif, given their profusion in the landscape. Significant exceptions are C.J. Visscher's etching after C.C. van Wieringen, *Landscape with a Windmill* (Fig. 157) and Jan van de Velde's 1617 etching of *Summer* from a series, the *Four Seasons*, in both of which symbolic allusions may be intended. Windmills are also given prominence in some works of Van Goyen, though not subjected to the radical opposition of light and shadow explored by Ruisdael in the Cleveland painting.[17]

Windmills caught Ruisdael's attention early in his career, featuring in a group of delicate black chalk sketches some of which are now in Dresden. As Giltay observed, these undated sheets are comparable to the black chalk stage of his 1646 drawings, such as Fig. 26, but are not worked up in pen.[18] Comparing one of these drawings, the *Windmill at the Edge of a Village* (Dresden, No. C. 1286; Fig. 35) to the Cleveland painting, the virtual transparency of the drawing is immediately striking. While this may be because it was most likely part of a sketchbook, with neither tonal washes nor pen highlighting adding body, the lack of mass and solidity shows once again his initial indebtedness to artists such as Van Goyen as well as his rapid transformation of their style.

In turning from this sketch to his painting of a windmill, the density and boldness of the foreground elements is striking. It also anticipates the strength of his later compositions, such as the Buckingham Palace version of this picture (Fig. 110), and the Amsterdam *Mill at Wijk bij Duurstede* (Fig. 156). In the Cleveland picture Ruisdael creates a foreful interaction between the mill and the sky, much as between sunlight and blasted trees in other early works, perhaps to draw attention to man's dependence on the elements, for which the mill was a recognised motif in moralistic literature.[19] The same was also true of the process of bleaching, also included in Ruisdael's picture. Bleaching was a characteristic feature of the Haarlem countryside, and with further draining of the polders the industry thrived. Bleaching fields had already featured in C.J. Visscher's etched series of 'Plaisante Plaetsen' surrounding Haarlem (Nos. 8 & 11), and were often depicted by Haarlem landscapists around the mid-century.[20]

In a variant of the Cleveland picture, a *Landscape with Cottages and a Windmill* (private collection, USA; formerly Hoogsteder–Naumann, New York; Fig. 36)[21] dated 1646, Ruisdael gave more attention to the figures laying out the bleach, relegated the mill to the middle ground and gave more prominence to the cottage, gate and trees in the foreground. Such variants, which are common throughout his oeuvre, as well as the differences between sketches and paintings, demonstrate Van Mander's advice that while an artist must work from life ('naer het leven'), his pictures must be conceived in the mind ('uyt zijn selven doen').

The precocity of plastic style in these two windmill pictures emphasises the fact that Ruisdael's later monumentality owes less to the influence of Claude

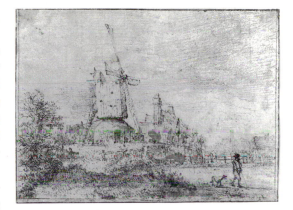

35. *Windmill at the Edge of a Village.* Drawing. Black chalk. 147 × 198. Dresden, Kupferstichkabinett. Photo: Staatliche Kunstsammlungen, Dresden.

36. *Landscape with a Cottage and a Windmill.* 1646. Panel, 34 × 46.5. Private Collection, USA; Formerly Hoogsteder-Naumann, New York. Photo: A Dingjan, The Hague (courtesy of Galerie Hoogsteder, The Hague).

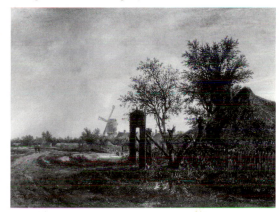

Detail from Fig. 34

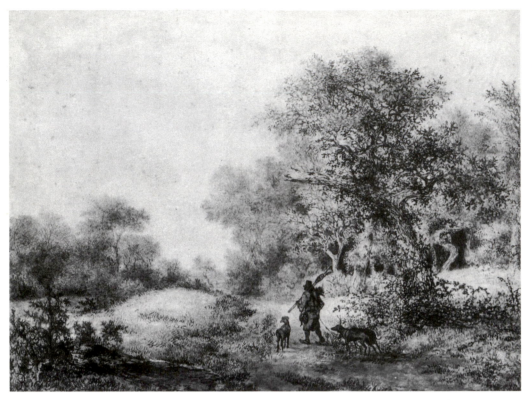

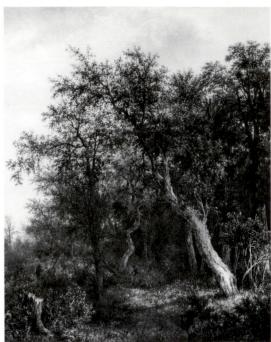

Lorrain's 'tectonic' structures, received via the Italianates, that some have suggested,[22] and more to his own forceful transformation of his earliest models, found in Van Goyen, his father and his uncle Salomon.

Another dimension of Ruisdael's many-sided activity in 1646 is seen in his first ventures into woodland landscape. When the native scene with its dunes and windmills becomes less frequent in Ruisdael's oeuvre, woodland takes on a dominant place as one of his favourite subjects. The detailed and graphic handling of vegetation seen in other early works comes into its own in a fine early drawing of woodland, his *Huntsman in a Wood with Three Dogs* (Berlin–Dahlem, No. 2618; Fig. 37) of 1646. The twisted forms of the branches and the texture of the trunks and foliage in the foreground are heightened in ink for added emphasis. The rich detail of their vibrant forms stand out against the less distinct background vegetation, which is softened by rubbing and by light washes in places. Woodland is evoked by introducing a screen of trees to the compositional scheme of his *Country Roads*. By comparison to earlier woodlands in Netherlandish art, Ruisdael's approach in this drawing is less stylised, with more careful attention to the characteristics of local vegetation. However, like many of the earlier mannerist painters, such as Jan Brueghel, he cannot resist including fallen timbers, presented in sharp focus in the immediate foreground. As suggested in the previous chapter, the broken tree trunk and fallen timber framing the figures, introduce a time scale which denotes the forest's longevity and eventual decay. The *Woodland Path with Hunter* (Vienna, Akademie der bildenden Künste, No. 1368; Fig. 38), is closely related to the Berlin drawing; in it he has adopted an upright format to heighten the density of the wood, eliminating the open side of the composition. The foreground detail and soft background correspond to the contrasted textures of the drawing, and his speckled, dark-green foliage is likewise delicately patterned against the flat, grey sky. A shaft of light relieves the density of the forest and provides a colour contrast in illuminating the warm

37. *A Huntsman in a Wood with Three Dogs*. 1646. Drawing. Black chalk, grey pencil, grey wash, black pen, 284 × 385. Berlin-Dahlem, Staatliche Museen, Kupferstichkabinett. Photo: BPK (Jörg P. Anders).

38. *Woodland Path with Hunter*. Panel, 57 × 47. Vienna, Gemäldegalerie der Akademie der bildenden Künste. Photo: Museum.

39. Salomon van Ruysdael: *Tree on a River Bank*. 1646. Panel, 62.5 × 89. Rotterdam, Museum Boymans-van Beuningen. Photo: Frequin.

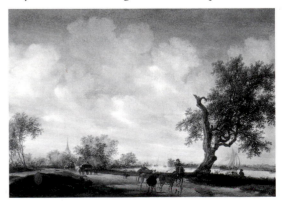

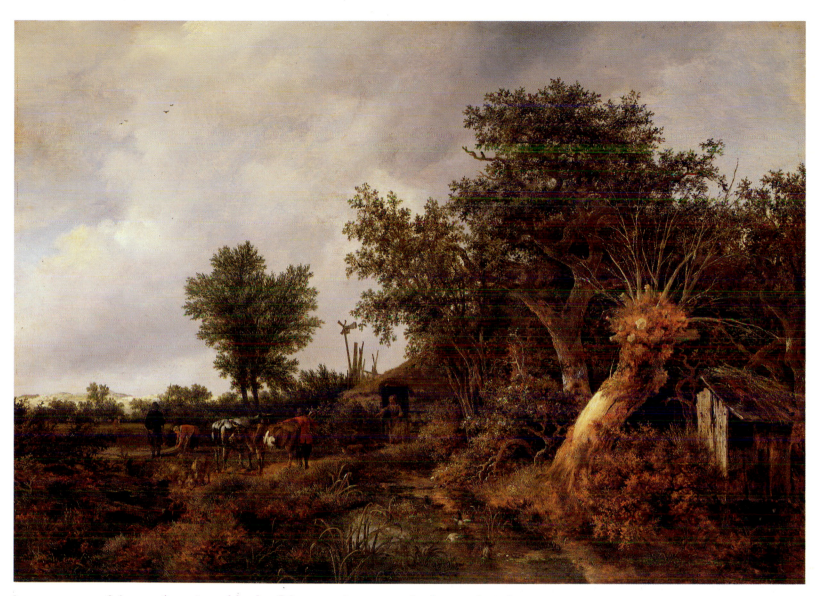

40. *Cottage under Trees*. 1646. Panel, 71.8 × 101. Hamburg, Hamburger Kunsthalle. Photo: Museum (Elke Walford).

brown tones of the partly stripped bark of the prominent tree. It also reaches the stump in the left foreground, beyond which the tiny figure of a hunter is just visible. A source for Jacob's early tree types with their stippled foliage fanned out against the sky is evident in his father's works, for example in the Stockholm *Country Road* (Fig. 25), and also in some of his uncle's, such as the 1646 *Tree on a River Bank* (Fig. 39).

Jacob's achievement in 1646 culminates in the *Cottage under Trees* (Hamburg, No. 159; Fig. 40), which displays the acute powers of observation with which he scrutinises details of the indigenous vegetation with an accuracy, and capacity to capture the divergent characteristics of different trees and bushes that far surpasses his predecessors or contemporaries. At the same time he avoids the risk of tight, dry description by his execution which uses a generous, pasty application of paint to achieve both substance and a remarkable freshness. Detailed attention to foreground vegetation is also a feature of the Italianate painters, with roots in the paintings of Paul Bril and Jan Brueghel. The Italianate painters use foreground detail to offset glowing distant prospects, but Ruisdael makes the foreground vegetation and its illumination the dominant pictorial concerns. In Ruisdael's *Cottage under Trees*, as in other early works, the willows, ditch, woodlands and

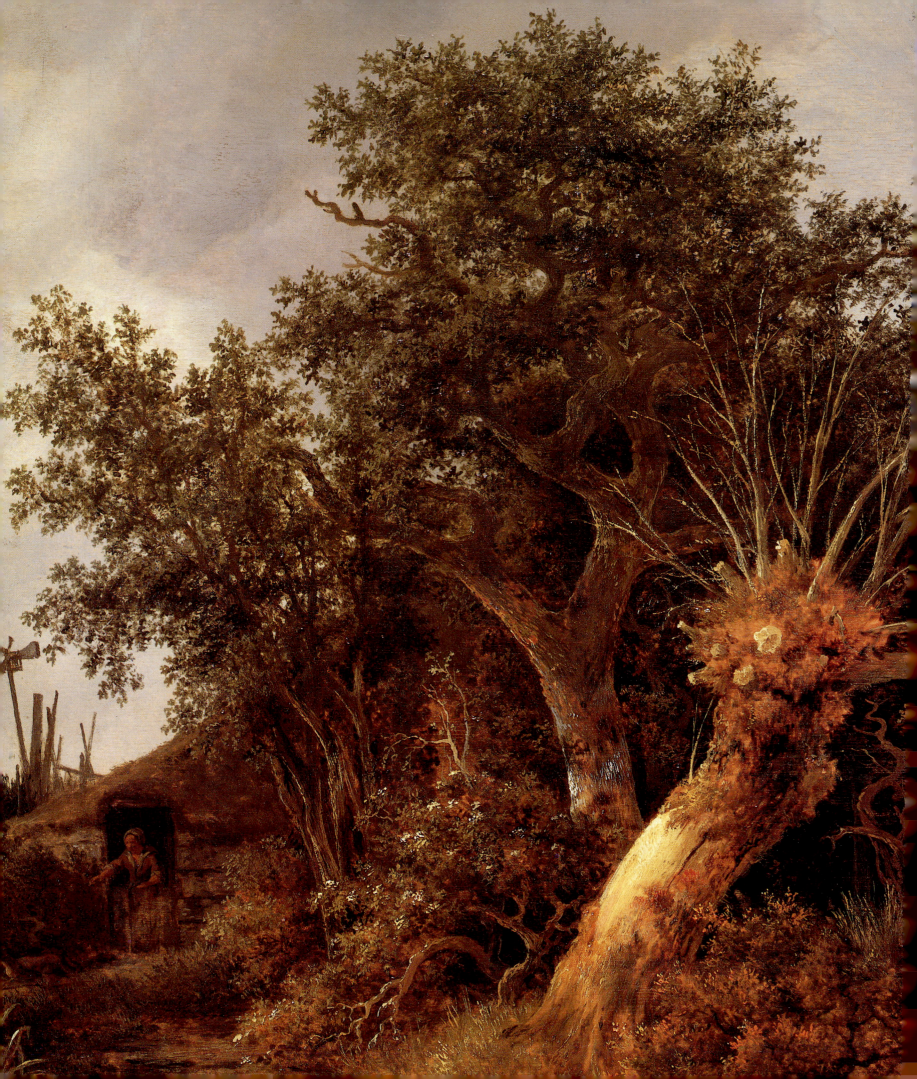

dunes derive from the vicinity of Haarlem. Its underlying structure is comparable to that of the Berlin *Woodland* drawing (Fig. 37), and the Cleveland *Windmill* (Fig. 34), but this structure now supports abundant vegetation of denser, richer texture. The trees are finer in detail and, in the case of the oak and pollarded willow, more solid in form, their deep green shadows animated by the white and tan highlights of a flowering elder bush, and by the warm sunlight that falls on the withered brown stem of the pollard willow. Ducks and reeds enliven the ditch, and on a path leading to a bleaching field, where a woman attends to the linen, a colourful group of figures, cows and pigs catch the last beams of the raking sunlight. The luxuriant detail and deep warm colour concentrated in the foreground is relieved by the sunlit grey-green dunes beyond and by the expanse of grey sky, which is lightly overcast and executed with a freshness reminiscent of Salomon van Ruysdael. The picture evokes a sense of the untroubled well-being of rural life in the setting of a localised landscape. The withered willow, and fallen tree trunk just visible in the foreground grass on the left, introduce a faint note of discord, which Ruisdael seems compelled to add to this otherwise peaceful scene.[23] Can it be that while the Italianates present an idyllic view, Ruisdael forces us back to reality? He represents the world as he knows it, beautiful but subject to corruption, and not as he might wish it to be.

In 1647 Ruisdael began to explore massive forms in land as well as trees. He achieved this by representing dunes from a low, close-up viewpoint. An early example, *Dune Landscape with Wooden Fence* (formerly Henle collection, Duisberg; Ros. 529; Fig. 42), of 1647, perhaps derives from a sketching expedition with his father, whose monogrammed version of the same subject, *Dune landscape with Wooden Fence* (formerly, S. Nijstad, The Hague; Fig. 41), came to light in the early 1950s.[24] Isaack's conception of the subject betrays once again the influence of Jan van Goyen, whose *Landscape with Figures* (Cambridge, No. 52; Fig. 43) of 1628 represents a road curving round a dune, from the top of which figures contemplate the landscape beyond. By contrast, Jacob concentrates on the fore-

Detail from Fig. 40

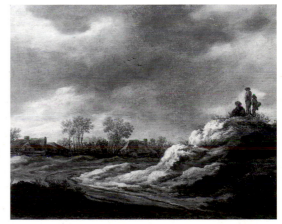

41. Isaack van Ruysdael: *Dune Landscape with Wooden Fence*. Panel, 40 × 60. Formerly S. Nijstad, The Hague. Photo: RKD.

42. *Dune Landscape with Wooden Fence*. 1647. Panel, 32 × 44. Formerly Henle Coll., Duisberg. Photo: Courtesy of Gallery Sanct Lucas, Vienna.

43. Jan van Goyen: *Landscape with Figures*. 1628. Panel, 28.9 × 37.7. Cambridge, Fitzwilliam Museum. Photo: Museum.

44. *Bush on the Dunes*. 1647. Panel, 69.7 × 91.7.
Munich, Bayerische Staatsgemäldesammlungen.
Photo: Museum.

ground; his figures, possibly by Isaack, turn their backs on the distance, so focus-
ing our attention on the nearby vegetation. The picture is vitalised by Jacob's
graphic brushwork in the writing forms of the bushes and the figures bathed in
a pool of sunlight on the sandy bank.

In his larger, more ambitious *Bush on the Dunes* (Munich, No. 1022; Fig. 44),
also of 1647, again from a low viewpoint, Ruisdael concentrates mass and detail
in the immediate foreground, leaving the transparent tonality of Jan van Goyen
and Salomon van Ruysdael far behind. The brushwork is thick and pasty, the
detailing rich; in places the translucent, reddish-brown ground is visible. Rain
cloud drifts over a flat, blue-grey surface evoking only a limited sense of volume
and depth in the sky. The leaning bush, rather than the sky, is the chief organ of
sentiment. Compared to the dune bushes in his earlier etching, *Cottages and Trees
on a Dike* (Fig. 32), the low, close-up viewpoint here accentuates the expressive
effect of a bush perched on an elevated dune top with its twisted branches bent by
the wind. Sheep grazing in a sunlit meadow under the lee of the sandbank intro-
duce a gentle contrast to the exposed dune. Windswept effects are also emphasised
by Ruisdael in his *Dune Landscapes* in Paris (No. 1819; Ros./Slive, illus. 211) and
in Düsseldorf (No. Dept. 27/1970; loan Bentinck–Thyssen collection; 1981
Exhib., No. 5; also dated 1647). These compositions avoid the idealising tend-
encies of Salomon van Ruysdael's paintings of the forties, but reinterpret the
blustery landscapes of the twenties and thirties with greater plasticity and force.[25]
To the extent that, in the Munich version of this subject, Ruisdael eliminates the
distant view of Haarlem seen in the Paris and Düsseldorf paintings, he concen-
trates undivided attention on the massive dune and sprawling vegetation.

Fascination with sand dunes was part of the new interest in the indigenous
landscape. First appearing around 1611–1614 in works of C.J. Visscher and Esaias
van de Velde, as a pictorial motif it came into prominence around 1625–30 in
paintings of Pieter van Santvoort, Jan van Goyen and others. In the context of the

actual Dutch landscape these sand dunes, even today, are something of a marvel; so insubstantial, fluid and yet strong, standing as a protective barrier between the North Sea and the lower-level polders of the adjoining countryside. No wonder that as poets and painters turned to the marvels of their own country, we find artists depicting them and the poet Huygens marvelling at how the dunes are able to withstand the lashing of waves driven against them by storms, a subject which Houbraken records Ruisdael as depicting. In the Munich picture, as in most others, Ruisdael looks at them from the land side, emphasising their protective strength while suggesting, in the wind-swept bushes, the storms to which they are regularly subjected.

In another work of the same year, his *Oaks by the Zuider Zee* (Charles Russell sale, London, Sotheby's 7th December 1960, No. 3; Ros. 571; Fig. 45) dated 1647, Ruisdael gives us a glimpse of the sea as well. It is one of a series of paintings and drawings showing coastal scenes and panoramas that must have resulted from a sketching trip on the coast of the Zuider Zee, southeast of Amsterdam, in the vicinity of Naarden, where his father was born. Using a composition similar to that of his Hamburg *Cottage under Trees* (Fig. 40), Ruisdael filled it with a new combination of elements: a coastal inlet with two fishermen, distant sailing boats, and, on the split of land, a low brick wall that provides a colour accent against the dark vegetation. Trees are still the main motif, scraggy and wind bent from constant exposure to the elements. The bark of one of them is also partly decayed, adding a pictorially dramatic note to the overall sense of erosion and impermanence, also found in his early woodlands and dune landscapes. It is a variation on a theme even more forcefully evoked by the tree and sky of his Cambridge *Landscape with Blasted Tree by a Cottage* (Fig. 22), which was probably painted about the same time. In both pictures the everyday activity of man is set in a landscape characterised by its exposure to the force of the elements. Compared to his later coastal scenes, trees, not sea and sky, are the most expressive elements in the Zuider Zee painting.

45. *Oaks by the Zuider Zee.* 1647. Panel, 44.5 × 63. Sale, Charles Russell, London [Sotheby's], Dec. 7, 1960, no. 3. Photo: By kind permission of Sotheby's.

46. *Oaks by the Zuider Zee*. 1648. Drawing, black chalk, grey wash, heightened in ink, 176 × 295. London, British Museum. Photo: Museum.

Ruisdael made two versions of his Zuider Zee composition the following year, 1648: his painting *Dunes by the Sea* (Ros. 567) and his drawing *Oaks by the Zuider Zee* (Fig. 46).[26] In both of them, as Slive has pointed out, Ruisdael's attraction to the refined works of Cornelis Vroom are seen for the first time in the fine filigree pattern of the foliage, as well as in the brighter, warmer tones of the sky in the painting. The highly finished drawing is not only worked up with the pen and a range of grey washes, but also shows traces of red, green and yellow watercolour, now mostly faded. Such high finish, the inclusion of several figures, and the overall conception of the drawing indicate that it is not a direct annotation from nature, but a studio product intended for sale as an independent work of art.

His drawing of the Zuider Zee coast shows a new interest in expansive space, that includes the ruins of Muiderberg Church, and, in the background further to the left, the church tower of Naarden. The previous year, 1647, he had painted an oblong *View of Naarden* (Lugano, Thyssen collection, No. 269; Fig. 47) which is his earliest extant flat landscape, other than his panoramic *View of Egmond* (Fig. 29) done the year before that. While the specifics of his *View of Naarden* are derived from a particular locality with which he had family ties, his treatment of the subject accords to convention. Panoramas with high skies were popularised by Van Goyen and Salomon van Ruysdael in the forties, while the oblong format with a hillock in the foreground and central winding road had been pioneered by Goltzius, Esaias van de Velde, and somewhat earlier by Seghers. Their appeal is analogous to the pleasure described by Dutch poets in surveying the landscape from the raised elevation of the look-out towers on their country estates. In painting such panoramas, spotlighting was a common device, which was also

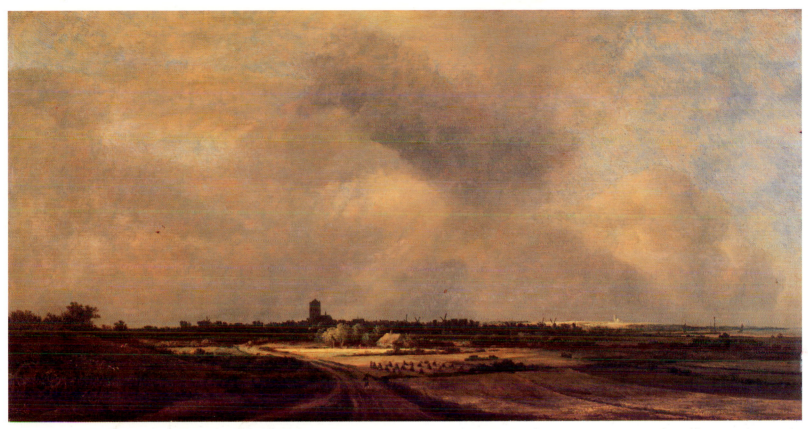

47. *View of Naarden*. 1647. Panel, 34.7 × 66.5. Lugano, Switzerland, Thyssen-Bornemisza Collection. Photo: Brunel, Lugano.

48. *View of Naarden*. Drawing. Black chalk, grey pencil, retouched by another hand with grey wash, 63 × 184. The Hague, Rijksbureau voor Kunsthistorische Documentatie. Photo: Courtesy of the RKD, The Hague.

49. *View of Naarden*. Drawing. Black chalk, grey pencil, 121 × 184. Darmstadt, Hessisches Landesmuseum. Photo: Museum.

used in many other types of landscape. But the dramatic effect achieved in the Lugano picture was perhaps also a more immediate debt to Rembrandt and Seghers.[27] Ruisdael used spotlighting in this picture, as he was to do in his later and finer flat landscapes, to create rhythm in the painting, at the same time fixing his planes, illuminating the fields and a cottage in the middle ground, and, further to the right, the ruined church of Muiderberg on the distant horizon. His lighting also creates a dramatic effect of light penetrating a storm-swept landscape, comparable to that in Rembrandt's painting *The Stone Bridge* (Fig. 15).

A black chalk drawing *View of Naarden* (The Hague, Rijksbureau voor Kunsthistorische Documentatie; Giltay 53; Fig. 48), touched up with grey wash in the foreground and sky by a later hand, corresponds closely to the painting and may have served as a preliminary study. Such close correspondence between surviving drawings and paintings is rare in Ruisdael's oeuvre, occuring almost always when topographical elements are included. A further black chalk and grey wash drawing, *View of Naarden* (Darmstadt, Hessisches Landesmuseum, No. HZ. 8735; Giltay 35; Fig. 49) shows the village of Naarden and the coastal inlet

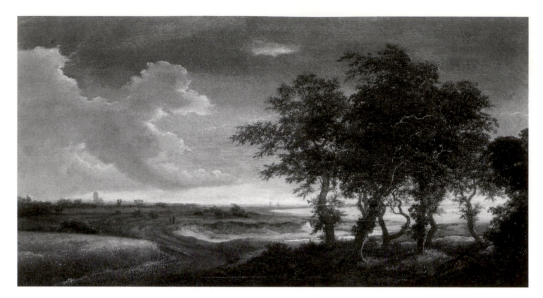

50. *Trees on a Coastline.* 1648. Panel, 31.7 × 57.2. Springfield, Massachusetts, Museum of Fine Arts, The James Philip Gray Collection. Photo: Museum.

from closer by, boldly eliminates the foreground hillock, establishes this plane with the barest suggestion of a pole on the right, and includes a far greater expanse of sky, presaging his later flat landscapes. The painting of Naarden is executed with a light, fluid touch reminiscent of Van Goyen and Seghers, and the thin application of blue and grey over pale brown underpaint in the sky recalls his uncle's technique. Ruisdael effectively synthesises these earlier achievements, while introducing a heavier tone, and failing only to achieve a satisfactory transition into the fore- and midground on the right.

Spatial transition is more effective in his *Trees on a Coastline* (Springfield, Massachusetts, No. 41.02; Fig. 50), a panorama of comparable proportions painted the following year, 1648, the year that he entered the Haarlem Guild. It is derived from the same locality, this time seen under an evening sky and set off by a foreground clump of trees, a device credited by Stechow to the influence of Rembrandt's 1643 etching *The three Trees*, (Bartsch 212). This device dramatically extends the spatial effects essayed in his own drawing of *Oaks by the Zuider Zee* (Fig. 46). Exploration of expansive space is a feature of another panorama of the same date, a *View of Egmond* (Manchester, New Hampshire, No. 291, Fig. 51), in which a stark, gnarled tree trunk, rendered in sharp definition, and recently identified as an exemplary rendering of an elm, is raised into a dominant motif before the village prospect.[28] With an upright format accommodating both the elm and a high sky, Ruisdael here explores a possibility to which he returned, without such a foreground motif, in his later *Views of Haarlem*. The contrast of tree and village prospect recalls Salomon van Ruysdael's *View of Amersfoort* (whereabouts unknown; Stec., Fig. 59) of 1634, but Jacob concentrates mass with greater vigour and replaces Salomon's smooth surfaces with richly textured grasses. The handling of space and architectural form is far more assured than in both his first *View of Egmond* (Philips collection; Fig. 29) and the version in Glasgow (No. 34), and the brighter, warmer colours are a new departure to which Berchem's figures contribute. In the Manchester picture Ruisdael pushes his early interest in foreground motifs of dead timber to their most expressively intense extreme. The very starkness of the dead elm has a potency that exceeds his earlier exposure of decaying timber. It goes far beyond Van Goyen's experiments with such symbolic imagery, as in his famous 1641 painting in Amsterdam, *The two Oaks* (No. A.123), or his earlier *Country Road* in Sheffield of 1633 (Fig.

51. *View of Egmond.* 1648. Panel, 61.5 × 49.5. Manchester, New Hampshire, Currier Gallery of Art, Currier Funds. Photo: Museum.

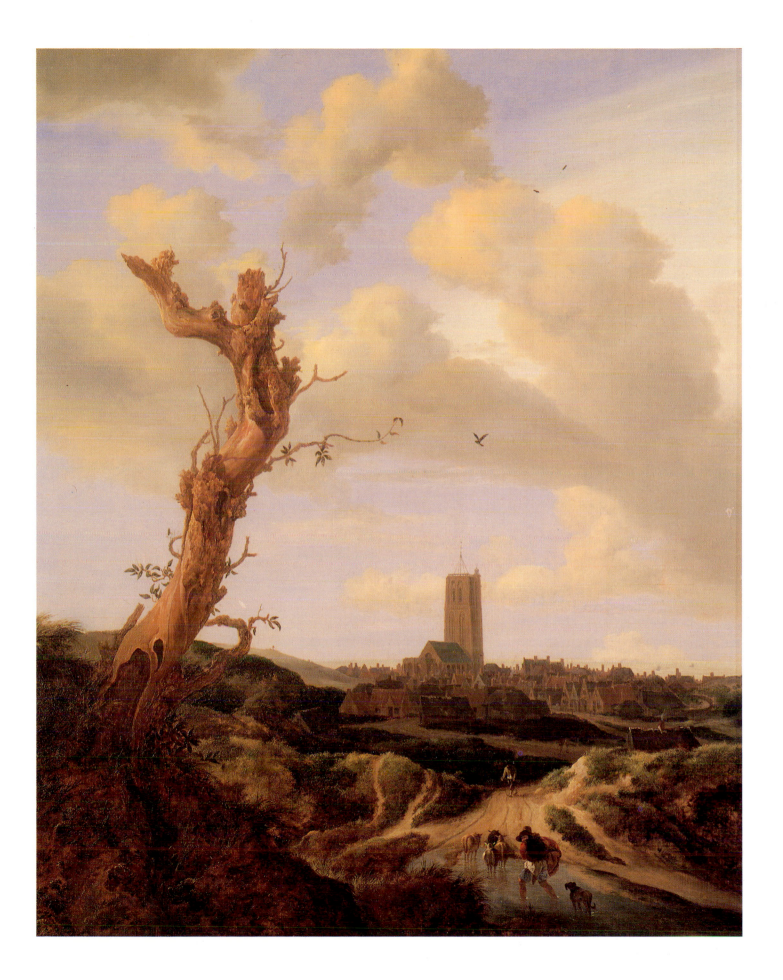

52. *Road through the Dunes*. 1648. Panel, 52 × 68.
Dr Hans Wetzlar sale, Amsterdam [Sotheby's-Mak
van Waay), June 9, 1977, no. 102. Photo: courtesy
Kunstveilingen Sotheby's-Mak van Waay.

13). Indeed Ruisdael's use of the dead tree motif has also been attributed by Kouznetsov to the influence of Rembrandt's graphic art.[29]

In contrast to such stark and dramatic imagery, a more calming influence on Ruisdael around this time came from the example of Cornelis Vroom. This can be seen in the brighter colouring, glowing evening light and greater elegance in the foliage which occurs in Ruisdael's works of 1648 and 1649. A fine example is his peaceful 1648 *Road through the Dunes* (Dr Hans Wetzlar sale, Amsterdam, Sotheby–Mak van Waay, 9 June 1977, No. 102; Fig. 52), which is bathed in the calm atmosphere of evening light. Its composition is derived from a reversal of his 1646 etching *Farm in the Dunes* (Fig. 33), or from a sketch for it. The structure is suppler, the forms more articulate, and contact with Vroom has enhanced his handling of fresh, green trees. Evening light breaks out from a break in the cloud on the right illuminating a farmer returning home from the fields, and evoking a sense of peaceful well-being after the day's activity. The location of this figure at a focal point within the composition demonstrates that despite their small scale, the figures in Ruisdael's painted landscapes have a greater significance than is usually credited. The frequent assertion that seventeenth-century landscapists broke with the anthropocentric tradition of Netherlandish landscape painting and that nature dominates over the human figure, overlooks the fact that small scale does not necessarily imply insignificance. Dutch landscapists consistently identified the world as the scene of man's activity and, at least in paintings, the human figure is rarely absent. On the other hand, in his etchings of the 1640s, Ruisdael generally omitted human figures, suggesting that such prints served a different function. In prints executed in the 1650s, which have the appearance of a set prepared for publication, figures are once more included.

The brighter colouring and peaceful mood of the *Road through the Dunes* (Fig. 52) is also a feature of his 1648 *Wooded Country Road* (The Hague, No. 728; Fig.

53. *Wooded Country Road*. 1648. Panel, 29.7 ×
37.3. The Hague, Mauritshuis. Photo: Museum.

54. Cornelis Vroom: *Pool in a Forest. c.* 1649.
Panel, 16 × 21. Berlin-Dahlem, Staatliche Museen,
Gemäldegalerie. Photo: BPK (Jörg P. Anders).

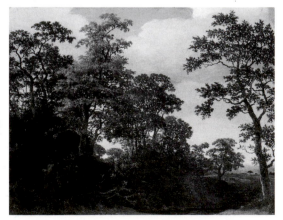

53),[30] which is illuminated by a glowing evening sky. A departure from his earlier works is the small format, the careful separation of the trees, and their delicate, individualised patterns. The impetus for this came from the woodlands of the older Haarlem artist, Cornelis Vroom. Vroom's prestige, celebrated by Schrevelius,[31] and his skill as a tree painter, apparent in his *Pool in a Forest* (Berlin–Dahlem, No. 888C; Fig. 54) of around 1649, had by now attracted the young Ruisdael. Vroom differs from the other landscapists who influenced Ruisdael in that he evokes a quiet contemplative mood, representing tranquil wooded landscape, the trees rendered with meticulous detail and deep colours, qualities that Ruisdael began to emulate. Vroom, already a refined painter of woodland, began to represent the forest proper in works of around 1647–49. This suggests interchange between the two artists, and Keyes identified the effect of Ruisdael's exuberant style in Vroom's late work. Yet, with Vroom, the process of motion and change is suspended.[32] By contrast to this stable and serene image of nature, Ruisdael represents the world as ever changing: water, cloud, and trees, latent forces suspended in Vroom's stilled images, are activated by Ruisdael. Vroom's refined image of nature was not to hold Ruisdael for long from seeking something more robust. But the attention to detail, the stature of his trees, and the contemplative tone of Vroom's work made a lasting contribution to Ruisdael's perception of landscape.

In Ruisdael's 1648 etching *Trees by a Cornfield* (Keyes 4, II; Fig. 55) Vroom's influence inspired the imaginary grandeur of the trees, quite foreign to the polder landscape, and the delicate, fretted patterns of their branches and foliage. Comparing the subject to that of Ruisdael's two etchings of 1646 (Figs. 32 and 33), poplars and massive oaks, enlarged in the imagination, have replaced the elms and pollarded willows of the dike and polder landscape. In this, the second state of the etching, Ruisdael has added cirrus and cumulus cloud to enhance the contrast of light and shade, and to balance the density of the lower right foreground.[33] Woodland and cornfield provide a juxtaposition of wild and cultivated land that recurs as a theme of his oeuvre. The scheme essayed here, derived from the binary composition of his earliest representations of cornfields and trees (e.g. Fig. 23), was to reach maturity in the spectacular *Edge of a Forest* (Worcester College, Oxford; Fig. 138) painted some twelve to thirteen years later.

Another small panel in the manner of Vroom is the 1649 *Two Oaks by a Pool* (Nancy, No. 113; Fig. 56). The subject and spacing of the trees is similar to Vroom's *Pool in a Forest* in Berlin (Fig. 54),[34] and it is the first of Ruisdael's woodlands to include a pool of water. The two figures in the centre foreground are quite out of keeping with the scale and character of the rest of the composition and were probably added later in deference to changing taste. Their prominence distracts from the overall effect which includes other figures set deep within the peace of the woodland itself.

In representing woodland, Vroom's influence enabled Ruisdael to advance considerably. But in attempting to transfer to paint the massive tree types of his 1648 etching (Fig. 55), the two foreground oaks remain somewhat graphic, lacking substance equal to their scale. Grand trees on a bank beside a pool also featured in his 1649 etching *The three Oaks* (Keyes 5; Dut. 6; Fig. 57).[35] Here Ruisdael has produced denser foliage by hatching in larger strokes. This massive effect, heightened by elevating the trees, presages the works of his maturity. His usual fallen trunk is given extra emphasis, and a further innovation is the ruined masonry in the fore- and midground. If there was a relation to Rembrandt's 1643

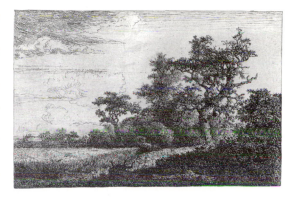

55. *Trees by a Cornfield*. 1648. Etching, 99 × 148. Photo: London, British Museum.

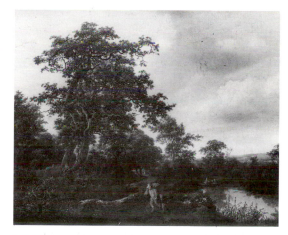

56. *Two Oaks by a Pool*. 1649. Panel, 48 × 60. Nancy, Musée des Beaux-Arts. Photo: Bulloz, Paris.

57. *The Three Oaks*. 1649. Etching, 123 × 146. Photo: London, The British Museum.

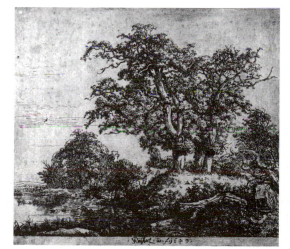

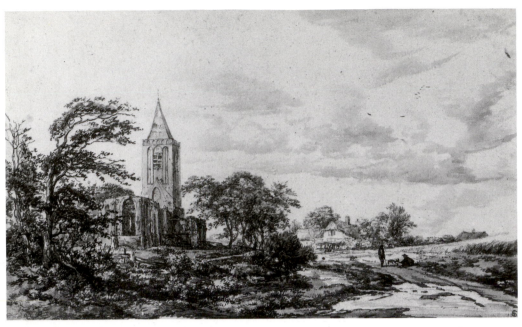

58. *Country Road with a Ruined Church and a Corn-field*. 1649. Drawing. Black chalk, grey pen, grey wash, with touches of yellow and green, 182 × 298. London, British Museum. Photo: Museum.

59. *Banks of a River*. 1649. Canvas, 134 × 193. University of Edinburgh (Torrie Collection), on loan to the National Gallery of Scotland. Photo: National Galleries of Scotland.

etching *The three Trees* (Bartsch 212), then Ruisdael failed to match Rembrandt's masterful lighting, ignored the grand vista, and concentrated on the group of trees. But, even if he was no match for Rembrandt, aged twenty or twenty-one, he had achieved the capacity to transform his landscape observations into a powerful composition, which expresses the great beauty of trees, and the protracted and unrelenting process of growth and decay.

Ruisdael's rapid early development can also be measured by the progress he made in his drawings, in comparing his *Country Road with Farmhouses and Leaning Willow* (Fig. 26), executed in 1646, with the beautiful sheet now in the British Museum in London, his *Country Road with a Ruined Church and a Cornfield* (No. 00 11 248; Fig. 58), which is dated 1649. The latter, like his *Oaks by the Zuider Zee* (Fig. 46) of 1648, is executed in black chalk and pen with grey washes and traces of faded yellow and green watercolour. Compared to the earlier drawing it displays a more open and extensive mastery of space, more subtle modulation of light, and a fluidity of penmanship in evoking the variegated textures of vegetation. He also gives bold prominence to ruins, perhaps those of the church of Soest, southeast of Naarden, a motif glimpsed in the background of several of his early works, and one that is given even more prominence in the next decade, in his two paintings of *The Jewish Cemetery*.[36]

Ruisdael's precocious talent, his masterly sense of composition and his capacity to transform his landscape observations is nowhere more apparent than in the large *Banks of a River* (Edinburgh, No. 75; Fig. 59) of 1649. Resulting from drawings of Rhenen on the Neder Rijn, the transformation so great that it has hitherto escaped recognition. Two surviving drawings, one in the Hermitage (Fig. 60)[37] and one in Berlin (No. 14712; Fig. 61), both show Rhenen from yet different angles, with the tower of St Cunera church and the pair of windmills on the hillside. The Hermitage drawing, from the hilly side, is topographically more accurate. In the Berlin drawing, the tower of St Cunera, seen from over the water, is treated more summarily. These features, and the twin towers of the watergate seen from beyond the smaller river Grift, are included in the painting, but subordinated to the overall conception which goes far beyond these incidental topographical elements.[38] Both drawings are undated, but Giltay, while following Rosenberg in linking them with Ruisdael's trip to Bentheim, and a date of around 1650–53, noted their similarity to the London drawing of 1649 (Fig. 58), the same year in which his painting, inspired by the Rhenen landscape, is dated. It is also worth noting that the ruined church in the 1649 drawing has been identified as that of Soest, which lies southeast of Naarden in the direction of Rhenen. All three drawings perhaps resulted from the same trip.

While Rhenen was frequently depicted by Dutch artists, one looks in vain for a precedent for Ruisdael's approach to the subject. Could it be that Ruisdael's use of a leaning tree as a coulisse before the river prospect was inspired by Vroom's 1638 *Waterfall above a River* (Haarlem, Frans Hals Museum, Fig. 62), and that he was consciously rivalling the older master? Such a coulisse was a common Netherlandish device, popularised by Pieter Breugel the Elder: but Ruisdael's use of it is similar to Vroom's, although in Vroom's less-ambitious work the foreground remains the focus.[39] In Ruisdael's picture the tree is of a type familiar from his 1648 drawing (Fig. 46) and from paintings of 1649 in Antwerp and Nancy (Fig. 56), but here more monumental, twisted and weathered. The foliage is also more fluid and colourful, with yellow and russet highlights.

The large dimensions (135 by 193.5 cm) accommodate an extensive space, yet Ruisdael runs a screen of cloud along the horizon and raises buildings and trees

60. *View of Rhenen*. Drawing, black chalk, grey wash, 125 × 194. Leningrad, Hermitage.

61. *View of Rhenen*. Drawing, black chalk, grey pencil, grey wash, 114 × 188. Berlin-Dahlem, Staatliche Museen, Kupferstichkabinett. Photo: BPK (Jörg P. Anders).

62. Cornelis Vroom: *Waterfall above a River*. 1638. Panel, 40.7 × 67.5. Haarlem, Frans Hals Museum. Photo: Tom Haartsen, Ouderkerk a/d Amstel.

above the skyline to restrict attention within a definite locality. This remains a feature even of his most spacious compositions and distinguishes his style from that of the Italianate landscapists, with their penchant for indistinct, evocative distances illuminated by glowing light. While the Italianates invite reverie, Ruisdael confronts us with the immediate environment. His setting is here enlivened by a colourful group of riders, fishermen, and figures on a ferry, provided by an unidentified hand. Two crows circle in the sky, top left and lower right, giving life and scale to the great expanse of sky. Banks of cumulus cloud are massed towards the right, balancing the density of the left foreground. Evening light falls on the trunk of the tree, the figures, cloud, and sandbank below, and is reflected off the sheet of water.

Many artists since Seghers had represented Rhenen, and Van Goyen had painted it three years earlier in his 1646 *View of Rhenen* (Corcoran Gallery of Art, Washington, No. 26.95). Compared to Van Goyen's sketchy detailing, soft atmospheric effect and gently undulating terrain, Ruisdael's picture is taut, massive, and richly detailed. Its solidity is reinforced by the colouring: dark-green and brown foreground vegetation, blue-grey water, and deep greens in the hills beyond. Ruisdael had developed by his twenty-first year, and before his trip to Germany, a mastery of plastic form and powerful compostion. He could infuse his works with a dramatic power that owed little to the Italianate landscapists' alleged import of Claude's tectonic structures, and depended on his own imaginative transformation of the resources available to him as a young artist in Haarlem. It is also evident that Ruisdael was less concerned than some of his immediate predecessors to invoke the specific virtues of the native habitat, subsuming motifs drawn from these sources into a more generalised and representative yet detailed image of the abundance and mutability of nature.

Ruisdael, moves beyond the conventional sources of Dutch landscape evolved in the 1620s in a number of ways. He gives less prominence to figures and buildings, and pays more scrupulous attention to the particulars of the indigenous vegetation, their growth and leaf patterns, their individual branch forms and bark textures, and their characteristic shapes and silhouettes. At the same time he tends increasingly to incorporate such elements within a more generalised image of nature, in which a sense of specific locality is often less pronounced.

By contrast to the landscapes of his predecessors, Ruisdael presents a world more removed from farms, inns and village roads, a more peaceful environment for a quiet country stroll and a time for reflection. But he also accentuates the contrast of storm-cloud and light-beams found in their works to create a more dramatic confrontation of natural forces. Thus, the diverse motifs and landscape themes that run through Ruisdael's entire career were already present in his early work. He gave form to his treatment of country roads, dune landscapes, coastal scenes, river scenes, woodlands, panoramas, and town views. Only hilly landscapes, waterfalls, and beach scenes had not yet been tackled, and his earliest marines and winters, the most difficult of his works to date accurately, had probably not yet been painted.

Within this range of themes certain characteristic motifs which subsequently recur in endless variations, had already been depicted. Many of these motifs, and his treatment of them, derive from the pictorial tradition discussed in the preceding chapter. Ruisdael's attention to windmills as a prominent motif, rather than as a mark on the horizon, is more novel but also has a precedent, in the prints of Jan van de Velde and C.J. Visscher.

All these features bring out some of the most fundamental aspects of the

landscape of the Netherlands, and at the same time they draw attention to the underlying state of nature itself, as well as the place of human life within it. It is in this way that Ruisdael gives form to the contemplative mode of landscape painting discussed in Chapters II and III above, and shows already in his early works the potential to become its most powerful exponent. With such themes Ruisdael was already evolving the nucleus of pictorial and expressive ideas from which his best known masterpieces would emerge. It would however take the stimulus of travel, probably undertaken the very next year, 1650, and a move to Amsterdam to broaden his range and develop his expressive powers.

Foreign and Domestic Motifs: The Early 1650s

By 1650 Ruisdael had demonstrated not only his technical mastery and a fairly distinct conception of landscape, but, in a work like his 1649 *Banks of a River* (Fig. 59), he had also produced a major masterpiece, outshining his fellow landscapists in Haarlem. His trip to Rhenen had been an evident stimulus, but he still needed to broaden his vision and extend his subject matter, all the more so because foreign landscape like other exotica, such as rare flowers and shells, appealed to the curiosity of collectors. In Haarlem, for instance, Frans Post since his return in 1644 was painting Brazilian landscapes, and Allart van Everdingen since his return from the North in 1645 was producing Scandinavian scenes.

In the 1650s Ruisdael ably rose to this challenge, not only extending beyond the range and interests of his earliest influences, but also, through travel, and in moving to Amsterdam, absorbing new ones. By the end of the decade he was established as a significant landscapist within the artistic milieu of Amsterdam.

Ruisdael's trip to the German/Dutch border country with his friend Nicolaes Berchem, probably in 1650, provided the first major impulse to the further development of his conception of landscape and of his pictorial style. There are many dated works by Ruisdael in the years 1646 to 1653, but none have come down to us from 1650, which, given the further evidence, suggests his absence from the studio at that time. More concrete evidence is supplied by a number of works by both Ruisdael and Berchem that include comparable views of Bentheim Castle, a motif that attracted them on their travels. One of them, a drawing by Berchem of the castle (Frankfurt, Städelsches Kunstinstitut, No. 3842), is dated 1650. The significance of this trip for Ruisdael has been widely recognised. It has been suggested that his 'romantic' sense was attracted by the hilly woodlands with castles and streams and that his desire for intensification of form found new stimulus; the robust, knotty oaks of the region matching the forms of his own imagination.[1] Limited financial resources were probably an inhibiting factor on the range of Ruisdael's excursions. His north-easterly route was less usual than the popular trip down the Rhine. It was probably chosen at the instigation of Berchem, whose father, Pieter Claesz., was born at Burgsteinfurt, one of the places they visited.[2]

In Ruisdael's painting, *Hilly Landscape with Burgsteinfurt* (London, Wallace Collection, No. P. 156; Fig. 63), the castle, which is in the immediate vicinity of Bentheim, is overlooked from an imaginary promontory, as in the earlier *Banks of a River* (Edinburgh; Fig. 59).[3] Side-lighting throws the tree, castle, and distant hill into shadow, so accentuating their substance. It also articulates the space with a rhythm of dark and light bands alternating between foreground and distance, as in his 1647 panoramic *View of Naarden* (Fig. 47). But now the manipulation of light and space is far more subtle, as it was in his 1649 Edinburgh *Banks of a River*. The side light is countered by cumulus cloud banked up on the right, suggesting the return of sunlight after rain. The painting is finely detailed, especially in the foreground, and coloured in a palette of greys and browns in the foreground, dark green in the shadows, yellowish green in the mid-distance, and blue green on the distant ridge of hills. The similarity of the overhanging tree to that in the

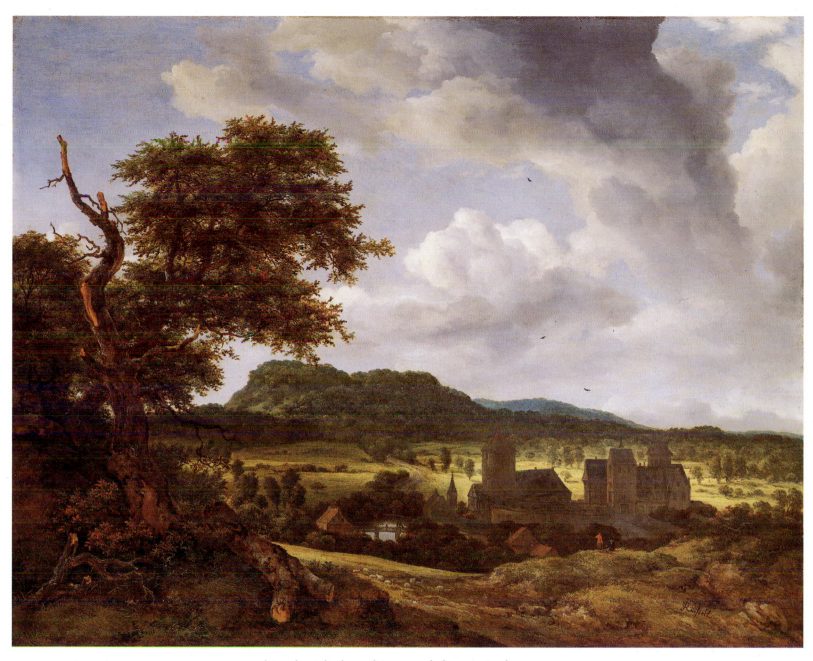

63. *Hilly Landscape with Burgsteinfurt*. Canvas, 75 × 92. London, Wallace Collection. Photo: Wallace Collection (Crown Copyright), by permission of the Trustees of the Wallace Collection.

1649 Edinburgh painting (Fig. 59), combined with the subject, and the particular form of the signature, with a flourish on the final 'l' (\mathcal{L}), which is found especially on works of the early fifties, suggest a date around 1650/52.[4]

When Ruisdael set out on his travels he was already a distinguished painter of trees and he had recently been inspired by the conceptual quality of Vroom's wooded landscapes. He was to find in the border country trees that would appeal to him for their age, scale and ruggedness. He also found architectural motifs to enhance his compositions. The castle of Bentheim proved a particular attraction for him and Berchem. Standing on a low elevation, its situation was transformed in their imaginations. In Ruisdael's 1651 *Bentheim Castle* (English private collection; Ros. 15; Fig. 64) the commanding form of the castle is executed with a firmness and clarity that, catching the light, draws the eye beyond the substantial foreground mass which first captures attention. The pale copper-coloured foliage of the most prominent foreground tree is executed in a heavy impasto that

supercedes the speckled patterns of the 1640s and introduces a suggestion of the changing seasons, a feature that remains characteristic of his trees thereafter. Only the trees in the Edinburgh *Banks of a River* (Fig. 59) had anticipated this change. Again the main tree, leaning out over a bank, acts as a foil to the view, and riders lead into the space beyond.[5] As in some of his etchings and other paintings of the early 1650s, the roots of this tree cling precariously to an eroded sandbank and in the foreground lies an uprooted tree, executed with far greater definition and sense of massive solidity than in earlier works. Structurally, the oblique angles of these two trees counteract the movement of the roadway on the right, so articulating the massive foreground. Compared to his earlier juxtaposition of a foreground tree and background architectural motif in the 1648 *View of Egmond* (Fig. 51), the spatial transition is more effective, the architectural features are crisper, and, above all, the solidity of land and trees is dominant, marking a new departure.

Comparison of Ruisdael's picture (Fig. 64) with Berchem's 1654 *Pastoral Landscape with Bentheim Castle* (Dresden, No. 1781; Fig. 65) reveals their differences. The relation of foreground to distance is in each case the same. Both painters transform the actual environment. Ruisdael's foreground motifs suggest storm and erosion. Berchem creates a placid setting; colourful peasants water their herds in a rocky hollow overshadowed by decorative trees that are festooned with creeper. Ruisdael accents nature's mutability, Berchem evokes an idyll.

While Ruisdael included Bentheim Castle in at least a dozen landscapes during his career, Berchem soon abandoned it as he immersed himself in lyrical Italianate landscapes. It is ironic that the taste of later generations was to be sharply divided between the works of these two friends. Whereas eighteenth-century collectors favoured Berchem, in the nineteenth century, Constable, an admirer of Ruisdael, urged their descendants to burn their Berchems. Berchem's occasional provision of staffage for Ruisdael ceased in 1653, presumably due to Berchem's departure for Italy, but recurs once more in Ruisdael's *Woodland Ford with Figures and Cattle* (Paris, Louvre; Fig. 145), a work of the 1660s, demonstrating that while their style and subject matter diverged widely, the contact between them remained. Perhaps Ruisdael owed a lasting debt to Berchem in the lightening of his palette and the inclusion of richer local colour, which is first evident in his works of the early 1650s.

Ruisdael's various depictions of Bentheim Castle, from below, from above, and from afar, demonstrate that, while he set the castle within the context of his conception of nature, he was not concerned with it as an illustration of a literary topos, as Wiegand and more recently Bruyn have supposed, but predominantly as a landmark.[6] This is born out by comparable representations of other landmarks from the region, as for example the castle at Steinfurt (Fig. 63).

In a further painting of *Bentheim Castle* (Dresden, No. 1496; Fig. 66), Ruisdael gives it an imaginary hilltop setting. The massive hillside, seen from very nearby, and the dark, overhanging trees are offset by the luminous central vista with a distant prospect towards which a man is pointing.[7] The sense of density and mass is a far cry from his 1647 *Bush on the Dunes* (Fig. 44), in which he had first attempted to render the mass of land formations from a low viewpoint. The effects achieved in the Dresden *Bentheim Castle* are carried even further in a stylistically analogous work which must also date from the early 1650s, the *Hilly Wooded Landscape with Figures and Cattle* (Selkirk, Bowhill, The Duke of Buccleuch and Queensberry Collection, No. D. 176; Fig. 67). Stylistically the composition, with high banks either side of a central vista, the tree types, with occasional dead branches silhouetted against the sky, and the palette of blues and greens in the distant prospect may be compared to other works of the early 1650s, such as the Dresden *Bentheim Castle* and the 1652 *Wooded River Valley* (New York, Frick Collection; Fig. 69). A remarkable innovation is inclusion of giant boulders in the densely massed foreground seen in deep shadow at very close quarters and contrasted with the deep central vista which is far more elaborate than in the Dresden *Bentheim Castle*. The rugged scene is enlivened by a shaft of sunlight that illuminates a man and a boy driving cattle towards a pool in the foreground, perhaps in modest emulation of effects used by his friend Berchem. Ruisdael's combination in this picture of rugged scenery and pastoral elements inspired Gainsborough to paint a similar composition in the following century.[8]

Ruisdael's fascination in the early 1650s with the effects of erosion is nowhere more evident than in a drawing derived from his travels, his *Tree over a Mountain Torrent* (Rotterdam, No. 7; Giltay 96; Fig. 68).[9] Roots clinging to crumbling

66. *Bentheim Castle*. Panel, 55 × 83.5. Dresden, Gemäldegalerie Alte Meister. Photo: Staatliche Kunstsammlungen, Dresden.

67. *Hilly Wooded Landscape with Figures and Cattle*. Canvas, 101.6 × 127. Selkirk, Bowhill, The Duke of Buccleuch and Queensberry. Photo: Sydney W. Newbery (courtesy of Thos. Agnew & Sons Ltd., London).

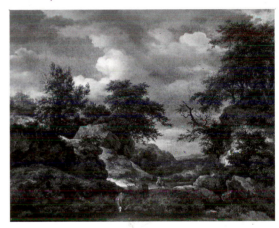

68. *Trees over a Mountain Torrent*. Drawing, black chalk, brush in dark grey, grey wash, heightened in white, 156 × 236. Rotterdam, Museum Boymans-van Beuningen. Photo: Frequin.

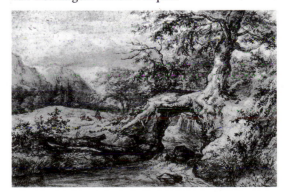

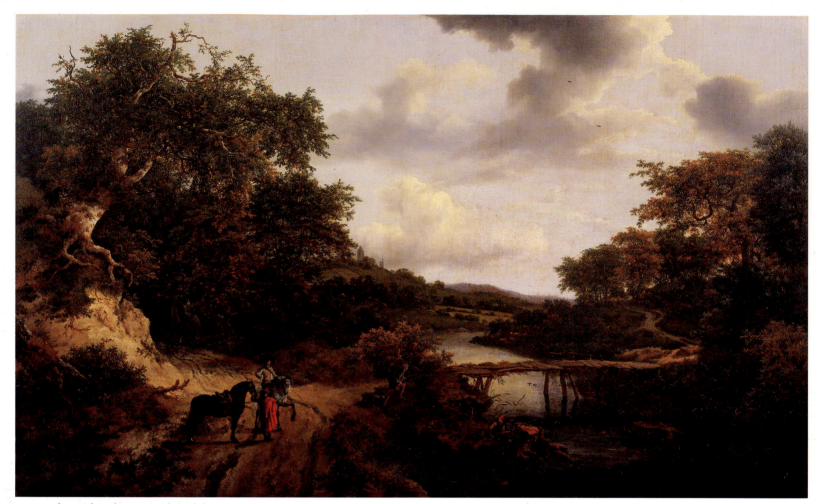

69. *Wooded River Valley*. 1652. Canvas, 99 × 159. New York, Frick Collection. Photo: Copyright The Frick Collection, New York.

ground evidently stimulated his imagination, suggesting both the strength and vulnerability of trees; and the stream itself is a motif that was to challenge his skill and to hold his attention thereafter. The power of torrents to wear down whatever lies in their path is uniquely conveyed by this early rendering of the theme. The drawing, with its fluently applied grey washes and white highlighting, has an assurance, substance and vigour that surpasses his achievements of the 1640s in this medium.

In his 1652 *Wooded River Valley* (New York, Frick Collection, No. A. 702; Fig. 69) a number of Ruisdael's first reactions to foreign landscape are masterfully combined in the imagination, to produce one of his most refined works of the early fifties. The composition, rather like the Buccleuch picture (Fig. 67), recalls the central vistas of woodlands by Gillis van Coninxloo and his circle, though Ruisdael's picture, nourished by his refined powers of observation, reveals greater fidelity to natural appearances. It is exemplary of the ideal of selective naturalness in which the conception of the mind is cast in forms that have the semblance of natural appearances though not an actual view. The picture contains, for instance, elements such as the massive beech clinging to the sandbank on the left that are found in different settings in other works. Here they are combined and rendered so as to create an effect that has the illusion of reality. By contrast, artists of Coninxloo's generation, whom Ruisdael evidently admired, were content with greater artifice in the stylisation of natural forms. In Ruisdael's picture woodland is conceived as a setting for sport, the decorative figures, by an unidentified hand, adding stature to the painting. The trees, more individualised than anything

Detail from Fig. 69

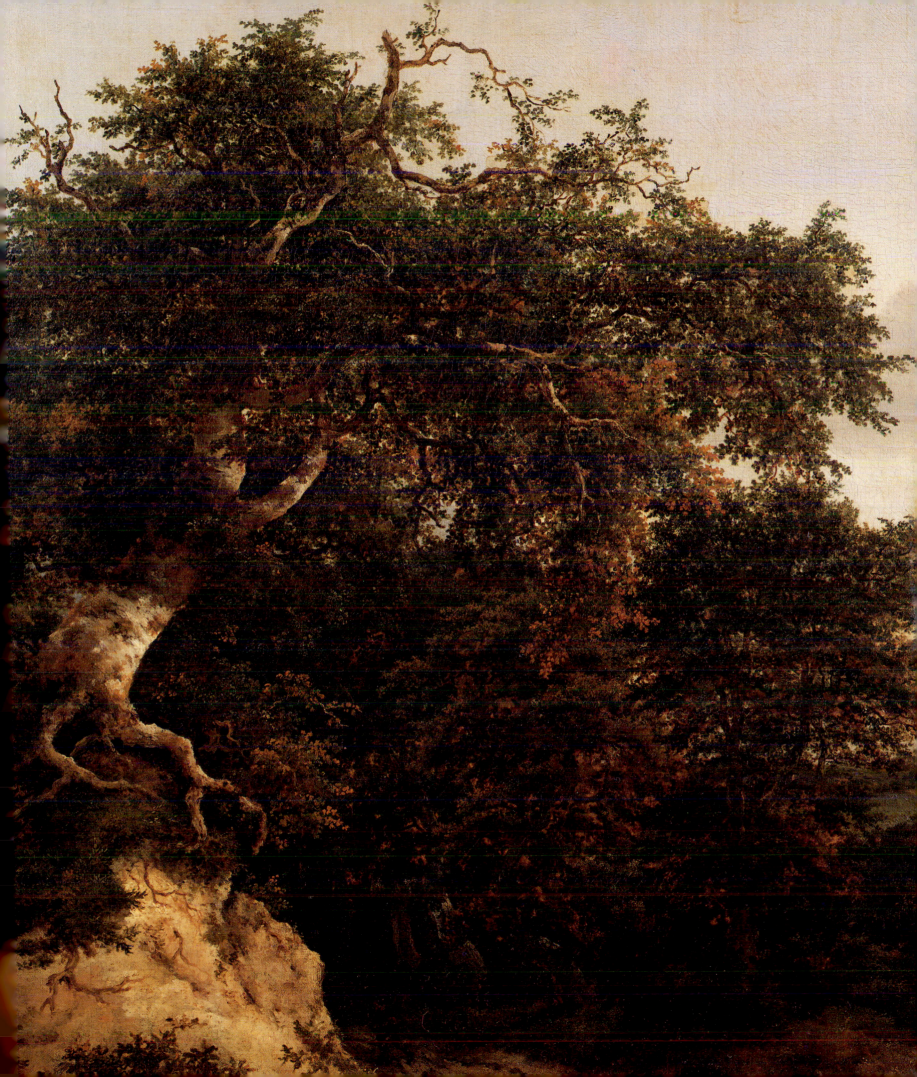

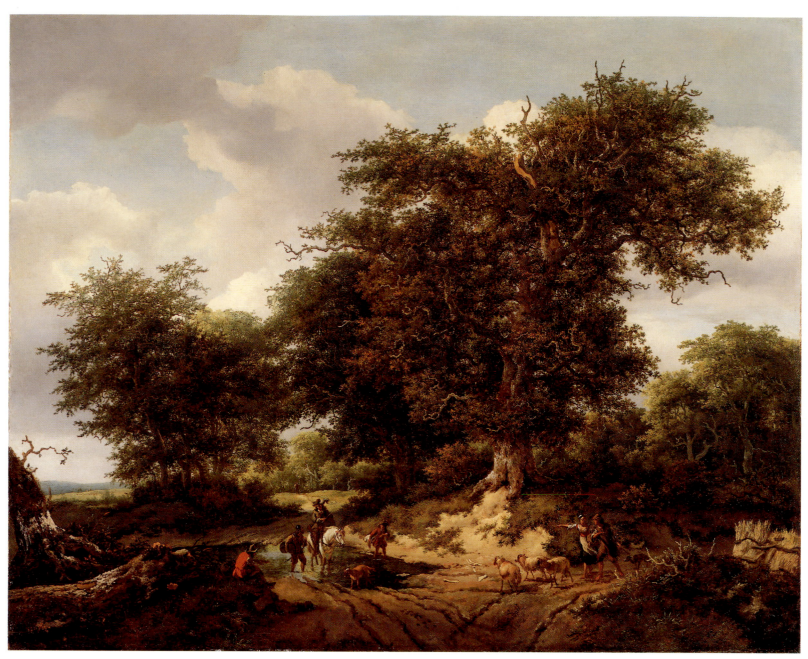

Conixloo produced, manifest Ruisdael's new-found idiom, their wild, twisted forms and sprawling roots replacing the dune-top bushes found in his works of the forties. A further innovation of the early 1650s is the rich, varied colouring of the foliage. In place of monotonous dark green patterns, the foliage is built up in layers of lighter over darker greens, with russet highlights, and the trunk of the foremost tree is heightened in silver-white and grey. While the trees on the left are predominantly dark green, several on the right are russet, suggesting the advent of autumn, as in his other works of the early 1650s. This allusion to the rotation of the seasons, recurrent in his oeuvre, recalls a theme also found in contemporary poetry as noted in Chapter II.

In the *Wooded Country Road* of 1652 (Los Angeles, Mr & Mrs Edward W. Carter collection; Fig. 70), he returned to the compositional scheme of some of his earliest works, this time including a mighty oak as the dominant motif. Compared to those in his 1649 etching *The three Oaks* (Fig. 57), his trees now have far

70. *Wooded Country Road*. 1652. Canvas, 86 × 112. Los Angeles County Museum of Art, promised gift of Mr. and Mrs. Edward W. Carter in honor of the museum's twenty-fifth anniversary. Photo: Los Angeles Country Museum of Art (courtesy of Mr. & Mrs. Edward W. Carter).

greater substance, the landscape greater depth, the whole illuminated by powerful contrasts of light and shadow. Berchem's elegant figures, animating the fore-ground as in Italianate landscapes, appear somewhat incongruous in this dark northern forest, beyond a fallen tree trunk and beside skeletal remains. But such figures provide the staffage expected of an important painting, termed a 'capital landscape'. Ruisdael's picture inspired not only a whole series of paintings by Hobbema, but it was also imitated in the nineteenth century by B.C. Koekkoek in Holland, and by James Stark in England, the latter's outright copy nevertheless passing under the title *Rabbiting in Windsor Park*.[10]

Mighty trees feature in many of his paintings of the early 1650s. They are also the dominant feature of his set of four etchings (Keyes 6–9), the last and finest that he produced. They are both larger in scale (all approx. 18.5 by 27 cm) and more robust in technique than his earlier etchings. They are datable to the years 1650–53, not only on account of the similarity in handling of their motifs to dated paintings of those years which reflect materials gathered on his travels, but also by the form of the signature they bear, with a distinctive flourish on the final 'l'.

His etching, *Trees with Half-timbered Cottage on a Hillside* (Keyes, 7, I; Fig. 71), from this series, shows how the hilly landscape and massive trees seen on his travels stimulated his propensity for intensification of form to reach a new pitch. By filling one side of the composition to the upper limits with massive forms and also including hills in the previously flat, open side of the composition, a new density is achieved, accentuating further the foreground motifs. The half-timbered cottages on the hillside and beyond the water that Ruisdael now incor-porates in many of his works, are characteristic of the vernacular architecture of the border country where he travelled.[11] The diagonal presentation of the leaning tree, unseen in any earlier works, is a stunning image of powerful growth and slow decay.

The theme is taken up again in two other etchings from the series, *The huge Beech with Cottage and Travellers* (Keyes 9; Fig. 72) and *Woodland Morass with Travellers* (Keyes 6; Fig. 73), in both of which he exploited the graphic potential of the wild tree forms that had captured his imagination. The vigorous, contorted forms of roots clinging to the soil and of shattered branches piercing the sky recall Roelant Savery's manneristic etchings of gnarled trees, executed earlier in the cen-tury. Ruisdael's last etchings are a far cry from the elegant, mid-century wood-land etchings of Simon de Vlieger, Herman Saftleven, Jan Both, Anthonie Waterloo, and Jan Hackaert, and indeed from the painted woodlands of Paulus Potter (e.g. Berlin-Dahlem, No. 872A) and Adriaen van de Velde (e.g. Frankfurt, Städelsches Kunstinstitut).[12] The composition of Ruisdael's *Huge Beech* (Fig. 72) resembles elements of a late work by Cornelis Vroom, his *Cattle Drinking at a Forest Pool* (Rotterdam, No. 2141), but its spirit is as different from Vroom's lyrical idyll as it is similar to Savery's earlier vision of growth and decay.

Ruisdael stands apart from this mid-century classicising trend. He employs the same attention to detail, but his wild, grotesque imagery is distinctly reactionary. As Giltay has noted, Ruisdael chose to depict his trees in a manner that Gerard de Lairesse, and others, later described as *schilderachtig* (picturesque): 'misshapen trees, their branches and leaves wildly and improperly splayed from east to west', as opposed to the perfect and straight growing trees of the received classical ideal.[13] In contrast to then current classicising trends, the elements of Ruisdael's *Woodland Morass with Travellers* (Fig. 73) are too similar to those of Savery's by then old-fashioned etching *Gnarled Tree in a Morass with Travellers* (Fig. 74) to be merely fortuitous. The sprawling roots in Ruisdael's *Huge Beech* (Fig. 72),

71. *Trees with Half-Timbered Cottage on a Hillside.* Etching, 185 × 271. Photo: London, The British Museum.

72. *The Huge Beech.* Etching, 184 × 269. Photo: London, The British Museum.

magnifying elements from his 1651 *Bentheim Castle* (Fig. 64) and his *Wooded River Valley* (Fig. 69), are likewise comparable to the great roots in the etching *Goatherd beneath a Tree* (I. de Groot, 10), which is attributed to Savery. Ruisdael's etchings are more detailed in observations than Savery's, and the contrast of light and shadow more pronounced, but it would seem that Ruisdael found not only in the observations of his travels, but also in this earlier mannerist art, imagery that conformed to his conception of nature. Already in his early dune landscapes, woodlands, and coastal scenes, Ruisdael had shown a preference for earlier trends in landscape painting, and for imagery evocative of the impermanence of the physical world. What he now found in earlier mannerist works, which was lacking in the idealised production of his contemporaries, was an artistic precedent for such representations which rejected classical order, harmony, and the illusion of stability. The stagnant pools and broken tree trunks of both Savery's and Ruisdael's etchings suggest primeval forests unsubjected to man's cultivating hand. Their trees have an awe-inspiring strength which suggests both great spans of time and eventual dissolution. The traveller or hunter is there but for a fleeting moment. Such imagery recalls that of Van Mander's 1599 print, *Allegory of the Life of Man* (Fig. 5), in which the world was compared to the growth and dissolution of a tree, the underlying text reminding man that he is but a sojourner here on earth.[14] This theme of impermanence persists in Ruisdael's paintings of the fifties and sixties, and marks the point at which, like Rembrandt, he distances himself from the idealising tendencies of his time, and looks back to the intellectual and artistic conceptions of an earlier generation. His outlook may be compared to that of *Vanitas* still-life painters such as Jacques de Gheyn II, Pieter Claesz. (the father of his friend Berchem), and Harmen Steenwijck, and, in the field of literature, to the outlook of the popular moralist and poet, Jacob Cats, as well as to that of the pietists Judocus van Lodensteyn and, from the next generation, Jan Luyken.

In comparing Ruisdael's etching *Woodland Morass with Travellers* (Fig. 73) with the woodlands of Savery, Gillis van Coninxloo and other mannerists, it is ap-

73. *Woodland Morass with Travellers*. Etching, 185 × 270. Photo: London, The British Museum.

74. Roelant Savery: *Gnarled Tree in a Morass with Travellers*. Etching. Photo: Amsterdam, Rijksmuseum.

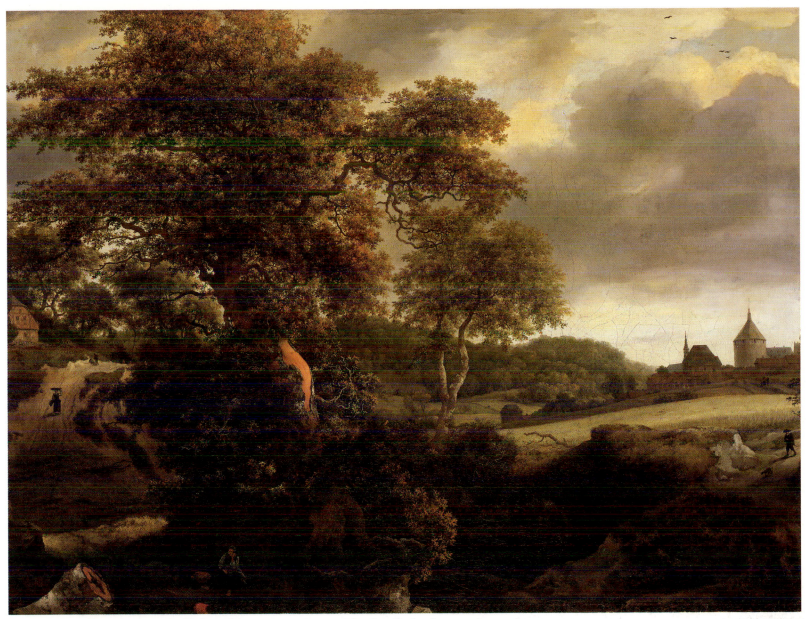

75. *Hilly Landscape with Oak, Cornfield and Castle.*
Canvas, 106 × 138. Brunswick, Herzog Anton
Ulrich-Museum. Photo: Museum.

parent that Ruisdael embellishes his conception with detailed observation of the visible world. His trees are not the monotonous, schematised type of the mannerists, but are imbued with individuality, vigour and life even though, like Savery's, they are placed in imaginary settings in which in reality they could not grow.[15] In this respect Ruisdael sacrifices veracity to his overall conception. For just as the mannerists often included figures contemplating the ancient and fallen trees, images of the life-span of man, so Ruisdael creates an image to delight the eye and to invite deeper contemplation.[16] By the mid-century most landscapists were content to offer pleasing escape and to appeal to the eye alone. The reactionary quality of Ruisdael's imagery may be seen as a rejection of such contemporary trends. Perhaps his etchings went too far for contemporary taste, and conceivably a cool reception discouraged further production. But, as with his earlier etchings, he used them as a source for his own production, and subsequently two of his followers, Hobbema and Kessel, did likewise, as will be noted below.[17]

In his *Hilly Landscape with Oak, Cornfield and Castle,* (Brunswick, No. 376; Fig. 75) Ruisdael realised in paint the massive tree type of his last group of etchings. It

manifests the breadth of conception and richness of execution that emerges in his works in the early 1650s. The composition, as now seen, suffers from having been cropped on all sides.[18] Technically, its detailing, textures and colouring are particularly rich, even if the overall tone is heavy and sombre. Sunlight illuminates the ancient, twisted oak trunk, orange-brown where the bark has peeled away, creating a focus in the mass of richly detailed and scrupulously observed foliage. The colouring of the whole picture ranges from silver-, blue-, and dark-greys, buff and brown on the roadways, buildings, and sky to yellow and pale blue-greens on the cornfield and hills, and olive-green tinged with russet on the great oak. Conceptually, it is equally rich. Under a stormy sky relieved by glimpses of sunlight, he presents a composite image of contrasting hilly woodlands and rolling cornfields, seen to either side of and beyond the massive oak tree. Two roads leading to the contrasting terrain diverge from the central motif, beyond which flows a stream. On the left a steep road passing a cottage leads into the hilly woodland. On the right, another roadway leads out beside the open cornfields, beyond which are glimpsed features of Steinfurt Castle, known from his travels. While travellers are seen on both roadways, at the foot of the great oak, beside its bared roots, is seated a woman in a meditative pose. Her presence and pose invite the viewer to contemplate the features of the landscape.

The position of this contemplative figure at the foot of the great oak, beside a stream, invites reflection on the well known and much quoted allegorical associations: man's life is like a tree, like flowing water, to both of which, as noted in Chapter III, Van Mander had made both pictorial and written reference in his *Allegory of the Life of Man* (Fig. 5). Like that print, which showed two paths through life, the low and easy and the steep and hard, one notes that the other figures in Ruisdael's painting are placed on the two divergent roads, which, as Giltay has noted, makes one wonder whether a further level of allegorical reference to the choice between the highroad and the lowroad, seen in sixteenth-century landscapes, was also intended.[19] This duality at first sight appears to be reinforced by other contrasting elements – wild and fertile land, even cottage and castle. However, not only is it difficult to gauge whether Ruisdael intended such a specific allegorical reading, but also the cropped condition of the painting produces a misleading effect. While we may assume that in its original state the felled tree trunk, visible lower left, and familiar as one of Ruisdael's *vanitas* motifs, would have been far more prominent, the remains of foliage from a further tree, just visible over the cornfield on the extreme right edge of the painting, suggests that in its original state the picture may well have extended significantly to the right, especially since Ruisdael invariably shows at least half of a tree at the edge of a composition.[20] In its original state the balance within the painting may therefore have been more like that of his etchings of the same period (Figs. 71–73), with the main tree more to one side, or even like that of his 1652 *Wooded River Valley* (New York, Frick Collection; Fig. 69) with a central open vista. In either case the main oak in the Brunswick painting would then have stood more to one side, even allowing for inclusion of the whole cottage on the left, as in his etching (Fig. 71), so reducing the effect, as now seen, of two divergent roads either side of a central motif. This, in turn, would reduce the likelihood of a contemporary beholder seeing the picture as a modern version of the age-old allegory of the choice between highroad and lowroad. Instead, it would have conformed more to his usual binary compositions contrasting open and closed vistas onto woodland and fields, showing both the wild and cultivated aspects of nature, seen as images of beauty, variety and abundance within a mut-

76. Nicolaes Berchem: *Landscape with High Trees.* 1653. Canvas, 130 × 195. Paris, Louvre. Photo: Musées Nationaux, Paris.

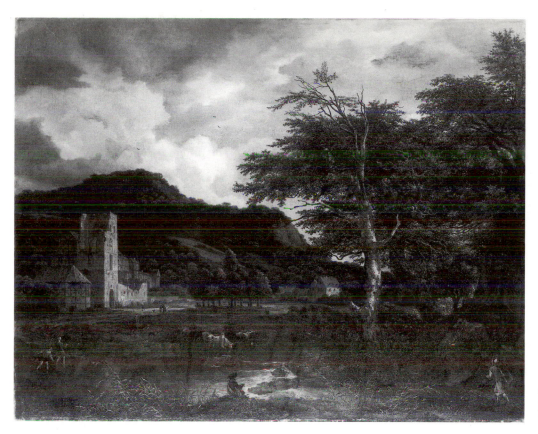

77. *Ruined Monastery by a River.* Canvas, 75 × 96. Dresden, Gemäldegalerie Alte Meister. Photo: Staatliche Kunstsammlungen, Dresden.

able world, to which the overall tone of the picture and its most prominent motif bears visible testimony.

In the Brunswick *Hilly Landscape with Oak, Cornfield and Castle* Ruisdael has transposed into his own richer idiom the conception of nature seen in Pieter van Santvoort's *Sandy Road* of 1625 (Fig. 21), Jan van Goyen's *Country Road* of 1633 (Fig. 13), and Rembrandt's *Stone Bridge* of around 1637/38 (Fig. 15), discussed in Chapter III as images of well-being and providence in a mutable world, battered by time and storm, yet irradiated by light. Comparison to his works of the 1640s shows that the intervening years and the experience of travel had enabled Ruisdael to broaden his vision, to introduce new motifs, and to extend his artistic powers. His forms are forceful, his colouring is rich, and his handling of foliage more elaborate and painterly. Large, leafy oaks replace the bushes, elms, and willows of his early landscapes, and remain a constant feature of his subsequent paintings. This had a passing impact on Berchem, whose 1653 *Landscape with High Trees* (Paris, Louvre, No. 1037; Fig. 76) reflects a debt to Ruisdael's handling of foliage.

Characteristic travel motifs also feature in his *Ruined Monastery by a River* (Dresden, No. 1494; Fig. 77). Berchem has added the two foreground figures, one a young artist, perhaps Ruisdael, sketching by the water.[21] A dark, enclosing hillside is once more incorporated into his earlier vertical-horizontal compositional scheme. Heavy cloud in a late afternoon sky contributes to the density of the image, once again relieved by shafts of light, here illuminating two novel features, the yellow-ochre coloured ruin on the left, and the glistening stem of a dead beech in the right foreground.[22] The interplay seen here between a dead tree and a ruined church had been essayed in his 1648 *View of Egmond* (Fig. 51) and was repeated, to even more dramatic effect in his two versions of *The Jewish Cemetery* (Figs. 89 & 94). The glistening beech, here substituted for the elm of the earlier picture, provides a brilliant contrast to the darker vegetation beyond, and was

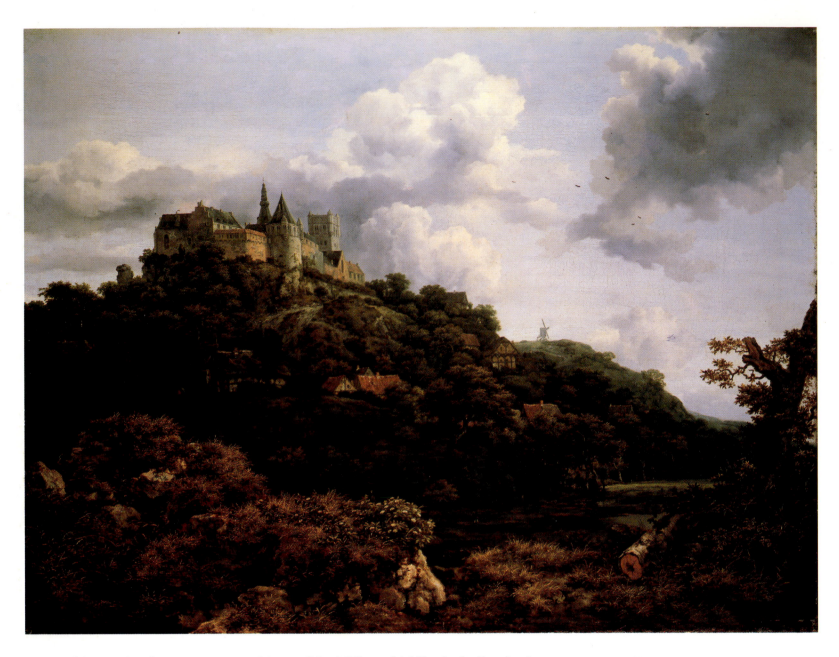

repeated in many subsequent compositions of the 1650s and 1660s, including both versions of *The Jewish Cemetery*.

The compostition of the *Ruined Monastery by a River*, with its river leading diagonally through the picture, and hills beyond, was masterfully adapted in what is acknowledged as Ruisdael's most imposing representation of *Bentheim Castle* (The Beit Foundation, National Gallery of Ireland; Fig. 78), painted in 1653. As Rosenberg first pointed out in juxtaposing a photograph of it to the painting, Ruisdael has greatly exaggerated the actual modest hillock to increase the dramatic power of his picture. He creates a remarkable combination of luxuriant foreground vegetation, seen in great detail, with a wide-open vista of the hillside and castle on the opposite bank. This is complemented by subtler and more voluminous cloud formations than Ruisdael had hitherto produced.

Watermills were another architectural feature which captured his attention on his travels. They provided the context for his first experiments in the depiction of gushing water. Ruisdael produced a number of paintings of two watermill

78. *Bentheim Castle*. 1653. Canvas, 111.8 × 152.4. National Gallery of Ireland (Beit Collection). Photo: National Gallery of Ireland.

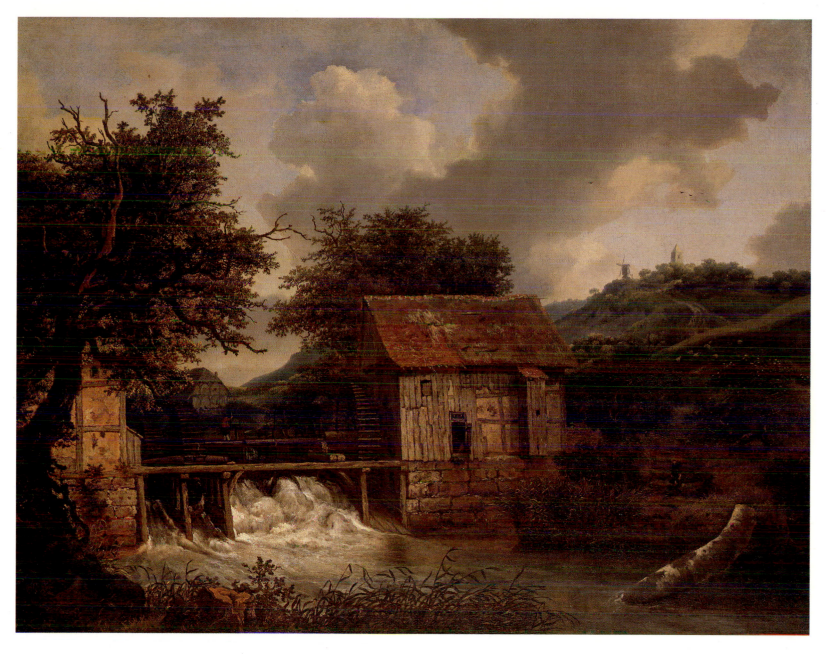

79. *Watermills and an Open Sluice in a Hilly Landscape*. Canvas, 87.3 × 111.5. London, National Gallery. Photo: Reproduced by courtesy of the Trustees, The National Gallery, London.

buildings with undershot waterwheels between them (see Figs. 79 & 80). While no specific topographical identification can be given, these mills are similar in structure and type to those of Haaksbergen, south-west of Enschede, but could equally have been inspired by some other, now-vanished watermills of the Twenthe region.[23] In different versions of the motif, Ruisdael depicts the right-hand building in various states of repair and ruin, which cannot be taken as an indication of chronology, but only of his imaginative and perhaps symbolic interest in ruins, that is so prevalent in this phase of his career.

Only one surviving watermill painting of this group is dated, the *Two Watermills and an Open Sluice* (Malibu, J. Paul Getty Museum, No. 82. PA. 18; Ros. 102 [with wrong dimensions]; Fig. 80) of 1653, which, like the *Bentheim Castle* painting of the same year, includes sharply defined elements in the immediate foreground plane.[24] Seen against a heavily clouded sky, a burst of sunlight draws the eye to the central motif of the half-timbered mill, the texture of its clay wall-filling, timbers, and thatched roof vividly evoked, and to the water gushing

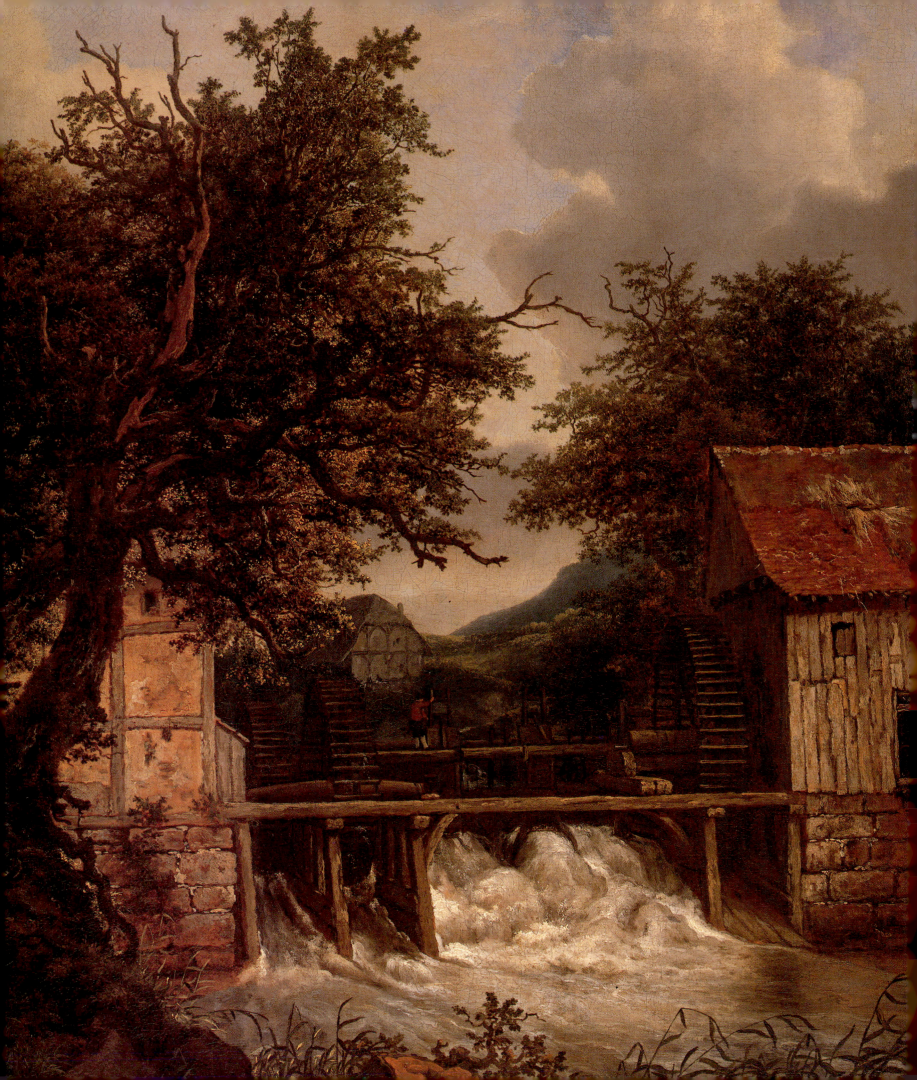

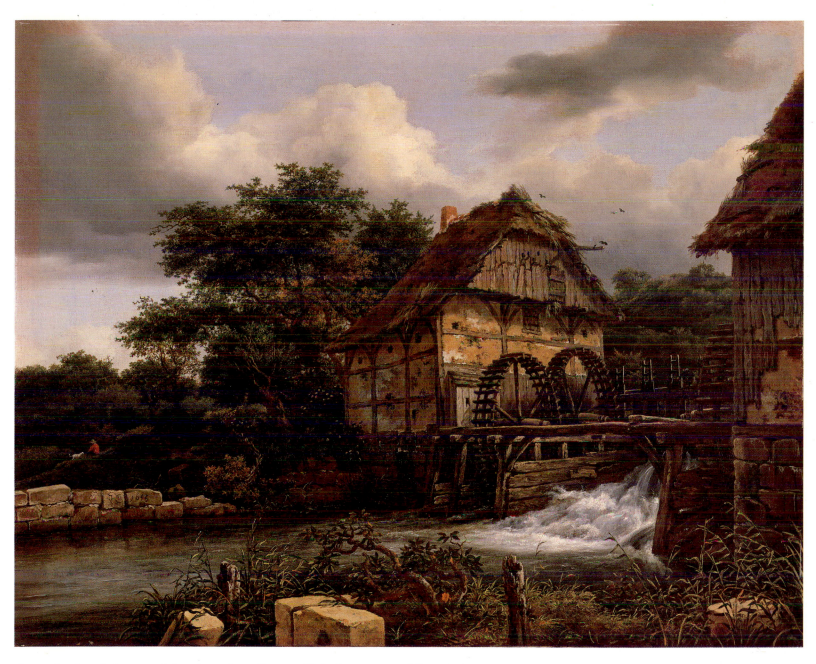

through the sluice, anticipating the effects of his later waterfall paintings. But here it is the mill, and its complex of water-wheels, shoots and sluices, standing out boldly from its setting, that is the centre of interest. A variant of the Getty painting, formerly in the collection of Lord Swaythling (Ros. 107), shows the same watermill from a similar viewpoint, a little to the right, but with the nearer mill depicted in ruins, and a leafless tree to the left of the further mill, further accentuating the effect evoked by the autumnal tints in the foliage of the similarly located tree in the Getty painting. A larger and more ambitious work, *Watermills and an Open Sluice in a Hilly Landscape* (London, National Gallery, No. 986; Fig. 79) was probably painted about the same time. The landscape setting is imaginary, not belonging to the same region as the mills, but perhaps including elements inspired by the immediate vicinity of Bentheim, the hillside silhouette with windmill and church tower, seen from a different angle in the 1652 *Wooded River Valley* (Fig. 69), recalling that of Gildehaus. Such a wide stream, however,

80. *Two Watermills and an Open Sluice.* 1653. Canvas, 66 × 84.5. Malibu, California, Collection of the J. Paul Getty Museum. Photo: Museum.

Detail from Fig. 79.

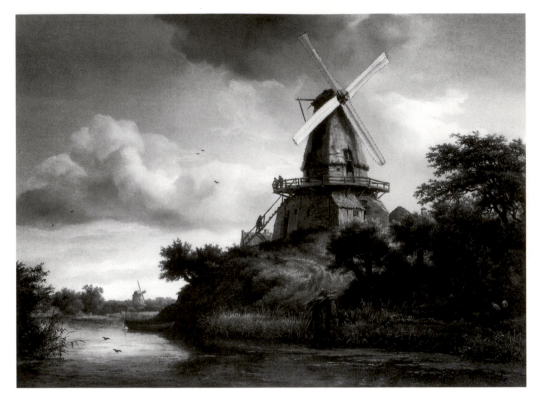

81. *Windmill on a River Bank*. Canvas, 49.5 × 66.5. Private Collection. Photo: Prudence Cuming Associates, courtesy of Robert Noortman (London) Ltd.

is not to be found in the vicinity, further underscoring the fact that the picture is an imaginary composition.[25] When Ruisdael uses details from his observations, he combines them in the studio, subordinating them to his overall scheme. It is a highly selective form of naturalness.

This prompts one to question what his guiding conception was, and what lead him to combine elements in this particular way. The visual appeal of these mills and the exotic setting must rank foremost. Furthermore, the buildings and water, besides their inherent appeal, introduce an array of browns, tan, russet red, blue-green and white which greatly enhance his earlier and more sober palette of greens and browns. In Goltzius's woodcut, *Fisherman by a Waterfall* (Fig. 8), the waterwheel, and the waterfall beside it were intended to evoke the unrelenting passage of time in the same way as hourglasses in still-life paintings. It is possible that Ruisdael has breathed substance and local detail into the imagery of Goltzius's small woodcut. Ruisdael's early attempt to capture the foam of gushing water is laboured, but it may have provoked his subsequent admiration for Van Everdingen's *Waterfalls*, and served as a prelude to his own fascination with this element. Ruisdael's watermills reflect his meticulous landscape observations, reassembled in the studio to create an image to delight the eye, to stimulate and nourish curiosity about foreign regions, and to invite reflection. A comparable mixture of observation and reflection is found in the travel literature of Huygens, Six van Chandelier, and later Claas Bruin.[26] When Houbraken wrote of Ruisdael, he was careful to praise his excellence in both local and foreign landscapes. His travels served to enlarge his vision and to provide subject-matter for later work.

The desire to exploit the fruits of his travels did not stop Ruisdael from painting motifs from the indigenous landscape in the early 1650s, though it may have affected the way he approached them. The bushes and dunes of his early works have gone. Instead he accentuates more massive elements, notably architectural features.

There is a small group of works of questionable attribution that feature wind-

82. *Windmill on a River Bank*. Drawing. Black chalk, 94 × 151. Formerly Bremen, Kunsthalle (lost in the Second World War). Photo: Bremen, Kunsthalle (Stickelmann).

mills and farms on river banks.[27] Among them the monogrammed *Windmill on a River Bank* (private collection; Ros. 112; Fig. 81) can be attributed with more certainty to Ruisdael. Its rather bright colouring, though more subdued than others in the group, can be compared to the series of watermill pictures considered above, and it may have been painted about the same time. A very sketchy black chalk drawing, *Windmill on a River Bank* (Formerly Bremen, Kunsthalle [lost in World War II]; Giltay 28; Fig. 82), dated by Giltay to the late 1640s or first half of the 1650s, very closely parallels the painting, though the bank in the drawing is less elevated.[28] The scale of the bank is exaggerated in the painting and the prominence of the mill, foreign to earlier river landscapes accords with Ruisdael's general practice in the early 1650s.

The *Landscape near Muiderberg* (Oxford, Ashmolean Museum, No. A. 875; Fig. 83) is a somewhat larger and more experimental composition, in which the ruins of Muiderberg church are once again seen on the far horizon. It contains a number of features found in his watermill paintings of around 1652–53 and is datable to about the same time. The bramble bushes in the left foreground and the wayfaring bush (or elder), a little to the right, both recall similar passages in the 1653 *Bentheim Castle* (Fig. 78). The prominent 'stag's-headed' oak and the beech trunk in the stream reiterate features of the London *Watermills* (Fig. 79) of about the same date.[29] The innovatory composition, with a clump of trees set back on a hillock offsetting a distant prospect, attempts to fuse elements of woodland, cornfields, features of the Dutch landscape – the ruined church of Muiderberg – and, somewhat inappropriately, a little waterfall carrying off a massive tree trunk. The painting, seen as a Dutch landscape is incongruous, but, as a conceit of the

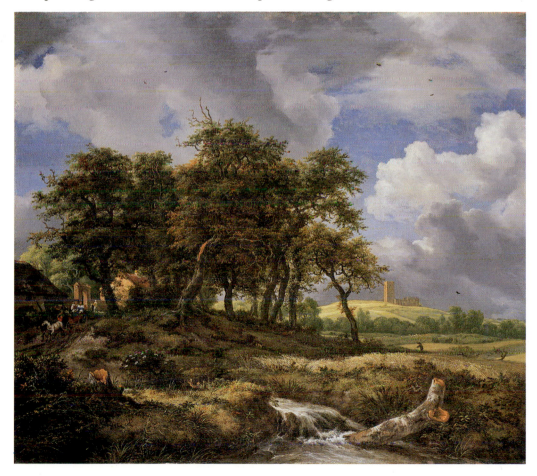

83. *Landscape near Muiderberg.* Canvas, 66 × 75. Oxford, Ashmolean Museum. Photo: Museum.

mind it is both engaging and more complex than an earlier prototype, the *Trees on a Coastline* (Springfield, Mass.; Fig. 50) of 1648. By comparison, the forms of the land are more massive and the vegetation more varied and textured. Its voluminous clouds, dramatic lighting and contrasting closed and open vistas suggest finer things to come. In the little *Wooded Road* (Amsterdam, No. A. 350; Fig. 84) of 1653, Ruisdael reverts to the theme of a peasant returning from the fields. It is more modest in conception, more intimate in mood, but comparable in the treatment of trees and bushes. Tranquility is evoked by evening sunlight breaking out after storm to illuminate the underside of streaky clouds. The composition recalls works of the forties, but the trees are now dense and scraggy as in other works of around 1653. If Berchem staffed the painting, as is generally held, he adapted his figures more successfully here to a northern landscape.[30]

Ruisdael's *Country Road with ruined Gateway* (London, National Gallery, No. 2562; Fig. 85) is a work of similar date. It has a comparable flat, streaky sky, similar trees, foreground vegetation, and a bound-rush fence on the right, as in the 1653 Amsterdam painting. A striking feature is the prominent ruined gateway, inserted into the vertical-horizontal scheme of his earlier country road pictures.

Ruins recur in his *Dune Landscape with Ruins* (London, National Gallery, No. 746) on which traces of the date 1653 remain. Despite their northern character, Ruisdael's ruins were seen by Rosenberg as evidence of the influence on him of Italianate landscapists, such as Both and Asselijn. They frequently used ruins as structural elements in a composition, offsetting distant landscapes. Ruins, however, were not exclusive to the Italianate landscapists. They were also part of the northern tradition. Both their appearance, and the associations they evoke in Ruisdael's landscapes belong completely within this northern tradition. Early in the century, and probably stimulated by their recent historical associations, Goltzius, Willem Buytewech and Seghers had represented the ruins of Brederode Castle, near Haarlem. Buytewech and C.J. Visscher depicted the ruined manor of Kleef, also near Haarlem. Both buildings had been destroyed by the Spanish in

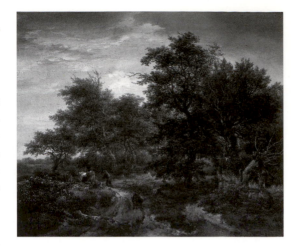

84. *Wooded Road*. 1653. Panel, 42 × 49. Amsterdam, Rijksmuseum. Photo: Museum.

85. *Country Road with Ruined Gateway*. Panel, 46.7 × 64.5. London, National Gallery. Photo: Reproduced by courtesy of the Trustees, The National Gallery, London.

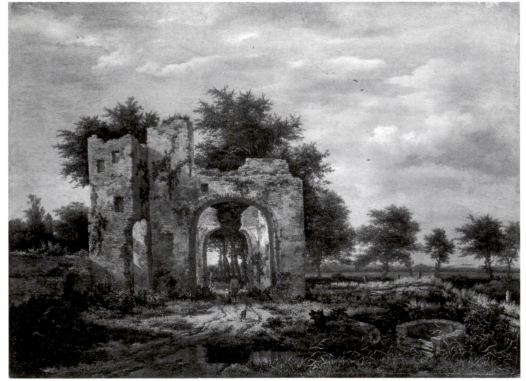

1573. In the inscription under Jan van de Velde's etchings (after drawings by Pieter Saenredam) of these two ruined buildings, made for Samuel Ampzing's 1628 *Praise of Haarlem*, reference is made to both the Dutch struggle for independence, and also to the brevity and impermanence of man's efforts.[31] Ruined churches were depicted by Savery (Fig. 9), Seghers (Fig. 86), and Cornelis Vroom. In an etching by Jan van de Velde of a *Dead Tree among Ruins*, published by C.J. Visscher in 1615, both tree and ruin recall the transience of life. As noted in Chapter II, Claas Bruin's lines written a century later on the ruined castle at Wijk bij Duurstede express a comparable sentiment. He wrote that the splendour of fine edifices is deadened by time, for nature loves change, and even massive buildings have finally to yield to the ravages of time.[32]

The function of ruins in these northern landscapes is distinct from that which they serve in Italianate landscapes. In Berchem's *Peasants with Oxen and a Goat by a Ruined Aqueduct* (London, National Gallery, No. 820), probably painted in the late fifties, the ruin emits from its stones the mystique of an idyllic past, brought into the present by the colourful figures to satisfy our escapist dreams. By contrast, in the northern tradition, ruins frequently signify the mutability of life. In Seghers's *Ruins of the Abbey of Rijnsburg* (Fig. 86) a figure contemplates the ruin before him as does the hermit in Savery's *Landscape with Ruined Church by a Waterfall* (Fig. 9), discussed in Chapter III. Van Mander's *Allegory of the Life of Man* (Fig. 5), the inscriptions on Jan van de Velde's etchings of the ruins of Brederode and Huis te Kleef and the lines of Claas Bruin all sugggest that such ruins would call to mind life's transiency, they invite reflection on the significance of life in a world of time and change.

In Ruisdael's landscapes ruins serve neither to offset glowing prospects, nor to evoke an idealised past. As in other northern landscapes, his ruins are appealing pictorial motifs that enhance the landscape and also recall the vanity of worldly splendour. There is visible in the landscape something that once has been but that is no more. In placing his figures in this context, he recalls both the accomplishments of former generations and the fleeting quality of life.

Indigenous motifs also occur in a number of drawings which, on stylistic grounds, may be attributed to the early 1650s. After his return from the German border country, Ruisdael perhaps visited his relatives in Alkmaar. An undated drawing, *The Gasthuisstraat behind the Grote Kerk (Sint Laurenskerk Alkmaar)* (London, British Museum, No. 1895.9.15. 1926; Giltay, No. 76; Fig. 87), is executed with an assurance and body lacking in drawings and paintings from his previous trip to this area, but comparable to the quality of his drawings of *The Jewish Cemetery at Ouderkerk* (Haarlem, Teylers Museum; Figs. 91 & 92).[33] It also reflects the new interest in architectural motifs, characteristic of his activity in the early 1650s. It was probably on this same trip that he made a number of drawings of the nearby ruins of Egmond castle, including the one in Stuttgart, *The Ruined Castle of Egmond* (No. C 64/1329; Fig. 88), which he used as the basis for the building in the background of the Dresden version of *The Jewish Cemetery* (Fig. 94). This trip would have been before 1653/4, the period of the two paintings of *The Jewish Cemetery* (Figs. 89 & 94), paintings whose character and tone belong more to the world of Amsterdam than Haarlem. This may well indicate that by the time Ruisdael painted them he had moved into the more sophisticated and cosmopolitan milieu of Amsterdam. It was here that he once more extended his range and gave his paintings their definitive character, adding first more monumentality and thereafter greater openness and luminosity to his earlier accomplishments.

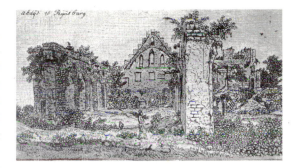

86. Hercules Seghers: *Ruins of the Abbey of Rijnsburg*. Etching. Photo: Amsterdam, Rijksmuseum.

87. *The Gasthuisstraat behind the Grote Kerk (Sint Laurenskerk), Alkmaar*. Drawing. Black chalk, grey pencil, grey wash, 200 × 311. London, British Museum. Photo: Museum.

88. *The Ruined Castle of Egmond*. Drawing, black chalk, grey wash. Stuttgart, Staatsgalerie. Photo: Museum.

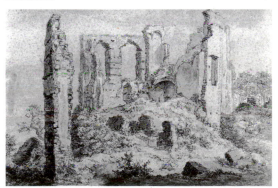

In evaluating the significance of his pictorial and thematic development at this stage, the impetus of foreign travel produced the most apparent innovations in Ruisdael's works of the early 1650s. The range of his themes, and the treatment of specific motifs, were extended and modified by these travel experiences. Once again Ruisdael's work is seen to be a mixture of convention and innovation, in which he now moves further towards the creation of more generalised images of the wilder and more rugged aspects of nature, especially in the woodland motifs that now take more prominence. They are landscape themes that lend themselves to the contemplative mode explored in Chapters II and III. In his interest in earlier mannerist landscapes, his attention to ancient, decaying woodland, and in the monumentality of many of these works, Ruisdael's work seems now to be less in harmony with his roots in Haarlem painting, and more in keeping with the traditions and tastes of Amsterdam.

Foreign and Domestic Motifs: Mid-Late 1650s

Amsterdam offered Ruisdael a more expansive and vital market than Haarlem. It exposed him to artistic traditions different to those of Haarlem, with a taste, in landscape, for the more imaginary and fantastic. It has been supposed that Ruisdael moved to Amsterdam around 1656. He was certainly resident there by the following year, and there is no documentary evidence linking him to either Haarlem or Amsterdam in the few years preceding. His drawings of the tombs in the Portuguese-Jewish Cemetery at Ouderkerk-on-the-Amstel, a village on the southern outskirts of Amsterdam, are evidence of his presence in the city, but not necessarily of his residence, by about 1653/4. On stylistic grounds *The Old City Gate of Amsterdam* (Sutherland collection) must date from about the same time. The only other hint of a move from Haarlem around 1653 is a break of continuity in the type of staffage found in his paintings in this year. This suggests that certain unidentified collaborators were no longer at hand. There are no more figures supplied by Berchem, nor are there any more of larger scale, colourfully costumed figures of the type that appear in several paintings from 1649 until 1652, for example the Edinburgh *Banks of a River* (Fig. 59), and the Frick Collection *Wooded River Valley* (Fig. 69). When colourfully costumed figures remake their appearance in some of his late works, they are of a different type and by other hands.[1]

If this supposition is correct, then the two versions of *The Jewish Cemetery* in Detroit and Dresden (Figs. 89 & 94), executed about 1653/4, may be seen as ambitious works aimed to catch the eye of his new public. The conception of these two paintings shows a grandeur, dramatic power, and breadth of imagination that surpasses anything he had yet produced. They would also have been more likely to appeal to the public of Amsterdam than to that of Haarlem. Furthermore, these paintings manifest, not an isolated incidence, but an important change in Ruisdael's style. Although he did not produce anything quite so richly allegorical again, the qualities found in these paintings nevertheless reflect a general transition in his style at this time. This may in part be attributed to his move to Amsterdam, and his exposure to the cultural milieu of that city. He developed a heightened use of chiaroscuro and spotlighting effects, which suggest the further influence of Rembrandt; a heavier quality in his brushwork, reminiscent of Philips Koninck and Rembrandt; and especially a tendency to create landscapes on a grander scale and of a more fantastic and conceptual quality. These leave the Haarlem-school 'realism' far behind and are more in keeping with the taste of painters and public in Amsterdam.

Amsterdam in the middle of the seventeenth century was full of opportunity for a young painter. The town was immensely prosperous; wealthy families, old and new, were moving into larger and finer houses along the newly laid-out canals ringing the old city; they were eager to furnish them in the latest fashions; large sums were being laid out on luxury goods. This expanding market was attracting painters from many quarters, who in turn contributed to the lively atmosphere of the city. Although Ruisdael probably went to Amsterdam with his eye as much on its economic as its artistic appeal, his new environment surely also contributed to the development of his art. Amsterdam enjoyed in landscape

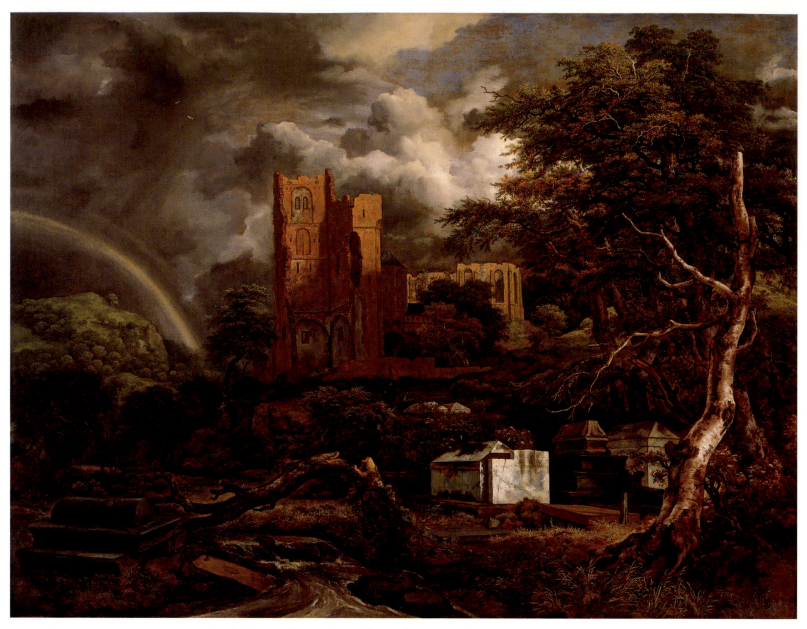

painting a tradition considerably different from that of Haarlem. Landscapists there had developed the imaginary aspect of the Flemish Mannerist tradition, with its predilection for fantastic, mountainous scenery and dense, leafy woodlands. This was in great measure due to the influence of Gillis van Coninxloo (1544–1606) and his followers, and, more recently, to the preference of Rembrandt and his circle, at least in paintings, for imaginary, mountainous landscapes. With the arrival of Allart van Everdingen in the city in 1652 this Mannerist trend in landscape received fresh impetus. Van Everdingen had been trained in Utrecht by Savery, an artist whose works first influenced Ruisdael in the early 1650s. Van Everdingen's compositions were massive; his subject matter was mountainous landscape with pine trees, craggy rocks, and waterfalls, reminiscent of Savery, and sometimes of Seghers.

Although this Flemish Mannerist tradition had undergone considerable changes and incorporated more realistic elements by the time Ruisdael came to Amsterdam, it still survived as an interest in fantastic and conceptual landscape, which was of significance for the development of his art. He also found there

89. *The Jewish Cemetery*. Canvas, 142 × 189. The Detroit Institute of Arts, Gift of Julius H. Haass, in memory of his brother Dr. Ernest W. Haass. Photo: Museum.

more powerful means of expression, especially in composition, the handling of light, and the use of heavy clouds. Rembrandt's example of a more substantial impasto to match this weight had been applied to landscape in the works of Koninck. Already in the early fifties developments in Ruisdael's paintings suggest intense exposure to the artistic life of Amsterdam. His move from Haarlem may have been earlier than the usually accepted date of 1656. He may well have been in Amsterdam by about 1653–54, to which years we would also date both versions of *The Jewish Cemetery* on stylistic grounds.

Dense composition, stormy skies, dead trees, ruins, and a little waterfall, elements developed by Ruisdael in the early fifties, are combined in his two versions of *The Jewish Cemetery* (Detroit, No. 26.3; Fig. 89, and Dresden, No. 1502; Fig. 94). They create in each an elaborate allegory of the life of man. The Dresden version (84 by 95 cm; Fig. 94) is dense and compact, and its heavy brooding mood has long captured attention. The foreground is tightly executed and richly detailed, the ruin lies in shadow, and the background hill and rainbow are indistinct. The Detroit version (142 by 189 cm; Fig. 89) is much larger, more luminous and finished. The waterfall in the Detroit version is however uninspired, and the painting lacks the intensity of the smaller Dresden version. But the space is better articulated, the ruin enlarged in mass and raised to prominence on a rocky bank, and the background hill and rainbow elaborated. In the Detroit version the dead beech (Figs. 89 and 90) is solid, firm in structure and outline, and the highlights are worked up into a fine sheen. Like the trees behind, it is more articulate, detailed, and vibrant than the weaker beech, and other trees, in the Dresden version.

Several other refinements in the Detroit version suggest that the Dresden version is the earlier. In the more studied Detroit picture the fallen oak has been relocated over the water, so linking the two foreground sets of tombs. The left-hand tombs have been rearranged, the brown slab now sinks into the water, and the black tomb has been turned to lead the eye into the composition. The two white tombs beyond have been moved into the space created on the rise of ground, and significantly, the figures (detail, Fig. 93) have been transferred to the central axis of the painting. The intensity of the Dresden picture (Fig. 94) approximates more closely earlier works such as the *Village under a Hillside* (Berlin-Dahlem, No. 885 F). Its trees and waterfall with white highlights on a dark ground, are similar to effects in a *Woodland with Waterfall* (Exh. Colnaghi, London, Summer 1979, No. 36), a work of about 1653, which was staffed with figures by Berchem. This suggests that the Dresden version is the earlier of the two, and was executed around 1653, the Detroit version not much later. This is indicated by its heavy, dark grey cloud, with streaks of dark blue over grey, not tempered by the restraint of his later works. The dense yet detailed dark green foliage, with grey, dead branches protruding, is also typical of works of around 1653/4. The flowering bush and brambles, at the foot of the dead beech, broadly painted in brown and olive green, with white flowers, are similar in execution to the foreground vegetation in the *Watermill* (Fig. 80) of 1653. The signature on the Detroit version, with a characteristic flourish on the final 'l', corresponds to that on other works from the first half of the fifties.[2]

These two paintings owe their title to the elaborate, marble tombs which still stand in the Jewish Cemetery at Ouderkerk, on the Amstel, outside Amsterdam. Two drawings (Haarlem, Teylers Museum, Nos. Q*48 & Q*49; Figs. 91 & 92 respectively), worked up as independent works of art and subsequently engraved, in reverse, by Abraham Blootelingh in 1670, record the tombs of important early

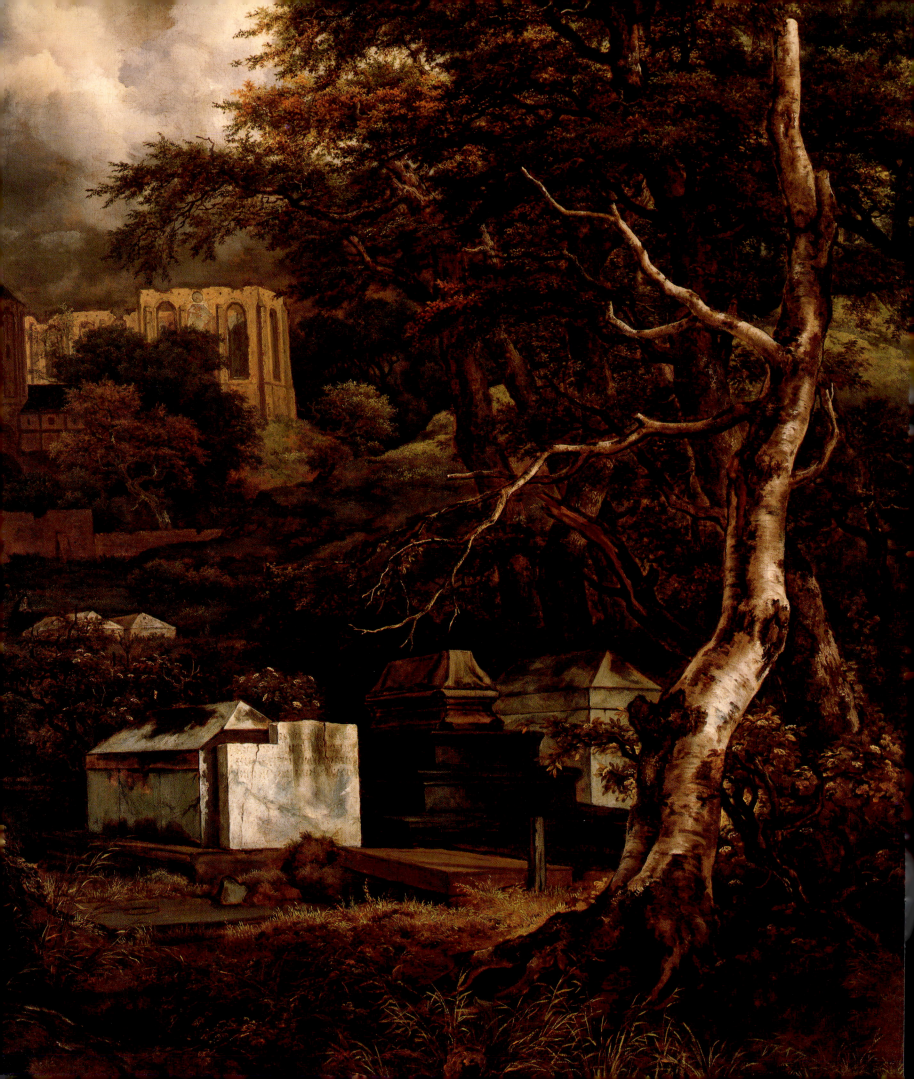

members and rabbis of the Portuguese Jews settled in Amsterdam. A less finished drawing, of *The Ruined Castle of Egmond* (Stuttgart, No. C 64/1329; Fig. 88), served as the basis for the ruin in the Dresden version. The ruin in the Detroit version was possibly inspired by the ruined tower of the Romanesque abbey of Egmond Binnen, and the choir of the adjacent early Gothic church of Egmond.[3]

Ruisdael's two paintings of *The Jewish Cemetery* have long been recognised as allegories of the life of man, although their specific interpretation is disputed.[4] Ruisdael's reference to the transience of earthly life is acknowledged. Dead trees, waterfalls, ruins, whether of sacred or secular buildings, were commonly associated with the transience of life by seventeenth-century poets and painters, and were integral to Ruisdael's subject matter (see Chapters II, III, and above). Depiction of Jewish tombs is peculiar to Ruisdael, and to Blootelingh and Romeyn de Hooghe following him, in 1670 and 1675 respectively.[5] As grave monuments, Jewish tombs were distinct in seventeenth-century Holland for their elaborate carving and lavish, imported marble, which Ruisdael carefully renders. His depiction of these tombs may be compared to Rembrandt's interest in the Jewish community of Amsterdam. Within the context of Ruisdael's allegory, Wiegand's explanation of them as an example of the vanity of outward display is well founded. In Matthew 23. 27, Christ condemned the scribes and Pharisees for holding the form but not the spirit of religion, comparing them to 'whitewashed tombs, which outwardly appear beautiful', but are vile within. As Wiegand mentions, this text was alluded to in Adrianus Hofferus's *Nederduytsche poëmata* (Amsterdam, 1635, p. 129) in relation to the outward show of Jewish ceremony. Jewish tombs being known at the time for their '*pronk*' (ostentation), Ruisdael's representation of their potential decadence, like that of the ruins behind them, recalls the vanity of all outward religion and worldly security, whether Jewish or Christian.[6]

Wiegand's assertion that the paintings convey no positive Christian assurance is, however, unfounded. Images of *vanitas* were in essence conceived to recall man's dependency on God, as is evident not only from the hermit paintings and prints of the late sixteenth and seventeenth century (e.g. Figs. 6, 9, & 17), but also from the text of Van Mander's *Allegory of the Life of Man* (Fig. 5). Furthermore, the function of the rainbow, and the light penetrating the darkness merit reconsideration, as does the significance of the figures in the Detroit version.

In seventeenth-century art and literature the rainbow was recognised as a reminder of Jehovah's covenant with man (Genesis 8 & 9), which has particular relevance in relation to a Jewish cemetery painted by one who was a 'Jacob, the son of Isaack'. The rainbow was also recognised as a sign of the judgment to come and hence a reminder to lead an upright life (II Peter 3. 4–14).[7]

Light-beams, in conjunction with storm clouds, represent more than just a state of the weather in these two paintings, as in Ruisdael's oeuvre as a whole. The significance of sunbeams dispelling darkness in both seventeenth-century literature and painting was reviewed in Chapters II and III. Their particular significance in *The Jewish Cemetery* recalls their function in the works of Goltzius (Fig. 17), Rembrandt (Fig. 14), Savery (Fig. 16), and Joos de Momper (Fig. 20), in all of which light-beams break into darkness conveying a sense of redemption or divine providence. Ruisdael's combination of rainbow, ruin, light and shadow may be compared to an analogous work of the early seventeenth century, *Noah's Thanksgiving* (Berlin-Dahlem, No. 1843) by Johann König. It represents, besides God the Father with a rainbow, ruins under a dark sky on the right, denoting judgment, contrasted on the left with Noah and his family illuminated by rays of

91. *The Jewish Cemetery at Ouderkerk on the Amstel.* Drawing, black chalk, brush, Indian ink, 190 × 275. Haarlem, Teylers Museum. Photo: Museum.

92. *The Jewish Cemetery at Ouderkerk on the Amstel.* Drawing, black chalk, brush, Indian ink, 190 × 275. Haarlem, Teylers Museum. Photo: Museum.

90. *The Jewish Cemetery* (Detroit version): Detail of Tree and Tombs. Photo: Museum.

light under a bright sky. In 1644 Rembrandt had represented *The Woman taken in Adultery* (London, National Gallery, No. 45), contrasting true mercy with the outward show of religion, symbolised by the glittering Jewish temple. The sentiment corresponds to that of Ruisdael's *Jewish Cemetery*. Also, about the same time as Ruisdael was painting these two pictures, Rembrandt was working on his 1653 etching *The Three Crosses* (Bartsch 78). The most significant change Rembrandt made from the first to the last state was to extend the shadows and to concentrate the light flooding the central scene from above. Rembrandt likewise suggested the presence of God in his *Baptism of the Eunuch* (Fig. 14) by a beam of light breaking into a dark landscape.

Ruisdael thus had precedent enough to assume that his public would recognise his light-beams breaking into the darkness as a symbol of redemption. The Dutch poet Van Lodensteyn presented in his *Niet en Al, dat is, Des wereld ydelheyd, en Gods Algenoegsaamheyd* (1654), an all embracing image of the vanity of earthly life in the context of God's all-sufficiency. Similarly, the end of Ruisdael's composition – like Van Mander's earlier *Allegory of the Life of Man* (Fig. 5) – was to manifest the folly of any worldly security, and to stimulate men to put their trust in God alone. Van Mander, Rembrandt, Van Lodensteyn, and Ruisdael all had pietistic connections that would have fostered this attitude.

The sentiment of Ruisdael's allegory is made more evident by the figures in the Detroit version (detail, Fig. 93). A man stands over a woman, pointing to an open book in her lap. This book, in such a context, may well refer to the Bible. One recalls Rembrandt's image (Berlin-Dahlem, No. 828L), painted in 1641, of the Mennonite preacher Anslo, with outstretched hand, comforting a woman with the Word of God. Ruisdael, raised a Mennonite, may have had this picture in mind when painting these figures. The myth of his melancholic disposition can be dismissed. His inspiration is more likely to have come from the text in I Peter 1. 23–24 (quoting Isaiah 40. 6–8): 'All flesh is like grass and all its glory like the flower of grass. The grass withers, and the flower falls, but the word of the Lord abides for ever'. This text is quoted by Van Mander on his 1599 *Allegory of the*

93. *The Jewish Cemetery* (Detroit version): Detail of the Figures. Photo: Museum.

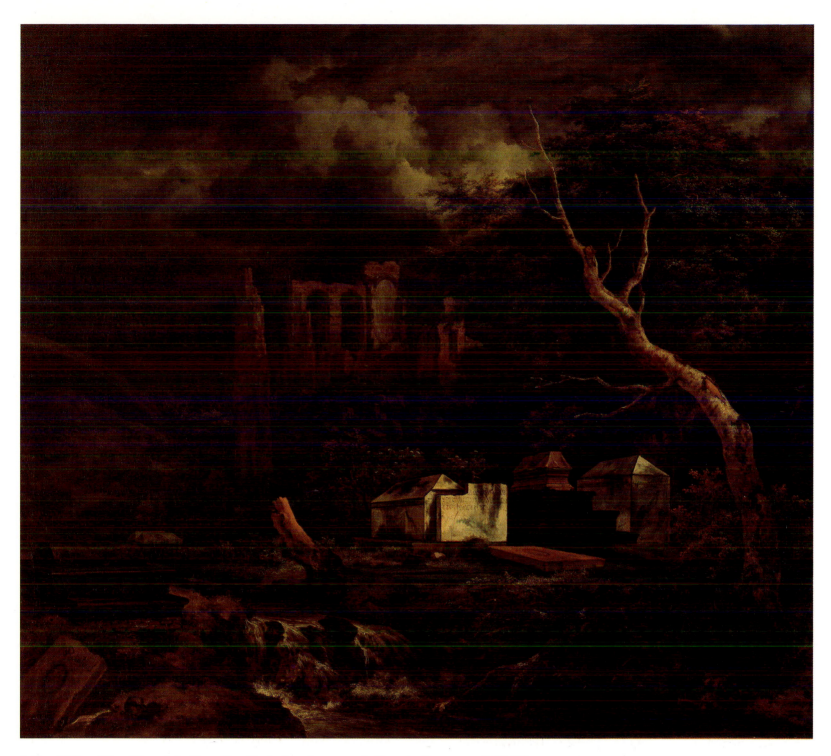

Life of Man (Fig. 5) and is directly alluded to in a poetic inscription on a *Still-life with a Vase of Flowers* (private collection) attributed to Jan Brueghel the Elder, which concludes that while all else, however fair, will fade, the 'one eternal bloom is the Word of God'.[8] No other 'abiding words' are more appropriate to Ruisdael's *Jewish Cemetery* than those of the Apostle Paul: 'for the creation was subjected to futility . . . but . . . in hope; because the creation itself will be set free from its bondage to decay' (Romans 8. 18–23). Light flooding the marble tombs may well allude to the text quoted by the Apostle Paul: 'Death is swallowed up in victory. O death, where is thy sting?' (I Corinthians 15. 54–55).

94. *The Jewish Cemetery*. Canvas, 84 × 95. Dresden, Gemäldegalerie Alte Meister, Staatliche Kunstsammlungen. Photo: Sächsische Landesbibliothek, Abt. Deutsche Fotothek (A. Rous).

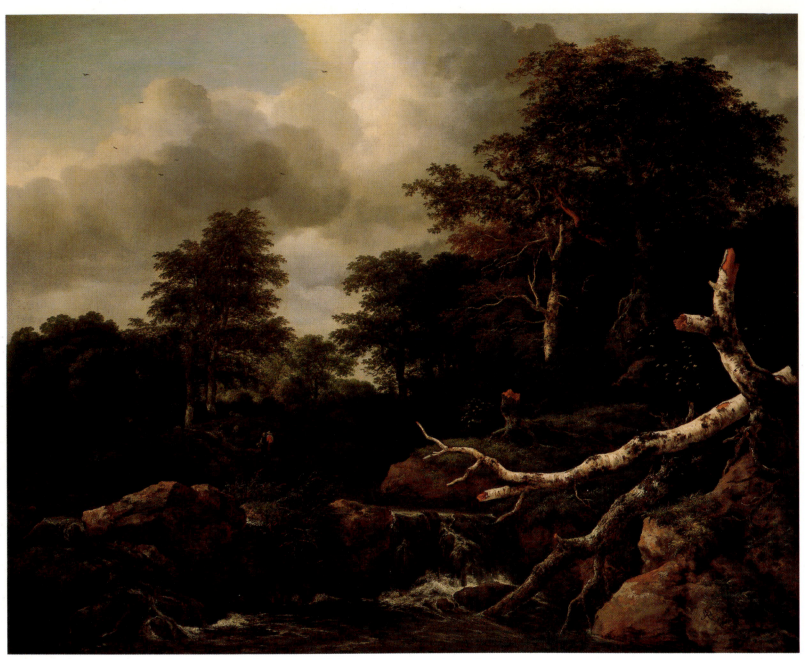

95. *Woodland Waterfall*. Canvas, 105.5 × 131. Washington, National Gallery of Art, Widener Collection. Photo: Museum.

In the two paintings of *The Jewish Cemetery* which perhaps were intended to catch the eye of Ruisdael's new public in Amsterdam, he stretched the conventions of landscape painting to the limits. Nowhere else did he make the significance of his chosen imagery quite as explicit, though all the elements, apart from the tombs, are found elsewhere in his oeuvre. Though he did not repeat such a full allegory of human life, he continued to accentuate the significance of landscape to the contemplative soul. He emphasised the same aspects of nature, a fact that is overlooked by those who treat *The Jewish Cemetery* paintings as unique exceptions that have no bearing on our understanding of the rest of his works. His *Woodland Waterfall* (Washington, No. 1942.9.80 [676]; Fig. 95), probably executed not long after the Detroit version of *The Jewish Cemetery*, and very similar in colour and rich brushwork, represents an immediate attempt to modify his mode of expression. The combination of dead beech and oak in the right foreground beside a waterfall, a clump of trees, and a cloudy sky barely illuminated by

Detail from Fig. 95

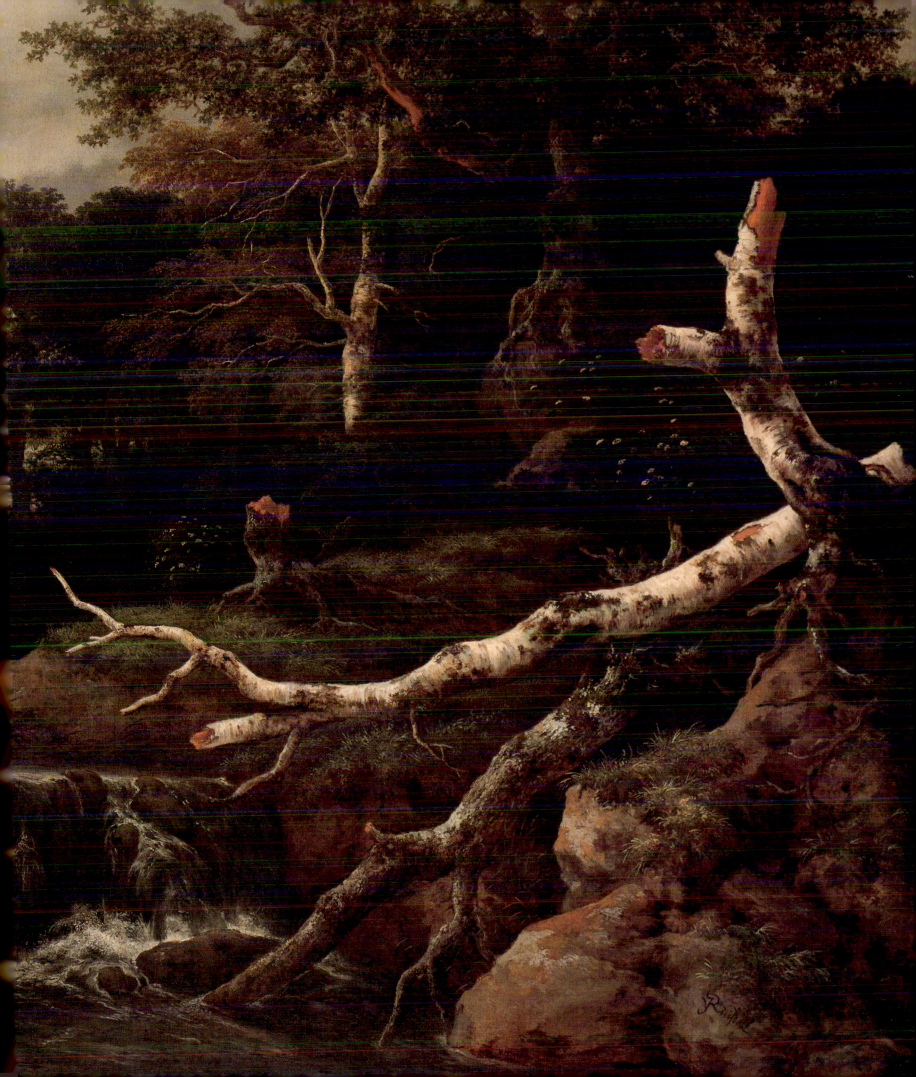

patches of light is familiar. The organisation of these components, with a bend in the stream and a wooded bank beyond, recalls also the Colnaghi *Woodland with Waterfall* staffed by Berchem and referred to above, although the scale now is larger, the impasto richer and the rocks more assured. The glistening beech and contrasting lichen-covered oak trunk, which he now frequently pairs, give a brilliant focus to the foreground. While contemporaries such as Cuyp were using *contre-jour* effects to bathe their landscapes in warm, evening light, Ruisdael here uses back-lighting to plunge most of the scene in shadow, offsetting the brilliant, sculptural form of the fallen beech. The heavy impasto, cloudy sky, and spot-lighting indicate Ruisdael's response to the Rembrandt studio and suggest sight of Philips Koninck's heavy, clouded skies.

The two trees leaning over the water, point towards two extremes within the landscape: to the vivifying light filtering down from the left, and to the rushing water, that will carry them away. As in contemporary still-lifes, objects of great beauty are represented in an imminent state of decay, which perhaps alludes to the attempt of painters to capture the transitory, as Houbraken wrote, so that nothing is lost in the contemplation of 'the wonderful transformations in created things'.[9]

Woodland streams in hilly landscapes recur in several of Ruisdael's works of the mid- to late-fifties.[10] In some of them he introduced features that reflect interest in the Scandinavian landscapes of Allart van Everdingen, such as a cottage perched on massive rocks above a torrent in his *Rocky Landscape with Waterfall* (Amsterdam, Rijksmuseum, No. C 212). In another large *Waterfall* (formerly Thos. Agnew & Sons, London) he includes Norway spruces, a tree it is believed Ruisdael never saw except in the works of Van Everdingen.

Although Ruisdael was no match for Van Everdingen's understanding of the actual terrain in which such phenomena occur, he nevertheless soon proved himself able to transform Van Everdingen's Scandinavian motifs into more effective works of art. Comparing Ruisdael's large *Waterfall* (Scottish private collection; Fig. 97) of about 1656–58 to the type of Van Everdingen's 1647 *Mountain Landscape with Waterfall* (Hannover, Landesgalerie, No. PAM 784; Fig. 96) which might have served Ruisdael as a model, one notes that in Van Everdingen's picture the eye wanders undirected, while Ruisdael accentuates features such as the trees and buildings, and introduces a clearer structure to unify the whole. A sketch for Ruisdael's composition, the *Waterfall* (New York, Pierpont Morgan Library, No. III, 218, Giltay 81; Fig. 98) is still preserved. It is Ruisdael's only surviving drawing of a waterfall. In the painting, Ruisdael substitutes studied detail for Van Everdingen's loose brushwork, so introducing richer differentiation in the textures. Van Everdingen's loose compositions and sketchy brushwork were thus challenged by Ruisdael's compact structures and articulate detail. Seventeenth-century inventory valuations indicate that, nevertheless, Van Everdingen held his own in public esteem. He was the one who had actually been to Scandinavia, a trip that lent authority, if not accomplishment, to his works.

The impression made on contemporaries by Van Everdingen's Scandinavian landscapes is seen from their imitation in the fifties by Cornelis Vroom, Salomon van Ruysdael (1653), Pieter Molijn (1657), Jacob van Ruisdael (*c.* 1655/8), Nicolaes Berchem, Klaas Molenaer (1658) and later Jan van Kessel.[11] In 1654, just two years after Van Everdingen's arrival in Amsterdam, and probably before Ruisdael began to paint waterfalls, Vondel included in his *Lucifer* some lines on northern waterfalls with rocks and fallen trunks, a further indication of the interest such pictures had aroused.[12]

96. Allart van Everdingen: *Mountain Landscape with Waterfall*. 1647. Panel, 48.2 × 60.3. Hannover, Niedersächsisches Landesmuseum. Photo: Museum.

97. *Waterfall*. *c.* 1656/8. Canvas, 119.5 × 180.5. Scottish private collection. Photo: R. Roddam, Glasgow.

98. *Waterfall*. Drawing, black chalk, grey wash, 197 × 233. New York, Pierpont Morgan Library, III, 218. Photo: Library.

Comparison of Van Everdingen's 1650 *Scandinavian Waterfall* (Munich, No. 387; Fig. 99) with Ruisdael's *Waterfall* (Antwerp, No. 713; Fig. 100), which was painted in or before 1658, indicates Ruisdael's initial dependence on Van Everdingen in developing waterfalls of upright format. It also shows their differences. In both paintings the water flows diagonally across the composition, and fir trees provide vertical accents. Ruisdael introduces a sharper contrast of light and shadow, and substitutes the half-timbered cottages seen on his travels for Van Everdingen's timbered watermills. In Ruisdael's picture the accent is on the water, trees and sky, the boulders remain unconvincing. It is evident that Ruisdael's waterfalls in general lack the benefit of the study from life apparent in Van Everdingen's early waterfalls. The geological structure of the rocky terrain in Van Everdingen's 1650 *Scandinavian Waterfall* (Fig. 99) could in reality precipitate a waterfall.[13] In all Ruisdael's waterfalls rocks perch improbably on the edge of

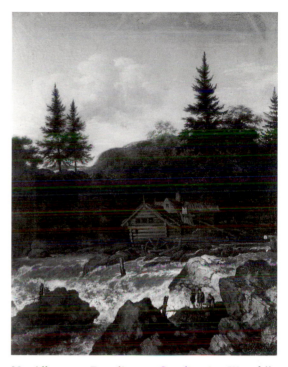

99. Allart van Everdingen: *Scandinavian Waterfall*. 1650. Canvas, 112.5 × 88.1. Munich, Bayerische Staatsgemäldesammlungen. Photo: Museum.

100. *Waterfall*. *c.* 1656/8. Canvas, 66.5 × 52.5. Antwerp, Koninklijk Museum voor Schone Kunsten. Photo: Museum.

101. Klaas Molenaer: *Waterfall*. 1658. Panel, 63 × 60. Formerly London, Alfred Brod Gallery. Photo: courtesy of Brod Gallery.

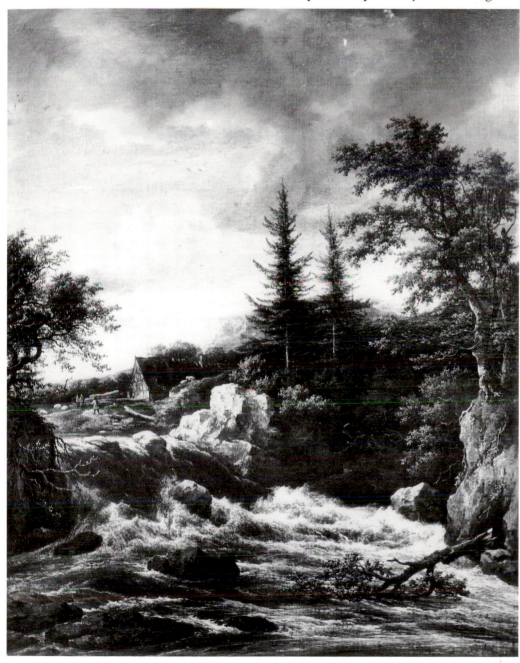

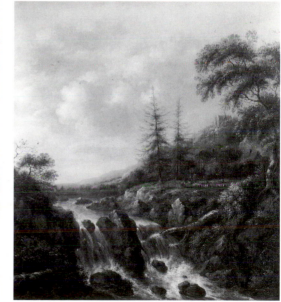

falls, set in terrain that could not in reality have produced them. Yet Ruisdael's compositions, brushwork, and detailing are more satisfying than Van Everdingen's.

In his Antwerp *Waterfall* (Fig. 100) Ruisdael has adapted elements from his large, oblong and presumably earlier *Waterfall* (Scottish private collection; Fig. 97) to an upright format, lowering the cottage and tree-fellers, elevating the fir trees, and setting an oak on a rocky bank in the right foreground. This crucial development of an upright *Waterfall* which provided the model for many subsequent pictures, must have occurred in or before 1658, the date recently discovered on Klaas Molenaer's *Waterfall* (formerly Alfred Brod Gallery, London; Fig. 101). This imitates Ruisdael's composition, taking elements from both the Antwerp and Scottish *Waterfalls* (Figs. 100 & 97 respectively). The upright composition, diagonal flow of water, bush on the left bank, oak and fallen trunk on the right bank are taken from the Antwerp picture; the arrangement of firs before a cottage, with a castle on a hillside above, derive from the Scottish painting.[14]

One of the most bizarre paintings Ruisdael ever produced can perhaps best be accounted for by his attraction to the work of Van Everdingen in the late 1650s and his desire to meet the demand in Amsterdam for exotic landscapes. It is Ruisdael's *Extensive Mountain Landscape with a Castle* (Sale, New York, Parke-Bernet, 6th December 1973, No. 65, illus; Ros. 410), which is closely modelled on one of Van Everdingen's most Mannerist and fantastic works, his *River in a Mountain Valley* (Paris, Louvre, No. 1270; Fig. 102), considered by Davies a work of the late fifties.[15] Van Everdingen's mountain fantasy is also the source for Ruisdael's *River in a Mountain Valley* (Leningrad, Hermitage, No. 932; Fig. 103). The scheme is Van Everdingen's: a river, seen from above, flows through the foreground, with beyond a watermill at the foot of wooded mountains. In Ruisdael's version, the mountain peak, lost in the clouds, is less extravagant than Van Everdingen's. Such cloud-capped mountain landscapes were part of the Flemish tradition, and had been popularised by Pieter Bruegel the Elder. Van

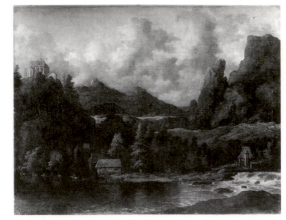

102. Allart van Everdingen: *River in a Mountain Valley*. Canvas, 172 × 220. Paris, Louvre. Photo: Musées Nationaux, Paris.

103. *River in a Mountain Valley*. Canvas, 100 × 108. Leningrad, Hermitage. Photo: Hermitage Museum.

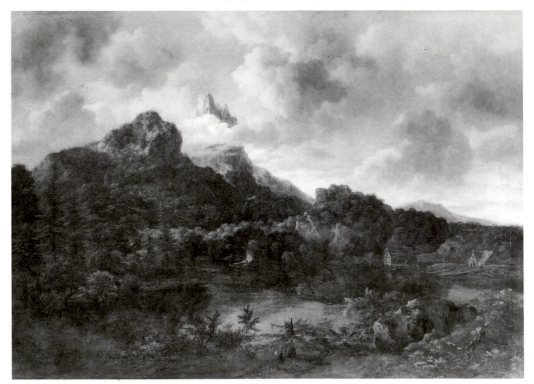

Mander praised Bruegel's rocky Alpine landscapes with views down into dizzy valleys, steep rocks, and pine trees that 'kiss the clouds' (*Grondt*, VIII, 25). Such landscapes were also depicted by Goltzius, Joos de Momper, and Hercules Seghers, inspiring Van Everdingen's own excursions into the imaginary. In the Leningrad *River in a Mountain Valley* (Fig. 103) Ruisdael avoids the extravagances of this style, and re-enforces it with firm structure and detailed observation to produce a landscape less topographical than Herman Saftleven's *Rhenish Vistas* of the fifties, but more controlled than Van Everdingen's wild fantasy.

Houbraken admired not only Ruisdael's waterfalls, but also his turbulent seascapes, with rising waves roaring against rocks and dunes. Images, as he said elsewhere, that make one contemplate far more than the mere art of the painted panel (see Chapter II). None of Ruisdael's extant marines is dated, but, to judge from their style, he must have commenced painting them by the mid-fifties or even earlier. His earliest marines, such as the *Sailing Vessels in a Stormy Sea* (The Hague, Rijksdienst Beeldende Kunst, No. N.K. 3274; Ros. 587; Fig. 104), are conceived in the manner of Jan Porcellis and his follower Simon de Vlieger, especially the latter's perilous, stormy coastal scenes. In this particular picture Ruisdael includes light-beams breaking out of dark thunderclouds, lightning flashes, evoking peril, and on the right there is a reassuring rainbow. These elements recall as much the dramatic qualities of *The Jewish Cemetery* as the images of peril and safety painted by Porcellis and De Vlieger. In another painting, *Shipping in a Storm off a Rocky Coast* (formerly Knoedler & Co., London; Ros. 593; Fig. 105), Ruisdael closely followed the composition and details of Van Everdingen's *Shipping in a Storm off a Rocky Coast* (Frankfurt, No. 777; Fig. 106), considered by Davies a work of the mid-forties.[16] In both paintings light-beams break out of storm-clouds illuminating breakers crashing upon rocks. A similarly rigged craft, with a figure leaning out, features in both paintings, with a man-of-

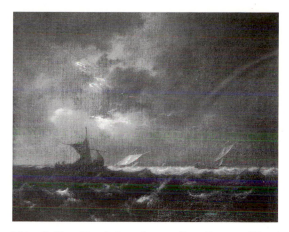

104. *Sailing Vessels in a Stormy Sea*. Canvas, 35 × 44. The Hague, Rijksdienst Beeldende Kunst. Photo: R.B.K.

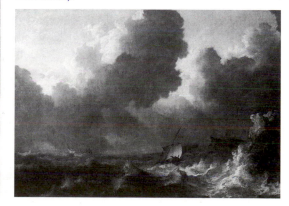

105. *Shipping in Storm off a Rocky Coast*. Canvas, 101 × 123. Formerly London, Knoedler & Co.

106. Allart van Everdingen: *Shipping in Storm off a Rocky Coast*. Canvas, 99 × 140.6. Frankfurt/M, Städelsches Kunstinstitut. Photo: Museum (Ursula Edelmann).

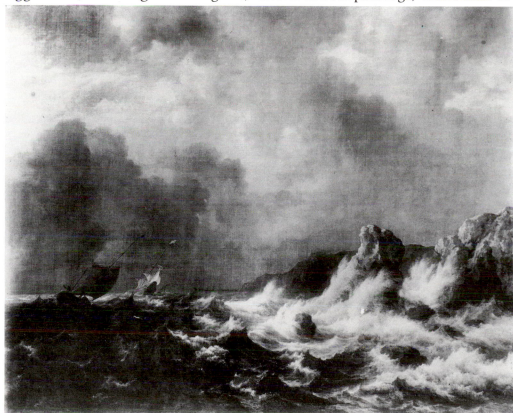

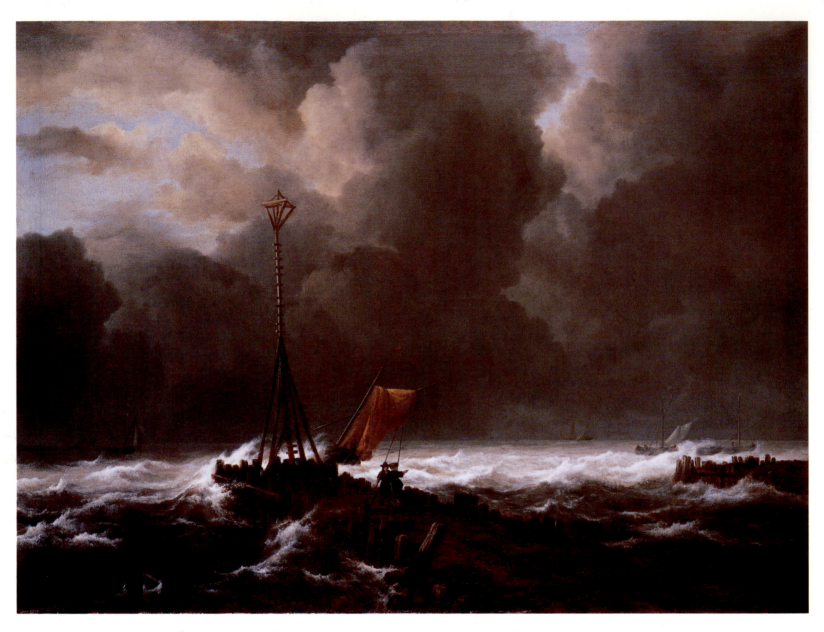

107. *Rough Sea.* Canvas, 98.1 × 132. Fort Worth, Texas, Kimbell Art Museum. Photo: Museum (Michael Bodycomb).

war in the background. The subtlety of clouds and waves distinguishes Ruisdael's picture which was perhaps painted some ten years later than Van Everdingen's. Perilous coastal scenes were considered in Chapter III as examples of providence amidst the uncertainty of life. They were already an established theme in late sixteenth- and early seventeenth-century Netherlandish art. The immediate antecedents for Van Everdingen as well as Ruisdael were works by Porcellis and De Vlieger. Van Everdingen and Ruisdael discarded the overt symbolism of their predecessors, though their notion that it was God who raises storm and who brings calm again is suggested by light-beams flooding the perilous scene, as well as by the rainbow seen in Fig. 104.[17]

While not renouncing the thematic approach of his earliest marines, Ruisdael defines his own conception with more independence in his *Rough Sea* (Kimbell Art Museum, Fort Worth, No. AP 1989. 01; Ros. 579; Fig. 107). The white tops of the driving waves, more subtly modulated, are illuminated by a brilliant burst of sunlight and seen against a dark, forbidding sky. Ruisdael may have taken a work by Van Everdingen as his model. The latter's *Snowstorm at Sea* (Chantilly,

Detail from Fig. 107

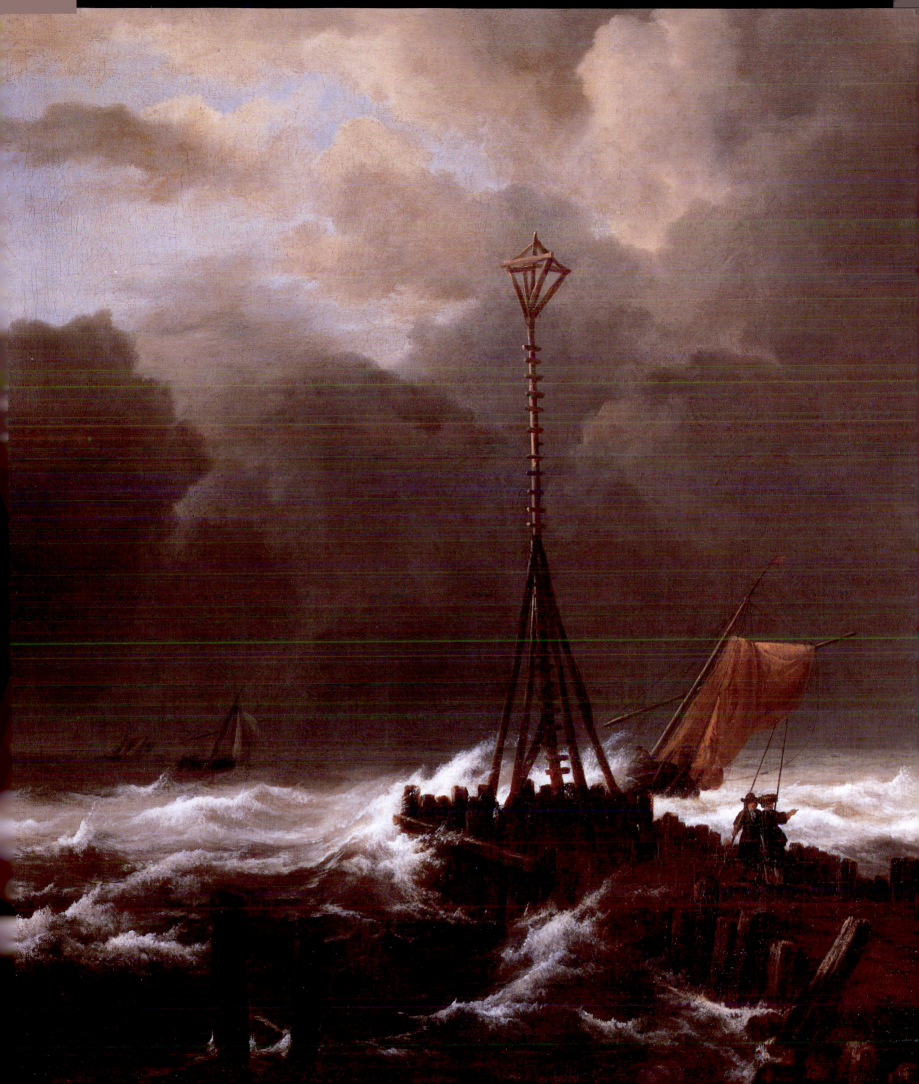

Musée Condé, No. 136), considered a work of the late 1640s or early 1650s, also gives prominence to waves lashing a foreground beacon in a storm. But in Ruisdael's painting a harbour mouth is more distinctly indicated by jetties to either side, and a ship, running before the wind with lowered sail, approaches the harbour where two men holding gaffs wait on the nearest jetty. Beacons, as a guide to helmsmen to secure anchorage, were given various allegorical meanings in contemporary emblem literature. In Ruisdael's painting the foreground beacon serves as a dramatic pictorial element, offsetting the great expanse of water. Given the content of his earlier works, and the precedent of Porcellis and De Vlieger's symbolic sea-storms, the beacon is perhaps also intended as an indication of safety to contrast the perils of the sea, as in the marine painting on the wall of Cornelis de Man's *Family Dinner* (Fig. 19) in which a couple, standing beside a beacon, gaze out to sea, as discussed in Chapter III. Ruisdael's painting, while pictorially totally different, shares the theme of a ship in a storm, driven before the wind, heading for harbour with an earlier print by Goltzius, *Cliff on Seashore* (Fig. 17).[18]

Ruisdael seems to have first experimented with winter scenes in the 1650s. Only about twenty-five survive, none of them dated. Like his early marines, they are typically seen under dark, forbidding storm-clouds, an element he carried to greatest extreme in works of the 1650s. In this respect his first formulation of the winter season is closest to that of Jan van de Cappelle and Jan Beerstraaten, both active in Amsterdam. The Haarlem painter, Philips Wouwerman also painted winters with dark, blustery skies. The *Winter Landscape with View of the Amstel and Amsterdam* (German private collection; Ros. 605; Fig. 108) was possibly painted soon after Ruisdael's arrival in the city. It has rather flat billows of dark snow-laden clouds, lacking the subtlety of the cloud formations developed in the

108. *Winter Landscape with View of the Amstel and Amsterdam*. Canvas, 44.5 × 55. German Private Collection. Photo: Courtesy the RKD, The Hague.

109. *Dunes and Sea in Stormy Weather*. Canvas, 26 × 35.2. Zürich, Kunsthaus, Stiftung Prof. Dr. Leopold Ruzicka.

early sixties.[19] While the overall tone of *Winter* is very dark, it is relieved by stray beams of sunlight coming from the west, an effect often experienced in Dutch winters, when a late afternoon clearing up brings a break in the clouds.

Another fine little picture with dark, blustery skies is his *Dunes and Sea in Stormy Weather* (Zürich, Kunsthaus, Stiftung Prof. Dr L. Ruzicka, No. R. 31; Ros. 573; Fig. 109), which may also date to the mid- to late-fifties. Ruisdael moves away from the more monochrome effects of Van Goyen and De Vlieger to introduce more forceful contrasts in the lighting. He achieves a marvellously fresh effect with the blown grasses on the dunes. The economy with which he captures the feel of wind-swept dunes is equally striking. His approach is quite different to that used in the 1640s, where bushes, not figures, take the brunt of the wind. The effect of the figures on the dune top, bracing themselves against the wind, is particularly true to life. By the time Ruisdael returned to coastal scenes in works of the 1670s, the whole mood and atmosphere of his works had changed.

Besides these new experiments with marines, coastal dunes, and winters, in the

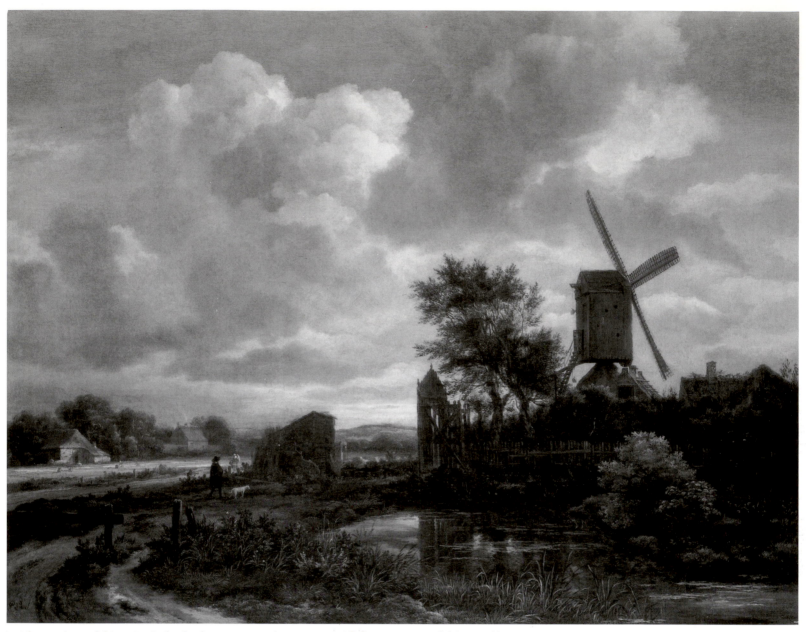

mid- to late-fifties Ruisdael also returned to a motif from one of his earliest works. The composition of his *Windmill by a Country Road* (London, Buckingham Palace, Fig. 110) is a reworking of his 1646 Cleveland *Windmill by a Country Road* (Fig. 34). A drawing in the British Museum, London may have served as a preparatory study.[20] In the later painting, Ruisdael has not only reversed the direction of the mill and substituted a willow for his earlier oak, but one also notices how, with the experience of the intervening years, he now greatly increases the foreground and extent of sky, creating an expanse of space around the mill and side-light catching the sails that presage the *Mill at Wijk bij Duurstede* (Amsterdam, Fig. 156). The heavy grey clouds, subtler than those of the forties or early fifties, nevertheless lack the softness and the colouring found in the sixties. Pale green highlights on the bleaching fields also indicate execution in the late fifties.

When Ruisdael started to depict the bleaching fields from the dunes, rather than the dunes from the bleaching fields, he formulated the scheme for his *Views of Haarlem*, or *Haarlempjes* as they were called in the 1669 inventory of the Douci

110. *Windmill by a Country Road*. Canvas, 77.5 × 100.5. London, Buckingham Palace. Photo: Reproduced by gracious permission of H.M. Queen Elizabeth II (Rodney Todd-White).

111. *Dunes and Bleaching Fields.* Canvas, 32 × 40. Berlin-Dahlem, Staatliche Museen, Gemäldegalerie. Photo: BPK (Jörg P. Anders).

collection (see Chapter I). Initiation of this theme cannot be dated precisely.[21] The *Dunes and Bleaching Fields* (Berlin-Dahlem, No. 885E; Fig. 111) is a prototype. Its scheme recalls Cornelis Vroom's *Panorama with the Dunes* (Heino, Stichting Hannema-de Stuers; Fig. 112), dated by Keyes around 1640–42. A strip of foreground dune overhangs fields patterned by ditches and hedgerows, with further dunes on the horizon. The alternating rhythm of light and shadow on the land is repeated in the layers of sunlight and cloud, as is particularly evident in Vroom's picture. Goltzius's drawing, *Panorama from Dunes* (Rotterdam, No. DN 199/96) of around 1603 provided an earlier prototype for this scheme.[22] Ruisdael's earlier panoramas, such as the *Hilly Landscape with Burgsteinfurt* (London, Wallace Collection; Fig. 63) had, like Vroom's painting, used a foreground tree coulisse. Philips Koninck's wingless panoramas, developed in the late forties, may also have inspired Ruisdael, though Koninck's panoramas are more imaginary, expansive, and larger in scale.[23] The lighting and tonalities in Ruisdael's *Dunes and Bleaching Fields* (Fig. 111) are more delicate than in his earlier *Hilly Landscape with Burgsteinfurt* (Fig. 63). The foreground dunes are olive green, with brown and grey highlights; the pale, lime-green bleaching fields are contrasted with the dark green trees; a thin film of blue runs along the horizon under smoky cloud edged by pale raw umber where shafts of light break out beside a patch of pale blue sky.

In a somewhat larger canvas of similar proportions, also in Berlin, the *View of Haarlem with Bleaching Fields* (Berlin-Dahlem, No. 885 C; Fig. 113) Ruisdael carries the effects of his earlier picture a stage further. He evolves the characteristic *Haarlempjes* which take on their full force in the following decade. Compared to his *Dunes and Bleaching Fields* (Fig. 111), in his *View of Haarlem* (Fig. 113) Ruisdael has diminished the foreground dunes, lowered the horizon line, elaborated the complex of fields, trees and buildings in the polders. He capitalises on the focal

112. Cornelis Vroom: *Panorama with the Dunes.* Panel, 73 × 105. Heino, Kasteel 'Het Nijenhuis', Stichting Hannema-de Stuers. Photo: Zeijlemaker (courtesy of Hannema-de Stuers).

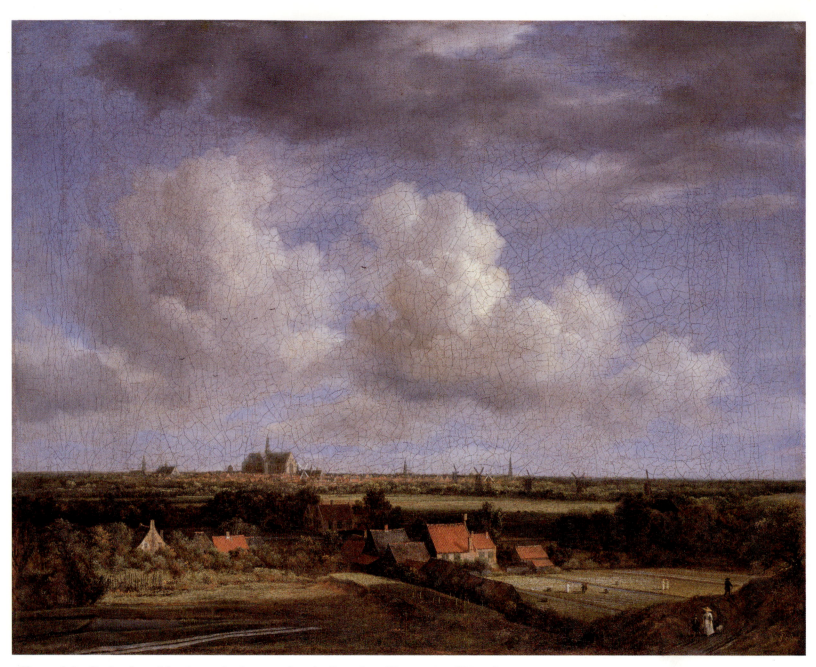

113. *View of Haarlem*. Canvas, 52 × 65. Berlin-Dahlem, Staatliche Museen, Gemäldegalerie. Photo: BPK (Jörg P. Anders).

effect of the little chapel by introducing on the skyline the silhouette of Haarlem, with the imposing mass of St Bavo's towering above the city rooftops. A dull terminus to the field of vision was thereby transformed into a focus that draws the eye from the land to the expanse of the sky above. The effect of height is accentuated by cumulus cloud rising diagonally above a lower bank of cloud.

Distant town silhouettes were a common schema of topographical prints from the sixteenth and seventeenth century. Early in the seventeenth century Claes Jansz. Visscher introduced them as borders to maps and city plans. Furthermore, as Stone-Ferrier has demonstrated, and as discussed in Chapter X, earlier city views of Haarlem, as well as of other Dutch cities, in both maps and prints, included scenes of bleaching fields outside the city, as Ruisdael now does in his Berlin *View of Haarlem*. As Stone-Ferrier observes, the Haarlem bleacheries were of particular renown, bringing fame and prosperity to the city.[24] Burke, commenting on a version in Montreal (Museum of Fine Arts, No. 945.920), notes that

Ruisdael's painting accurately portrays the principal landmarks of the city, to be seen equally on an engraved bird's-eye view map of Haarlem made by Pieter Wils in 1647, with later additions by F. de Wit.[25] His drawings in Museum Bredius (Nos. 147 & 148; Figs. 114 & 115) show details of the city profile much as they appear in the Montreal and Berlin paintings. The arrangement of the foreground, especially in No. 147 (Fig. 114), is reminiscent of several of his *Haarlempjes*, but is different in detail to them all. While the panoramas of Seghers, Van Goyen, and his contemporary Philips Koninck represented endless space, Ruisdael, by contrast, restricts his prospect, concentrating attention within familiar limits. He builds his compositions upon a clear structure, and fills them with detailed observation. In the Berlin painting (Fig. 113), near-by figures of a woman, child and dog link the spectator with the scene below, enhancing its immediacy. Man's prospering activity is set in an ambience of sunlight and shadow. The combina-

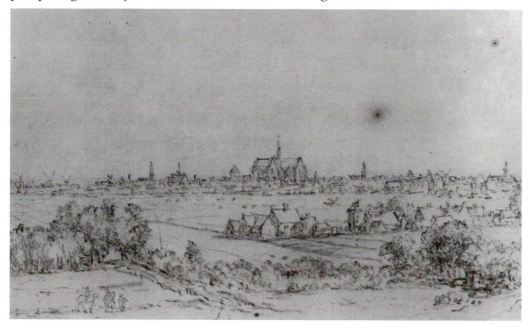

114. *View of Haarlem from the north-west.* Drawing, black chalk, 100 × 160. The Hague, Museum Bredius. Photo: Museum.

115. *View of Haarlem from the north-west.* Drawing, black chalk, light wash, 90 × 150. The Hague, Museum Bredius. Photo: Museum.

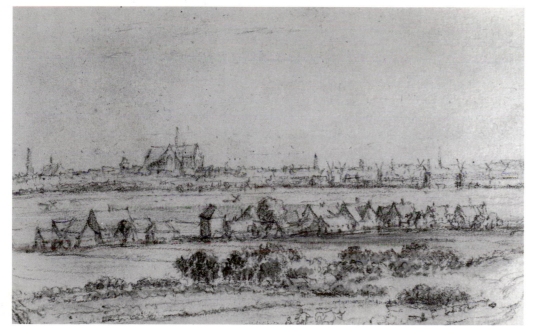

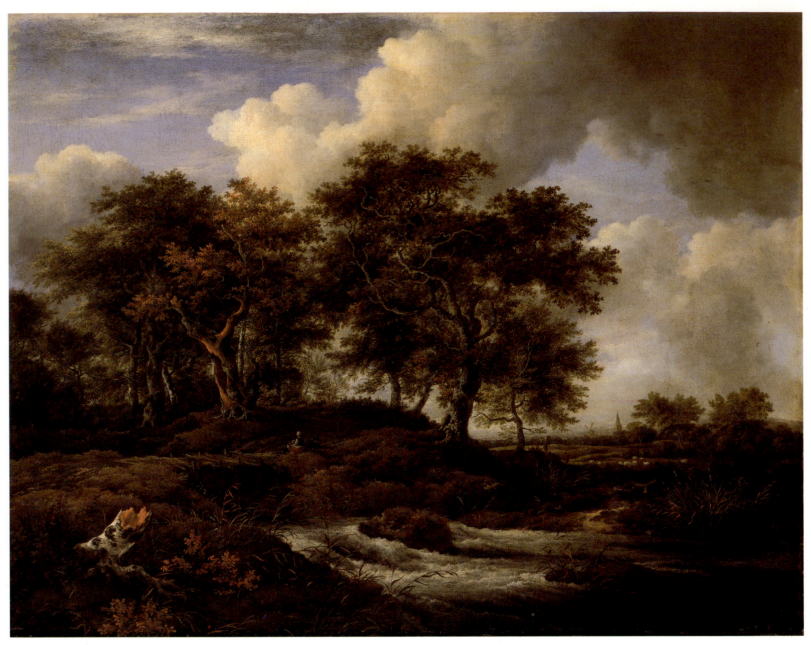

116. *Woodland Stream*. Canvas, 72 × 90. Munich, Bayerische Staatsgemäldesammlungen. Photo: Artothek.

tion of cloud movement and light-beams suggests sunlight returning after storm, and, used in combination with bleaching fields, recalls Joos de Momper's *Spring* (Brunswick; Fig. 20; see Chapter III). However there are marked differences: Ruisdael's colour is less decorative, his detail less accumulative, and his image more natural. In both paintings the prevelant tone is of prospering activity in a peaceful, orderly world. It is the kind of scene in which Dutch poets found signs of nature's bounty, the sight of which brought them physical relaxation, delight to the senses, and filled their hearts with thankful joy. No doubt Ruisdael's painting was intended to do likewise.

By the end of the fifties Ruisdael was an accomplished and versatile painter. He had broadened his range to include hilly and wooded river landscapes, waterfalls, seascapes, winters and *Haarlempjes*. Exemplifying the ideal of selective natural-ness, he could adapt similar components to different compositions, working from the imagination, but rendering them fresh and lifelike. This is evident in three *Woodlands* now in Munich, Stuttgart and Cleveland. They were executed in the

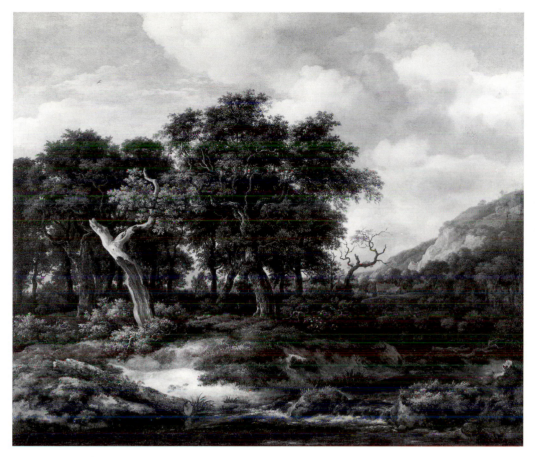

117. *Hilly Woodland with Stream*. Canvas, 106.5 ×
127.5. Stuttgart, Staatsgalerie. Photo: Museum.

late fifties, to judge from their assured handling, rich detailing, lighting and
subject matter. In the *Woodland Stream* (Munich, No. 1038; Fig. 116) Ruisdael re-
worked the composition of his Oxford *Landscape near Muiderberg* (Fig. 83) with its
spinney on a rise beyond a stream, tree stump in left foreground and vista to the
right with distant church. In the Munich picture the trees are solid, their autumnal
foliage distinct; the vegetation is refined, the water lively, and, by comparison to
the Oxford painting of the early fifties, the sky is toned down. In the second
picture of this group, the *Hilly Woodland with Stream* (Stuttgart, No. 3048;
Fig. 117), the scheme of a spinney on a bank is combined with a hilly landscape.
A fork-trunked dead tree, similar to that in the Munich painting (Fig. 116) is
prominent. Compared to an earlier wooded, hilly landscape such as the Dresden
Ruined Monastery by a River (Fig. 77), the Stuttgart painting is articulate and
luminous. A drawing in the British Museum (No. 1910–2–12–194; Fig. 119)
may relate to the third painting in this group, the *Woodland Stream with Dead Tree*
(Cleveland, No. 67.63; Fig. 118). The arrangement of a torrent before a bank of
trees is comparable to the smaller Munich canvas (Fig. 116), though the screen of
trees is opened up. Beyond, a ruin looms above woodland before which two
figures and a dog in a sunlit field provide a peaceful focus amid a scene of beauty,
transience, and decay. The gleaming, sculptural beech trunk recalls that of the
Washington *Woodland Waterfall* (Fig. 95) of the mid-fifties. The Cleveland paint-
ing is more luminous, spacious, detailed, and colourful: qualities that anticipate
his finest compositions of the following decade.

During the course of the 1650s, Ruisdael's range of motifs and conception of
landscape were significantly stimulated by the experience of foreign travel and his
subsequent move to Amsterdam. He had developed a range of landscape types

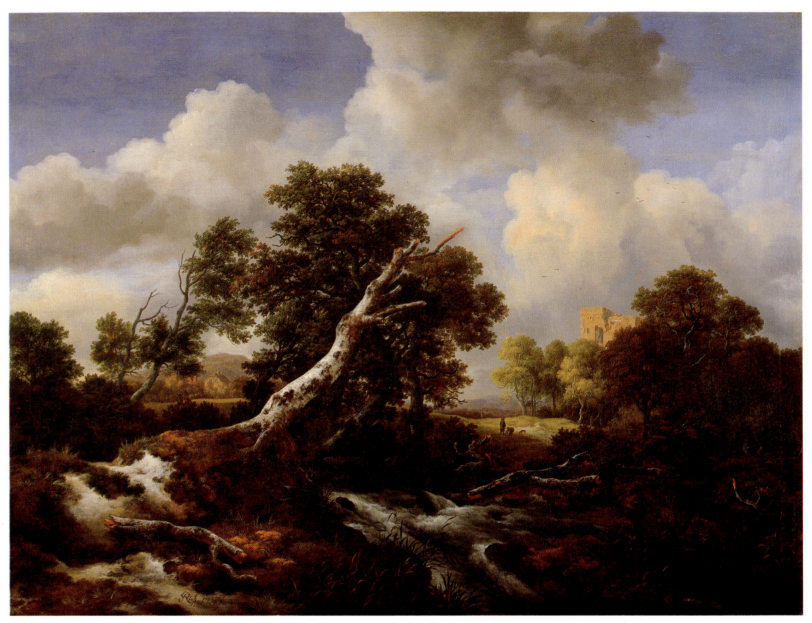

and made significant new use of architectural elements. His landscapes of the fifties, especially the foreign motifs, are still nourished by the scrupulous observation of nature seen in his earliest works. However, they are more contrived in conception than his more limited but direct approach of the forties. In painting marines, winters and waterfalls, he developed the emphasis on stormy effects and the drama and force of nature initiated by the older generation. He had also evolved the scheme used in his *Haarlempjes*, in which he looked at his native surroundings from a greater distance and wider perspective than his initial isolation of dunes, bushes, trees, mills and bleaching fields.

Exposure to the artistic life of Amsterdam had a significant effect on Ruisdael's paintings, most notably through the works of Allart van Everdingen which set Ruisdael off in new directions. Paintings of fantastic, cloud-capped mountains in the manner of Van Everdingen, such as the one in Leningrad (Fig. 103), were experiments which Ruisdael did not pursue further. The popularity of Van Everdingen's Waterfall paintings, however, prompted Ruisdael to develop what became one of his most frequent motifs. Ruisdael's Waterfalls, less appreciated

118. *Woodland Stream with Dead Tree*. Canvas, 99.2 × 131. The Cleveland Museum of Art (Mr. and Mrs. William H. Marlatt Fund, 67.63).

119. *Woodland Stream with Dead Tree*. Drawing, black chalk, grey wash, Indian ink, 130 × 177. London, British Museum. Photo: Museum.

today, were however the motif most frequently linked with his name in the earliest literature, and among the first choices of noble collectors. Van Everdingen was perhaps for Ruisdael the link to the taste of that earlier generation for landscapes of a more fantastic and conceptual character, less dependent on the local scene. This link certainly contributed to Ruisdael's subsequent treatment of such subjects. Ruisdael surpasses these models by enriching his compositions, however fantastic, with a wealth of naturalistic detail in the treatment of vegetation. Ruisdael's Waterfalls complemented his Woodlands in providing matter for contemplation of a more foreign and exotic nature. During the 1650s Ruisdael also enriched his Woodlands by pairing a dead beech and oak, the respective texture and colours of their trunks, with lichens on the oak, creating a vivid contrast when seen together, as in his Washington *Woodland Waterfall* (Fig. 95). Ruisdael exploited the vivid pictorial effect of this combination of beech and oak in a number of subsequent works that would appear to respond to the call of the poets and moralists discussed in Chapter II that exhorts the viewer whether of actual or painted landscape to allow their mind to pass from aesthetic delight to deeper contemplation.

Besides these imaginary and exotic motifs, Ruisdael had also continued to depict indigenous motifs in the 1650s. Here too Ruisdael transforms what were conventional images into new and powerful pictorial effects. If Ruisdael's Woodlands and Waterfalls emphasise the mutability of all existence, these paintings of cornfields and bleaching grounds, filled with light and a sense of prospering well-being, assure the contemplative viewer that meanwhile one is secure and well provided for. By the end of the fifties Ruisdael was less preoccupied with massive compositions densely filled with ruins, wooded hills, dead trees and heavy, clouded skies. In works of the following decade these elements still persist, and are equally forceful. However, the pictorial structure is less dense, the space and skies more open and the mood brighter. At times the atmosphere is sublime, but it is always calmer than the tempestuous imagery of the fifties.

Watermills, City Views, Forests and Swamps: The 1660s

During the 1660s Ruisdael capitalised on his earlier endeavours and created landscapes of unprecedented force and majesty. In the 1640s he had developed his powers of observation and his capacity for meticulous depiction. He extended his range of invention in works of the 1650s. In the 1660s he blends vividly rendered natural phenomena with a breadth of invention to create images of both the domestic and imaginary foreign landscape. These are richer in colour, more brilliantly illuminated and more expansive than the heavy, dense imagery he produced in the 1650s. His handling of the sky and of light is more refined, diffuse, and less melodramatic in its concentration, which, combined with a warmer palette, creates a calmer mood.

His image of nature continues to suggest the force of the elements and to include great trees and forest swamps which evoke long, slow but unremitting natural cycles of growth and dissolution. Ruins, often featured in works of the 1650s, are less evident in works of the 1660s. His typical, prominent trees, of awe-inspiring strength and majesty – both living and dead – are developed with even more painterly brilliance and assurance in the 1660s. The ever-present storm clouds, built up to new heights in soft puffy billows, are marvellously observed within a vast expanse of sky. With land and sky less overbearing and more expansive, the tone of his pictures becomes more serene.

The woodlands and numerous waterfalls are composed with similar pictorial elements to his earlier works, but their underlying allegorical allusions seem less forced and better integrated with his conception of nature. At their best, his compositions become potent images to enrapture the eye and to nourish the contemplative imagination.

This shift in the tone and emphasis of his work, leaving the viewer captured as much if not more by the sheer force of the pictorial image and less by its self-conscious allegorical allusions, parallels similar trends in genre and still-life painting. Such differences can also be seen between the genre painters Jan Vermeer and Jan Molenaer and the still-life painters Willem Kalf and Pieter Claesz. His numerous waterfalls were no doubt intended for the same market that esteemed those of Van Everdingen. However, in painting forest swamps and gnarled trees, Ruisdael resists the contemporary taste for classical idealisation, with its characteristic depiction of graceful, unsullied trees, much as Rembrandt resisted parallel trends in figure painting. The *Haarlempjes* depict the very essence of the Dutch landscape. But his country roads, river scenes, marines and winters, for all their sensitivity to observed local detail, have less of the domestic familiarity than those of the earlier generation of landscapists and his own early work. Instead they evoke associations that draw on the essence of the local landscape to suggest more general forces of nature within which the specific is embedded.

In the 1660s Ruisdael was at the height of his powers, respected in the artistic community and prospering as a citizen of Amsterdam. He had taken Hobbema under his wing, and a number of lesser artists were attempting to exploit his innovations. Their dated imitations of his compositions at times serve as a *terminus ante quem* for innovations within Ruisdael's own oeuvre. His motifs in

the 1660s could appeal both to those with a taste for the indigenous landscape and to those with a more cosmopolitan outlook, who responded to generalised and idealised images of nature. There is a wide range of works from those that would fit in the grandest Amsterdam patrician household to those for a more modest burgher.

In July 1660 Ruisdael declared that Hobbema had served him and studied with him for some years. In the late 1650s Hobbema seems to have been influenced by Ruisdael's early river landscapes. He also joined Ruisdael in depicting architectural and woodland motifs in the environs of Amsterdam.[1] Thereafter, around 1662, as Stechow noted, Ruisdael's impact on Hobbema is particularly evident. Hobbema turned from painting riverscapes to wooded country roads and watermills. This may possibly result from a joint trip which appears to have taken them through the Veluwe, past Deventer, to Ootmarsum, north-east of Almelo. The evidence for this journey is to be found in their drawings and paintings, and probably took place between 1660 and 1662.

In the early 1660s watermills reappear in Ruisdael's paintings, such as the *Watermill by a Wooded Road* (Amsterdam No. C213; Fig. 120) of 1661. Not a forceful work in either conception or execution, suffering further from loss of surface detail especially on the mill and trees, it echoes a motif treated with much greater vibrancy in the early 1650s. The mill is seen from an angle similar to that in the 1653 *Watermill* (Fig. 80) in the Getty collection, but it is now set back in space and treated with much less focused interest in the mass, texture, and workings of the mill, let alone in the play of intricate waterwheels and foaming water. Instead the motif has been recast into what appears to be a somewhat tame allegory, in the spirit of Goltzius's allegorical woodcuts, with travellers 'on the path of life.' They pass a prominent tree, felled timber and a waterwheel – stock motifs for the older generation of life's transiency – and make their way towards a partly concealed hillside church, intended probably as a reminder of man's final destiny. The composition has the feel of mass production from stock imagery, little nourished by observation from life, and, as such, his pupil Hobbema had little difficulty repeating it, with only minor variations, shortly thereafter in the picture now in Toledo.[2] If it was not dated, and repeated by Hobbema, Ruisdael's rather dry and lifeless picture might easily be taken for one of his late works. It is not only an indicator of variations in Ruisdael's style and execution, but also serves as a guide to the dating of other works of similar composition, feel and execution, such as *The Ruined House Kostverloren* (Amsterdam, Amsterdams Historisch Museum, No. A.38217; Fig. 121) and a group of other watermill paintings to which we will return.

Kostverloren, a familiar landmark on the banks of the river Amstel on the southern outskirts of Amsterdam, had featured in prints and drawings of Simon Frisius, C.J. Visscher and Rembrandt. In 1650 it was severely damaged by fire and in 1658 the ruinous site was sold. In the same year all but the tower was demolished and rebuilt.[3] A number of drawings and closely related paintings of it, showing the unrestored tower, are by or attributed to Ruisdael, his pupil Hobbema and to another close imitator, Jan van Kessel.[4] Given the history of the site, the original drawings were most likely made in the summer of 1658. The paintings may well have been produced somewhat later: their compositions, scale, relationship of buildings and trees and manner of execution resemble the 1661 *Watermill by a Wooded Road* (Fig. 120) in Amsterdam. While the painting of Kostverloren in Amsterdam is more forceful than the 1661 *Watermill* in composition, and bathed in strongly contrasting light and shadow, another monogram-

120. *Watermill by a Wooded Road.* 1661. Canvas, 63 × 79. Amsterdam, Rijksmuseum. Photo: Museum.

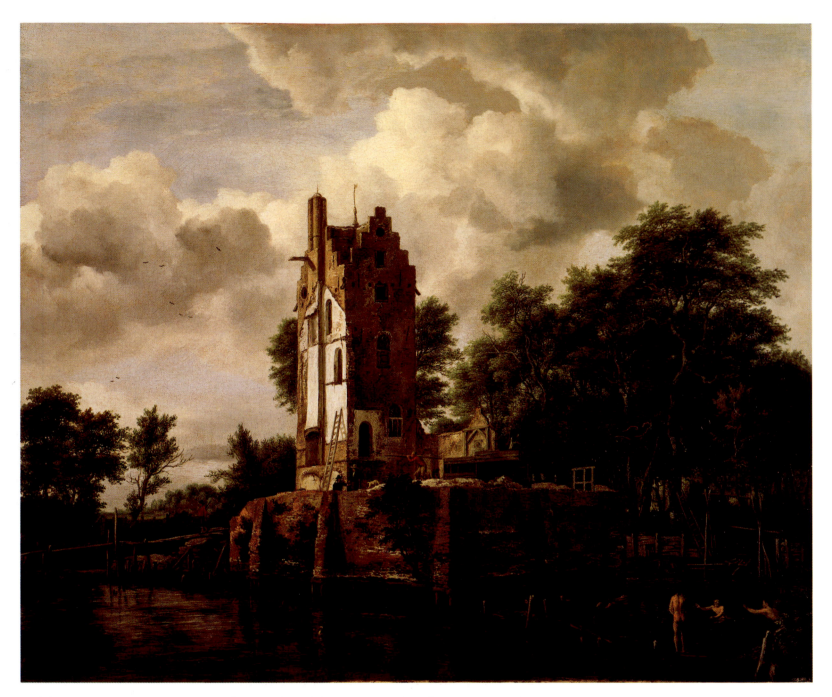

121. *The Ruined House Kostverloren on the Amstel.* Canvas, 63 × 75.5. Amsterdam, Amsterdams Historisch Museum. Photo: Museum.

med painting of Kostverloren (Sale, London, Christies', 1st April 1960, No. 73), showing the house from a different angle, to the south of the tower, while weaker in execution is more similar in composition to the 1661 Amsterdam *Watermill by a Wooded Road*, with the ruined tower seen below and beyond a prominent clump of trees that reach almost to the top of the painting. Two drawings, one in the Teylers Museum, Haarlem (Inv. Q. 52; Giltay 59; Fig. 122) the other in the Rijksmuseum, Amsterdam (Inv. A.4216; Fig. 123), show the house from an identical angle to the monogrammed painting, as does a painting by Hobbema (Broulhiet 435; sale, New York, 13th February 1913, No. 24).[5] The drawing in Haarlem is usually accepted as by Ruisdael because of its similarity to his other drawings and its treatment of light. The drawing in Amsterdam is a copy of the sheet in Haarlem. The fluid execution and bold play of light and shadow

are similar to other drawings attributed to Hobbema, and this drawing should perhaps also be attributed to him, given that he also produced a painting based on the same composition.[6]

The depiction of the House Kostverloren by both Ruisdael and Hobbema in the late 1650s and perhaps early 1660s confirms an already documented relationship between these two artists. There are also other drawings and paintings by both Ruisdael and Hobbema where details and treatment suggest that Hobbema was no longer merely copying works in Ruisdael's studio. He was working beside Ruisdael, depicting in his own manner motifs far from home which they may have visited together. This journey, taking them through the Veluwe, past Deventer, as far as Ootmarsum, northeast of Almelo must have taken place around 1660–62, certainly before 1663, the date of Hobbema's *Road into a Forest* (Washington, National Gallery of Art; HdG 171), in which motifs from these regions are already absorbed with assurance into Hobbema's oeuvre.[7]

There are surviving drawings and paintings by both artists of an unusual type of watermill differentiated from all others that Ruisdael represented by its heavy wheel construction, raised conduit, and tile-roofed building with a conical brick chimney. It appears in his *Watermill* (Melbourne, National Gallery of Victoria, Felton Bequest, 1922; Fig. 124). It is distinct from the watermills found in Twenthe and Overijssel, but a mill of this type has been found in the Veluwe, near Apeldoorn.[8] Ruisdael's study for this painting is preserved in the Teylers Museum, Haarlem (No. R38, as Hobbema; Giltay, No. 60, as Ruisdael; Fig.

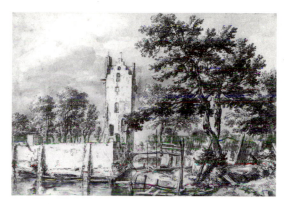

122. *The Ruined House Kostverloren on the Amstel.* Drawing. Black chalk, grey wash, 203 × 291. Haarlem, Teylers Museum. Photo: Museum.

123. Meyndert Hobbema (?), after Jacob van Ruisdael: *The Ruined House Kostverloren on the Amstel.* Drawing. 200 × 290. Amsterdam, Rijksprentenkabinet, Rijksmuseum. Photo: Museum.

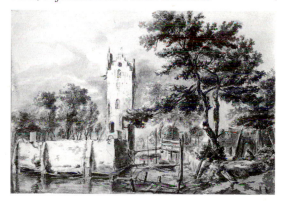

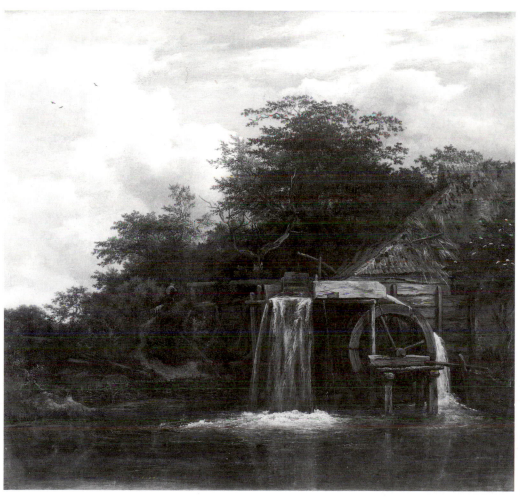

124. *Watermill.* Canvas, 65 × 71.3. Melbourne, National Gallery of Victoria (Felton Bequest 1922). Photo: By permission of the National Gallery of Victoria, Melbourne.

125. *Watermill.* Drawing, black chalk, grey wash. Haarlem, Teylers Museum (as Hobbema). Photo: Museum.

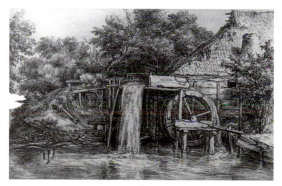

125).[9] A drawing by Hobbema of the same mill, made from the same angle, is in the Musée du Petit Palais, Paris (No. 1056; Fig. 126). Its broad handling and luminosity is characteristically distinct from Ruisdael's dense, detailed study (Fig. 125). Hobbema's painting (The Hague, No. 884, on loan from the Rijksmuseum, Amsterdam; Fig. 127) is likewise distinguished from Ruisdael's subdued palette and dense brushwork by its sparkling highlights, fresh bright colour, and tiny vista. This vista is thereafter opened up into a gleaming prospect over sunlit fields to a village in Hobbema's 1664 *Watermill* (H.E. ten Cate, Almelo; HdG 86).

Ruisdael's *Watermill* (Toledo, No. 75.86; Fig. 128) represents the same mill, seen from the dune path over low wattles at an angle of ninety degrees to his other representation. His composition reflects, in mirror image, that of his 1661 Amsterdam *Watermill by a Wooded Road* (Fig. 120), with the mill backed by trees on a slope, a mill pool to one side, flanked here by wattling. The Toledo painting is however more detailed and luminous and was also preceded by a detailed study (Amsterdam, Rijksprentenkabinet, Rijksmuseum, No. A.1392; Giltay, No. 8 and Fig. 40).[10] One of Hobbema's finest extant drawings (Haarlem, Teylers Museum, No. R37; Fig. 129) shows the same mill from a similar angle, slightly more to the left. It formed the basis for several of his paintings, for example the *Watermill* (Cincinnati Art Museum, Ohio; HdG 75). In representing it from this and other angles (e.g. the painting in the Chicago Art Institute; HdG 71), Hobbema's fluid execution, bright, clear tones, and vistas over gleaming distant fields offer freshness and charm not to be found in Ruisdael. However, in depicting this watermill Ruisdael seems to pay less attention to some of the elements that attracted him in the early 1650s, (see for example Figs. 79 and 80). In the 1661 *Watermill*, he gives much less emphasis to the drama of rushing water. Furthermore, in setting the mill deeper into the middle ground, in choosing less ravaged trees and in allowing a glimpse into a sunlit meadow, which create a more peaceful and spacious effect, perhaps he was in turn influenced by the innovations of his own pupil Hobbema.

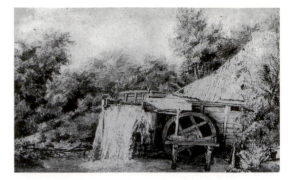

126. Meyndert Hobbema: *Watermill*. Drawing, black chalk, Indian ink, grey washes, 180 × 290. Paris, Ville de Paris, Musée du Petit Palais. Photo: Bulloz.

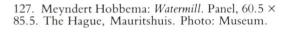

127. Meyndert Hobbema: *Watermill*. Panel, 60.5 × 85.5. The Hague, Mauritshuis. Photo: Museum.

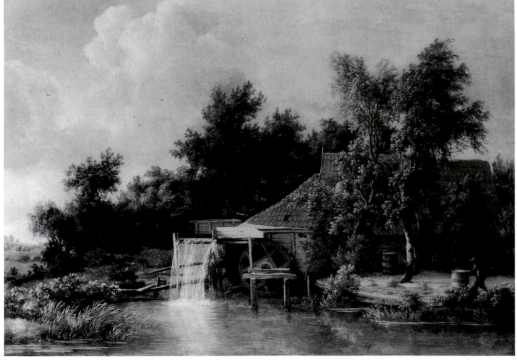

Not far beyond the locality of the type of watermill seen in these drawings and paintings of Ruisdael and Hobbema, lies the city of Deventer, whose features are included in Hobbema's *Wooded Landscape with View of Deventer* (The Hague, Mauritshuis, No. 899). The depiction of trees and fallen timber in this painting owes a large debt to Ruisdael. On stylistic grounds it can be dated to around 1662/63. The two artists apparently made a stop in the city, both making drawings of Deventer Mill. The difference in their draughtsmanship is apparent from a comparison of two of their drawings, Ruisdael's in the British Museum (No. 00–11–242; Fig. 130) and Hobbema's in the Musée du Petit Palais (No. 1052; Fig. 131): Ruisdael's is compact and tightly worked; Hobbema's is looser in construction but more luminous. Hobbema scarcely departed from his sketch in a painting of much later date, his *View of Deventer* (Edinburgh, National Gallery of Scotland, on loan from the Duke of Sutherland) of 1689. Another drawing of Deventer Mill by Ruisdael (Paris, Louvre, No. 23.014), when transposed in

128. *Watermill*. Canvas, 73.5 × 95. Toledo, Ohio, Museum of Art, (Gift of Mrs. George M. Jones, Jr.).
129. Meyndert Hobbema: *Watermill*. Drawing, Indian ink, grey washes. Haarlem, Teylers Museum. Photo: Museum.

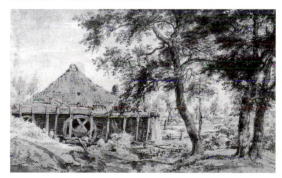

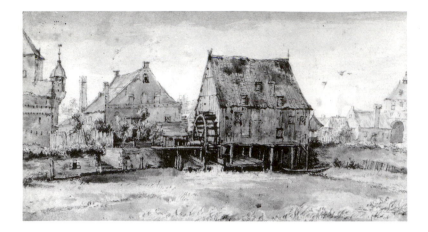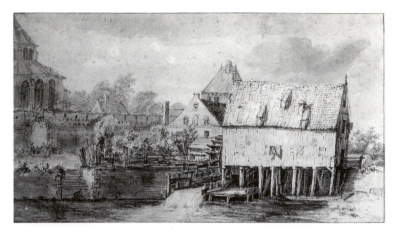

an etching of 1782 by J.J. de Boissieu after Ruisdael, was furnished with an imaginary setting with ruined buildings at the foot of a rocky hill beside a river, which would have taken the citizens of Deventer somewhat by surprise.[11]

Leaving Deventer behind them the two artists apparently went on as far as Ootmarsum, a small village in the Twenthe near the border with Germany, about twenty kilometers to the northwest of Bentheim, where Ruisdael had been in the previous decade. Ruisdael's undated panorama in Munich (No. 10818; Fig. 132) has been identified by Maschmeyer as a *View of Ootmarsum*, seen from the summit of Kuiperberg, which still today is a popular lookout point commanding a fine view of the region. The church in Ootmarsum in the middle ground can be identified from a drawing by Meyling dated 1733; the ruins of the windmill on the extreme left, known as the 'molen van Bokkers', are still extant. On the right, behind a clump of trees, is the turret of the manor house of the Barons von Heyden; in the far distance, a little to the left, the silhouette of Bentheim Castle is just visible. As Slive has pointed out, in painting this view, Ruisdael characteristically took a number of liberties, shifting the position of Bentheim Castle so as to include it in the picture, and vastly enhancing the size of the church, to provide a strong focus for the composition.[12] The style of this painting is quite different to Ruisdael's earlier paintings of Bentheim and Steinfurt Castles. Its composition presupposes the first *Haarlempjes*; its rich, tightly executed detailing, warm olive-green and brown tonalities, and the delicate cloud formations, corresponding to patches of light and shadow on the land, suggest a date in the early sixties. While the proximity of Ootmarsum to Bentheim may suggest that it was derived from an earlier drawing, it is striking that Hobbema, who was too young to have shared in the 1650 trip, is also found to have sketched in Ootmarsum, as well as in near-by Singraven. The Ootmarsum manor of the Barons von Heyden, glimpsed in Ruisdael's painting, was drawn by Hobbema (Chantilly, Musée Condé, No. 352; Fig. 133). This drawing is sometimes attributed to Ruisdael, but its imprecision is foreign to his hand. It can be attributed to Hobbema on the basis of its general similarity to Hobbema's *View of Deventer* (Paris, Musée du Petit Palais, No. 1052; Fig. 131). In both these drawings and others by Hobbema, (e.g. Figs. 126 and 129), the right hand architectural verticles tend to lean outwards. Hobbema also produced a painting (Broulhiet 55) based on this drawing. From Ootmarsum, Ruisdael and Hobbema appear to have moved on a few kilometers to Singraven Manor, near Denekamp, which lies between Ootmarsum and Bentheim. The mills of Singraven, distinct from those painted by Ruisdael in the 1650s, feature in several paintings by Hobbema (e.g. London, National

130. *View of Deventer*. Drawing, black chalk, grey wash, 124 × 224. London, British Museum. Photo: Museum.

131. Meyndert Hobbema: *View of Deventer*. Drawing, black chalk, grey wash, Indian ink, 180 × 290. Paris, Ville de Paris, Musée de Petit Palais. Photo: Bulloz.

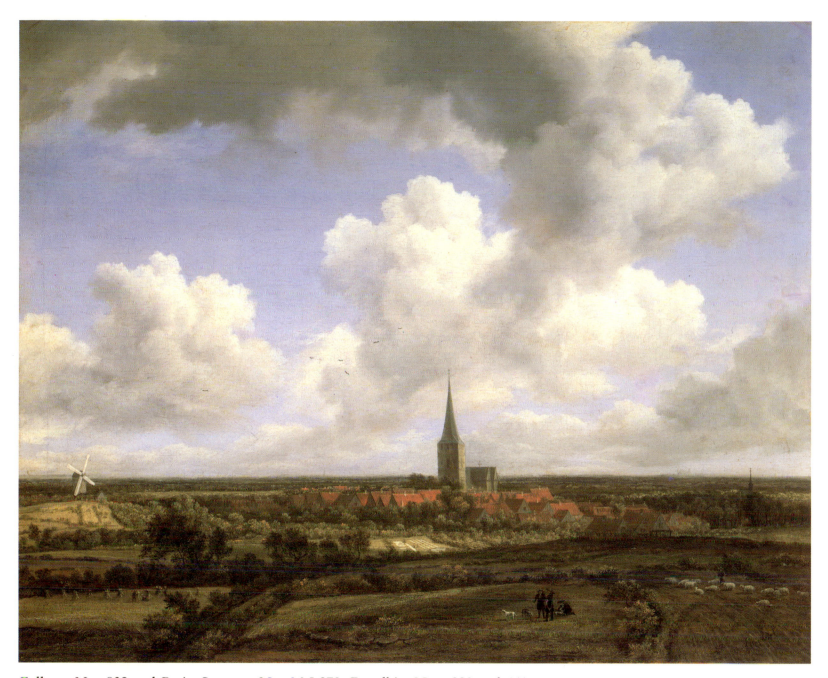

Gallery, No. 832 and Paris, Louvre, No. M.I.270; Broulhiet Nos. 220 and 441 respectively). A sluice, identical in type to that still used today at Singraven, but common to the vicinity, appears as an unusual motif in Ruisdael's oeuvre in the *Wooded Landscape with a Sluice* (Toledo, Museum of Art, No. 78.68) which was perhaps based on drawings made on this trip. Slive reasonably dates the painting to the late 1660s.[13] The cumulative evidence of these joint activities indicates that Hobbema was not merely dependent on Ruisdael's earlier drawings, but had actually visited the area, perhaps even being taken on by Ruisdael to near-by Bentheim, which the older master had often depicted, and included once again, in works of the late 1660s and 1670s.[14] There can be little doubt that this trip was as valuable for Hobbema as it had been for Ruisdael a decade earlier. Perhaps it was even more influential, since the wooded country roads, watermills and sunlit meadows seen and sketched on this trip became the staples of his later work.

132. *View of Ootmarsum*. Canvas, 60.5 × 73.2. Munich, Bayerische Staatsgemäldesammlungen. 133. Meyndert Hobbema: *Moated Mansion in Ootmarsum*. Drawing, black chalk, grey wash, Indian ink, 144 × 268. Chantilly, Musée Condé.

Hobbema rarely departed from the elements evolved in the years 1660–63, although by 1663–64 he was developing them independently. The fresh greens of his shady groves and bright sunlit fields suggest midsummer rather than autumn; his bountiful landscapes, bathed in sun and water, are populated and colourful, exuding peaceful well-being. At his best his freshness and luminosity bring more cheer than Ruisdael, but he lacks his master's range and depth of reflection.[15]

Returning to Amsterdam, both Ruisdael and Hobbema gave their attention to the topography of the city as well as exploiting the fruits of their recent travels. It is striking that in the works of both artists the characteristic spot-lighting of a generally overcast landscape gives way to a more generous distribution of sunlight and open space. In the absence of dated paintings it is difficult to determine exactly when this happened in Ruisdael's works, but in the case of Hobbema, it happened around 1662–63 and became a lietmotif of his subsequent work.[16] Likewise Ruisdael's paintings of the 1660s are significantly enriched by greater subtlety in the handling of expansive cloudy skies complemented by the brilliant new play of light and shadow, in which greater expanses of space are illuminated. This developed sensitivity to lighting, giving form and structure to the entire composition, is paralleled in the drawings of both masters, in nearly all those attributable to Hobbema, and in those of Ruisdael generally considered as works of the 1660s. Ruisdael was perhaps influenced by Hobbema's propensity for fresh, open and sunlit effects to open up his own backgrounds, seen already in the Toledo *Watermill* (Fig. 128), and to introduce a more diaphanous structure in his foregrounds, which is a distinguishing feature of his majestic woodland paintings executed in the 1660s. This apparently parallel development may have been a matter of mutual exchange. That the two artists remained close friends is testified by Ruisdael's attendance as the formal witness at Hobbema's marriage some years later, in 1668.

These pictorial developments, seen across a range of motifs painted by Ruisdael in the 1660s, served well to enhance the compositional strength, breadth of conception and visual force of his *Haarlempjes*. One of the finest of them, the *View of Haarlem* in The Hague (Mauritshuis, No. 155; Fig. 134) shows Ruisdael even more assured in his handling than when he executed the Berlin painting, discussed above (Fig. 113). Using a rich palette of contrasting warm and cool colours, he knits his expansive composition boldly together. He employs a combination of alternating bands of sunlight and shadow and a series of intersecting diagonals, which delineate the edge of bleaching fields, the lines of trees, ditches, and the long strips of white linen laid out in the fields. The pools of sunlight articulate the space. They illuminate yellowish-green bleaching fields, a colourful group of cottages, an expanse of polder and the town beyond. A diagonal axis leads from foreground dunes past the foremost group of cottages, over further shadowed cottages to the church and city. The colouring of the distant buildings repeats in muted tones the bronze-rose and pink of the cottages, with blue-grey roofs, seen in the foreground. Burke's study of Ruisdael's *Haarlempjes* demonstrates that this is not a precise topographical rendering and is not delineated from any specifically identifiable spot. However, various features of the city are clearly recognisable on the skyline, which is dominated by the imposing form of St Bavo's, the spire of which leads the eye up into the expansive sky. Compared to his earlier *View of Haarlem* in Berlin, Ruisdael has now modified his format, increasing the height while reducing the width, thereby accentuating the multiple layers of cumulus cloud rolling across the expansive panorama.[17] Through this interplay of light and shadow, land and sky, Ruisdael imparts a new force and

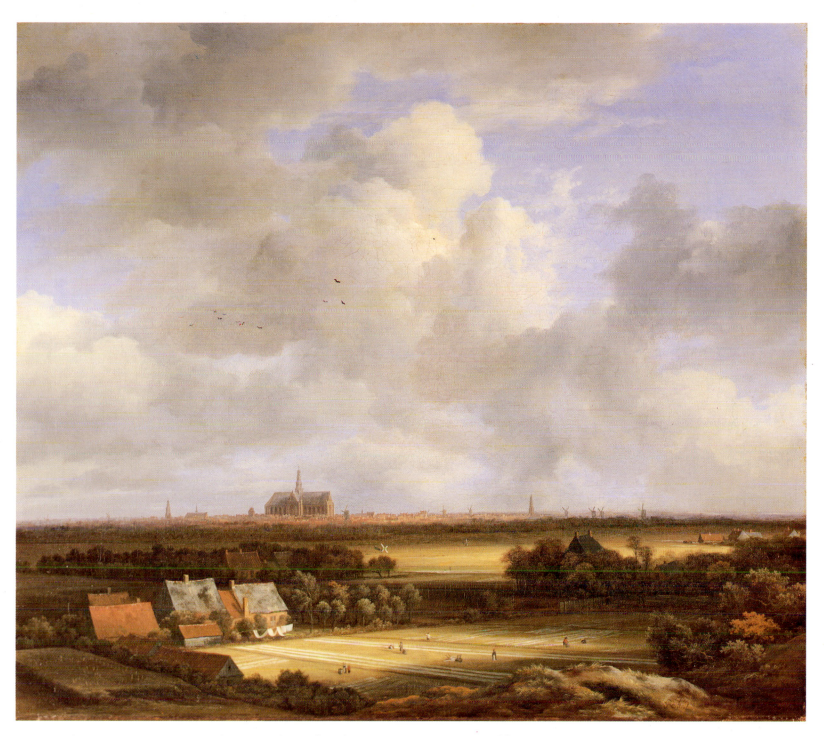

134. *View of Haarlem*. Canvas, 55.5 × 62. The Hague, Mauritshuis. Photo: C. Mauritshuis, The Hague, inv. nr. 155.

structural intensity not seen in the more limpid and vaporous panoramas of his immediate forerunners. Ruisdael's innovations in this area were soon picked up and imitated, seemingly already early in the 1660s by Jan van Kessel, a friend of Hobbema and possibly also a pupil of Ruisdael, and by Jan Vermeer van Haarlem.[18]

Amsterdam's topography also attracted Ruisdael in the first half of the 1660s, perhaps in response to growing interest on the part of artists, publishers, and public in such material. Four richly illustrated historical-topographical descriptions of Amsterdam were published in the sixties. They coincide with a blossoming in painted and etched cityscapes. Around 1660 Renier Nooms, also known as

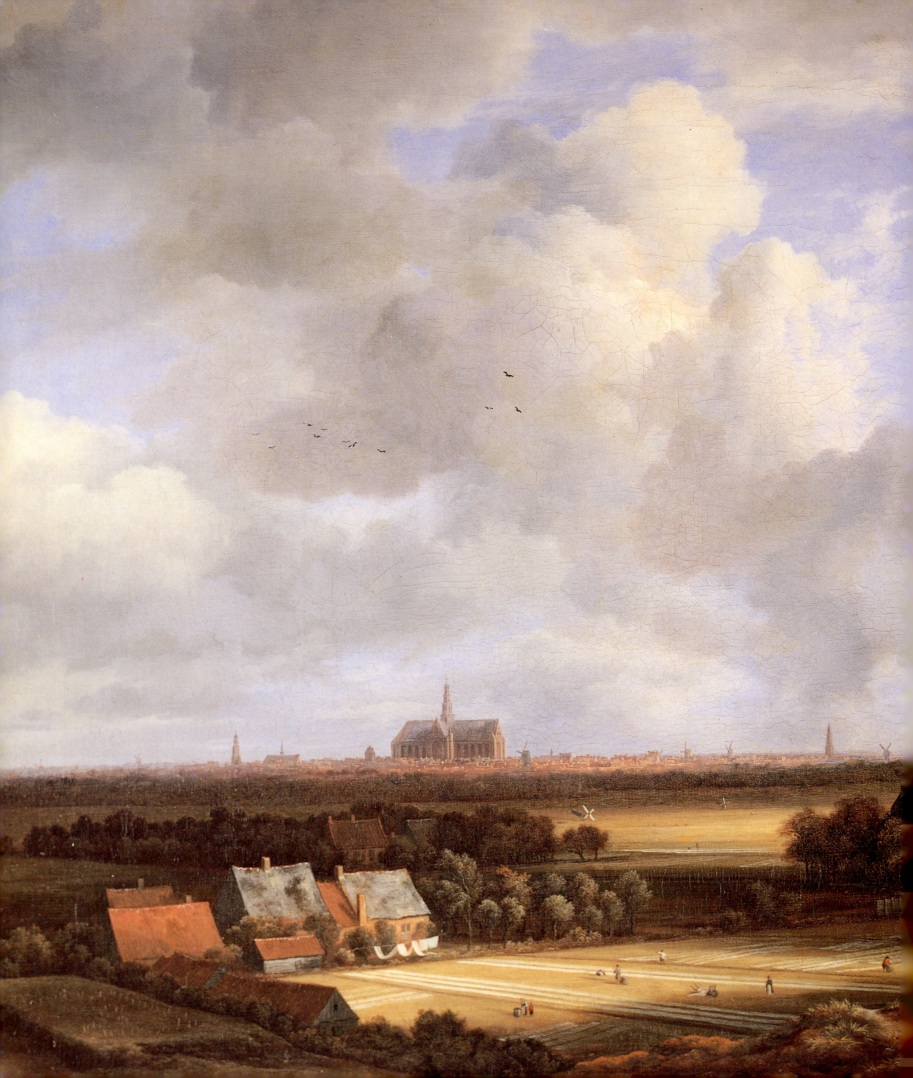

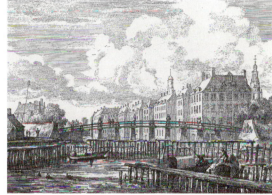

135. *The Blauwbrug, Amsterdam*. Drawing. Black chalk, grey pencil, grey wash, 150 × 212. Paris, École des Beaux-Arts. Photo: École des Beaux-Arts.

136. A. Blootelingh after Jacob van Ruisdael: *The Blauwbrug, Amsterdam*. *c.* 1663/4. Engraving.

137. *View of the Binnenamstel, Amsterdam*. Canvas, 52.5 × 43.5. Budapest, Museum of Fine Arts. Photo: Museum.

Zeeman, etched several series of views of Amsterdam, and Abraham Blootelingh produced a similar series of six prints after drawings by Ruisdael, representing the city boundaries just before their expansion in 1664. Ruisdael's associates Hobbema and Jan van Kessel also made drawings of Amsterdam at this time.[19] Ruisdael's representation of *The Blauwbrug, Amsterdam*, for which the drawing survives (Paris, École des Beaux-Arts, No. M.1.945; Fig. 135) was engraved by Blootelingh (Fig. 136) around 1663/4. Characteristically, it gives more space to the sky than Nooms's etched city views. The *View of the Binnenamstel, Amsterdam* (Budapest, No. 4278; Fig. 137) is a painted version of the same subject, perhaps made some years later. In it Ruisdael adopts a more distant viewpoint and an upright format, accentuating the sky even further.[20] This series of six prints, and two others of the tombs in the Jewish cemetery, represent the extent of Ruisdael's contribution to the demand for topographical prints. In the 1670s he depicted the city of Amsterdam again in both drawings and paintings.

The open spaciousness and luminosity seen in Ruisdael's *View of Ootmarsum* (Fig. 132) and his *View of Haarlem* in The Hague (Fig. 134) are found also in his calm, majestic woodlands of the 1660s, such as his vigorous *Edge of the Forest* in Oxford (Worcester College; Fig. 138) and his translucent *Woodland Swamp* in Leningrad (Fig. 140). Rich colour, finely observed and fluidly executed detail, massive forms set back in space and contrasted with open sunlit vistas, developed by Ruisdael and Hobbema alike around 1662–63, to judge from Hobbema's dated paintings, blend harmoniously in Ruisdael's stately *Edge of a Forest*.[21] A glistening pool animated by water plants, felled timber, and reflections of the forest beyond is set in front of lofty oak and beech trees, with all the moss and lichen on their massive trunks vividly rendered. Their branches, some living, some dead, throw up a rich canopy of autumn-tinted foliage into space. The composition is not overwhelmed as it is in his darker, denser images of the 1650s, such as the Brunswick *Hilly Landscape with Oak, Cornfield and Castle* (Fig. 75). As in Hobbema's contemporary works, the trees are given space and light within which to breathe, and a central, open, sunlit vista gives release to the eye.

Detail from Fig. 134

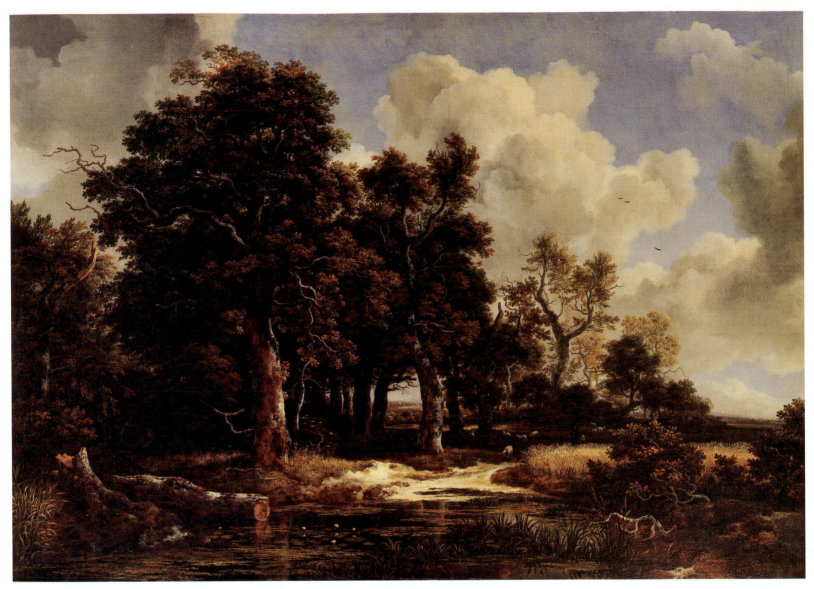

In Ruisdael's Worcester College *Edge of a Forest*, spatial depth is introduced to his binary formula of wooded, upright near-view and open, horizontal far-view by means of diagonal axes. Two, springing from the foreground, intersect on the sunlit pathway and reach into the distance beyond; the third descends the line of treetops and terminates where one of the ascending diagonals reaches the horizon. The lofty trees are executed in thick impasto and a rich gamut of colour, that far surpasses works of the 1650s: pale- and olive-greens and pale yellows, russet, and copper, with silvery, white and grey highlights. Sunlight returns from a warm blue sky as voluminous cloud is blown leftwards, its movement counteracting the thrust of the receding line of trees. His conception of rural well-being, depicted already in his earliest works, such as the 1646 Hamburg *Cottage Under Trees* (Fig. 40), is here conveyed on a grandiose scale, as is the contrast of wild and cultivated land, first essayed in his 1648 etching *Trees by a Cornfield* (Fig. 55). Figures and sheep enjoying the cool shadows of leafy trees, ripening crops, flowering lilies, and sunbeams glinting on distant fields, evoke peace and plenitude, only tinged by signs of decay. Ruisdael presents his public with a majestic conception of nature, freed from all the bustle of people, wagons, boats and ice skates on Holland's roads and canals, that had appealed to an earlier generation. For all its

138. *Edge of a Forest*. Canvas, 102.5 × 146.2. Worcester College, Oxford, Photo: Thomas-Photos, Oxford (courtesy of Worcester College).

richly observed detail, it is an image of nature in general: beautiful, bountiful, varied, expansive and mutable. Its visual force has great sensory appeal and its underlying conceptual structure would appeal to those mentioned by the poets who contemplate the beauty of nature with a spiritual eye. Its naturalistic presentation would have astonished Federico Borromeo as an ideal way for the city dweller to wander in mind through the quiet of the countryside in summertime or winter. Surely it was with images like this in mind that Houbraken wrote of Dutch landscapists and still-life painters that while nature is always changing, artists, by capturing elements of it, preserved the transitory so that one might contemplate the Creator in the creation as in a mirror.[22] When Hobbema attempted a similar motif, in his *Edge of a Forest* (Frankfurt, No. 783; Fig. 139), the effect is at once more mundane, less generalised than Ruisdael's conception, and altogether lacking his master's profundity.[23]

In Ruisdael's *Woodland Swamp* in Leningrad (Hermitage, No. 934; Fig. 140), a smaller painting than his Oxford *Edge of a Forest*, massive trees and sunlit vistas recurr, but this time the tranquil lily-clad pool of water, once again reflecting the trees beyond, recedes further into the middle ground and the trees are distributed less densely around its banks allowing the eye several points of release into the sunlit space beyond. Once again careful attention is given to the depiction of the water plants and the texture of tree trunks and foliage. The inspiration for the composition came from a design by the mannerist landscapist, Roelant Savery, executed by Aegidius Sadeler (Fig. 141), which also shows clumps of trees around a pool with water plants in the foreground and sunshine beyond. Ruisdael had used Savery much earlier as a source of inspiration for his etchings of woodland swamps. The Leningrad painting is another example of his interest in the earlier mannerist conception of landscape. Characteristically Ruisdael breathes vitality derived from his own meticulous observations of natural phenomena into the subject. In adapting Savery's composition, Ruisdael has omitted the former's

139. Meyndert Hobbema: *Edge of a Forest*. Panel, 59.8 × 84. Frankfurt/M, Städelsches Kunstinstitut. Photo: Museum (Ursula Edelmann).

140. *Woodland Swamp*. Canvas, 73.6 × 100.3. Leningrad, Hermitage. Photo: Hermitage Museum.

141. Aegidius Sadeler, after Roelant Savery: *Woodland Swamp with Deerhunt*. Etching. Photo: Amsterdam, Rijksmuseum.

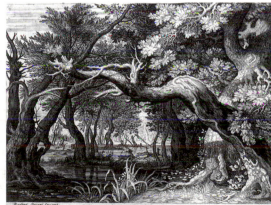

most ravaged tree and substituted a solitary traveller for Savery's deer hunt.[24] Ducks add to the scene's tranquillity. The detail and range of browns, greens, and silvery highlights in the grasses, tree trunks and foliage recall his two woodlands from the late fifties in Munich and Stuttgart (Figs. 116 & 117). The massiveness of the oaks, reaching almost to the upper border, is a debt to Savery, whose vision of nature had much earlier weaned Ruisdael from the idyllic woodlands of Cornelis Vroom (Fig. 54). To link Ruisdael's woodlands with personal melancholy, as has sometimes been done, is to overlook the conventionality of his imagery. Not only is it similar to Savery's, but such details are also described in literature. Bredero, in a *Liedeken* on the month of May, takes his reader into the wild woodland, beside a watery morass, where one sees precious plants, fine flowers and grass, hears hounds chasing a wild pig or dear, and glimmering reflections on the water of men, trees and sky.[25] In Ruisdael's painting, the copper-coloured tree that leans over the pool provides a rich visual accent, while also indicating advancing autumn. Like the contemporary Dutch still-life painters, Ruisdael mixes images of sublime natural beauty with tinges of its inbuilt decadence.

142. Cornelis Buijs, after Jacob van Ruisdael: *Hilly Landscape with River.* 1805. Watercolour. Formerly Art Trade, Boston. Photo: Courtesy of James Golob.

Ruisdael's Leningrad *Woodland Swamp* was probably executed in the early sixties around the time that both Hobbema and Kessel painted woodland swamps, basing themselves both on this composition, as seen in the lefthand portion of Hobbema's *Wooded Landscape with a Pool and Watermills* (Cincinnati, Ohio, Taft Museum, No. 1931.407) of around 1663, and on Ruisdael's earlier etching *Woodland Morass with Travellers* (Fig. 73). The back lighting seen in Ruisdael's Leningrad *Woodland Swamp* also features in a painting of Hobbema (Lugano, Thyssen Collection, No. 132). This is one of Hobbema's earliest woodlands, painted at the time of Hobbema's intense imitation of Ruisdael, around 1662.[26] Jan van Kessel's *Woodland Swamp* (Dresden, No. 1493), based on the same composition, is cruder than Hobbema's, and filled with narrative incident. Lack of restraint is seen in the contrast of dark blue sky and intense white cloud. Kessel also exaggerates the tree's decay with elongated dead branches, but in so doing makes clear his intention that the viewer should focus on such manifestations of nature's mutability.[27]

Jan van Kessel's imitations of Ruisdael are also an indication of Ruisdael's further activity in the early sixties. A watercolour by Cornelis Buijs dated 1805 (formerly Art Trade, Boston; Fig. 142) records a *Hilly Landscape with River* by Ruisdael.[28] Its open spaciousness and grand trees exceed Ruisdael's Stuttgart *Hilly Woodland with Stream* (Fig. 117) from the late fifties. A copy by Jan van Kessel (Fig. 143), in which the location of the buildings has been changed, bears the remnants of his signature and the date 1664. The grandiose dead beech in the foreground is a distinct feature of both Ruisdael's lost composition and Jan van Kessel's 1664 version of it. The tree's height and proportions far exceed those seen in works of the previous decade, such as the Dresden *Ruined Monastery by a River* (Fig. 77), the Detroit and Dresden versions of *The Jewish Cemetery* (Figs. 89 & 94) and the *Woodland Stream with Dead Tree* in Cleveland (Fig. 118). On the other hand its treatment has much in common with the heavier and more massive rendering of this same motif in another group of paintings, namely the *Oaks and Shattered Beech by a Lake* in Berlin, the *Woodland Ford with Figures and Cattle* in Paris, the *Woodland Swamp with Deer Hunt* in Dresden, and the *Three Great Trees in a Mountainous Landscape* in Pasadena (Figs. 144–147). The 1664 date on Jan van Kessel's version of Ruisdael's lost composition, serves, at the very least, as a confirmation that this latter group of pictures derives from pictorial ideas developed by Ruisdael in the early- to mid-1660s, and perhaps pursued for a number of

143. Jan van Kessel: *Hilly Landscape with River.* 1664. Canvas (?), 98 × 175. Formerly Van Diemen, Berlin.

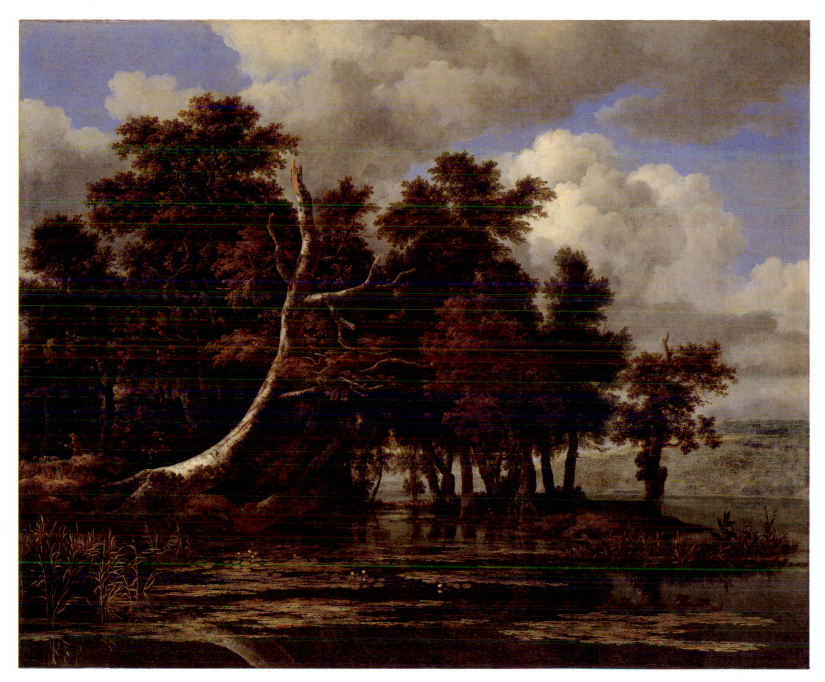

144. *Oaks by a Lake*. Canvas, 114 × 141. Berlin-Dahlem, Staatliche Museen, Gemäldegalerie. Photo: BPK (Jörg P. Anders).

years thereafter into the late 1660s or early 1670s. It is to this latter group of magnificent woodlands that we will now turn, noticing how Ruisdael produced such a variety of effects using the same basic stock of motifs.

The palette of colours and pictorial effects seen in the Leningrad *Woodland Swamp* reappear in Ruisdael's *Oaks and Shattered Beech by a Lake* (Berlin-Dahlem, No. 885G; Fig. 144), which also features reflections on a lily-strewn pool of water partly surrounded by trees. Here the theme of nature's beauty and mutability is expressed with solemn grandeur, with the contrast of dead and living vegetation reaching one of its most perfect expressions. The curve of the white beech trunk, reaching out into space, is echoed by the flowering lilies on the tranquil water. As in the Leningrad *Woodland Swamp* and in other paintings of the second half of the sixties, autumn tints prevail on densely foliaged, lofty oaks and foreground beech. The expanse of still water and contrasting sky, filled with voluminous

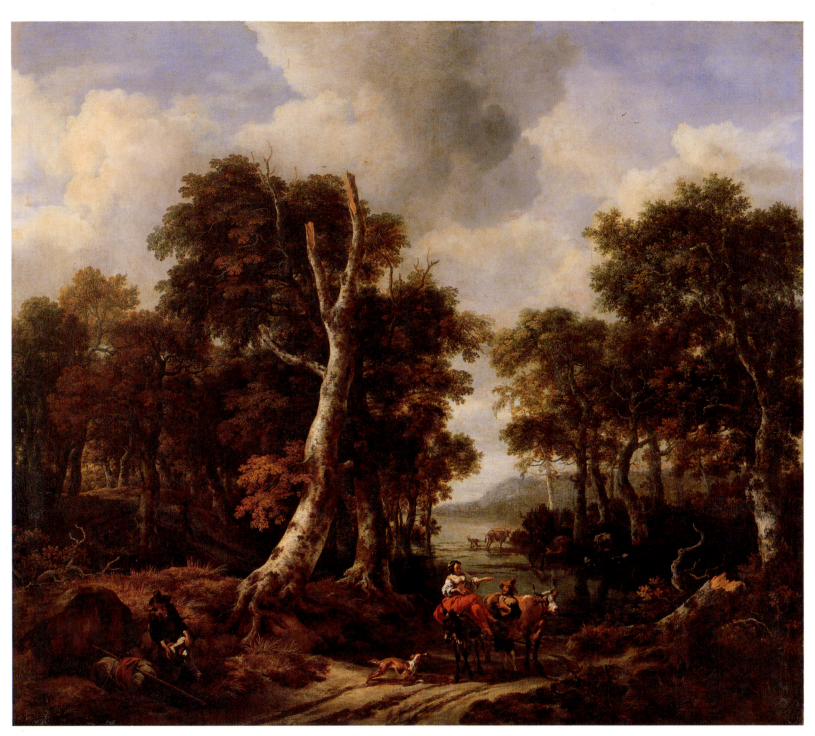

banks of cumulus cloud, blown by the wind, provide space and air around these aged trees. Below them, a passing shepherd makes his way, a sojourner on earth.[29]

Another picture in this group is also one of the largest he ever produced, the *Woodland Ford with Figures and Cattle* (Paris, No. 1817; Fig. 145), with figures by Berchem, who had moved to Amsterdam sometime in the sixties. The composition retains the massive white beech trunk and central, watered vista of the Berlin painting, but opens up the forest, introduces figures on a sandy road, and screens the right vista with further trees. This was one of the pictures by Ruisdael that impressed Gainsborough.

145. *Woodland Ford with Figures and Cattle.* Canvas, 171 × 194. Paris, Musée du Louvre, on extended loan to Douai, Musée de la Chartreuse. Photo: Giraudon, Paris.

Ruisdael carries the effect of trees either side of water before a sunlit background even further in his *Woodland Swamp with Deer Hunt* (Dresden, No. 1492; Fig. 146). While the conception is bold and the silhouette of the central tree against the sky effective, the quality of execution is not sustained and there is a loss of definition. As in the Paris *Woodland Ford*, the picture is enlivened by prominent staffage, consistently attributed to Adriaen van de Velde, whose death in 1672 provides a *terminus ante quem* for Ruisdael's painting. The large size of these two works, their monumental effects, and the inclusion of staffage beyond Ruisdael's usual solitary travellers or shepherds, suggests that Ruisdael intended these works to suit the more cosmopolitan taste and larger rooms of the wealthiest patrician class of Amsterdam. The hunt takes more prominence than in his *Woodland Swamp* in London (National Gallery, No. 854). However, in comparison to sporting scenes by Philips Wouwerman, Jan Wijnants, and Jan Hackaert, where sportsmen, hounds and quarry are the main focus, with castles and country houses in the background, Ruisdael's attention is still held by the forest itself. The hunt introduces human presence. The posture of the huntsman,

146. *Woodland Swamp with Deerhunt*. Canvas, 107.5 × 147. Dresden, Gemäldegalerie Alte Meister. Photo: Staatliche Kunstsammlungen, Dresden.

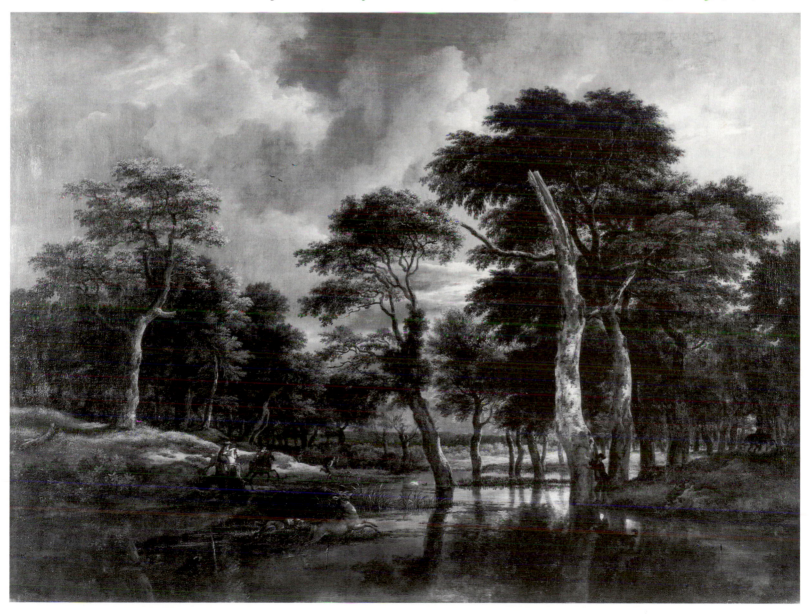

Watermills, City Views, Forests and Swamps: The 1660s 137

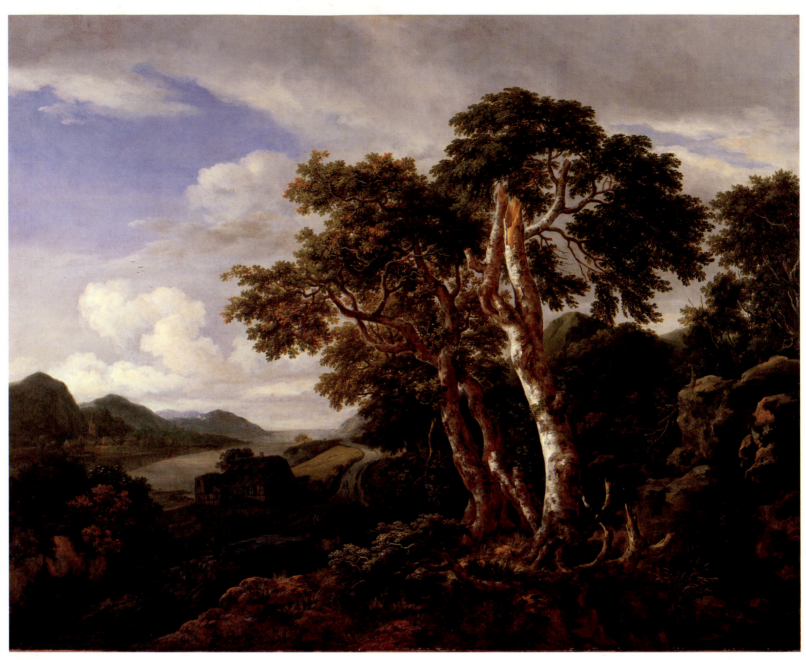

147. *Three Great Trees in a Mountainous Landscape.* Canvas, 138 × 173. Pasadena, California, The Norton Simon Foundation. Photo: The Norton Simon Foundation.

with raised horn, shows that Savery's print (Fig. 141) was still in Ruisdael's mind.

A tendency to open up the space in these woodlands is carried further in a number of late works. Another monumental painting, his *Three Great Trees in a Mountainous Landscape*, now in Pasadena, California, (The Norton Simon Foundation, No. F.71.2.P.; Fig. 147) displays the same characteristics. This picture, probably painted in the late 1660s, is closely related to his other woodlands from the second half of the 1660s. But in it Ruisdael, by a bold stroke of imagination, transposes his familiar clump of stricken beech and thriving oaks onto an imaginary hilltop poised above a river landscape. The river is flanked by a road, a partly ruined house, and, on the further bank, by a village set below a range of mountains. The general conception of Ruisdael's setting may owe a debt to the mountain landscapes and imaginary 'Rhineland' vistas of artists such as Allart van Everdingen, Philips Wouwerman and Herman Saftleven, painted in the 1640s and 1650s, and may perhaps even be intended to recall the engraved mountain and

Detail from Fig. 147

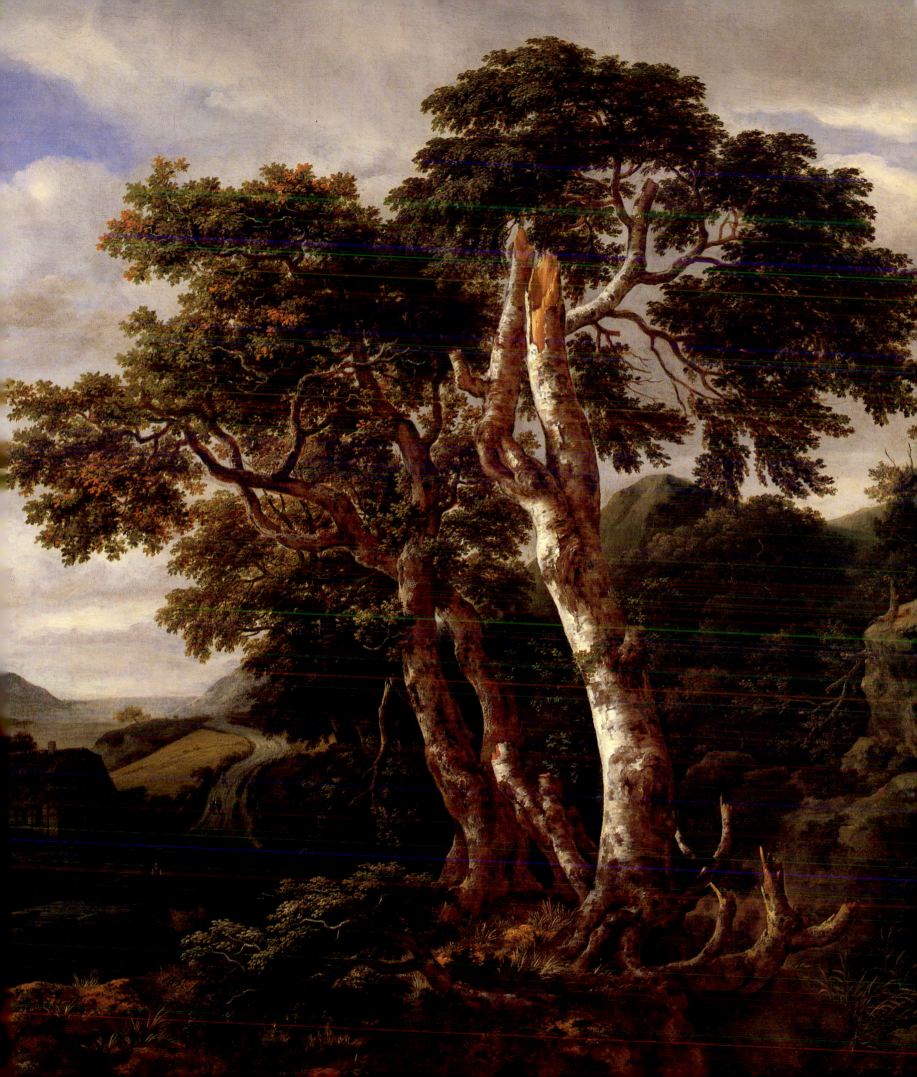

river-valley world panoramas of Pieter Bruegel from the previous century.[30] It may itself be intended as such a generalised image of the world. However, Ruisdael's inclusion of a prominent clump of trees in such a setting reveals a breadth of pictorial imagination matched only by Van Goyen's *Two aged Oaks* of 1641 (Amsterdam, Rijksmuseum, No. A.123) and Rembrandt's famous etching *The three Trees* (Holl. 212) of 1643. Both of these, however, show clumps of trees overshadowing expansive flat landscapes and neither artist comes close to or even attempts Ruisdael's masterful delineation in brilliant colour and detail of the particularities of the species of trees depicted.

It is Ruisdael's capacity to combine such acute observation with such a variety of imaginary settings to evoke the beauty, diversity and mutability of nature that give such distinction to this group of woodlands of the second half of the 1660s. In the Berlin picture Ruisdael had focused on the water and sky, as well as on the plants and trees, in the Paris *Woodland Ford* the figures and cattle added a more pastoral note, while in the Dresden *Woodland Swamp* the deer hunt introduced yet another accent. But in the Norton Simon picture none of the secondary elements is sufficiently compelling to draw one's eye away for long from the unsurpassed clump of oaks and beech. In this work Ruisdael seems to have reached the furthest point from his beginnings in Haarlem, and by the same measure his *Three Great Trees* invites comparison with the landscapes of Claude, among whose works one readily discovers immeasurably finer distant prospects, but rarely a clump of trees as fine as Ruisdael's. This serves only to underscore the fact that Ruisdael's strength as a landscapist, seen already in his early works, lent itself best to the careful delineation of powerful, dense near-by forms, particularly of trees. Even in his panoramas, the expanse of his space is usually more restricted than in those of his immediate predecessors and contemporaries.

Waterfalls, Flat Landscapes, Marines and Winters: The 1660s:

Ruisdael's growing propensity in the 1660s to create images of nature in general rather than localised scenes reaches its apogee in his *Waterfalls*. He produced great numbers sometimes with little variation and they form the largest single category within his oeuvre. The majority are in an upright format, which lends itself to the dynamism of the falling water as it crashes down from level to level. There are also a significant number of larger compositions, using a horizontal format. Both types were essayed by Ruisdael in the 1650s, prior to 1658 at the latest, and were initially modelled on those of Allart van Everdingen, as noted in Chapter VI above. Their most typical characteristics and variations, however, seem to have been developed by Ruisdael in the 1660s, drawing on the range of his pictorial repertoire. It is not possible to establish any exact chronology or dating for them. As far as is known, all were figments of his imagination and most, if not all, are geological impossibilities.

Van Mander had mentioned that waterfalls offered the painter a challenge to create with the power of the brush such a vivid image as to evoke the very sound of rushing water (*Word hier Echo*), and there is little doubt that Ruisdael became known as one who had mastered this challenge. Houbraken marvelled at how Ruisdael 'could depict the spray, or the water foamy from dashing on the rocks, so naturally clear and translucent that it appeared to be just like real water'.[1] He also saw in Ruisdael's waterfalls, as did Jan Luyken, an allusion to the artist's own name: Ruis–dal, a valley of noise, which at the same time referred to the oldest and most common allegorical associations of this motif.[2] It is striking that in giving such attention to waterfalls in the 1660s, when he was already focusing on images of nature in general, Ruisdael now concentrated on an element of nature that was particularly known for its biblical and allegorical associations, as discussed in Chapter III. In many of his pictures he incorporated these associations in his treatment of the subject.

The typical characteristics of those in an upright format, the vivid pictorial qualities to which Houbraken referred, and their obvious intent as allegory are well represented in Ruisdael's *Waterfall with Hilltop Castle* in Brunswick (Herzog Anton Ulrich-Museum, No. 378; Fig. 148). The trees and bushes are executed in comparable detail to the cool, autumnal tones of his *Woodland Swamps* of the 1660s. The density and spot-lit effect indicate a date earlier rather than later in the 1660s. Water surges down towards the viewer, almost overwhelming one, carrying away tree trunks as it tumbles over rock-strewn ledges, the turbulent movement in the foreground being contrasted to the stable, massive form of the mountains beyond, where a castle stands prominently on an outcrop of steep, inpenetrable rock. At the foot of the cliff, beyond the falls, shepherds shelter with their flocks in the shade of trees, providing an element of tranquillity under the protection of the hill and in contrast to the rushing water. From a blue clearing in the stormy sky light-beams shine on the rocks and castle, and shimmer on the silver-grey, foamy water as it dashes down from boulder to boulder.

How did a contemporary view such an image? What associations did it evoke for him? Certainly most would have responded as Houbraken did to the painterly

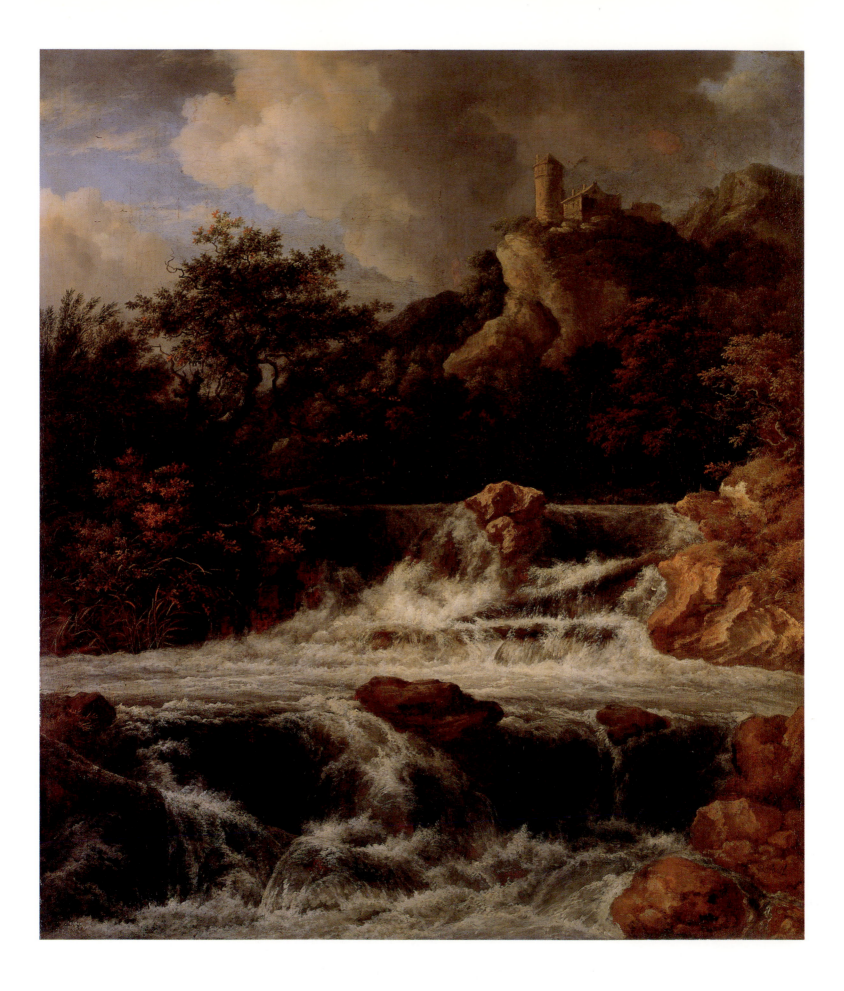

skill and the vivid rendering of the rushing water that seemed to evoke its very sound. Perhaps some would have made a mental comparison to Van Everdingen's versions and noted the more subtle treatment of the water. Probably none were put off by its geological inexactitude, accepting it as a conceit of the imagination that took its point of reference in pictorial and allegorical traditions rather than a concern, found in other types of landscapes, for topographical exactitude. As for those who were more familiar with these pictorial and allegorical traditions, reviewed in Chapter III, those who were sharpened by the constant admonition from pastors and poets to look at nature, or its pictorial counterpart, with a spiritual eye, no doubt they could discover a host of metaphorical associations in Ruisdael's chosen imagery.

Of those associations, few would miss the comparison of the tumult of life in this world with a rushing torrent in a darkened landscape, in which some even saw an allusion to the artist's own name. Few would miss the *vanitas* allusions of rushing water carrying off tree trunks, which evoked long-exploited biblical associations between men and trees, time and flowing water, as images of mortality. Perhaps more of those who bought and viewed such pictures than we today are willing to credit, would have also recognised the intention of Ruisdael's light-beams penetrating a predominantly dark valley and his juxtaposition of a steadfast mountain, crowned by a sunlit castle, to the rushing torrent below. There are a number of biblical texts which employ such imagery. Psalm 144 reiterates David's song of praise from 2 Samuel 22, in which God is described as steadfast and unmovable, like a rock and a fortress when one is buffeted by the waves and assailed by torrents, to which even the viewer is vulnerable in Ruisdael's vivid image, and as a light who lightens our darkness. In Psalm 39, the Psalmist acknowledges the fleeting quality of life, where he is 'but God's passing guest, a sojourner on earth' – like the shepherds in Ruisdael's picture – who sets his hope in God alone. In Hebrews, chapters 12 and 13, we are told that since 'here we have no lasting city', we are to seek 'the city which is to come'; that we are to approach Mount Zion, the city fortress on the hill, which will not be shaken when all else is. For the viewer who has been nourished by such imagery, as many in seventeenth-century Holland would have been, there is food for thought in Ruisdael's juxtaposition of a rushing torrent and a hilltop fortress.[3]

It is only when the concept of creation as God's second book of revelation recedes from view, as it did in the course of the eighteenth and nineteenth centuries, and is then only partly recovered through *vanitas* imagery, that the effect of Ruisdael's waterfalls seems depressing, even morbid. In view of the material discussed in Chapters II and III, we can infer that Ruisdael, on the contrary, intended them as celebrations of God's illuminating all-sufficiency in face of the constant inconstancy of all things under heaven, and that a good number of his contemporaries would have bought his pictures in this knowledge. Their point, beyond their pictorial merits, and their delight in the play of light on foaming water, is to stimulate a hope that cannot be shaken, either by all the vicissitudes of life or by death itself. In painting such images, Ruisdael was no lonely melancholic, but quite simply heir to a specific tradition, ignored by many of his fellow painters, but passed down from the generation of Goltzius, Van Mander and Savery by the latter's pupil Van Everdingen to Ruisdael himself. It was part of the heritage that laid the foundations for the eighteenth-century notion of the sublime, and the subsequent Romantic attraction to mountains and waterfalls.

Turning to his horizontal waterfalls, the largest extant example is his *Woodland Waterfall* in Amsterdam (Rijksmuseum, No. C210; Fig. 149), which was prob-

148. *Waterfall with Hilltop Castle*. Canvas, 100 × 86. Brunswick, Herzog Anton Ulrich-Museum. Photo: Museum.

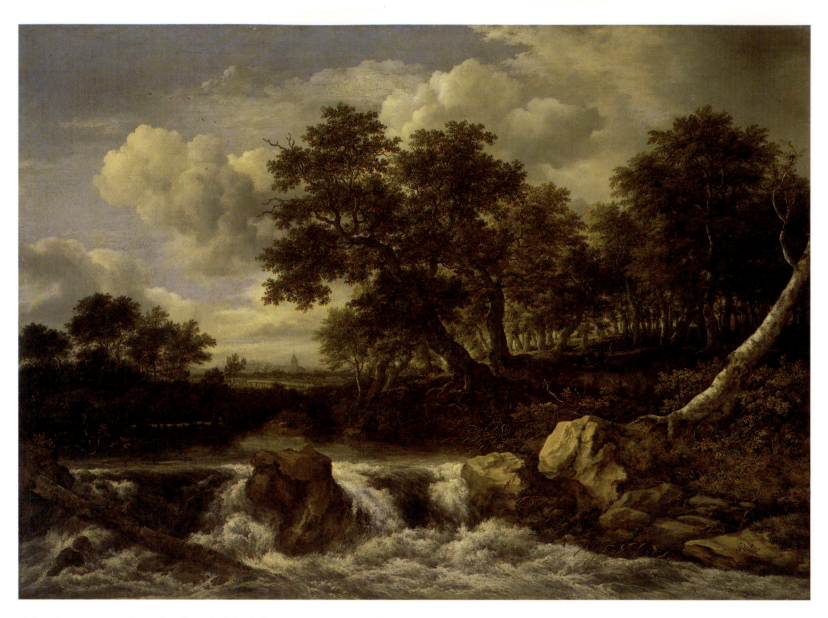

ably also executed in the first half of the 1660s. Its overall composition is based on prototypes developed in the mid 1650s, such as his *Woodland Waterfall* in Washington (Fig. 95). It also develops a number of features found in his Munich *Woodland Stream* (Fig. 116), probably painted in the late 1650s. But its richer colour, subtler treatment of clouds, luminosity and spaciousness are characteristic of elements found in his *Woodlands* of the first half of the 1660s. Compared with the Munich *Woodland Stream*, and the earlier Washington *Woodland Waterfall*, the waterfall is more prominent, strewn with the most improbable boulders, but enhanced by the softer, more delicate texture and transparency of the foaming water. The woodland has been enlarged from a screen of trees into an expansive canopy of foliage over a deep, shady glade, where figures rest. The background elements, repeated from the Munich picture, have been elaborated to include figures stooking sheaves, while the shepherd seen in the same picture is now fording the pool with his flock, thereby animating an otherwise dull area of the composition. The overall effect of these modifications is to enhance the visual interest with a variety of elements that are blended into a harmonious and unified composition. Each element is so lifelike, and the transitions so smooth, that one

149. *Woodland Waterfall*. Canvas, 142 × 195. Amsterdam, Rijksmuseum. Photo: Museum.

can easily overlook the fact that he has combined natural phenomena, such as a plain and a rocky waterfall, that could not in reality co-exist. He formulates a composite image of Nature in general, combining opposites: forest and open plain, uncultivated and cultivated land; sunlight and shadow, tranquillity and flux; and active and resting figures. Harvest fields and autumn tints manifest the annual cycle of growth and decay; young saplings, mature oaks, and a withered stem reflect the cycle of life itself; the juxtaposition of waterfall and distant church suggest the contrast of temporal and eternal life, of life's mutability and divine providence. The harvest fields serve not only as images of nature's bounty, our 'daily bread', but also like ears of grain in *Vanitas* still-life paintings, as a reminder that, 'What is sown is perishable, what is raised is imperishable' (I Corinthians 15.42), an echo of the theme elaborated in Ruisdael's *Jewish Cemetery*.[4]

The pastoral element seen in this and other *Waterfalls* is given even more emphasis in another large, oblong composition, the *Waterfall* in Leningrad (The Hermitage, No. 942; Fig. 150) with prominent figure of a shepherd and his little flock by Adriaen van de Velde, who also provided the staffage for his Dresden *Woodland Morass*. By comparison to the Amsterdam *Waterfall*, its greater depth of space, scaled down trees and liberal distribution of open sunlit vistas suggest that it was probably painted in the later 1660s. Van de Velde's death in 1672 provides a *terminus ante quem* for Ruisdael's picture. Once again Ruisdael goes back to a composition first essayed in the 1650s, the large oblong *Waterfall* of around 1656/8 in a Scottish collection (Fig. 97), for which the drawing (Fig. 98) was probably still in his studio. While his earlier work is reminiscent of effects seen in comparable works by Van Everdingen, such as the distribution of boulders and the inclusion of Norway spruces, the Leningrad picture has a less melodramatic and more tranquil tone, which is enhanced by the interplay of lightly foliated, shady trees and sunlit meadows on undulating terrain beside a tranquil pool.

150. *Waterfall*. Canvas, 109.5 × 143.5. Leningrad, Hermitage. Photo. Museum.

Despite the rushing torrent in the immediate foreground, there is little here of the metaphorical allusions so densely built into his Brunswick *Waterfall* discussed above, testifying to the range of expression to which Ruisdael gave form. It is this more pastoral note which becomes the dominant tone in works from the last phase of his career.[5]

Although he painted many pictures of woodlands and waterfalls in the 1660s, Ruisdael did not neglect the flat, open landscape, more typical of Holland. At this time he produced some of his most memorable images of country roads winding through cornfields and coastal regions, river scenes, expansive panoramas, as well as marines and winter landscapes. It is precisely this range of interest and diversity of approach that sets him apart from the sometimes narrow specialisation of some of his contemporaries.

Ruisdael had depicted the country roads of his native land since the very beginning of his career. In these early works the sandy dunes and windswept bushes found in the environs of Haarlem were the chief focus of interest. By the 1660s his interest had shifted to the effects of wide open spaces, dappled with sunlight and shadow, complemented by the fabulous cloudscapes that unfold above them. If once Ruisdael was entranced by the bush right in front of his nose, now he looked up and out and around, scrutinising not only what was to be seen as far as the horizon, but watching the layers of cloud as they drifted over the flat landscape. In the early works the tone of a picture might be set by a dune-top bush, bent by the wind. By the 1660s he had discovered, as Constable was to do much later, that in landscape painting sky can be the chief vehicle for sentiment. Ruisdael had always been sensitive to light effects, but in the early 1660s, what had been schematised skies give way, especially in his flat landscapes, to cloud formations that are infinitely more subtle. They show more variation not only in their overall shape, but also in their internal texture and modulation. This is first noticeable in works like his *View of Ootmarsum* (Fig. 132), painted probably in the early 1660s. It has been demonstrated that Ruisdael's trees are some of the most accurately delineated in the entire history of western art. The quality of the cloud formations in his mature works should not be underestimated either. He started out a painter of trees, but he ended as a painter of clouds and Constable was the first to acknowledge it.

These developments can best be observed in studying the skies in his flat landscapes. Ruisdael's *Country Road with Cornfields and Oak Tree* in Florence (The Uffizi Museum, No. 1201; Fig. 151) combines his predilection in the sixties for prominent forms and open spaciousness. The forms, and the contrast of light and shadow are more powerful than in his country roads from the fifties, such as the Buckingham Palace *Windmill by a Country Road* (Fig. 110) suggesting a later date. The prominent tree, projected against a diamond-shaped area of brighter sky, is comparable to the forceful contrast of light sail and dark cloud in his *Rough Sea* in Boston (Fig. 160). A guide to the date of the Uffizi *Country Road* is provided by Van Kessel's drawing of a *Country Road with Mansion and Trees* (Paris, Ecole Nationale Superieure des Beaux Arts, No. 305, M.1.744; Fig. 152), which adopts Ruisdael's winding road with a shattered tree by a pool. It is dated 1665, which provides a *terminus ante quem* for Ruisdael's Uffizi *Country Road*. The sky in Ruisdael's picture, impressive as it may be, is nevertheless schematic. The contours and interior structure of the clouds are treated in a rather summary manner, inferior to those in the Amsterdam *Woodland Waterfall* considered above.

On the other hand, in his large *Wheatfields* in New York (Metropolitan Museum, No. 14.40.623; Fig. 153), a work that is related to the Uffizi *Country*

151. *Country Road with Cornfields and Oak Tree.* Canvas, 52 × 60. Florence, Uffizi. Photo: Soprintendenza alle Gallerie.

152. Jan van Kessel: *Country Road with Mansion and Trees.* 1665. Drawing, pen, Indian ink, grey wash. Paris, École Nationale Superieure des Beaux-Arts. Photo: École des Beaux-Arts.

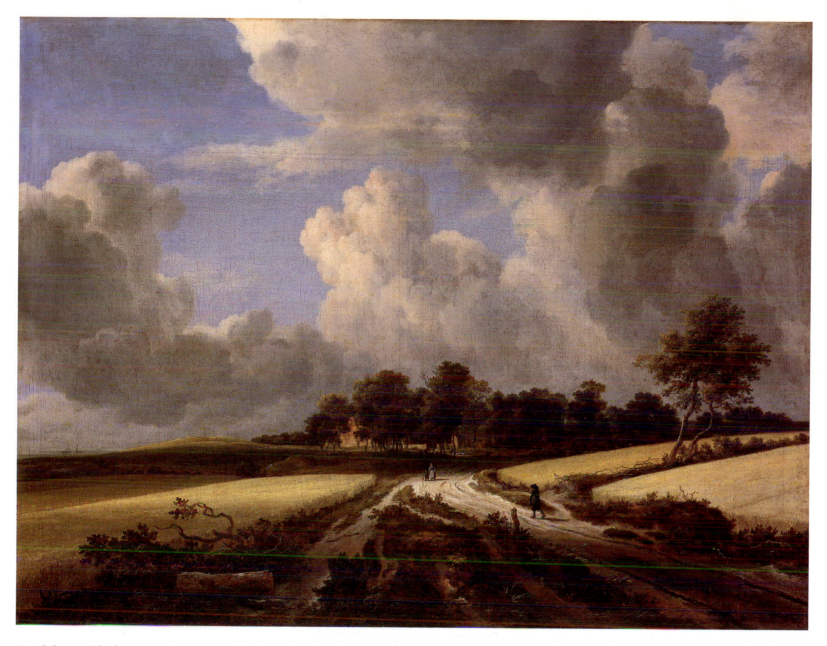

Road, but with the prominent tree eliminated, there is not only a more convincing co-relation between the lighting effects on land and sky, but the clouds are also more carefully orchestrated in their relationship to one another. Their external contours and overall texture are more precisely observed and subtly modulated. At the same time they are also more expressive of rolling storm-clouds casting their shadows on sunlit wheatfields, while leaving a blue clearing in the late afternoon sky, tinged with pink on the central mass of cloud. Lines on earth and in the sky converge on a pool of light where the homely figures of a woman and child, holding hands, are approached by a man. Centrality, rather than scale, establishes their relevance to the overall tone of the picture. Their world is subjected to storm, yet filled with sunlight, which ripens the corn. They are exposed to winds blowing off the sea, but their buildings are protected under the trees. The serenity of the painting derives from this harmonious combination of rugged elements with the smooth, abundant surface and warm tonalities of the wheatfields. The painting perfects the opposition of storm cloud and sunlight over

153. *Wheatfields*. Canvas, 100 × 130. New York, Metropolitan Museum of Art, B. Altman bequest. Photo: Museum.

154. *Country Road with Cornfields*. Canvas, 47 ×
57. New York, Metropolitan Museum of Art, The
Michael Friedsam Collection. Photo: Museum.

155. *Cornfield*. Canvas, 61 × 71. Rotterdam,
Museum Boymans-van Beuningen. Photo: Frequin.

cornfields essayed by Pieter van Santvoort in his Berlin *Sandy Road* (Fig. 21) some forty years earlier, in 1625. In both man is represented as vulnerable yet provided for. Poot's poem, *Een schoone dagh*, written some years later and quoted in Chapter II, likewise overflows with a sense of well-being aroused by the sight of sunbeams breaking out of cloud, bringing growth and joy to the bountiful countryside below. The work was probably inspired by the coastal regions of the Zuider Zee, to the south and east of Amsterdam. It is a triumph of observation and Ruisdael characteristically moulds these observations into an image of the essence of nature's fragile bounty as experienced by man.

Variations on this motif and on the general composition of the New York *Wheatfields* are found in a smaller version also in New York (Metropolitan Museum, No. 32.100.14; Fig. 154), another in Rotterdam (Boymans Museum, No. 1742; Fig. 155), and in a number of other related pictures. Ruisdael's attraction to this motif, featuring in at least twenty of his known works, is striking given the rarity of the motif in Dutch painting at that time. While cornfields, as Chong has noted, were frequent in sixteenth- and early-seventeenth-century Flemish landscapes, especially in representations of Summer in cycles of the seasons, in Holland the motif had become quite rare before Ruisdael revived it. In so doing, as Chong points out, Ruisdael was also now representing what had become a crop associated with a particular region to the South and East of the Zuider Zee, whose topography is compatible with that seen in a number of works in this group of Ruisdael's paintings.[6] The smaller New York *Country Road with Cornfields* (Fig. 154), featuring, like the larger one, two oak saplings in a gently rolling landscape, more intimate in mood, as well as scale, is filled with a serene atmosphere despite the predominantly cloudy sky. While some of its elements recall his country roads of the 1650s, such as the picture in Buckingham Palace (Fig. 110), light and space are of the essence here. These qualities, as well as the characteristic contrast of summer and autumnal tints on the two oak saplings, indicate a date in the 1660s. Ruisdael has scaled the mill, church and trees to blend into the landscape rather than stand out in sharp contrast, thereby achieving a sense of rural tranquillity and well-being. It is a landscape such as the poets loved for peaceful country walks and quiet contemplation. The viewer could participate in the scene, whether in the city or in winter, joining in his mind the traveller and his dog as they make their way along the peaceful country road, with the mill and church adding a familiar, local touch to the rural scene.

In the Rotterdam *Cornfield* (Fig. 155), once more featuring the autumn-tinted oak saplings of the larger New York *Wheatfields*, the coastal setting is brought into greater prominence and the cornfields are more sharply contrasted with the watery marshlands in the left foreground. Here Ruisdael creates a more blustery sky, bringing out the rawness of such a coastal region unlike the serenity of the New York picture. This is counterbalanced, as in Pieter van Santvoort's cornfields under blustery skies of 1625 (Fig. 21), by the intensity of the light-beams shimmering on the surface of the golden-yellow wheat, to create a sense of rural well-being, as enjoyed by the figures resting at the foot of the hill.[7]

Windmills were another aspect of the local landscape that had attracted Ruisdael's attention from time to time. They were the emblem and symbol of the young Dutch Republic. Yet surprisingly, given their omnipresence and pictorial qualities, they are relatively infrequent as prominent motifs in Dutch landscape paintings. Ruisdael had drawn a number of them very early in his career (see, for example, Fig. 35), and he used one as the major motif of his two pictures of a *Windmill by a Country Road* in Cleveland (Fig. 34) painted in 1646,

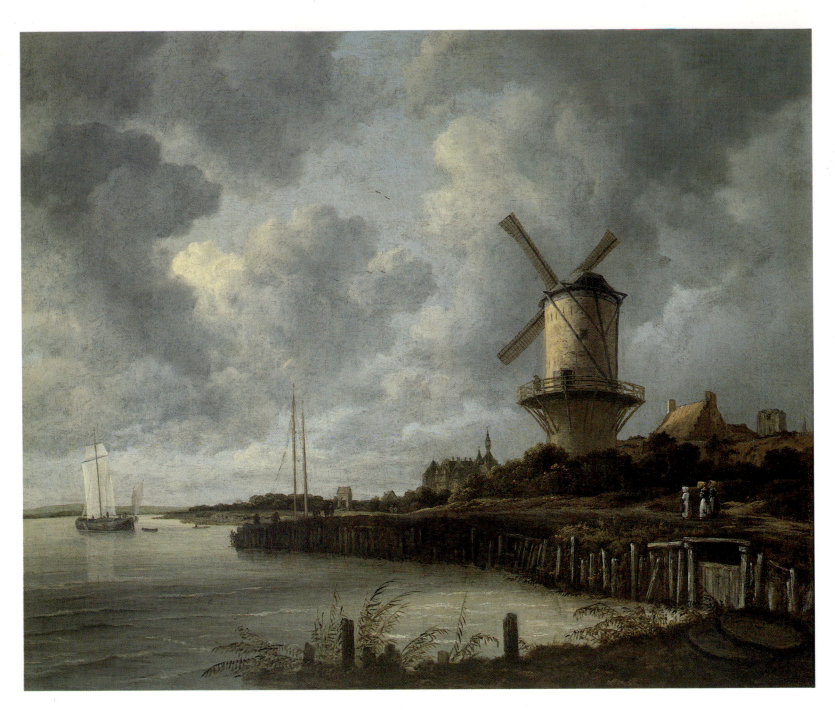

156. *Mill at Wijk bij Duurstede*. Canvas, 83 × 101. Amsterdam, Rijksmuseum. Photo: Museum.

and in London, Buckingham Palace (Fig. 110), painted in the late 1650s, as well as of his *Windmill on a River Bank* in a private collection (Fig. 81), also painted in the 1650s. At the end of the 1660s he gave the subject his definitive treatment in his justly famous *Mill at Wijk bij Duurstede* (Amsterdam, Rijksmuseum, No. C.211; Fig. 156), which was painted after 1668, the year when the clock visible on the unfinished church tower was installed.[8] Colour is more subdued than in works of the early sixties; predominantly grey water and sky are contrasted with muted russet-browns and olive-greens on the buildings and vegetation; the creamy-brown on the mill is echoed in the sky where light breaks out from behind cloud. The mill, unusual for its cylindrical stone structure, has unprecedented prominence, surpassing his previous treatment of such a motif. Ruisdael characteristically has exaggerated its size so as to give it a commanding presence,

and also enhanced this effect by eliminating a wall that in reality obstructed such a view.[9] Although derived from a specific location, the most interesting features of which are carefully included, Ruisdael goes far beyond topography to create a masterful pictorial structure. It is more massive and monumental than any of the river landscapes of his predecessors, such as Van Goyen and his uncle Salomon van Ruysdael, and, through his selection of elements and pictorial organisation, evokes a range of associations.

The painting can be appreciated on several levels: topographic, aesthetic and intellectual. As a traditional river landscape, it appeals to the visual and topographical interest in a well-known and prominent landmark on a favoured travel route. The castle at Wijk had historical associations, and its representation by Ruisdael may be compared to river landscapes by Salomon van Ruysdael (De Young Museum, San Francisco), Jan van Goyen (Walters Art Gallery, Baltimore), and Aelbert Cuyp (Herron Museum of Art, Indianapolis) depicting Charlemagne's palace, the Valkhoff at Nijmegen.[10] Ruisdael's painting satisfies the eye with its colour and its rhythms of horizontals, verticals, diagonals, and curves. It integrates detail with the overall design: the stakes and millstones in the foreground are a prelude to the main theme, corresponding to the pattern of masts, gatehouse, castle tower, and mill; the millstone echoes the curve of the mill itself. The windmill's sails project towards the furthest reaches of water and sky; light returns upon them. The play of light on the mill in turn invites contemplation. The thoughtful seventeenth-century observer, reminded by the catechism that the invisible nature of God may be perceived in the things that have been made (Romans 1.20), would grasp the relationship of light and mill as having particular significance, as Kauffmann noted. In emblem literature, a man without the spirit of God is compared to a mill without wind. In one such emblem, light-beams, focused on the mill, accentuate the notion of man's dependence on providence. It is analogous to the image of light-beams on bleach- and cornfields in Ruisdael's paintings. They are not emblematic, but symptomatic of the way in which the seventeenth-century viewer, raised on the language and imagery of the Bible, had been conditioned from earliest childhood to experience the various phenomena of nature.[11] For example in an etching of C.J. Visscher (Simon 77; Fig. 157) man's prospering activity is associated with light-beams breaking through cloud and falling on a mill. In Ruisdael's painting all these elements are invoked: women bring their sacks to the mill; lack of wind leaves a boat's sails limp; and the composition culminates in a shaft of light illuminating the mill. Ruisdael makes one characteristic addition to this theme: two worn millstones are displayed prominently in the foreground, like the cracked tombstones in the *Jewish Cemetery*, or split marble and fallen petals in a flower-piece, they indicate that even durable objects are transient. The visual structure of the painting was surely made to induce a progression from delight to contemplation, representing men and women in a beautiful, yet vulnerable and uncertain world. Ruisdael showed people prospering, as the Dutch were, not least from their mills, yet in that prosperity aware of their dependence on the providence of their Creator. Rightly or wrongly, they credited Him with their delivery from the Spanish tyranny into the 'New Canaan', the promised land flowing with milk and cheese![12]

This seems to be the spirit in which another of his expansive landscapes, also depicting motifs of the indigenous Dutch landscape, is conceived. His *Extensive Landscape with a Ruined Castle and a Village Church* (London, National Gallery, No. 990; Fig. 158) does not however, so far as is known, take its point of departure from such a specific site, as the *Mill at Wijk*, although the church which

157. Claes Jansz. Visscher, after C.C. van Wieringen: *Landscape with Windmill*. Etching. Photo: Amsterdam, Rijksmuseum.

provides a significant accent within the composition resembles a type found in the vicinity of Blaricum, in Gooiland, the area from which Ruisdael's family originated. In the nineteenth century it was known as a *View of Beverwijk* (near Haarlem), and at sale in Amsterdam in 1800 as a *View in Gooiland*. This latter description was probably intended in a generic rather than a specific sense. The former description, isolating it even more specifically, misses the artifice of Ruisdael's conception. Derived from pictorial effects developed in his *Haarlempjes*, it recasts them into an imaginary but believable panorama, much as he did in his paintings of great trees during the 1660s.[13]

This type of picture, achieving a *tour de force* of space, light, shadow, detail and colour, in which more than half the canvas is filled by sky, capitalises on the pictorial qualities developed by Ruisdael in the 1660s. As in the Leningrad *Waterfall* (Fig. 150) and the Dresden *Woodland Swamp with Deer Hunt* (Fig. 146), the foreground staffage of two shepherds and their little flock were painted by Adriaen van de Velde. Like those two paintings, it was most likely painted around 1665–70. The great layers of cloud, drifting majestically over the expansive landscape,

158. *Extensive Landscape with a Ruined Castle and a Village Church*. Canvas, 109 × 146. London, National Gallery. Photo: Reproduced courtesy of the Trustees, The National Gallery, London.

159. *View of Haarlem*. Canvas, 62 × 55. Zürich, Kunsthaus, Stiftung Prof. Dr. Leopold Ruzicka. Photo: Museum.

are carefully observed, subtly modulated, and unify the entire composition with their interplay of lighting between sky and land below. These compelling effects, so masterfully rendered, support such a dating.

The National Gallery picture is more expansive in conception than the *Haarlempjes* and it is also more all-embracing, including elements which recur separately in other works such as the castle ruin, not typical of his flat landscapes, the prominent church and figures stooking sheaves. A distant mill is illuminated brilliantly by shafts of light, to whose hidden source our attention is drawn by the church spire, serving its ancient function as a finger pointing to the sky. The contemporary beholder might see contrasting allusions to fleeting temporal power and enduring spiritual life in the juxtaposition of ruined castle and church spire. Likewise, the sunbeams, breaking into an overcast landscape, may have been intended to arouse thoughts about man's dependency on God's providence in a mutable world. Whether or not such associations were explicit, the pictorial impact of the composition can be taken as celebrating the beauty, variety, and mutability of nature and the works of man, this time conceived in terms of the indigenous Dutch landscape. Ruisdael has once again selected his motifs and orchestrated their inter-relationships in keeping with his underlying conception of nature, doing so in a manner so vivid and realistic that we take it for a mirror of the actual Dutch landscape.

In the late sixties Ruisdael adapted his mastery of sky and expressive use of light to paintings of small scale as well as large. The narrow, upright proportions of his *View of Haarlem* (Zürich, No. R32; Fig. 159) are used to accentuate depth in land as well as height in sky, the ratio of sky to land being no greater than in his oblong *Haarlempjes*. Once again Haarlem's famous linen bleacheries feature prominently in the midground, bathed in the sunlight whose rays, combined with the pure water, filtered by the sanddunes, bleached the linen. This time the supply of water, collected at the foot of the dunes, is also included. The viewpoint is higher and more remote, the near-by figure sketching is thus smaller scaled than in the *Haarlempjes* in Berlin and The Hague (Figs. 113 and 134). This distancing of the figures on the foreground dunes and in the bleaching fields below is however more than compensated for by the additional attention given to the sky, in which billowing cloud, modelled with endless variations of tone, rises majestically over the land and is reflected off the sheet of water.

As well as woodlands, waterfalls, country roads and panoramic flat landscapes, Ruisdael also painted a number of marines and winter landscapes in the 1660s. Marines were particularly popular with collectors who paid high prices for them. This is not surprising in a culture so dependent on the sea.[14] Artists such as Jan Porcellis made a speciality of marines. In Ruisdael's work they are incidental, but not any less forceful and vivid for that. In painting marines, as noted in Chapter VI, he modelled his treatment on the Porcellis-de Vlieger type, with shipping seen under blustery skies riding on the choppy grey waters of the North Sea. His marines also at times share the warmer palette and characterisation of Willem van de Velde the Younger's marines.[15]

Ruisdael's *Rough Sea* in Boston (Museum of Fine Arts, No. 57.4; Fig. 160), with its powerful composition, lively sky, and dynamic contrast of light and shadow, articulating the space, is comparable in strength to his London *Extensive Panorama* (Fig. 158).[16] Foreground breakwaters lead the eye towards a boat whose sails, catching the light, stand out against dark grey cloud, much as the mill in his *Mill at Wijk*. Beyond and to the left, further shipping, echoing the rhythm of the foreground pilings are silhouetted against the sky, their masts pointing up to a

break in the cloud whence sunlight illuminates choppy waves before a distant man-of-war. Its solid upright form in the right background acts as a counterpoint to the foreground breakwaters, stabilising the composition. More stately and less stormy than his earlier seascapes (Figs. 104, 105 & 107), Ruisdael was not however attracted by the still waters, reflections, and decorative patterns of ships's masts, sails and rigging painted by Jan van de Cappelle and Willem van de Velde.[17] Stechow wrote that in Ruisdael's seascapes, 'man seems to abdicate before nature' and that vessels are 'swept into the solitude of vast seas', comments in no way justified even though space in the Boston picture is expansive. Land is in sight, shipping is plentiful, and under control. Words like 'abdication' and 'solitude' show how romantic interpretation creates the expectation of non-existent things.[18]

In another marine, his *Rough Sea* in Lugano (Thyssen Collection, No. 274; Fig.

160. *Rough Sea*. Canvas, 106 × 123. Boston, Museum of Fine Arts (William Francis Warden Fund). Photo: courtesy Museum of Fine Arts, Boston.

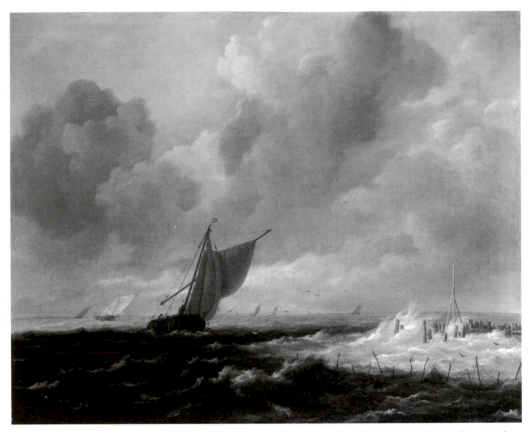

161. *Rough Sea*. Canvas, 49.8 × 62.2. Lugano, Switzerland, Thyssen-Bornemisza Collection. Photo: Brunel (courtesy of Thyssen).

161), Ruisdael once more shows his preference for breezy rather than calm weather in his characterisation of life at sea. It shares with the *Mill at Wijk* a dominant grey tonality contrasted with brown, in the sails, and a corresponding pale grey-brown in the sunlit clouds. It is more subdued in colour than his Boston *Rough Sea*, and seafaring life is here characterised by driving wind, and sunlight breaking out of a cloudy sky, much as it had been formulated by Jan Porcellis. A recurrent feature of Ruisdael's treatment is seen in the waters lashing on the breakwaters, creating effects comparable to his *Waterfalls* and ones that Houbraken noted as emphasising the strength of the sea.

The sensitivity to the elements seen in Ruisdael's marines is also a hallmark of his winter landscapes. While ice skaters are not entirely excluded from his treatment of this popular subject, much more frequently Ruisdael replaces these typical figures with occasional people bringing in firewood or simply making their way along the frozen canals. His interest is focused less on the activity of winter and more on the mood, atmosphere and quality of lighting on wintery days. In front of Avercamp's winters one thinks to reach for one's skates, in Ruisdael's one's thoughts turn more readily towards a warm coat and a blazing fire. None of Ruisdael's *Winters* are dated, but many have the small size and upright format of his mature *Haarlempjes*, and are generally considered works of the 1660s and 1670s. However he also produced a number in larger, horizontal format, such as his *Snowballing on a Frozen Canal* (Lugano, Thyssen Collection, No. 273; Fig. 162), a powerful composition in which the dominant motifs are set back in space in a manner consistent with his practice in the 1660s. In this case Ruisdael treats the fun and recreation of village life in winter. His atmospheric conception is comparable to Jan Beerstraaten's winter cityscapes. The richly textured snow highlights the trees, the warm brown buildings, lit by the sun, stand out against the sky, like the windmill in the *Mill at Wijk bij Duurstede*, and

like the main ship in his Boston *Rough Sea*. Ruisdael's winters may also have been an inspiration to his imitator Jan van Kessel, whose winters, Houbraken says, were specially appreciated.[19] One of them, Van Kessel's *The Heiligewegspoort, Amsterdam, in Winter* (Amsterdam, No. A2506) was possibly based on drawings done in 1664. While its conception may have owed as much to the winter town-views of Jan Beerstraaten as to those of Ruisdael, it may nevertheless be an indication that such winter town-views were also produced by Ruisdael around that time.[20]

The tender little *Winter Landscape* in Amsterdam (Rijksmuseum, No. A349; Fig. 163) is much more compact in structure and monumental in effect. Its massive forms belie its modest dimensions. The combination of silver-grey and brown tonalities, strong effects of chiaroscuro, and shafts of light illuminating monumental forms recall qualities seen in his marines in Boston and Lugano, while its taut, compact pictorial structure and the monumentalisation of the tallest building, catching the light, recalls the composition of the *Mill at Wijk*. Like these works, it is probably a work of the late 1660s. Rosenberg and Slive wrote of it: 'Forbidding black clouds hang over a forlorn snow-covered scene, an extremely moving and stark symbol of sadness and imminent tragedy'. But it is unlikely that Ruisdael intended it as such. As with many of his landscapes, traditional elements are conveyed with renewed vigour: Aert van der Neer, Van Goyen,

162. *Snowballing on a Frozen Canal*. Canvas, 65.6 × 96.7. Lugano, Switzerland, Thyssen-Bornemisza Collection. Photo: Brunel (courtesy of Thyssen).

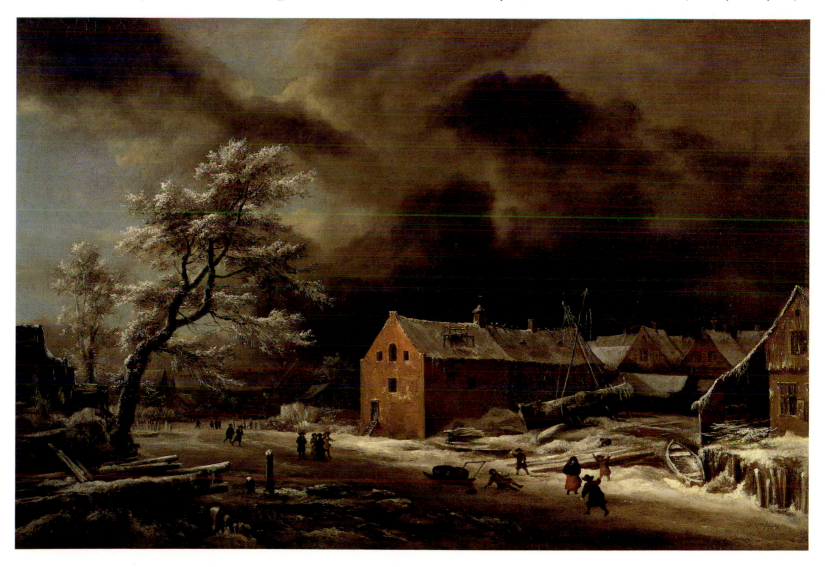

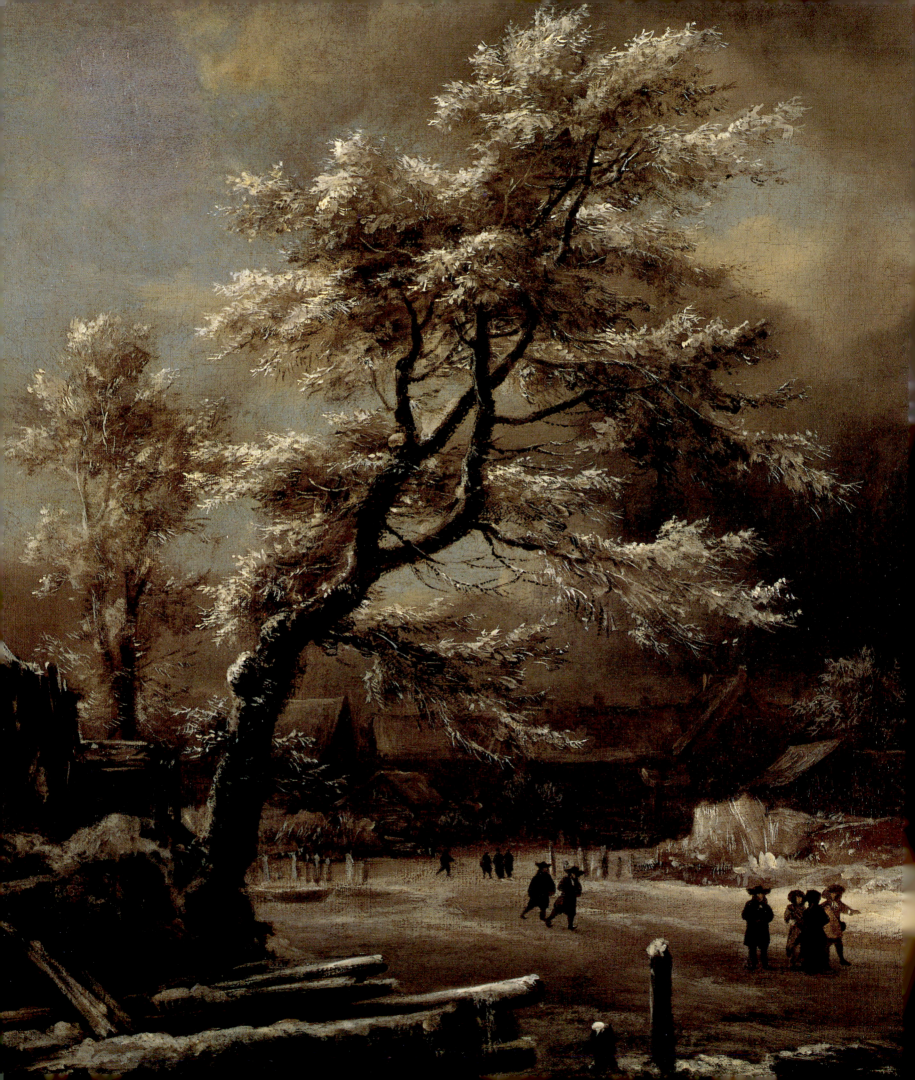

Wouwerman, Berchem, and Van de Cappelle all characterised winter by dark skies.[21] In Ruisdael's painting, winter's harsh reality is also indicated by the thickness of the exhumed ice block in the left foreground. This also denotes the season, ice-breaking being the characteristic activity of Allart van Everdingen's drawing *February – Ice Breaking* (Rotterdam, No. H194). Winter fuel, piled up before the cottage in Ruisdael's picture, is another typical feature of the season. In Van Everdingen's *February – Woodcutting* (Rotterdam, No. H107) its collection characterises the month. Ruisdael's image is not one of 'sadness and imminent tragedy' for he represents, in contrasting warm tones, the relieving cheer of a typical, late afternoon '*Opklaring*' – brightening up. The figures go quietly about their tasks. A man approaches a cottage whence smoke is drifting from the chimney, an image Van Mander associated with the warmth and comfort of home.[22]

Detail from Fig. 162

163. *Winter Landscape*. Canvas, 42 × 49.7. Amsterdam, Rijksmuseum. Photo: Museum.

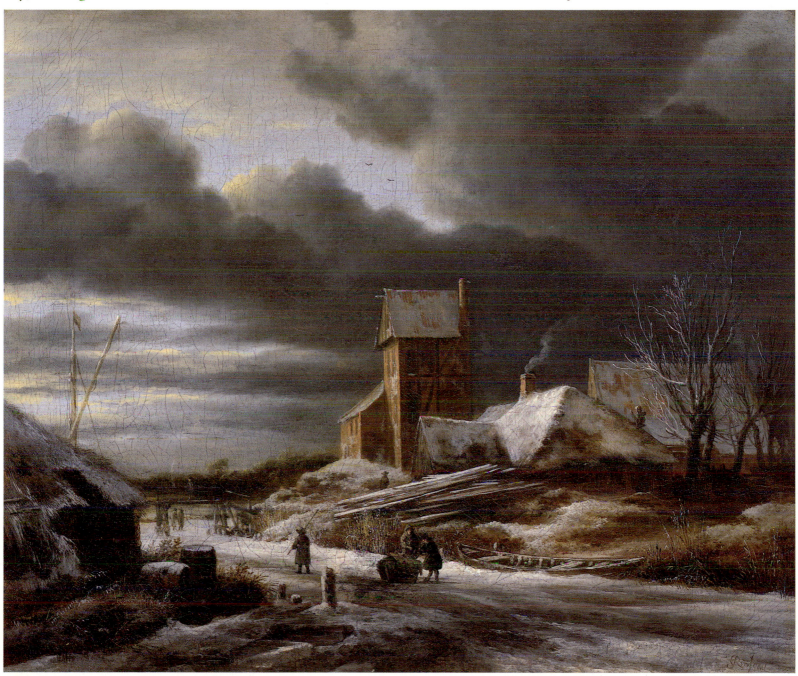

Ruisdael thus characteristically captures all the severity of the winter season, in which, nevertheless, human well-being is securely preserved.

The small scale and upright format of two further winter landscapes by Ruisdael, his *Village in Winter* (Munich, No. 117; Fig. 164), and a further *Village in Winter* (Leipzig, No. 1057) presage the serene intimacy of some of his late winters; they are also rare in his oeuvre as moonlight pictures. The compact yet powerful composition of the Munich *Winter* has somewhat more depth but greater intimacy than the Amsterdam *Winter* (Fig. 163) to which composition it is related. A man and boy drag home a log, and, as in the Amsterdam painting, a puff of smoke drifts from the chimney of a nearby cottage. That such a painting could come from the same hand at about the same time in his life as the *Three Great Trees* in Pasadena and the *Extensive Panoramic Landscape* in London is an indication of both the extraordinary versatility of the artist and his sensitivity to such varied aspects of the natural world.[23]

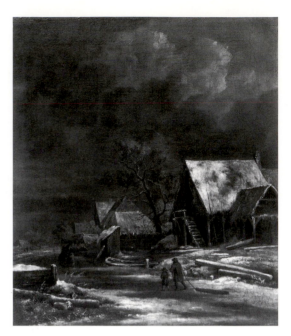

164. *Village in Winter*. Canvas, 36 × 31. Munich, Bayerische Staatsgemäldesammlungen. Photo: Museum.

During the 1660s Ruisdael had matured beyond the melodramatic propensities and density characteristic of many of his previous works. He had absorbed the lessons of Allart van Everdingen's popular mountain landscapes and waterfalls and recast them in his own subtle pictorial language. Travelling with Hobbema had stimulated a new breadth of space and openness in his landscapes, as well as more brilliant illumination. His powers of observation, first focused on trees, had now scrutinised and mastered the life of the sky and clouds as well, resulting in some of the most majestic panoramic landscapes of the seventeenth century. His woodlands and waterfalls, less dense and overbearing than in the 1650s displayed a grandeur of conception and brilliance of execution that captivates the eye and arouses the contemplative imagination. By the end of the 1660s his compositions manifest a taut and compact strength which may be seen in country roads, river landscapes, marines, and winters.

During the 1660s Ruisdael extended the range of his themes only marginally, to include a series of city views of Amsterdam. He also introduced some new motifs, such as his drawings and paintings of the ruined house of Kostverloren, and the type of watermill seen in both his and Hobbema's paintings. Far more striking than these innovations is his pictorial transformation of his own earlier subjects, resulting in works of extraordinary pictorial force. Refined powers of observation married to a greater force of pictorial expression give an enhanced sense of reality to what were in almost all cases conventional subjects of both domestic and foreign landscape. His extraordinary sensitivity to the elements is particularly striking. While his early works reveal his scrupulous observation of local vegetation, in the 1660s, this capacity to observe and thereafter transform into paint the most subtle phenomena of the visible world is also applied to shipping in coastal waters, to the harsh, cold atmosphere of winter, and above all to the life of the sky, with its rolling, billowing clouds. But in the place of other artists' sensitive, tonal effects, he offers something more monumental, focusing on the essence of the theme. He paints *winter*, not so much people skating *in* winter.

Two earlier themes that recur in the 1660s are his country roads with cornfields (see Figs. 151, 153, 154, & 155), and his panoramas (see Figs. 132, 134, 158, & 159), the latter often including Haarlem and its economically important bleaching fields. It is worth noting, however, that Ruisdael also includes both bleaching fields and cornfields, with both standing grain and stooks of corn, in his *View of Ootmarsum* (Fig. 132), a village in the extreme east of the country, close to the German border. Ruisdael may have intended such signs of prosperity, whether

seen in the vicinity of Haarlem, on the shores of the Zuider Zee, or further afield, outside the little village of Ootmarsum, to indicate not only local, economic interest, but also a more comprehensive reality in which the material and spiritual intertwine, and to which the process of pictorial selection and presentation gives an aesthetic form. Such a painting would thus be intended to attract the eye and to arouse the spirit of the contemplative beholder, a process of reflection that contemporary poets were fond of nurturing in their readers. Perhaps a key to the significance to Ruisdael of the motif of cornfields with harvested corn is to be found in his *Woodland Waterfall* in Amsterdam (Fig. 149), discussed above, a composition of such obvious artifice that it relates to no known or possible topography. Thus the interrelation of elements, where harvest fields with stooks of grain are set between the foreground waterfall and a church spire in the far distance, depends entirely on the artist's conception of his subject. Whatever contribution economic and agricultural trends may have had to Ruisdael's treatment of these motifs, or to the way that the contemporary beholder viewed them, for Ruisdael both bleaching fields and cornfields had been among his earliest motifs. Ruisdael's paintings of cornfields respond to pictorial tradition as much as to other concerns. Like others he emphasised the contrast of natural forces, but his gift was to transform this convention with his superior powers of observation and pictorial invention. In the 1660s his paintings of cornfields also reach far beyond his own earlier treatment to create a panoramic sweep of terrain under a vast panoply of cloud-laden sky.

By around 1670 he had produced a mature body of works which was partly sustained but not surpassed in the last phase of his career. Grandeur and breadth is replaced by a calmer intimacy. The mood of his landscapes had changed, so that by the end of the 1660s a quiet serenity pervades his scenes. In the 1670s small-scale paintings were to predominate, permeated by this same peaceful mood.

Ruisdael's Works in a Declining Art Market: 1670–82

After a period of unprecedented economic expansion and flourishing artistic activity in the 1650s and 1660s, severe recession hit the art market in the 1670s, especially following the French occupation of Holland in 1672, described by Houbraken as 'that fatal year . . . that brought everything to a halt.' This situation resulted in the bankruptcy or near bankruptcy of two prominent Amsterdam art dealers, as well as of one of the most popular portrait painters. Many other artists, numerous landscapists among them, found themselves more dependent than ever on alternative forms of employment and some virtually ceased to paint. In this context, if we are to believe the rather obscure records, Ruisdael too pursued an alternative profession, more unusual than that of any of his colleagues, registering as a surgeon in 1676. Reputedly he performed many successful operations, for which his keen eye and steady hand must have given him at least some small advantage. In Ruisdael's case, however, there is also evidence of continued artistic production, some of it of uneven quality, right up to the end of his life.

Those changes in the artistic life of Amsterdam were also accompanied by a general shift in taste around this time, so that the year 1672 also marks something of a watershed in the history of the Dutch school. The decline in production that followed was accompanied by the growing influence of French taste, both in clothing and art. The influence of French academic art theory is not only noticeable in the writings of Samuel van Hoogstraeten and Gerard de Lairesse, but also in actual artistic production. This is seen not only in works such as the latter's 1672 *Allegory of Amsterdam Trade* (The Hague, Peace Palace), but also in the landscapes of his collaborator, Johannes Glauber, who began painting in the style of Gaspard Dughet. Likewise Jan Weenix's decorative game pieces were set in parks graced by statues and urns in the French manner.[1] Not even Ruisdael, or his patrons, were entirely exempt from this assumed sophistication, as seen in pictures of fashionably dressed figures disporting themselves in exotic countryhouse parks. This shift in taste also accounts for the success of the small, bright, highly finished paintings of Adriaen van der Werff, and is reflected by the prices paid for Italianate landscapes. Brightly coloured, finely detailed cityscapes were also in vogue, but few landscapes of distinction were painted after 1670.

In the case of Ruisdael, the volume of his production appears reduced, as does the scale, and some paintings show a marked deterioration in quality. The small scale of his late works may be attributed to contemporary trends. His brush-work is tight, but, unlike that of other contemporary painters, it is often thin and dull, lacking the vigour of his earlier works. This loss of force is however compensated for by their gentle, pastoral mood.

The massive, near-by forms, and rich detailing of the fifties and sixties are not repeated in the seventies. There is a distancing of the subject-matter, with deeper foregrounds, scaled-down trees, and high skies. His paintings are consequently less dense and overbearing, gaining in spaciousness and light effects. An innovation is his recurrent use of evening light, seen in layers of streaky cloud, tinged with pink and yellow, occasionally backlit. His skies are typically calmer, the wind but a breeze, and storm-cloud less threatening. Gentle lighting and calm

skies harmonise with the serene, at times pastoral mood that characterises many of his late woodlands, country roads, panoramas and tender winter landscapes. These effects are even found in his waterfalls, in which the contrast to the strong chiaroscuro and dynamic, rushing waters of his earlier pictures could hardly be greater. It is this new, peaceful calm that sets the dominant tone to the best paintings from the last dozen years of Ruisdael's life, and it is a mood that accords with the changing taste of the period.

Absence of dated works makes Ruisdael's activity in the last dozen years of his life difficult to follow. The signature and date of 1678 on the *Hilly Landscape* (Dublin, National Gallery of Ireland, No. 37) are almost certainly false. The 'scintillating brush strokes' of the *Pond Near a Forest* (Hannover, Landesgalerie, No. 341) in which Stechow saw, 'A kind of intimate Rococo', are merely remnants of the abraded picture surface. Its flimsy appearance is therefore not representative of Ruisdael's late style.[2]

Some indications of his activity are given by historical elements in his city-scapes: The Butter and Cheese Market, visible in the left foreground of his painting of *The Damrak, Amsterdam* (New York, Frick Collection, No. A.605; Fig. 167), was moved elsewhere in February 1669. Ruisdael had lived in the immediate neighbourhood since the mid-fifties and may well have commem-orated it soon after closure. The elegant, French-styled costumes of the women were fashionable in the late-sixties and the seventies.[3] In his bird's-eye view of *The Damrak, Amsterdam* (The Hague, Mauritshuis, No. 803) a procession of the Civic Guard carries an Orange ensign, thus postdating 1672, when Prince William of Orange was elevated to Stadthouder and Captain-General, the anti-Orange Amsterdam regents fell from power, and resistance to the French inva-sion centered on Amsterdam.[4]

Another bird's eye view of Amsterdam, his drawing in Leipzig showing *The View of Amsterdam from the Amstel* (Museum der bildenden Künste, No. J. 413; Giltay 65; Fig. 190) postdates 1675, the date of completion of the Portuguese Synagogue, visible as the prominent rectangular mass on the far right of his drawing. It may have been executed even later, after 1681, the year in which construction on the Reformed Church's Home for Old Women (Het Besjehuis), began, if one is to accept A.E. d'Ailly's identification of the long low mass of buildings seen between the large, arched Amstelbrug and the tall spires of the Zuiderkerk and the more distant Oudekerk beyond. In any event, the Home for Old Women, a large building with a façade of more than one hundred metres in length when completed in November 1683, distinctly appears in Ruisdael's painted version, based on this drawing, his *View of Amsterdam from the Amstel* (Cambridge, Fitzwilliam Museum, No. 74; Fig. 189). It must have been painted by Ruisdael in the very last year of his life, even before the building was finally completed, its architectural discrepancies testifying to the fact that Ruisdael completed it in his imagination.[5]

These works reflect Ruisdael's repeated attention in the last years of his life to his adopted city of Amsterdam, of which he had also made drawings for Blootelingh's print series around 1663. Ruisdael's subsequent city views may have been stimulated by the current vogue for such views, in which some artists even specialised. Among all his depictions of the city of Amsterdam, none is more original in conception, more detailed in execution and more striking in effect than his *Panorama of Amsterdam and its Harbour* (private collection, England; Fig. 165), which is based on a drawing now in the Rijksmuseum, Amsterdam (Rijksprentenkabinet, No. 1960:116; Giltay 3; Fig. 166).

165. *Panorama of Amsterdam and its Harbour*. Canvas, 41.5 × 40.7. Private Collection. Photo: Tim Stephens, London.

There has been much dispute about the date of this drawing, provoked by an old inscription, perhaps from the seventeenth century, on the verso. It states that it was drawn from the burned roof of the Nieuwekerk at Amsterdam, looking towards the IJ. Since the fire occurred in January 1645, it must then have been drawn by 1647, while the scaffolding was still in place. On the other hand others, and more recently Slive, have argued with good reason that the inscription is not necessarily to be trusted and that the drawing was more likely made about 1665 from the tower of the New Town Hall, completed in that year. This prospect would provide a similar view, from which Ruisdael, probably for pictorial reasons, has omitted the Nieuwekerk spire in the right foreground, concentrating rather on the overall prospect, into which the tower of the Oudekerk fits more harmoniously. Such a date is more consistent with Ruisdael's mature control of spatial effects and with the fluid execution and 'brilliant atmospheric effects' of the drawing, as Slive rightly points out.[6]

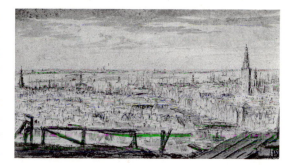

166. *Panorama of Amsterdam and its Harbour.* Drawing. Black chalk, grey pencil, grey wash, 86 × 152. Amsterdam, Rijksprentenkabinet, Rijksmuseum. Photo: Museum.

It is conceivable that the painting derived from it was executed shortly thereafter. However, it was not at all uncommon for paintings to be produced long after the drawings on which they were dependent. In this case the small size, upright format, contrasting warm brown and blue-grey tonalities, height of the sky, evening lighting and subtle blending of masterfully highlighted detail with other areas submerged in shadow, argue for a date around 1670. The striking effects of this panorama are due partly to Ruisdael's lighting effects, atmosphere, and pictorial qualities which ignore the bright, mid-day light and crisp, geometrically delineated topographical detail of other city painters. But it results even more from the breadth of Ruisdael's vision and the originality of his conception. Town prospects from the Middle Ages onwards typically show the city from the land, as the culminating point of interest, which Ruisdael here uniquely reverses. In so doing he characteristically reverses the historical emphasis in the relation of the works of man and nature. How did he conceive of this unique perspective? Since his move to Amsterdam in the 1650s Ruisdael had lived at various addresses close to the 'Hof van Holland' and the Dam, and from about 1670 onwards he lived on the south side of the Dam itself, above the shop of the book and art dealer Hieronymus Sweerts, who published an edition of Ruisdael's six views of Amsterdam, etched by Blootelingh.[7] Sweerts would have carried in his inventory examples of those sixteenth-century city views, such as Cornelis Anthonisz's, that are partly cartographic and partly pictorial, showing the city from an imaginary bird's eye view, from above, rather than in the more traditional profile format. It would be in keeping with Ruisdael's interests and keen sense of observation, so evident in the painting, inspired by such images, to take the opportunity provided by construction of the tower of the New Town Hall, to go up and take a closer look for himself. Whether or not such maps and city prospects influenced Ruisdael's viewing point, it was his instincts as a landscape painter and his keen, scrutinising eye that prompted him to search as far as the horizon, and to treat Amsterdam, its houses, churches, towers, harbour and shipping as a prelude to the great expanse of water, land and sky beyond, a perspective that is unprecedented in Western art, and was subsequently taken much further by the Romantics.

The area of the Dam, where Ruisdael was living, features in a number of his works executed during the last phase of his career. In one of the finest the view of *The Damrak, Amsterdam* (New York, Frick Collection; Fig. 167), women, by an unidentified hand, wander through the early morning market sporting fashionable French head-dresses, shawls, ribbons and frills.[8] While men were to indulge

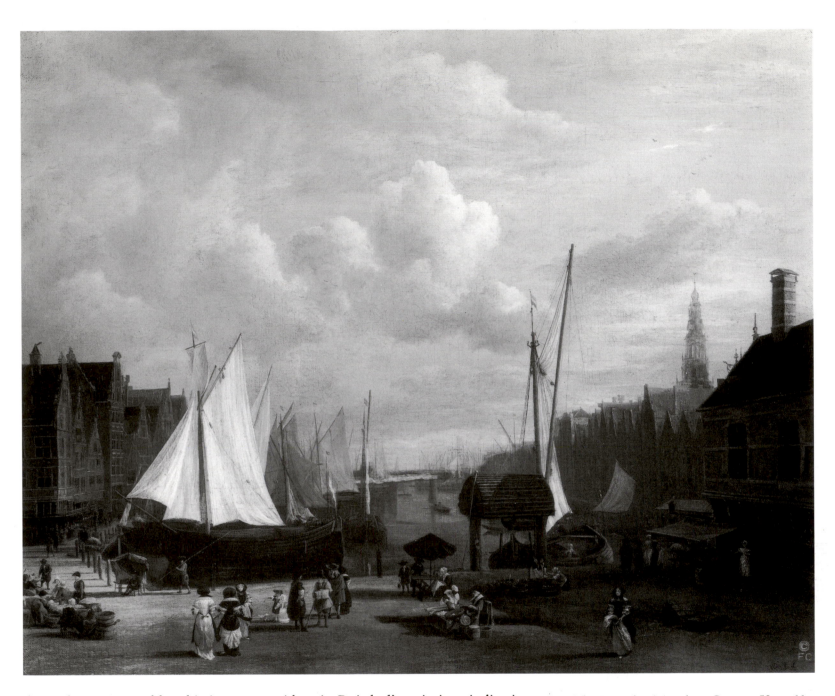

167. *The Damrak, Amsterdam*. Canvas, 52 × 66. New York, Frick Collection. Photo: Copyright The Frick Collection, New York.

themselves comparably, this is not so evident in Ruisdael's painting, indicating its execution in the early 1670s. As a sequel to his drawings of the city boundaries of 1663 and 1664, Ruisdael here represents the heart of the city. Nevertheless, shipping is as prominent as the buildings, the sky even more so. Beyond the spacious foreground, with its colourful figures, the composition focuses on the busy pattern of ships masts, light and tan sails, and gabled buildings, contrasted with the expansive, cloudy sky. The thin execution of the sky also points to a date in the 1670s. As a cityscape, Ruisdael's painting is distinct from those of Jan van der Heyden and Gerrit Berckheyde. In the latter's 1674 view of *The Dam, Amsterdam* (Amsterdam Town Hall, Mayor's Room, on loan from the Amsterdams Historisch Museum)[9] architectural detail is distinct; rigid, linear perspective clearly defines the space; and the scene is represented in bright, local colour under sharp, mid-day lighting. By contrast, Ruisdael's buildings are less

rigidly studied; atmospheric perspective is more significant; shadows are softer, and the palette of dull rose-brown, silvery-grey, and pale grey-blue is more subdued. Ruisdael's atmospheric conception of the cityscape is that of a landscape painter. His approach, like that of Renier Nooms, Allart van Everdingen and Meyndert Hobbema, is evocative rather than calculated.[10]

The elegantly dressed figures seen on the Dam Square in Ruisdael's painting in the Frick Collection recur in other late works. They stroll in his beach scenes, and disport themselves in the grounds of country houses. Three paintings of this subject survive and others of country estates are mentioned in old inventories. In the 1660s Ruisdael had provided the landscape setting for Thomas de Keyser's representation of the De Graeff family in a carriage and on horseback (Dublin, National Gallery, No. 287), including such a country house in the background.

Fashionable retreat to country houses is evident in other landscapes of the period, such as Philips Koninck's 1676 *River Landscape* (Amsterdam, Rijksmuseum, No. A.206), and in works of Allart van Everdingen and Jan Steen, likewise painted in the seventies.[11] That Ruisdael also turned his attention to such subjects appears out of character, perhaps they were done under the pressure of taste and inadequate sales during the post-1672 market depression. Among these paintings by Ruisdael, in an upright example in Berlin (Staatliche Museen, No. 885A) the figures verge on the absurd and the painting lacks any real conviction. The larger, oblong and more elaborate *Country House in a Park* in Washington (National Gallery of Art, No. 1551; Fig. 168) is much finer. Under a cloudy sky, elements of formal gardens – two fountains, plants in tubs and an arbor – are incongruously scattered in a dark woodland glade dominated by Norway spruces, with a fine country mansion closing the view beyond. One group of elegant figures admires a fountain on the left. Others, on the right, flee from jets of water spraying them

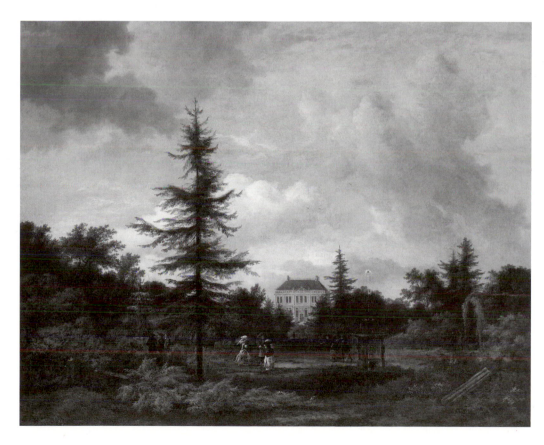

168. *Country House in a Park.* Canvas, 76.3 × 97.5. Washington, National Gallery of Art, Gift of Rupert L. Joseph. Photo: courtesy of the National Gallery of Art.

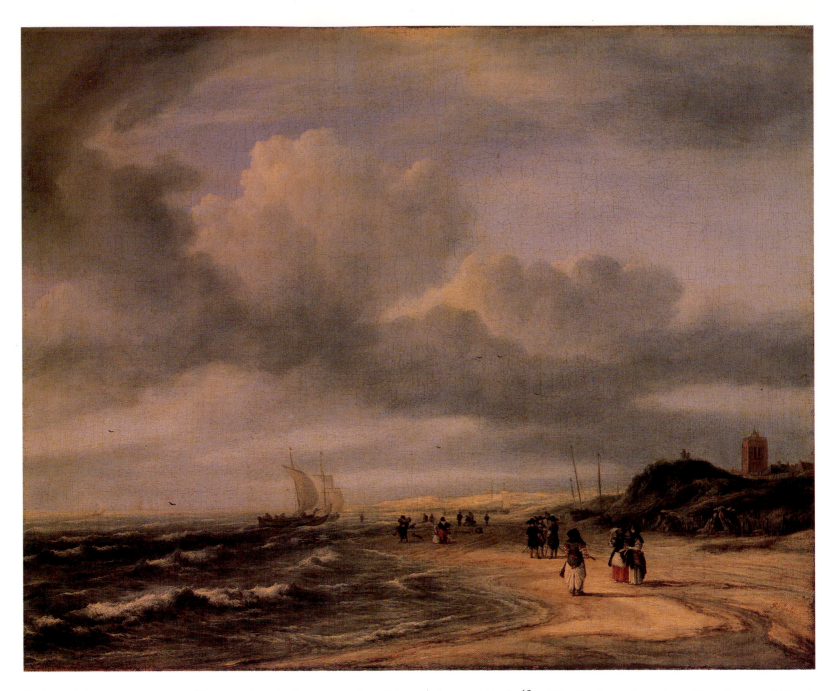

169. *Beach at Egmond-aan-Zee*. Canvas, 53.7 × 66.2. London, National Gallery. Photo: Reproduced courtesy of the Trustees, The National Gallery, London.

from hidden spouts, providing a rather lighter note than his usual woodlands.[12] While the production of such a picture may have been a response to contemporary taste and country pursuits, its rendering of a Dutch park is completely at odds with the prevailing practice of laying out formal, geometric gardens in the French manner, and can in no sense be topographical. The painting has curious incongruities, including the use of a foreign species of tree, the Norway spruce, one of which has fallen across the architectural fragments on the opposite side of the foreground. Such architectural fragments, like the dislodged tombstones in his *Jewish Cemetery* and the fallen spruces in the *Waterfalls*, may be intended as a comment on the vanity of such country pursuits. Dutch genre paintings frequently comment on pleasure simultaneously indulged and admonished. Whether or not this was Ruisdael's intention, these works depart from his previous interests.

The elegantly dressed figures seen in some of these pictures of the 1670s fit more naturally into a number of beachscenes Ruisdael painted around this time. In the *Beach at Egmond aan Zee* (London, National Gallery, No. 1390; Fig. 169), a canvas of similar dimensions to the Frick painting of *The Damrak, Amsterdam*, women, dressed in comparable attire, stroll along the beach. A group of three men, with long hair, lace ruffs, and broad-brimmed hats, display the latest fashions. Ruisdael was not attracted by the idealised realism of Adriaen van de Velde's brightly coloured beach scenes. Nevertheless, comparing the London painting to earlier Dutch beachscenes, few fishermen are about and the mood is recreational: a dog leaps in the air as a young man sweeps a girl off her feet.[13] Ruisdael's new conception of a beach scene, and its composition, is a far cry from his 1647 *Oaks by the Zuider Zee* (Fig. 45), but its composition is however comparable to Simon de Vlieger's *Scheveningen* (Cologne, Wallraf-Richartz Museum, No. 2563), and to Willem van de Velde's *Beach at Scheveningen* (London, National Gallery, No. 873; Fig. 170).[14] Van de Velde accents the shipping, Ruisdael the space and filtered light of a moisture-laden sky. The colourful figures, the pale rose-brown church tower, and creamy sands offset predominantly grey tones, as in his *Mill at Wijk* (Fig. 156). A difference – characteristic of his late paintings – is that the scene is distanced from the spectator, less overbearing, and imbued with a fine, gentle atmosphere.

Grey tones also predominate in Ruisdael's *Shipping on the IJ* (Worcester, Mass., No. 1940.52; Fig. 171) in which the long roof of the East India Company's Amsterdam warehouse is visible on the skyline. Compared to the larger Boston *Rough Sea* (Fig. 160), the colour is subdued and the contrasts less forceful, a tendency paralleled in the London *Beach at Egmond aan Zee*. Severe paint loss accounts for the poor appearance of the sky. The grey tonality of this and other

170. Willem van de Velde, The Younger: *Beach at Scheveningen*. Canvas, 42.6 × 56.5. London, National Gallery. Photo: Reproduced courtesy of the Trustees, The National Gallery, London.

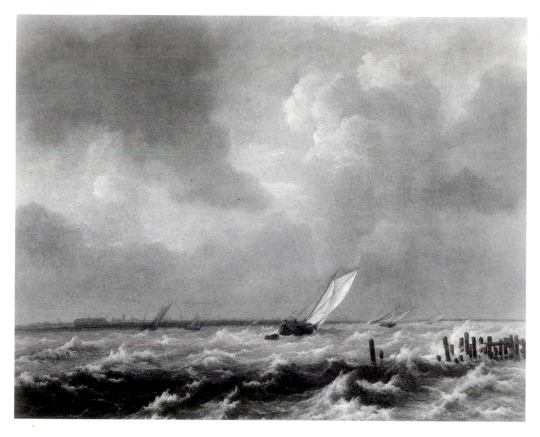

171. *Shipping on the IJ*. Canvas, 65.8 × 82.7. Worcester, Massachusetts, Worcester Art Museum. Photo: Museum.

Ruisdael's Works in a Declining Art Market: 1670–1682 169

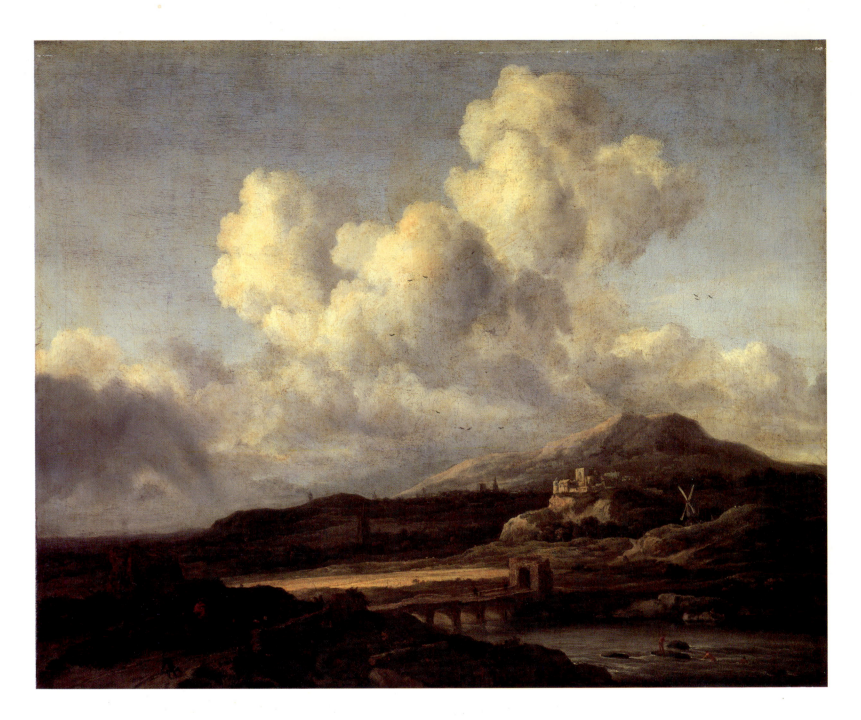

seascapes and beach scenes by Ruisdael is characteristic of some of his late works, such as his *Winter Landscape with a Windmill* (Paris, Fondation Custodia, collection F. Lugt).[15] The scale and treatment of the ships in his *Shipping on the IJ*, as well as the white horses blown up on the crests of the choppy water, splashing on a breakwater and darkened by a long, foreground shadow, reflect Ruisdael's on-going indebtedness to the earlier achievement of Porcellis and de Vlieger. The more forceful sky and lighting, though, was his own enrichment of the motif.

In painting hilly landscapes, woodlands and waterfalls Ruisdael was on his own territory and less dependent on the inventions of others. However in one incident, in a painting that is virtually without precedent in his own oeuvre, Ruisdael pays homage to quite a different landscape school, that of Rembrandt and his circle. Their typical conception of fantasy landscapes is emulated in Ruisdael's famous

172. *Le Coup de Soleil.* Canvas, 83 × 99. Paris, Musée du Louvre. Photo: Musées Nationaux, Paris.

painting in Paris, long known as *Le Coup de Soleil* (Louvre, No. 1820; Fig. 172), a picture bought in 1784 for Louis XVI of France. It is difficult to date this painting, because it is so unlike others he produced. However, its expansive space, unfolding so fluently, and its high sky with softly-textured, billowing cloud, would suggest a date in the 1670s, or a little before. The picture shows figures crossing a wide river on a road which leads towards a windmill. Beyond there is a brightly illuminated, impregnable hilltop castle and a city just visible in the remote distance at the foot of mountains. The composition has broad similarities to Rembrandt's *River Landscape with Ruins* in Kassel. These similarities, however, are more in the combination of motifs than the pictorial treatment, which Ruisdael adapts to his own manner. The combination of motifs is also found in other landscapes by Rembrandt, such as his *Landscape with a Thunderstorm* in Brunswick (No. 236), and has been interpreted recently by J. Bruyn as an image of man's earthly sojourn, the traveller heading for a remote city: his destination, Mount Zion, the New Jerusalem, depicted as a remote city or castle set on a hill.[16] Such an interpretation, given the imaginary quality of these landscapes, is quite plausible and could have attracted Ruisdael, given the similar sentiment that inspired some of his *Waterfalls*, such as the one in Brunswick (Fig. 148). This type of landscape and its generalised treatment in Ruisdael's *Coup de Soleil* appears as a byway in his art, different in conception, tone and handling to his other pictures of rivers and hills, the detail of vegetation being uncharacteristically supressed.

Ruisdael's treatment of rivers and hills in the 1670s is seen in more representative manner in another group of works which are very closely related to each other in subject, treatment, mood and execution. They feature hills, woodlands and waterfalls. In all of them the trees are scaled down by comparison to his

173. *Hilly Woodland with River*. Canvas, 67 × 83. Vienna, Gemäldegalerie der Akademie der bildenden Künste. Photo: Museum.

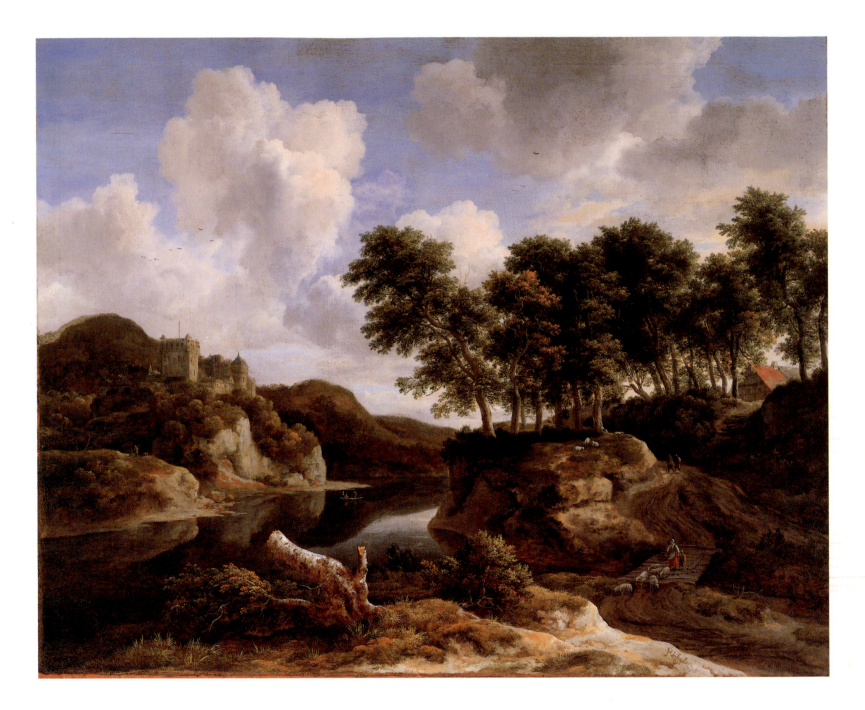

earlier woodlands, they are also set back deeper into space, the lighting evokes the calm of late afternoon or early evening, and tranquillity prevails.

The subject of his *Hilly Woodland with River* (Vienna, Akademie der bildenden Künste, No. 889; Fig. 173) recalls his massive, wooded river landscapes first painted in the 1650s,[17] as well as works of the 1660s such as the *Hilly Landscape with River* copied by Buijs and Jan van Kessel (Figs. 142 and 143 respectively), and the Dresden *Woodland Swamp with Deer Hunt* (Fig. 146). But the space is opened up, and the trees, rising from hilltops and catching the evening light, are drastically scaled down. The sluggish water has lost the force to shift a log that has sunk into it. Static calm prevails, only a duck stirs the surface of the water, and a man, woman and child make their way through a scene that bears little trace of the flight of time, or the decay of earthly things.

174. *Hilly River Landscape with Castle*. Canvas, 102.2 × 126. Cincinnati, Cincinnati Art Museum (Gift of Mary Hanna, 1946). Photo: Museum.

A similar transposition of motif and mood is seen in his *Hilly River Landscape with Castle*, (Cincinnati, Art Museum, No. 1946.98; Fig. 174) a picture with fine colouring and light, which is related to but radically modifies the elements and composition of his *Three Great Trees* in Pasadena (Fig. 147). The mighty trees which command the foreground of the Pasadena painting are replaced by others less robust, which are set back on a hilltop in the middle ground, with sky seen between their sinuous trunks. While in the Pasadena picture the trees dominated the composition at the expense of all else, here the pictorial effects and the lighting are more diffuse. The castle on the far bank, whose tower bears some resemblance to that of Bentheim, adds a further note of interest. In changing the scale and lighting of his motifs, Ruisdael achieves an image of absolute tranquillity, reinforced by the still water, soft evening light and figures driving sheep down the roadway.

A similar calm, peaceful atmosphere pervades two smaller woodland landscapes of almost identical dimensions, his *Wooded Hills at Evening* (Cleveland, No. 63.575; Fig. 175) and the *Ford in the Woods* (Krannert Art Museum, No. 53–1–2; Fig. 176). In the Cleveland painting, small scale trees on a rise of ground in the mid-distance are illuminated by the gentle glow of an expansive, evening sky. Light filters between their trunks to illuminate the passing figures and tufts of grass on the left bank, leaving much of the deep foreground in shadow. There is no towering dead tree, as in works of the late 1660s, just a fallen trunk and golden, autumn foliage on one of the trees. Expansive skies and filtered light, developed in his panoramas and country roads, now add serenity to his woodlands. As in the New York large *Wheatfields* (Fig. 153), a man approaches a woman and child coming from reverse directions. Figures passing through evening landscapes were already characteristic of works of the forties, such as his 1648 Wetzlar *Road Through the Dunes* (Fig. 52). Ruisdael's subsequent development of cloudy, wind-swept skies enabled him to contrast the tranquillity of evening to days of wind and storm. The Cleveland painting, considered by Stechow a work of the early to mid-sixties, despite recognition of its intimate

175. *Wooded Hills at Evening*. Canvas, 51.5 × 59.3. The Cleveland Museum of Art, Purchase, Leonard C. Hanna, Jre., Bequest, 63.575. Photo: Museum.

176. *Ford in the Woods*. Canvas, 52.5 × 60. Krannert Art Museum, University of Illinois. Photo: Museum.

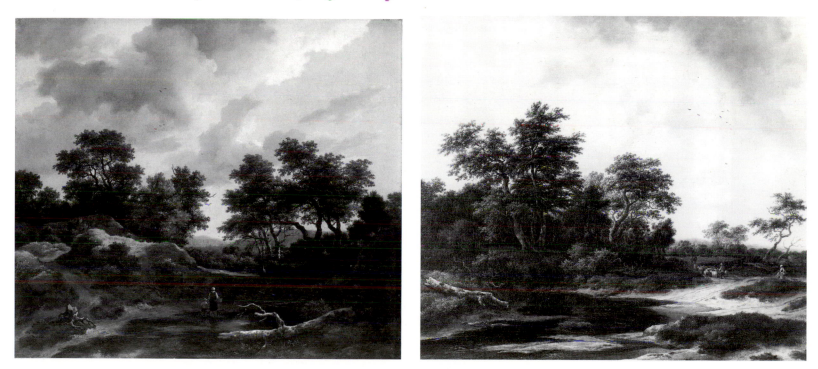

mood and small-scale trees, was probably executed in the first half of the seventies.[18]

The second of these two paintings, the Krannert *Ford in the Woods* (Fig. 176) is similar in conception, mood and in the tight, precise brushwork on the grasses and trees. In both paintings a fallen trunk lies on a bank beside a flooded country road; the trees are similarly scaled, set back in space under skies higher than in his earlier woodlands; a woman with a basket on her arm, accompanied by a child and dog, is present in both paintings. Just as the Cincinnati *Hilly River Landscape* modifies and reinterprets the motifs of his earlier *Three Great Trees*, so here in the *Ford in the Woods* Ruisdael returns to the motifs and composition of his earlier *Edge of a Forest* in Oxford (Fig. 138). He reinterprets its grandiose effects on a small, intimate scale and more pastoral mood.[19] In like manner the Cleveland *Wooded Hills at Evening* can be seen as a modified version of motifs first seen in his much earlier *Hilly Wooded Landscape with Cattle* in the Duke of Buccleuch's collection (Fig. 67), the massive, sharp-edged rocks, scraggy trees and dark stormy skies, so characteristic of his landscapes of the 1650s, now being replaced by gentle undulating hills, more delicate trees and a soothing evening light.

The tranquillity of these hilly landscapes and woodlands was also allowed to permeate his *Waterfalls*, transforming their mood and effect. This is particularly noticeable in his *Wooded Hills with Waterfall* (Florence, Uffizi Gallery, No. 8436, now hung in the Pitti Palace; Fig. 177) in which the mood, terrain, tree types and lighting are very closely related to his Cleveland *Wooded Hills at Evening* and Krannert *Ford in the Woods*. Its composition, and combination of elements, is similar to the earlier Amsterdam *Woodland Waterfall* (Fig. 149), but with the larger trees shifted to the left, and reduced in scale. As in so many works from the 1670s, trees are now seen against a peaceful evening sky evoking a sense of rest at the end

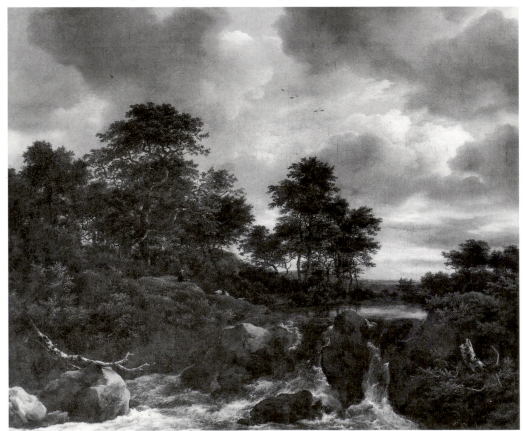

177. *Wooded Hills with Waterfall*. Canvas, 52.3 × 61.7. Florence, Uffizi Gallery (hung in the Pitti Palace). Photo: Soprintendenza alle Gallerie.

178. *Waterfall at Sunset*. Canvas, 69 × 53. Berlin-Dahlem, Staatliche Museen, Gemäldegalerie. Photo: BPK (Jörg P. Anders).

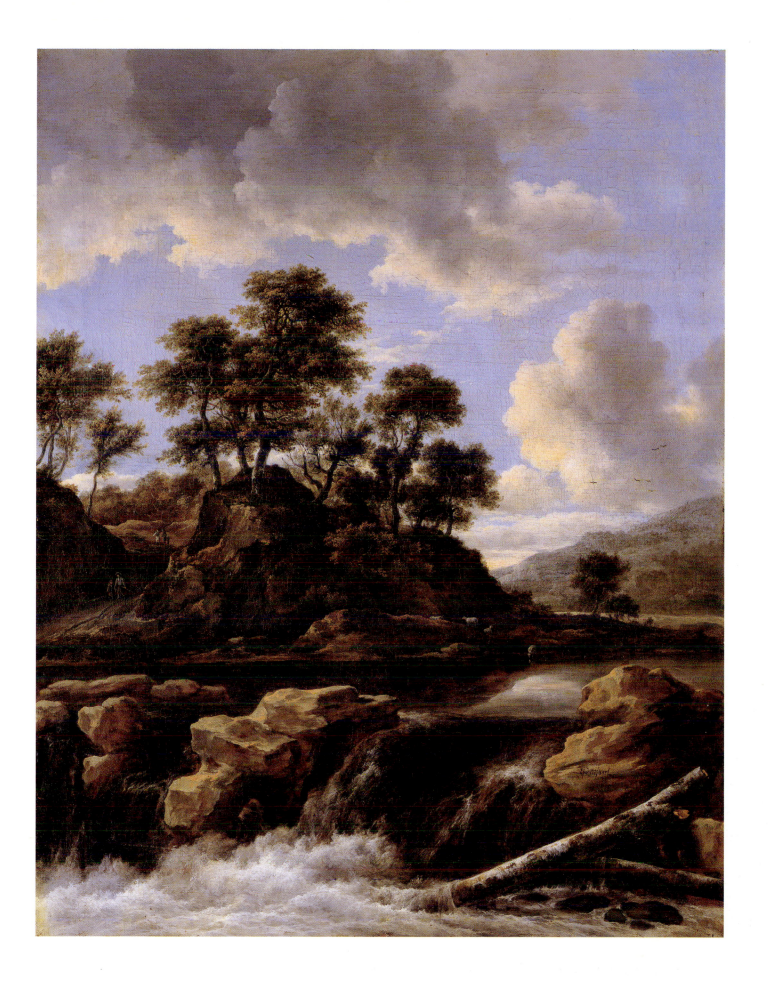

of the day, indicated by the small seated figure of the shepherd. By the same token the water trickles rather than gushes over the falls, barely disturbing the peace, and arousing associations quite remote from the thunderous din of the water in his earlier Brunswick *Waterfall* (Fig. 148) or the Amsterdam *Woodland Waterfall* mentioned above. Now it is the life of the evening sky, not the water, that catches the eye and sets the tone of the painting. In another upright *Waterfall*, one of the finest of his late works, the *Waterfall at Sunset* (Berlin-Dahlem, No. 899A; Fig. 178), radiant evening light dominates rather than rushing water. It penetrates between the trees and colours the undersides of dark grey clouds with warm, creamy-brown hues. Compared to the earlier waterfalls the ratio of sky to land is substantially increased; objects are reduced in scale and set back in space. The graceful trunks and sparse foliage of the trees, which rise from the crest of a hillock, are silhouetted against the warm blue of the evening sky. The rocks are tightly executed in crisp definition, but lack vitality, like those in his *Hilly Woodland with River* in Vienna (Fig. 173). Reflections off the tranquil pool of water draw the eye from the lifeless waterfall to the glowing light of the sky. The waterfall, once a dynamic symbol of motion and change, is here included in a calm, pastoral landscape.[20]

The tranquillity of these late woodlands, river landscapes and waterfalls is also manifest in his country roads, panoramas and winters painted in the 1670s. The mood is so all pervasive in his late works that one wonders whether it was a reflection of the interior well-being of the mature artist or rather a form of escape for his clients from the economic stresses of the period. Whatever the cause, it resulted in a series of works that are soothing to behold, ideal for stressed city-dwellers, whether in winter or summer.

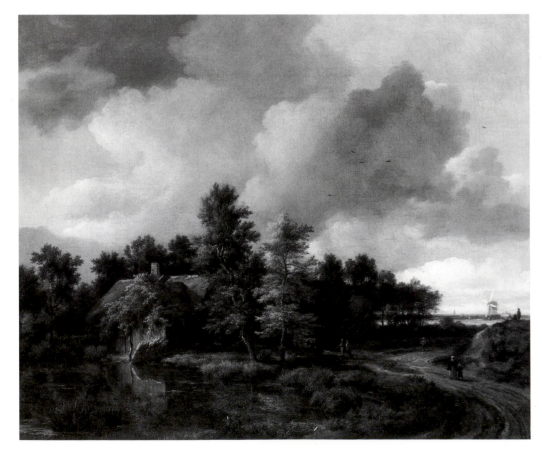

179. *Country Road with Cottage under Trees.* Canvas, 38 × 44.5. Private Collection, U.S.A. Photo: A.C. Cooper (courtesy of Edward Speelman Ltd., London).

In this last phase of his life, Ruisdael's country roads profit from the high skies of his panoramas, and, as in other late works, elements of the landscape are scaled down and set beyond extensive foregrounds. While some of these paintings are thin and dull in execution, the *Country Road with Cottage under Trees* (private collection, U.S.A.; Fig. 179) is finished with richly textured detailing, and its innovatory composition combines elements from his woodlands, country roads and panoramas. The foreground and background are linked by the dune-top figures gazing into the distance. A distant mill, bathed in sunlight is contrasted to a wooded near-by scene, which includes a cottage among trees, reminiscent of Hobbema's paintings. As in the Cleveland *Wooded Hills at Evening* (Fig. 175), golden foliage adorns one of the tall trees before the cottage.

In two further paintings of country roads, of almost identical dimensions, figures drive cattle and sheep towards the spectator, their small scale creating a sense of distance. In one of them, the *Country Road with Cornfields* (formerly Thos. Agnew & Sons Ltd., London; Fig. 180) the central roadway recalls the New York large *Wheatfields* (Fig. 153), but the painting is more intimate in scale and conception. The brushwork is more timid, and some of the outlines are dull and lifeless. This peaceful and unpretentious scene appealed to Constable, who sketched its composition when it was exhibited at the British Institution in 1819.[21] The second of these country roads, the *Cornfields by the Zuider Zee* (Lugano, Thyssen Collection, No. 270; Fig. 181) again revises the motifs of his *Cornfields* from the 1660s in more intimate terms and without any prominent motifs before the softly rolling forms of hills and cornfields. The eye is thus led without interruption down the central winding road towards a village where a church and a mill, prominent on the horizen, close off the scene. While the execution is rather dry and summary, sunlight on the distant cornfields and a shower of rain falling from a blustery sky animate the picture, recalling similar effects in earlier works, but altogether more peaceful in mood.

The noticeable distancing of even the foreground elements in these *Country Roads* is also seen in two very small and finely executed panoramas, in square format, now in the collection of the Earl of Wemyss (Figs. 182 and 183), which were probably originally intended as a pair. Both have been called *Views of*

180. *Country Road with Cornfields.* Canvas, 45.7 × 54.6. Formerly Thos. Agnew & Sons Ltd., London. Photo: Sydney W. Newbery (courtesy of Agnews).

181. *Cornfields by the Zuider Zee.* Canvas, 45 × 55.6. Lugano, Switzerland, Thyssen-Bornemisza Collection. Photo: Brunel (courtesy of Thyssen).

182. *View of Haarlem with Bleaching Fields.* Canvas,
41.9 × 41.9. Earl of Wemyss and March, Gosford
House. Photo: AIC Photographic Services, Edin-
burgh.

183. *Distant View of Alkmaar*. Canvas, 41.9 × 41.9.
Earl of Wemyss and March, Gosford House. Photo:
AIC Photographic Services, Edinburgh.

Haarlem and in one of them (Fig. 182) the church of St Bavo and other features of the Haarlem skyline are painted with exquisite attention, especially to the architectural detail of St Bavo's. However, in the other painting (Fig. 183) the familiar landmarks of Haarlem are absent. The squat form of the church and the smaller spire, too low for St Bavo's do resemble ones seen in a number of his other panoramas, such as the one in Boston (Museum of Fine Arts, No. 39.794). This is also datable to the 1670s and has recently been identified as representing the Grote Kerk in Alkmaar, a nearby town in which Ruisdael had also made drawings.[22] The Wemyss picture lacks the foreground motif of the ruins of Egmond Castle and the little village of Egmond op den Hoef, seen in his other *Views of Alkmaar*. However, this is not surprising since the Grote Kerk of Alkmaar is depicted from a different, more northerly angle, more to the left. The village church in the mid-ground, seen beyond a pool of water and cornfields, remains unidentified. It recalls, in its pictorial effect, but not necessarily topography, the village church, cornfields and foreground pool of water seen in the *Extensive Panorama* in London (Fig. 158). A feature of this beautiful little pair of panoramas is their lighting, with the light source high in a wind-swept sky in the *View of Alkmaar* (Fig. 183) and with evening light emerging lower in the sky from passing storm-clouds in the *View of Haarlem* (Fig. 182).[23] As a pair they also contrast viewpoints found in his panoramas: a lower, closer one, with larger-scaled foreground cottages; and a higher, more remote bird's eye view, as in the Zürich *View of Haarlem* (Fig. 159). The Wemyss pair also contrast the two types of rural prosperity most commonly celebrated in his panoramas, in one the bleaching of linen, in the other the harvesting of corn, with stooks of corn standing in the fields. Thus the two paintings, while both quite small, are richly complementary, also demonstrating Ruisdael's capacity for variation within a chosen format.

The greater spatial recession, smaller scaled foreground elements, high skies, evening lighting and calm mood seen in many of his late works are also evident in some of Ruisdael's winter landscapes. A group of them, perhaps painted earlier in the 1670s, features windmills as the principal motif, as in Ruisdael's *Village with Windmills in Winter* (Philadelphia, John G. Johnson Collection, No. 569; Fig. 184), now regrettably in poor condition. Its former qualities are now more evident in the replica painted by Constable when the original was in the collection of Sir Robert Peel and which is known for its fidelity to the original (see Chapter X).[24] Ruisdael's painting in Philadelphia, having more prominent foreground elements, is perhaps one of the earliest of the group. In it he represents winter with the same calm serenity found in the *Mill at Wijk* (Fig. 156). The composition, in mirror image, has comparable elements: brightly coloured women move along a road which leads obliquely into the landscape, with mills beyond, and a pattern of stakes in the foreground. Compared to the *Mill at Wijk*, and to his earlier winters, the buildings are set back and the ratio of sky to land is increased, so creating a less monumental effect.[25]

Similar effects are seen in the *Town in Winter* (Rotterdam, Museum Boymans-van Beuningen, No. 1745; Fig. 185) in which the execution is thin and lifeless. This is compensated for by Ruisdael's sense of design and handling of light. The space is more extensive than in the Lugano *Snowballing on a frozen Canal* (Fig. 162), and in the distance the sun is setting behind the streaky cloud of a late afternoon sky, with layers of light and shadow which reinforce the effect of spatial recession. The gradual lightening of tone towards the distance effectively evokes the soft, subdued atmosphere of a winter afternoon.

184. *Village with Windmills in Winter*. Canvas, 55.3 × 66. Philadelphia Museum of Art, John G. Johnson Collection. Photo: Museum.

185. *Town in Winter*. Canvas, 61 × 86.5. Rotterdam, Museum Boymans-van Beuningen. Photo: Frequin.

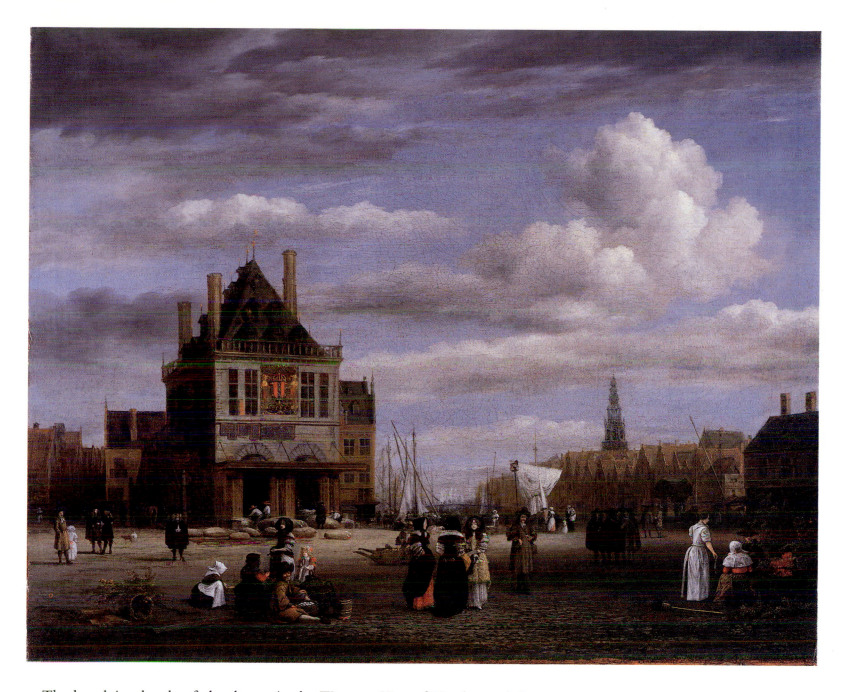

The low-lying bands of cloud seen in the Wemyss *View of Haarlem* and the Rotterdam *Town in Winter* are found also in *The Dam with the Weigh House at Amsterdam* (Berlin-Dahlem, Staatliche Museen, No. 885D; Fig. 186), this time illuminated by early morning light from the southeast. Its rather thin and stiff execution suggests a very late date and, as has been pointed out by Slive, preparatory drawings for the painting comprise two sheets of paper, (Figs. 187 and 188) now in Brussels. These were perhaps once joined, as is the drawing (Fig. 190) for the *View of Amsterdam from the Amstel* in the Fitzwilliam Museum, Cambridge (Fig. 189), mentioned above as a work of 'perhaps the very last year of his life'.[26] The drawing of the *Weigh House on the Dam* was made in late afternoon light from the west. In the painting Ruisdael has altered this to conform to the long shadows and side lighting of the early morning market. It is striking that Ruisdael has chosen a lower view point in *The Dam* than in the Frick Collection

186. *The Dam with the Weigh House at Amsterdam.* Canvas, 52 × 65. Berlin, Staatliche Museen, Gemäldegalerie. Photo: BPK (Jörg P. Anders).

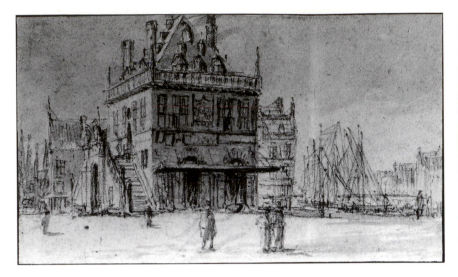
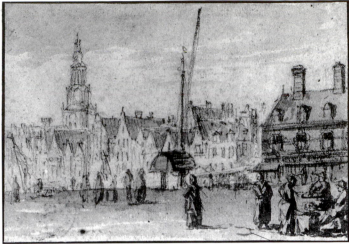

picture (Fig. 167), which may be earlier. This both magnifies the dominant position of the Weigh House, and gives a greater sense of the sky not merely as a backdrop but as a canopy over the entire scene, under which even the viewer can feel included. This is also true of some other late paintings, such as his little *Winter Landscape* in Frankfurt (Fig. 191). In this respect, for all its shortcomings, this paintings testifies to Ruisdael's endless efforts to share with his viewers some of his own sense of the majesty of the sky above us.

Ruisdael's interest in Amsterdam as a pictorial motif in his last years culminates in his panoramic *View of Amsterdam from the Amstel* (Cambridge, Fitzwilliam Museum, No. 74; Fig. 189), probably painted in the last year of his life. The view is far more comprehensive than his earlier *View of the Binnenamstel* (Budapest; Fig. 137), and it shows the Amstelbrug and city wall completed. The painting is also more strictly topographical than his *Haarlempjes* had been. His draughtsmanship has weakened however, and his outlines are less firm. The heavy, laboured effect of the clouds is due to condition rather than to loss of faculty, but the overall execution is less fluid than in his earlier works. The painting is based on a drawing of the city profile preserved in Leipzig (No. J.413; Fig. 190), but the view is extended to include the Weesperpoort and other buildings on the right bank. The foreground and sky are also extended, enhancing the bird's eye view effect.[27]

While Ruisdael showed repeated interest in Amsterdam as a pictorial motif in his last years, he did not forget his native town of Haarlem either. In his remarkable little *Winter Landscape with Lamp Post and distant View of Haarlem* (Frankfurt, Städelsches Kunstinstitut, No. 1109; Fig. 191), which is rather thinly painted, Ruisdael compresses some of the qualities seen in his other late winters – depth of space, high skies, and diffuse lighting – into a small canvas, whose pictorial intensity belies its size. The filtered rays of the setting sun break through a dark grey, evening sky, which is warmed by patches of blue and yellow-ochre and contrasts with patches of brilliant white, sunlit snow in the fields below. Tall, delicate trees, set in the immediate foreground are silhouetted against the high sky, providing a scale for the expansive space beyond. An intriguing feature is the prominent lamp post in the foreground, never before seen in a Dutch landscape painting. With it Ruisdael seems to have paid a tribute to a fellow painter, Jan van der Heyden, who, as a result of improvements to street lamps, was appointed Director of Street Lighting for the city of Amsterdam in 1670.[28] At the same time, its unexpected insertion in this tender winter landscape also perhaps

187. *The Dam with the Weigh House at Amsterdam.* Drawing. Black chalk, grey pencil, grey wash, 90 × 151. Brussels, Koninklijke Musea voor Schone Kunsten, collection de Grez. Photo: Museum.

188. *The Dam and the Oude Kerk at Amsterdam.* Drawing. Black chalk, grey pencil, grey wash, 87 × 123. Brussels, Koninklijke Musea voor Schone Kunsten, collection de Grez. Photo: Museum.

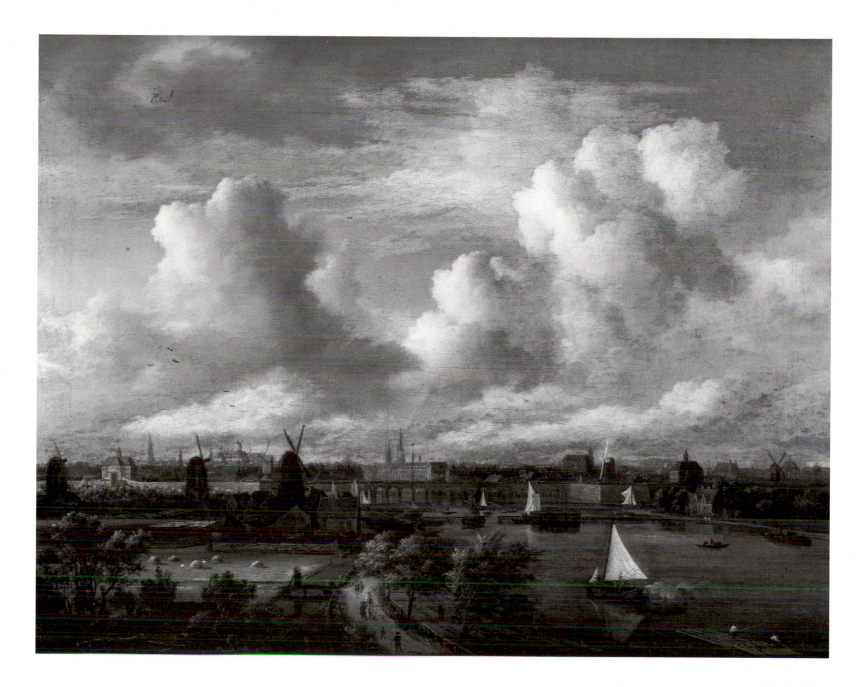

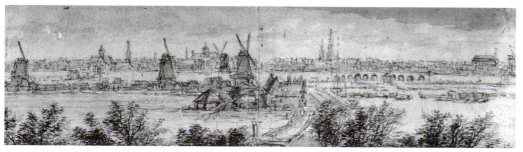

189. *View of Amsterdam from the Amstel*. Canvas, 52.1 × 66.1. Cambridge, Fitzwilliam Museum. Photo: Museum.

190. *View of Amsterdam from the Amstel*. Drawing, black chalk, grey wash, Indian ink, 83 × 306. Leipzig, Museum der bildenden Künste. Photo: Museum.

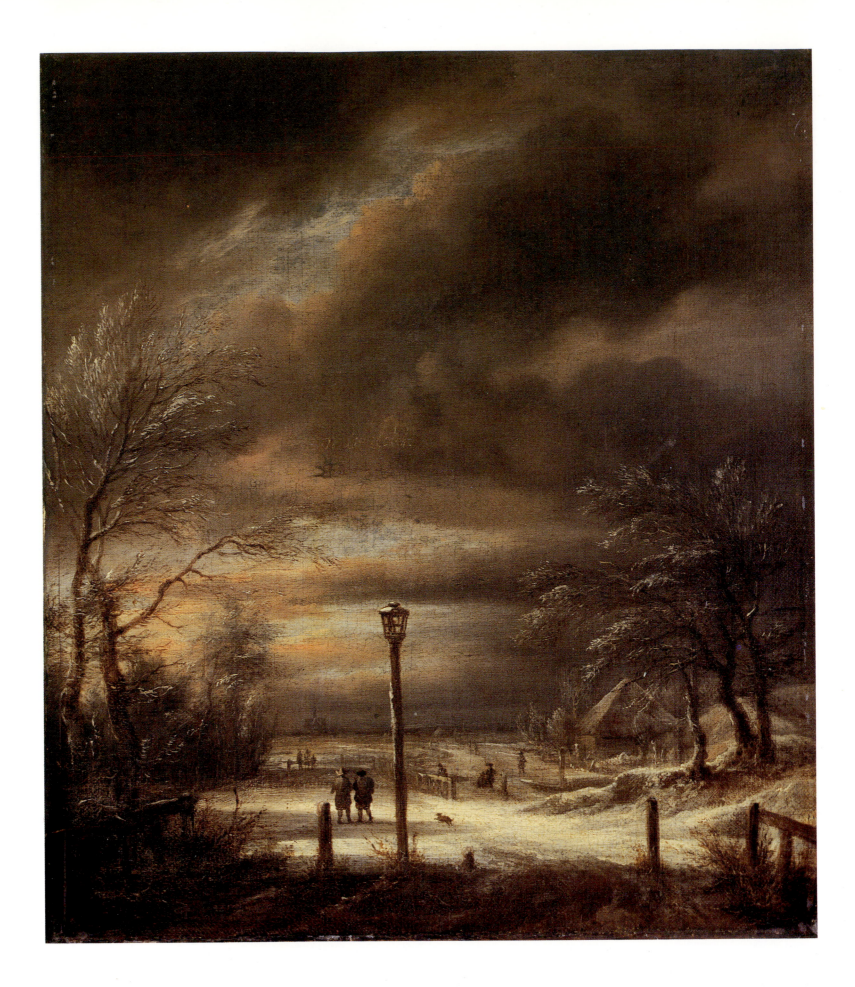

serves as a modern symbol of the lamp that illuminates the path of travellers. Here they make their way into a polder landscape that extends to the far horizon, where, the form of St Bavo's church, Haarlem faintly marks their destination. It was also there that Ruisdael was laid to rest at the end of his journey, on 14 March 1682, leaving us some of the most poetic landscapes ever created to illuminate our way.

191. *Winter Landscape with Lamp-post*. Canvas, 37 × 32. Frankfurt/M, Städelsches Kunstinstitut. Photo: Museum (Ursula Edelmann).

Tempus omnia terminat.

Ruisdael's Critics

No contemporary comment on Ruisdael has come down to us other than a reference to him in 1707 by Gerard de Lairesse, twelve years his junior, as an 'admired' painter of modern, as opposed to antique, landscapes. Jan Luyken, twenty years Ruisdael's junior, alluded to him in coining the word 'Ruis-dal' when writing of waterfalls in his *Beschouwing der Wereld*.[1]

Already in the last decade of Ruisdael's life, the growing influence of French taste and academic theory diminished appreciation of his type of landscapes. In late seventeenth-century France, the only Dutch landscapists mentioned by Félibien are Breenberg, Poelenburgh, Swanevelt, Asselijn and Pynacker; all painters of idealised, Italianate landscape. Félibien was prepared to recognise the virtues of these painters, but others were dismissed for lack of 'qualities one would desire to imitate'.[2] Painters of the so-called 'national' school of Dutch landscape, who depicted the polders, woods and dunes of their own environment, were rated no better by De Piles. Like Félibien, he wrote that 'if the prospects are not well chosen, . . . and the scene animated by the Figures, by Animals, or other Objects, . . . the Picture will never be esteem'd, nor be admitted into the Cabinets of the true Criticks'.[3]

Despite the influence of French art theory, a less exclusive view is found in Holland itself. In 1707 Gerard de Lairesse distinguished 'antique' and 'modern' landscapes. He accepted that the modern landscape, as practiced by 'the admired painters, Everdingden, Pynacker, Ruysdael, Moucheron and others who followed this trend', should include figures and features of the countryside, such as farm huts, fishermen and wagons as are fitting to it.[4] In 1721 Houbraken considered Ruisdael 'one of the finest masters of the time', describing him as a painter of 'both local and foreign landscapes', and praising his imitation of the foam and spray of waterfalls, and of the crashing surf of the sea. Houbraken concluded his notice on Ruisdael with the remark that he did not have 'luck as his friend' and remained unmarried to the end of his life.[5]

Esteem for Ruisdael's *Waterfalls* in the first half of the eighteenth century was also shown by German collectors: Augustus the Strong acquired a pair for his Dresden Gallery before 1722. His son Augustus III had acquired a further nine Ruisdaels by 1754, including two more *Waterfalls*. In 1738 the Duke of Brunswick acquired three Ruisdaels, two of them *Waterfalls*; and in 1750 a Ruisdael *Waterfall* was added to the gallery of Landgrave Wilhelm VIII in Kassel. Outside Holland there was otherwise little interest in Ruisdael before about 1740 and within Holland his paintings changed hands at very low prices.

The next decade saw a change, especially in England. Until then the number of Ruisdaels that had passed into English collections was negligible. Among landscapists, late Mannerists, such as Jan Brueghel and Gillis van Coninxloo, the Dutch Italianates, and above all Gaspard Poussin, Claude Lorrain and Salvator Rosa were preferred.[6] But in the 1740s a taste for Ruisdael, Wijnants and Hobbema developed, and their works began to enter the country. According to Hayes, between 1748 and 1750 more than one hundred Ruisdaels, thirty Wijnants and

ten Hobbemas were auctioned in London. This trend has been attributed by Hayes partly to the taste of middle-class collectors, people who patronised Hogarth and Hayman, and partly to a movement towards naturalism that is also to be seen in music, theatre, and literature. In all these arts there was a growing tendency to take subjects from everyday life.[7]

On account of their truth to nature, Ruisdael's works became an example for imitation. The minor English amateur painter, Ebenezer Tull (1733–62), owned four Ruisdaels among other Dutch landscapes. He derived his own compositions from Ruisdael, Hobbema and Van Goyen, and was described in the sale catalogue of his works as 'The *British* RUYSDALE'.[8] The more-gifted, young Gainsborough also found inspiration in the national Dutch school, particularly in Ruisdael and Wijnants. Their influence is apparent in his early work, and by the end of his life both artists were represented in his picture collection.[9] In the late 1740s Gainsborough made a drawing (Manchester University, Whitworth Art Gallery) after Ruisdael's *Woodland Ford with Figures and Cattle* (Paris; Fig. 145). This drawing formed the basis for Gainsborough's *Landscape in Drinkstone Park* (Sâo Paulo, Museu de Arte), and was probably also the inspiration for his *Cornard Wood* (London, National Gallery). This is apparent from the detailed handling of the trees and grasses, in the lighting effect, and in the painting's general conception. Ruisdael's inspiration is also evident in other early Gainsboroughs. That Ruisdael's landscapes appealed to Gainsborough because of their natural appearance is apparent from this imitation and from his appraisal, at the end of his life, of 'the truth and closeness to nature in the study of the parts and *minutiae*' in his own *Cornard Wood*.[10] Gainsborough retained an appreciation for Dutch landscapes. In one of his last letters, he wrote to his patron, Mr Thomas Harvey of Catton Hall, Norfolk: 'I feel such a fondness for my first imitations of little Dutch landskips that I can't keep from working an hour or two a day, though with a great mixture of bodily pain . . .'.[11] His own landscapes were compared by Reynolds in one of his *Discourses* to 'the portrait-like representations of nature, such as (are) seen in the works of Rubens, Ruisdael, and others of those schools'. This was hardly a commendation, since in an earlier *Discourse*, Reynolds had said that 'the practice of Claude Lorrain, in respect to his choice, is to be adopted by landscape painters in opposition to that of the Flemish and Dutch Schools, . . . as its truth is founded upon the same principles as that by which the Historical Painter acquires perfect form'.[12]

By the mid-eighteenth century, however, the type of truth found in Ruisdael's landscapes was beginning to be appreciated in some quarters in France as well as Britain. From about 1745, T. A. Desfriches (1715–1800), a collector, draughtsman and art-teacher imported works by Ruisdael, Van Goyen and other non-Italianate landscapists into France, and began to imitate their studies from nature. A number of Ruisdael's landscapes were engraved. Early examples were De Moitte's engravings after the Ruisdaels in the collections of the Comte de Vence, and of Count Brühl at Dresden, published in 1747, 1750 and 1752. These included some of the landscapes now in the Hermitage, such as the *River in a Mountain Valley* (Fig. 103). Many more had been engraved by Jaques Philippe Le Bas and Jean Jacques de Boissieu by the early seventies, such as the *Beach at Egmond aan Zee* (London, National Gallery; Fig. 169), engraved before 1754 as a '*Vue de Skervin*', or Scheveningen, and the *Two Oaks by a Pool* (Nancy; Fig. 56), engraved in 1773. During the same period Fragonard painted some woodland landscapes in the style of Ruisdael, and Diderot noted the influence of Ruisdael in the landscapes of J. B. Le Prince (1733–81).[13]

This situation is reflected in Dezallier d'Argenville's additions to De Piles's *Lives of the Painters*, translated by James Burgess and published in London in 1754. It contained biographies of many Dutch painters, including Jan van Goyen, whose style was considered 'quite natural', Jan Wijnants and Jacob van Ruisdael. Ruisdael's naturalism was emphasised: his teachers being unnamed by his biographers, it was concluded that nature alone supplied their place, as is suggested by his colouring, and his trees, foregrounds and skies. It was also observed that in his sea-views, waterfalls, and stormy seas breaking on rocks, 'nature had hardly greater force than his pencil'.[14]

In academic circles these qualities were acknowledged, but not appreciated. In a letter to *The Idler* in 1759 Reynolds dismissed the type of imitation of nature found in Dutch paintings as 'mechanical drudgery'.[15] A journey to Flanders and Holland in 1781 did not cause Reynolds to change his outlook. He commended their mastery of 'all the mechanical parts of the arts', and conceded that 'however uninteresting their subjects, there was some pleasure in the contemplation of the truth of the imitation'. He considered Wouwerman, Potter, Berchem and Jacob van Ruisdael the best for landscapes and cattle, and wrote that, 'the landscapes of Ruisdael have not only great force, but have a freshness which is seen in scarce any other painter'. Reynolds must have appreciated these qualities, for in 1756 he had purchased a pair of landscapes by Ruisdael, which he kept for the rest of his life.[16] Walpole was more dismissive of 'those drudging mimics of nature's most uncomely coarseness'; likewise the collections surveyed in Thomas Martyn's *The English Connoisseur* show that classical landscape still predominated. Dutch naturalism appealed in particular to the middle-class collector, such as Charles Jennens, who owned nine Ruisdaels.[17]

But this situation was changing. The Duke of Bedford, Lord Ashburnham, Lord Petersham and Sir William Beauchamp had all bought Ruisdaels in the 1740s; by 1766 the Devonshires had a Ruisdael at Chiswick House. The third Earl of Bute, who became Prime Minister, was a great collector of Dutch paintings in the late sixties. He may have acquired this taste when a student at Leiden University. Another Scottish peer, the seventh Earl of Wemyss, was also buying Dutch paintings, Ruisdael's *View of Haarlem* and *View of Alkmaar* (Figs. 182 & 183) entering his collection before 1771.[18] A similar trend is perceptible on the Continent, and is reflected in the purchases of Catherine the Great of Russia (1762–96), a German-born princess. She had acquired five Ruisdaels with the Brühl collection from Dresden, and in later years purchased further works by Ruisdael and Wijnants, who had both become fashionable during her lifetime.[19] Also in Holland, around 1770, Ruisdael, Wijnants and Hobbema came back into fashion with both collectors and painters.[20]

This growing appreciation for Ruisdael and other painters of the 'national' Dutch school was linked with the nature cult that was spreading through Western Europe. The comments of writers on landscape gardening and on the 'picturesque' reveal the qualities that were appreciated in their paintings. In *The English Garden* (1772–81), William Mason recommended as the essence of landscape and of landscape gardening: a 'lowly site', a shadowy glade, such as Ruisdael painted, with a giant oak that 'flings his romantick branches' over a pool of water.[21] Lord Terrington, in a tour of the Midlands in 1789 noted how 'the morning mists retired: and in the contest between clouds, and sun-shine, there gleam'd beautiful tints, worthy of Ruysdael's pencil'.[22] In an essay of 1794 Uvedale Price described a type of beauty, distinct from the sublime and the beautiful, which he called 'picturesque': winding roads, screened vistas on forest edges, fallen tree trunks,

rough sandy banks, old neglected pollards and old mills. These were essentially the irregular, variegated aspects of nature found in the works of Dutch landscapists, such as Ruisdael and Wijnants, who were also well represented in his own collection.[23]

By the end of the eighteenth century Ruisdael's landscapes were recognised for a type of beauty that was more natural than the idealised world of Gaspard Poussin and Claude Lorrain. They also provided a model for imitation. A critic writing in *The Gazetteer* in May 1790, commented that many landscape painters 'copy their trees from Hobbema, their water from Ruysdael and their docks and weeds from Wijnants'.[24] A similar trend is perceptible in Germany, where J.F. 'Pascha' Weitsch (1723–1803) turned in his later years from imitating Both to Ruisdael, and, in France, Lazare Bruandet (1755–1804) and his some-time painting companion Georges Michel (1763–1843) painted the countryside around Paris in a manner imitative of Ruisdael.[25]

In the following century Ruisdael's landscapes continued to be appreciated for their truth to nature, and, with the spread of the Romantic movement, a further quality was enjoyed: their poetic mood.

In the first half of the nineteenth century Dutch landscapists were the example that showed many painters, especially in England and France, how to paint their own country naturalistically, as well as expressively. The lighting and atmosphere of Ruisdael's landscapes were of particular significance in this latter respect. In England, the Dutch influence is particularly noticeable in Constable, Turner, Crome, and painters of the Norwich School. In France it can be seen in the works of Georges Michel, the early Corot, and painters of the Barbizon School, such as Paul Huet, Théodore Rousseau, N. Diaz and J. Dupré. In the mid-century Dutch influence is visible in the works of Daubigny and the young Boudin.[26] The qualities that these painters appreciated in the Dutch masters were conditioned by and influenced their own artistic goals.

In England, the young Constable was probably introduced to Ruisdael's art by J.T. 'Antiquity' Smith. Constable wrote to him in January 1797 requesting the loan of Ruisdael's etching *Woodland Morass with Travellers* (Fig. 73), or the 'one which your father copied', either of which he wished to copy.[27] This was the beginning of a lifelong admiration for Ruisdael, who was frequently in Constable's thoughts, with Claude, whom he equally admired as a student of nature. He wrote to his wife in 1821: 'all my thoughts spite of Claude and Ruysdael are with you and my dear infants'.[28] Over the span of thirty-five years, 1797 to 1832, Constable copied works by Ruisdael, choosing the unassuming 'rural' landscapes, with cornfields and windmills, one of which was a winter scene. This selection, coupled with his scorn for Jan Both and Berchem, reveals Constable's preoccupation with direct study of nature. He noted the variety of Ruisdael's landscapes, acknowledged the quality of his waterfalls, and imitated one of his beach scenes: Constable's 1816 *Weymouth Bay* (London, Victoria & Albert Museum) is composed on similar lines to Ruisdael's *Beach at Egmond aan Zee* (London, National Gallery; Fig. 169), of which Constable owned a print, showing the scene in reverse.[29]

The qualities Constable expressly admired in Ruisdael are the freshness, for which he himself strove, intelligent observation of nature, and the ability to transform an ordinary subject with lighting effects. He wrote to his friend Fisher in 1826 of Ruisdael's *Watermill* (Rotterdam, Museum Boymans-van Beuningen, No. 2520): 'It haunts my mind and clings to my heart . . . the whole so true, clear, and fresh – as brisk as champagne – a shower has not long passed . . . '. In an

earlier letter of 1824, he wrote that his own 'freshness' had been praised, and went on to describe Ruisdael as 'the freshest of all'.[30] In his 1836 lectures to the Royal Institution, Constable discussed Ruisdael's understanding of his subject, taking as examples a seascape, and the *Village with Windmills in Winter* (Philadelphia; Fig. 184), of which he had made a copy in 1832, soon after hearing news of Fisher's death. Constable showed how Ruisdael's understanding of what he was painting was manifest by the relationship of the two mills, one with sails furled, the other with canvas on the poles, and turned to the light in the southern sky, indicating a change of wind and an oncoming thaw. Constable found the allegorical content of Ruisdael's *Jewish Cemetery* (Fig. 89) to difficult to fathom. In his view it failed for attempting 'that which is out of the reach of the art'. For Constable, Ruisdael's great merit was that '(he) delighted in, and has made delightful to our eyes, those solemn days, peculiar to his country and to ours, when without storm, large rolling clouds scarcely permit a ray of sunlight to break the shades of the forest. By these effects he enveloped the most ordinary scenes in grandeur, and whenever he has attempted marine subjects, he is far beyond Van de Velde'.[31]

Admiration for Ruisdael's marines was shared by Turner. In 1802 he made sketches in the Louvre after Ruisdael's *Shipping off a Coast* ('*The Tempest*'; Ros. 596), and his '*Coup de Soleil*' (Ros. 413; Fig. 172), adding some comments in his sketchbook: the latter is 'full of truth', and the former 'finely pencil'd'. He praised the disposition of the ships, 'riding in stress of weather', but objected to inclusion of the house on the embankment, the intensity of the lighting on the foreground surf, and Ruisdael's neglect of the forms which waves make upon a lee shore embanked'. Turner's concern with the truth of the representation caused him to modify the objectionable elements in his copy. Turner subsequently entitled two of his own seascapes *Port Ruysdael* (1827) and *Ship being towed into Port Ruysdael* (1844), indicating his continued respect for the painter. His own romantic interpretation of Ruisdael's marines creates a more sublime and uncertain image of nature. The difference is like that between Tennyson's lines: 'Are God and Nature then at strife, That Nature lends such evil dreams?' and those of the early eighteenth-century Dutch poet Poot: 'Keep courage in hard times. It is God . . . who causes tempest. It is He . . . who makes it abate'.[32]

Ruskin, infatuated by the veracity of Turner's landscapes, writing in 1843, could only concede of Ruisdael's *Tempest* (Louvre): 'though nothing very remarkable in any quality of art, (it) is at least forceful, agreeable, and, as far as it goes, natural'. Likewise, 'Ruisdael's painting of falling water is also generally agreeable; more than agreeable it can hardly be considered'. 'Stand by the Fall of Schaffhausen for half an hour, then you will have discovered that there is something more in nature than has been given by Ruisdael' – a judgment that reflects the precision of Ruskin's own geological studies. Ruskin could scarcely appreciate Ruisdael's naturalness, especially in his imaginary waterfalls and he was insensitive to his poetry: 'There appears no exertion of mind in any of his works; nor are they calculated to produce either harm or good by their feeble influence. They are good furniture pictures, unworthy of praise, and undeserving of blame'.[33]

Meanwhile in France, where Ruisdael's truth to nature had already been recognised in the eighteenth century, a vogue for landscape painting had been further stimulated by the love for nature expressed in the writings of Jean-Jacques Rousseau, Bernardin Saint-Pierre, and Chateaubriand.[34] Deperthes, in his *Théorie de Paysage* (1818), was one of the first to proclaim that the rural landscapes of some Dutch painters were of equal merit to the historical landscapes of Poussin and Claude, and subsequently recommended study of the Dutch Italianates and

of Ruisdael.[35] In the 1830s and 1840s the example of Dutch landscapists, and not least Ruisdael, played an important rôle in enabling Corot, Théodore Rousseau, and the Barbizon painters 'to free themselves from academic trammels', and 'to redefine their attitude towards nature'. Ruisdael's etching *Woodland Morass with Travellers* (Fig. 73) was an inspiration to more than one painter, and Dutch pictures in the Louvre were frequently copied.[36]

Delacroix who was known for his admiration for the landscapes of Constable, was struck by the naturalness of a winter landscape and a marine by Ruisdael, which he saw when visiting the collection of the Duc de Morny in 1847. Their 'astounding simplicity' lessened his estimation for the artificiality of a Watteau and a Rubens in the same collection.[37] For Dumesnil, in 1850, Ruisdael was more than a model equal to Claude: his earthy realism, rather than Claude's idyllic illusions, could speak to the modern soul.[38] After the 1848 Revolution, Dutch art was frequently associated with republican ideals in France. Dumesnil's opposition of Ruisdael and Claude is an early example of this trend, which probably originated in 1835 with Hegel's correlation of the national situation and the character of the arts in Holland.[39]

Thus the example of Dutch landscapists, including Ruisdael, contributed to the break made by Corot, Théodore Rousseau and the Barbizon painters from the earlier French academic traditon of landscape painting, as embodied in the works of Poussin and Claude. The achievements of these nineteenth-century French landscapists and of their successors, the Impressionists, has in turn influenced the way in which later generations have looked at the Dutch masters. Consequently, those elements that are most similar to nineteenth-century landscapes have received most attention. Contemporary appreciation for Van Goyen's sketchy technique is a case in point. It has also led to estimation for the more 'realistic' of Ruisdael's landscapes, those portraying the local Dutch landscape, such as his *Views of Haarlem*, while his *Waterfalls*, once highly regarded, have gone out of fashion.

In England and France Ruisdael's truth to nature had been appreciated, but it was in Germany that Ruisdael was first especially praised for his poetic conceptions. On 3rd May 1816 the *Morgenblatt für gebildete Stände* carried an article by Goethe, 'Ruisdael als Dichter'. This proved seminal for Ruisdael studies, and echoes of it can still be heard today. Goethe, sensing just those qualities that Ruskin missed in Ruisdael, selected three paintings in the Dresden Gallery to demonstrate that Ruisdael combined skill and thought to please the eye, to stimulate the imagination, and to express an idea. The first picture, a *Waterfall* (No. 1495), 'shows in one place the successive stages of the human development of the world', and suggested to Goethe the activity of watermills and iron works upstream and down. The second picture, *The Convent* (Fig. 77 [*Ruined Monastery by a River*]), 'represents the past in the present', achieved by 'visibly uniting the living and the dead'. Present day activity takes place in a scene that shows signs of the busy activity of former years: the ruined convent, opposite a grove of trees beneath which pilgrims used to gather, and the remains of a bridge where travellers now ford the stream. The thriving circle of old lime trees, 'show that nature's works live and endure longer than the works of men'. Goethe adds, lest we be 'depressed' by the leafless old beech in the foreground, around it thriving trees 'help out' with their 'rich display of branches and twigs'. The painting, he deduces, has been 'conceived from nature, and elevated by thought'. The third picture, *The Cemetery* (Fig. 94), 'is entirely devoted to the past: without allowing any rights to the life of the present . . . The tombs in their ruinous condition even

point to something more than the past: they are tombstones to themselves'. A once vast cathedral and its precinct are but a mean ruin in a wilderness, its former importance indicated by the fine tombs. A stream, diverted by fallen masonry, now finds its way through the overgrown cemetery. Goethe concludes that Ruisdael's purity of feeling and clarity of thought show him to be a poet.[40]

Goethe's imaginative interpretation of these pictures is in the spirit of Schelling's influential nature-philosophy. In Goethe's assessment, Ruisdael achieved in these paintings 'a perfect symbolism'. He had written in the *Introduction to the Propyläen* that an artist ought to 'produce something spiritually organic, and to give his work of art a content and a form through which it appears both natural and beyond nature'. He had also written in a letter of 1809 that every little thing in nature is 'pregnant with meaning'. This was the ideal against which Ruisdael's landscapes were measured, and from which those of Caspar David Friedrich were created.[41]

Thereafter, this type of response to Ruisdael became more widespread. In England, for example, where the volume of Dutch paintings passing through the sale rooms had prompted two prominent dealers into publication, estimation for Ruisdael was expressed in terms of both his truth to nature and his poetic imagination. Nieuwenhuys, in a description of his recently dispersed collection, praised Ruisdael's fidelity to nature: in a *View of Haarlem* (Berlin–Dahlem, Fig. 113) it was 'such that one may almost fancy the eye resting on the reality'. But he also admired the poetic, 'elevated' character of *The Tempest* (Louvre), and considered the 'power of imagination' in his waterfalls left him unrivalled in the representation of 'romantic scenery'.[42] Of more lasting importance was John Smith's extensive *Catalogue Raisonné* (1829–42) of the Dutch masters, which laid the foundation for subsequent critical studies. Smith likewise admired Ruisdael's truth to nature and his poetic effects. He considered Jacob van Ruisdael's early works to have been almost wholly painted on the spot, but he preferred the selection of 'nature's majestic forms' evident in his mature works. The grandeur of his 'dark and stormy' marines showed that Ruisdael was 'both a poet and a painter', and he stated that the two versions of *The Jewish Cemetery* 'were evidently intended as allegories of human life'. This observation, presumably picked up from Goethe, was perhaps the source for Constable's comments made the following year.[43]

In 1835 Waagen, on visiting many English collections, also admired Ruisdael's poetic moods, as well as his truth to nature and technical ability. He recorded that since 1792 many Dutch pictures had entered the country, and noted a 'rage', in landscape, for Hobbema, Cuyp, and Potter. Of the Ruisdaels he saw, he admired the painter's technical ability: correctness of drawing, delicate tones, striking lighting, and careful execution. He observed their truth to nature: the 'feeling of winter' in the picture in the Peel Collection (Philadelphia Museum; Fig. 184), the 'force and freshness' in the *Waterfall* in the same collection (London, National Gallery, No. 855), and the 'solitude and quiet repose' in a *Woodland* in Dr Wells's collection (Berlin–Dahlem; Fig. 144). Waagen also commended their poetic mood: *The extensive Landscape* in Mr Sanderson's collection (London, National Gallery; Fig. 158) 'powerfully impresses' one with 'a profound, serious, melancholy feeling'.[44] Some twenty-five years later, Waagen was to develop this estimation for their poetic mood even further.

By the mid-nineteenth century Ruisdael was likewise esteemed by French critics as much for his poetic mood as for his truth to nature. Indeed, for the detached reactionary Gustave Planche, realism, as then practiced in France, was

the final decadence. It was lacking in imagination, a quality which was not absent in Ruisdael. In the last year of his life, 1857, Planche wrote that most painters now follow Ruisdael, not Claude or Poussin (which would be preferable), but in so doing they overlook that for all Ruisdael's attention to the details of nature, his work goes beyond imitation. His observations are subjected to reflection, and reveal his melancholic disposition.[45] The influential art critic Thoré (Bürger as he became known), who was attracted by his republican views to the Dutch school, was likewise captured by the poetry of Ruisdael. Thoré, like his friend the Barbizon landscapist Théodore Rousseau, sought soul and atmosphere in landscape. In the dedication of his 1845 *Salon*, Thoré took Ruisdael's *Bush* ('*Buisson mélancolique*') and *Tempest* in the Louvre as examples of poetic response to nature.[46] Subsequently, in 1858–60, writing on the Dutch school, he commented again on the poetic mood of Ruisdael's landscapes, but considered Ruisdael's waterfalls 'a little mannered'. Despite their time-honoured reputation, he found them inferior to the woodlands, flat landscapes, coastal scenes and seascapes. The 'whims of nature', agitation of the elements, sudden squalls, these bring out the best in Ruisdael, as in the *Beachscene* (The Hague) and the *Tempest* (Louvre). He found similar grandeur of execution and profound sentiment in *The Mill at Wijk bij Duurstede* (Rijksmuseum; Fig. 156). The subject is so commonplace, yet the effect is captivating: 'one looks at it with I do not know what irresistible melancholy . . . Oh! What a great poet is Ruisdael to communicate poetry with a windmill, the tip of a bell-tower, and some waves which quietly erode a row of piles'.[47]

In 1875 Fromentin made the trip to Holland. Like Planche, he was conscious that modern French art suffered from imitating nature slavishly, without imagination. He wrote that the Dutch had pointed the French to nature, now it was time to study Dutch painting techniques. Fromentin's sensitive assessment of Ruisdael contains similar romantic overtones. Ruisdael stands out for him, despite deficiencies in draughtsmanship and monotonous colour, as for Goethe, 'as a master and, still more worthily, as a great mind . . . he has his own way of impressing you with respect, attracting your attention – he warns you that you have before you the soul of someone of high race, and that he has always something important to tell you . . . there is in the painter a man who thinks, and in each of his works a conception'. Further on he writes: 'A canvas by Ruisdael is an entirety in which we can feel there is composition, a grasp of the whole, a master purpose . . . and withal a certain contempt for what is unnecessary, too agreeable or superfluous, great taste with great sense . . . this is what one finds on analysing a picture by Ruisdael'. As examples, he mentions the *Views of Haarlem* in Amsterdam and The Hague (Fig. 134) and the *Mill at Wijk bij Duurstede* (Fig. 156). Fromentin continues: 'A painting by Ruisdael . . . might be called a lofty and sustained thought expressed in language of the strongest fibre'. He compares it to the diction of the great French writers of the seventeenth century and imagines that if Ruisdael had not been a Dutchman and a Protestant, he would have belonged to Port-Royal. Fromentin also wonders about the melancholy that tints his pictures with a sombre hue, and imagines him a dreamer who loved to fly from the town. He wonders what life had done to him, referring to his supposed distress and solitude.[48]

Some years later, in 1890, another French writer, Emile Michel, projected an even more romantic image of Ruisdael: he characterised him as a man whose lot was obscure and severe, reserved and in poverty he found in nature a solace for his suffering, and in her melancholy and rugged forms he found an echo of his own

troubled existence. Into the severe landscapes that have rendered his name immortal, he put not only his genius but his whole soul. This was to be admired not in the waterfalls, still less in the 'unnatural and improbable' works of a composite nature, such as *The Jewish Cemetery* (Dresden; Fig. 94) although in the latter are found echoes of 'all the sadness with which his life was burdened'. Michel preferred the 'purely Dutch landscapes': the *Views of Haarlem*; the paintings of cornfields and dunes, such as the *Bush on the Dunes* (Munich; Fig. 44) and *The Bush* (Paris), which give the impression of 'struggle and sadness'; and paintings of winter, 'in all its sadness'. Michel was particularly taken with the 'forbidding sadness' of his marines (e.g. Fig. 171), with 'storm-tossed boats', threatened by sea and squalls, trying to reach port. He concluded: 'An intense poetry emanates from them and tells us the sorrowful secrets of the man who, next to Rembrandt, and poor like him, was the greatest artist of Holland'.[49]

Estimation for Ruisdael's indigenous Dutch landscapes continued unabated at the expense of his waterfalls and other more imaginary motifs. His Dutch landscapes were at the same time perceived as projections of the artist's personal mood, his temperament being most perfectly matched by the prevailing conditions found in Holland. This view has continued in the modern tendency to view landscape paintings too exclusively as expressions of the artist's own temperament; an idea which is more relevant to landscape paintings from the time of the Romantics onwards.

In the latter part of the nineteenth century this emphasis on the poetic mood of Ruisdael's landscapes was also expressed by certain German critics. They also began to focus on yet a third quality in Ruisdael, which Fromentin had esteemed: the strength of his compositions. Thus Waagen pursued his earlier comments on the melancholy mood of Ruisdael's landscapes in his *Handbook of Painting* (1860). Developing Hegel's theory of culture, he expressed a marked preference for realistic Northern, as opposed to idyllic Italianate landscape, and considered Ruisdael beyond all dispute the greatest of the Dutch landscape painters with his 'feeling for the poetry of northern nature and perfection of representation united in the same degree'. Ruisdael's works have 'poetic grandeur', evoked by sunbeams falling through heavy grey clouds, which give a melancholy character to pictures of his native country and attract us by their deep pathos. The profound melancholy of the *Jewish Cemetery* (Dresden; Fig. 94) can be conveyed by no description. By contrast he found Hobbema, a favourite of the English, inferior to Ruisdael 'in two most important qualities: fertility of inventive genius, and poetry of feeling'. The range of Hobbema's subjects is narrower, and his pictures have 'a thoroughly portrait-like appearance, decidedly prosaic, but always surprisingly truthful'.[50]

Waagen's compatriot, Wilhelm von Bode, likewise considered that the poetry of the Northern landscape found its highest and most conscious expression in Ruisdael. In a pioneering article of 1872 he distinguished a new trend in Dutch landscape painting that originated in Haarlem shortly before the mid-seventeenth century. He found in Ruisdael its leading exponent. The older generation of landscapists had been content to portray the general characteristics of the Dutch landscape faithfully, animating it with the daily activity of the populace. Ruisdael and the younger generation accentuated an individual form with a greater force of stylisation, bringing out the essential soul and atmosphere of Northern landscape, as Claude had that of the South. Human activity was suppressed, nature dominated, its forms echoing man's inner moods. With this new trend, there developed a corresponding attention to detail, more powerful, naturalistic colour, and

intensified contrasts of light and shadow. Bode's conception remains little altered in contemporary literature which continues to differentiate 'tonal' and 'classical' phases in Dutch landscape painting, with Ruisdael seen as the foremost exponent of the latter.[51]

During the nineteenth century the poetic mood of Ruisdael's landscapes had provoked speculation about his personal circumstances. Bode, too, wondered whether his melancholy poetry had to do with personal sorrow, recalling Houbraken's remark that he did not have luck as his friend. Others enlarged our knowledge of Ruisdael's life in attempting unsuccessfully to verify this account.[52]

By the end of the nineteenth century his truth to nature and his poetic mood were more highly esteemed than ever. Fromentin and, to an even greater extent, Bode had emphasised a third quality: the strength of his compositions. As a contemporary preoccupation, this was to attract even more attention in the twentieth century, when formalistic studies have dominated the field. Ruisdael studies initially focused predominantly on formal analysis, and, more recently, on iconological and contextual concerns. The former emphasised, besides his realism and poetic mood, his stylistic development and the strength of his compositions. Already in the late nineteenth century, Wilhelm von Bode and Emile Michel had related Ruisdael's development to that of the older Haarlem landscapists. Starting in 1906 with Bode, attempts were made to establish a chronology of Ruisdael's oeuvre, which is undated after 1653. While modifications have been made to Bode's chronology, his overall view of Ruisdael has prevailed. Masterpieces which Bode attributed to the sixties were admired by him for their rich compositions, delicate lighting, clear colouring, and, above all, for 'their great and thrilling poetic mood: They are the grandest delineations of landscape ever produced by art'. Bode admired the great variety of Ruisdael's landscapes, as well as the strength of his compositions. He noted the fine observation of nature, especially in the clouds, but pointed out that his pictures were not prospects, being constructed from selected elements.

As to the poetic mood of Ruisdael's landscapes, he followed Goethe in seeing man portrayed as insignificant before the 'eternal rejuvenescence of nature'. Bode considered the feelings ascribed by others to him as a misanthropist and a lonely dreamer 'too modern and romantic', yet he himself writes: 'The world must have bitterly deceived him; misfortune and envy must have persecuted him, for sorrowful feelings never quite leave him, even in the calm of nature, where he found refuge and peace'. Bode is impressed 'by his modest way of hiding himself behind a great representation of nature': 'Into these pictures . . . Ruisdael has put his soul; they also tell us of his personal mood'.[53]

Another foundation for modern Ruisdael studies was laid by the 1912 volume of Hofstede de Groot's *Catalogue Raisonné of . . . Dutch Painters* (HdG),[54] which provided substantial information and commentary on a large body of Ruisdael's works. Hofstede de Groot noted Ruisdael's *Views of Haarlem* as currently the most highly regarded of his works, and observed that it was his 'combination of truth to nature and of imagination, which has made him the greatest landscape painter of Holland'.[55]

Bode's 1872 observations about the mid-seventeenth-century trend towards forceful composition, fine details, and local colour were taken up in 1920 by Ledermann. He associated this change with Claude's 'tectonic' compositions, 'imported' into Holland by Asselijn, Both, and Berchem, and thereafter of crucial importance to Ruisdael, Hobbema, and Van der Neer. He also attributed Ruisdael's attention to detail and local colour to the influence of the Italianate

painters.[56] The ideas of Bode and Ledermann were than absorbed into Rosenberg's 1928 Ruisdael monograph and have thereby come down to the present.[57]

It was Rosenberg who provided the first comprehensive study of Ruisdael's artistic personality, addressing the chronology of his works, the origin and stylistic development of his landscape themes, and their relationship to the older Haarlem masters, the Italianates, Allart van Everdingen, and Hobbema. He also provided a revision of Hofstede de Groot's catalogue of Ruisdael's works.

Rosenberg particularly admired the strength of Ruisdael's compositions, ranking him, with Claude and Poussin, a great painter of the High Baroque. He observed that, in terms of composition, Ruisdael's power of stylisation made nature speak with greater force. He too characterised Ruisdael as having a romantic sense, creating in his landscapes a sombre, gloomy, melancholic, sometimes even compellingly tragic mood, and followed Goethe's interpretation of *The Jewish Cemetery*.

Rosenberg's monograph set the tone for a number of shorter studies, in which the artist's formal strengths continued to be emphasised. Thus in 1936 the Dutch historian Martin esteemed Ruisdael's Dutch landscapes, many of which he dated to the early 1650s, suggesting that Ruisdael's move to Amsterdam stimulated him to turn in a romantic direction to produce the monumental compositions of marshy woodlands, ruins, waterfalls, and hilly landscapes. He concluded that it was his endlessly varied compositions that distinguished him as the most inventive of all landscape painters.[58]

In 1952 another Dutch scholar, Gerson expressed high estimation for Ruisdael, while preferring his less romantic subjects. Like Rosenberg, he attributed Ruisdael's compositional strength to the influence of the Italianate landscapists, finding his compositions so satisfying that the 'romantic implications' of his dead trees were not irritating. But he preferred the Dutch landscapes, which he thought Ruisdael painted with more power and pathos than Van Goyen, considering Ruisdael's *Mill at Wijk bij Duurstede* (Amsterdam; Fig. 156) his most 'monumental and harmonious creation', and a highlight of the Baroque tradition.[59]

Rosenberg, on moving to the United States, influenced a whole generation of scholars in their appreciation of Ruisdael. Writing on Dutch art in 1966, Rosenberg in co-operation with Slive reiterated ideas expressed in the former's 1928 monograph, identifying Ruisdael as a master of heroic composition, creating in his woodlands 'an archetype of the loneliness and grandeur of nature', and responding to the Dutch countryside according to personal mood.[60] Ruisdael was by now acknowledged as the foremost representative of a classical phase in Dutch landscape painting.

This view was underscored by the organisational structure of Stechow's *Dutch Landscape Painting of the Seventeenth Century*, which facilitated comparisons of Ruisdael's compositions with those of other landscapists depicting similar motifs. In Stechow's view Ruisdael's compositional strength was based on selective naturalness, to be seen in his panoramas, where a 'deliberate choice from the storehouse of nature' is made 'under the impact of a specific mood'. For Stechow, Ruisdael's mood was so tragic and gloomy, that he considered Ruisdael a *rara avis* among Dutch landscapists, and assumed that his landscapes – together with those of Seghers and Rembrandt – were unpopular. Furthermore, he wrote that by minimising the rôle of man, Ruisdael sometimes achieved 'near-romantic' effects.[61] In an earlier article (1960), Stechow had discussed the 'tragic mood' of his winter landscapes, such as the one in Amsterdam (Fig. 163), in which winter is interpreted 'as the corollary of sadness and even death'.[62] In 1966 he compared

the mood of another of Ruisdael's winters (Munich; Fig. 164) with the 'deep gloom' of a religious tragedy by Rembrandt. He noted the 'profoundly elevated mood' of some of Ruisdael's woodlands, for example the pictures in Leningrad, London, and Berlin (Figs. 140 & 144). In his marines, man 'seems to abdicate before nature', and of the *Beach at Egmond aan Zee* (London; Fig. 169) Stechow said that the great expanse of land and water is accentuated to the point of dwarfing the figures. Stechow followed Goethe in considering *The Jewish Cemetery* 'essentially a glorification of nature', exceptional for Ruisdael and a rarity in Dutch painting. Despite these comments on expressive mood, twentieth-century emphasis on formal analysis led Stechow to write in his epilogue that the paramount concern of Dutch landscapists was not the conquest of space, as many maintain, but picture-plane organisation. Consequently he hoped that, in the study of Ruisdael, 'his struggle with basic problems of composition has emerged as a decisive feature of his art'.[63]

While Stechow's study of Dutch landscape painting facilitates comparison of Ruisdael's motifs to those of his predecessors and contemporaries, Keyes has produced a valuable new catalogue of Ruisdael's etchings, and Giltay a much needed analysis and catalogue of some one hundred and thirteen of his drawings.[64]

As a consequence of these studies Ruisdael is seen today as the 'supreme master' of the 'great monumental or structural phase of Dutch landscape painting', as a realist with a romantic, melancholic temperament whose finest works are generally agreed to be the 'typically Dutch panoramas with the sun breaking fitfully through the clouds'.[65] More recently Haak acknowledged Ruisdael as 'an acute observer of natural phenomena', who nevertheless reveals a 'predilection for the romantic and monumental'. Not only does this reveal his 'almost inexhaustible fantasy and compositional innovation' in portraying nature imagined rather than observed, but it also leads to a loss of sensitivity and 'a certain heaviness and hardness'.[66] This preference for Ruisdael the realist is such that it has not been beyond the scruples of some to modify his compositions before marketing them, removing the disturbing 'romantic' elements to create a 'typically Dutch panorama'. Furthermore, his stature is such that even the severed element, when put up for sale, attracted a buyer.[67]

With the growing attention paid in recent sudies to the cultural context of Dutch art and specifically to the allegorical meanings of seventeenth-century Dutch genre, still-life and portraiture, Ruisdael has now also become the focus of a number of iconological studies of Dutch landscape, challenging the romantic presuppositions of much of the earlier criticism.

Wiegand in 1971, rejecting both the realistic and romantic interpretations of Ruisdael, presented him as a Baroque allegorist who used conventional imagery found in poetry and emblem books. He relied on the premise that the 'Baroque' was an essentially unified intellectual movement, and that the humanistic view prevailed that painting should imitate poetry: *Ut pictura poesis.* Asserting that the ideal of the learned painter was not foreign to Dutch painters and citing Ruisdael's Latin education, he also rightly noted that the content of high literature was reflected in schoolbooks, sermons, popular and church songs, emblems and moral literature, and could have been accessible to Ruisdael through these channels. On this basis Wiegand reasoned that where a motif is found repeatedly in emblem books or poetry, it must have the same literary meaning in the paintings.[68] Wiegand's study demonstrated the degree to which some of Ruisdael's imagery, such as waterfalls, dead trees and ruins, belonged to the common stock of Baroque allegory and was not therefore simply the product of the artist's

alleged melancholy temperament. But in trying to isolate specific meaning in even the minutest details of the landscape, Wiegand failed to differentiate between the expressive possibilities and functions of literature, emblems and landscape painting. He relied for his interpretations too heavily on literary and emblematic sources and took far too little account of painterly traditions. His premise that painting imitated poetry is at odds with the fundamental characteristics of the Dutch school, and greatly underestimated both the originality and visual curiosity of seventeenth-century Dutch landscapists. Nevertheless, Wiegand's study serves to increase our awareness of the frame of mind and type of associations that certain landscape motifs might have for the landscapist, with which the contemporary beholder would be familiar. Wiegand, however, repeatedly paid insufficient attention to whether or not the artist had structured his compositions to accentuate these associations. Thus he neglected the pictorial organisation and expression of Ruisdael's paintings.

Fuchs (1973) in a short study of Ruisdael's *Cornfield* (Rotterdam; Fig. 155), critical of Wiegand's rigid, emblematic interpretations, explored a method of analysis derived from semiotics. He demonstrated that the formal structure of Ruisdael's painting embodies a series of contrasting qualities of nature to create an image of its essence. Differentiating between the realism of the *Cornfield* and the fragmentary representation of isolated phenomena by nineteenth-century landscapists, Fuchs remarked that Ruisdael carefully observed the visible world, but thereafter it was transformed for allegorical contemplation. He proposed that the painted landscape, as *speculum naturae*, was intended to be seen in the same contemplative manner expressed in contemporary literature.[69]

It the same year, Kouznetsov, writing on the symbolism in a number of Ruisdael's landscapes, identified some of the same motifs mentioned by Wiegand – dead trees, ruins, and flowing water or waterfalls – as images of mortality, noting their biblical orgins, historical developments and contemporary usage in both Dutch literature and visual art. He believed that Ruisdael's use of the dead tree was derived from the graphic art of Rembrandt, though in fact it is more pervasive among Netherlandish landscapes. Unlike Wiegand, Kouznetsov did not indiscriminately suppose that landscapes are painted emblems or illustrations of literary texts, but that the symbolic content of these images is found in the vital and essential phenomena of nature itself. Indeed he also observed that in Ruisdael's paintings the symbolic aspect enters organically into the general artistic structure of the painting, creating a unity of form and content.[70]

A few years later, in 1977, Kauffmann analysed Ruisdael's *Mill at Wijk bij Duurstede* (Amsterdam; Fig. 156) from a similar perspective to Kouznetsov's. He stated that Ruisdael, here as elsewhere, represents a piece of nature, yet at the same time evokes allusions to traditionally loaded allegorical notions. He quotes Goethe's definition of a symbol as an image that contains spiritual allusions, and yet is identical with the situation. He also points to Jacob Cats, who wrote that one learns from contemplation of all that one finds in nature.[71]

Fuchs, Kouznetsov and Kauffmann have thus, in different ways, all helpfully suggested that the meaning of Ruisdael's landscapes is to be found in the inherent and essential qualities of nature, as conceived in contemporary consciousness and as pictorially embodied by the artist. More recently Bruyn (1987), much in the spirit of Wiegand's earlier study, has argued for the interdependence of word and image in seventeenth-century Dutch culture, thus reading a narrative structure into the landscapes of Ruisdael, Rembrandt and others. Like Wiegand, his basic premise is that 'the "visual language" of Dutch landscape painting found its point

of departure in the spoken word', an assertion that is hard to accept in view of the visual sensitivity of Dutch landscapists to the beauty and diversity of their environment. Bruyn does however shed light on a distinct, narrow and more conventional strain of fantasy landscapes within Dutch landscape painting, from which Ruisdael also took strength. Travellers make their way along a winding road, bridging a river and so going on towards a remote hill-top city or castle, which may be read as an allegory of life's pilgrimage. In some cases Bruyn's observations are illuminating, but in others they seem at odds with the overall tone and effect of the picture. Bruyn's method sheds light on certain types of landscape. In applying it to a wider range of Dutch landscapes, Bruyn has inevitably attracted a storm of criticism.[72]

Some critics such as Schama and Freedberg have argued with justification, that his analyses fail to appreciate the sheer visual and aesthetic sensitivity of most Dutch landscapists. His interpretation that Dutch landscapes with travellers represent a lonely figure, beset by sin, looking to life after death, ignores the fact that these paintings patently celebrate the world, even in its transient, fallen state.[73]

Other critics, such as Chong and Stone-Ferrier, have also recoiled from such a spiritualised interpretation, to focus instead on more mundane matters, thus illuminating the socio-economic contexts of specific motifs. Chong focuses on Ruisdael's depiction of cornfields and windmills and Stone-Ferrier concentrates on the Haarlem bleaching-fields.[74] Chong, in discussing Ruisdael's *Country Road with Cornfields* (New York; Fig. 154), provides a useful review of the sixteenth and early seventeenth-century origins, usage and frequency of the motif of wheat fields, especially in Flemish paintings of the cycle of the seasons, and its relative rarity in Dutch seventeenth-century landscapes before Ruisdael, who by contrast depicts them in more than twenty of his known works. The motif appears in all phases of his career, especially in the 1660s and after. Chong attributes rarity of wheat fields in Dutch as opposed to Flemish painting to the lack of an aristocratic tradition in the Northern Netherlands, and to changing patterns of agricultural production. Chong states that while almost no wheat or other grains were grown in Holland by the mid-seventeenth century, after 1650 they began to be grown again, especially to the South and East of the Zuider Zee, an area not suited to the grazing of cattle. In this latter respect, it is interesting to note, as Chong points out, that Ruisdael's paintings of wheat and other cornfields often include hilly terrain, which in some cases is located in a coastal region, and of a character compatible with the area to the South and East of the Zuider Zee. Ruisdael thus appears to evoke the topography of a particular region, and one that Chong has identified as notable for the reintroduction of wheat and other cereals at the time he was painting. Chong concludes, as he does in discussing Ruisdael's *Mill at Wijk bij Duurstede* (Amsterdam; Fig. 156) that Ruisdael thus represents topographic features of Holland noteworthy for their 'enormous economic and social import-ance for the Dutch' and that 'in his interest in industries of the land – such as bleaching fields and windmills – Ruisdael was unique'.

Chong's findings confirm Ruisdael's unique attention to noteworthy phenom-ena within the landscape, but his claim that for the contemporary beholder these topographical, economic and industrial associations were more important than other concepts relating to such imagery is open to question. Cornfields and wind-mills were certainly of importance to the Dutch economy, and many prospering Dutchmen may well have had their eye more on material gain than on spiritual enrichment. However, the overall tone of Ruisdael's landscapes suggests that

while for the merchant such elements may have been strictly economic indicators, for the artist they were also a manifestation of nature's bounty, to which details of lighting, atmosphere and setting draw attention. The motif of the cornfield especially when found in an otherwise infertile region, lends itself well to Ruisdael's characteristic approach to landscape, embracing specific local phenomena within a wider vision of reality.

Chong's approach illuminates possible contemporary viewer response to a range of Ruisdael's motifs: cornfields, bleacheries, and windmills. Stone-Ferrier focuses on a group of some eighteen panoramic city views by Ruisdael that include bleaching fields, nine of which are specific *Views of Haarlem*, others being similar views of neighbouring communities. Noting the rarity in seventeenth-century Dutch painting of depicting a particular industry and its association with a particular community, she points to the importance of the Haarlem bleacheries to the city's great economic prosperity and international fame as the probable inspiration for this group of paintings. She relates the particular way Ruisdael depicts these bleaching fields to an existing pictorial tradition, namely late sixteenth- and early seventeenth-century maps of Haarlem, illustrations on maps, and topographical prints and drawings showing the trades in Dutch cities and their environs. She also provides a wealth of information on the Haarlem bleaching industry, its dependence on specific natural resources, and its importance to explain why bleaching fields were included in earlier cartographic and topographical representations of the city. Rejecting Wiegand's theory of the possible moral intent of such a combination of bleaching fields and city views, Stone-Ferrier's evidence points to the commemorative and laudatory function of these earlier maps and prints, concluding that Ruisdael's group of paintings are best understood as sharing their general purpose, as a 'commemorative expression of civic pride' in an industry that 'provided the city with great economic success and international fame'. In considering the market for such paintings, Stone-Ferrier recognises that they were not likely to have been guild commissions, but points to the bleachers, merchants, and Haarlem citizenry as providing a market for such paintings. One wonders, however, whether Ruisdael's fellow citizens of Amsterdam, where he painted them, would have received them in this way with similar enthusiasm were it not for their significant pictorial appeal and their capacity to arouse a wider range of reflection as well. It is noteworthy that here again Ruisdael drew from and transformed an earlier pictorial tradition. Stone-Ferrier notes that it was a rare to depict a particular industry and its associations with a particular community. However, when one is made aware of the close links between the bleacheries and the fame of Haarlem, it is not surprising that Ruisdael should give them prominence. This accords with his general practice of characterising the local landscape by its most significant features.

These and other iconographic studies,[75] while complementing and challenging the stylistic concerns and views of earlier critics have in no way replaced them or rendered them obsolete, as could be seen in the exhibition and its acompanying catalogue dedicated to Ruisdael in 1981–82, coinciding with the three-hundredth anniversary of his death.[76]

This first major exhibition dedicated exclusively to Ruisdael was mounted at the Mauritshuis, The Hague and at the Fogg Art Museum, Cambridge, Massachusetts, with the purpose of showing the extraordinary quality and unmatched range of Ruisdael's landscapes, exhibiting fifty-six paintings, thirty-nine drawings and a full set of his thirteen etchings. In selecting from around seven hundred paintings currently attributable to Ruisdael, the full range of his

landscape types was represented. While this included some of Ruisdael's wooded, hilly and even mountainous landscapes, the selection was nevertheless weighted significantly towards works that are closer to the indigenous Dutch landscape, playing down the ponderous, dark woodlands and waterfalls to present the more open and airy side of Ruisdael's oeuvre, which evidently has more appeal to contemporary taste. The accompanying catalogue by Slive was more informative than evaluative, and while referring to certain allegorical interpretations nevertheless acknowledged that the symbolic level of Ruisdael's paintings had not yet been satisfactorily measured. Hence the exhibition, and its accompanying catalogue, which otherwise so beautifully demonstrated the quality and range of Ruisdael's landscapes, gave weighted preference in the selection to the 'realist' rather than the 'baroque' side of Ruisdael. It emphasised once again his truth to nature, personal mood and compositional strength, but left interpretative questions largely to one side.

It was, however, exactly these questions that were subsequently raised in the catalogue of the exhibition *Masters of 17th-Century Dutch Landscape Painting* (Amsterdam/Boston/Philadelphia, 1987–88), in which various authors, representing widely contrasting viewpoints, presented the current state of criticism. Two extreme and opposing positions were taken by Bruyn, for whom Ruisdael's waterfalls and hilltop castles were exemplars of the pilgrimage landscape, and by Chong, for whom Ruisdael's depiction of windmills, bleach- and cornfields revealed a unique interest in the industries and productivity of the land. More moderate positions were taken by Schama, Sutton and Giltay. Schama's essay focused on the radical novelty of Dutch landscapes of the 1620s and 1630s, which he attributes to a 'poetry of aggressive localism', which emphasises, self-consciously, the modest virtues of the homeland. From this framework Ruisdael emerges as one who, accepting this native aesthetic, moves beyond it to create a more universal and grandiose one, based on both domestic and foreign motifs, striving to 'reconcile loyalty to the homely with thirst for the grandiose'. Sutton, sensitive to the wide diversity of streams within Dutch landscape painting, and having reviewed the symbolism of *The Jewish Cemetery*, praises Ruisdael in particular for his power to capture so compellingly the moods of nature, rather than man, in a form of poetic realism, but also notes that his paintings of woodland swamps and great trees 'offer a universal image of decay and regeneration'. Giltay, attentive to the range and character of both iconographic and pictorial traditions, and hence more balanced than Bruyn, comments that Ruisdael 'raised the art of landscape painting from the mere rendering of a *playsante plaats* to classic images of untamed nature'. At the same time Giltay takes note of the possible symbolic meaning of a number of his landscapes, concluding that 'the depiction of earthly nature can be (in Ruisdael) an occasion for mirroring the spiritual world'.[77]

Over three centuries Ruisdael's critics have thus emphasised three main qualities: his truth to nature, his poetry and allegorical allusions, and the strength and variety of his compositions. Yet his truth to nature still begs the question of realism in Dutch landscape painting, and most critics today acknowledge that a painted landscape can never be rendered value free. Even the depiction of a simple bush or dune is motivated by some underlying stimulus, be it only delight in such phenomena, which influences the way in which the image is both seen and represented.

It is assumed that the character of Ruisdael's landscapes is derived predominantly from a projection of the artist's personal feelings and mood into his

landscape motifs, as a nineteenth-century romantic might have done, and consequently Ruisdael has been considered by some authorities a rare bird among his contemporaries. By contrast, others have cited emblem books and allegorical literature to assert that Ruisdael's imagery was conventional and capable of specific interpretation. Alternatively, his motifs have been considered in light of socio-economic factors.

In view of these concerns, we have reconsidered Ruisdael's personal circumstances, explored the relationship of his art to the surrounding artistic and cultural environment, and analysed the function and effects of his compositional methods. It is hoped that this has brought us not only to a fresh appreciation for Ruisdael's work, but also enhanced our understanding of some of the elements that influenced the relationship between art and reality in seventeenth-century Holland.

Conclusion

Ruisdael's works have been esteemed diversely through the centuries, particularly for their truth to nature, poetic mood and effective composition. This study examines the correlation between the elements of nature that attracted his attention and his pictorial treatment of them. It provides not only an overview of stylistic and thematic developments, but also clarifies some of the issues of representation and meaning inevitably raised when landscape is transformed into art. It should be apparent even from the little that is known of Ruisdael's life and circumstances that there is no justification for the romantic association of Ruisdael's chosen imagery with a melancholy temperament, and that Ruisdael's imagery was far more deeply embedded in certain streams of contemporary artistic and spirtual culture than is generally credited.

Our understanding of the perception of landscape in seventeenth-century Holland is increased by these considerations. There were a variety of approaches to landscape painting followed at that time and we have tried to identify certain fairly narrow currents within the overall stream and to consider some of the associations aroused by the imagery depicted. With respect to the type of landscape paintings explored in this book, we have indicated certain fairly specific associations which some of these images may have had for the contemporary beholder. Meaning in landscape paintings is never a matter of transposing emblems into landscape painting, even if emblems themselves do at times help us understand some of the layers of associations. Landscape paintings do not have their point of departure in a word-oriented culture, as pictorial embodiments of those words. It is more a question of how individuals in seventeenth-century Holland, because of their education and upbringing from their families, schools and churches, had been conditioned from earliest childhood to experience the various phenomena of nature in certain ways. They accepted nature as 'God's second book', an alternative and complementary mode of revelation to written and spoken words, loaded with significance in its very character and being.

In seeking to identify the significance of a landscape painting to the artist who made it and to the contemporary beholder, it would be helpful to abandon the notion of 'disguised symbolism' or 'hidden meaning' that has plagued Netherlandish studies. Meaning is hidden only from the unaware. For the contemporary beholder it would have been as accessible as the subtle, but loaded images, gestures and body language by which all of us pass signals, direct and indirect, to one another in the context of our culture. Meaning is inherent, not disguised, but to perceive it one must be aware of the multiplicity of connotations that were attached to images which were depicted, at the time of their representation. While such associations can never be fully recovered, the more we can immerse ourselves in the original context, the more fully we will be rewarded.

Dutch landscape paintings were capable of triggering a wide range of associations: patriotism, love of travel, winter pleasures, local pride among them. Some of them were also certainly both capable of and intended to arouse the type of metaphorical associations found in the Bible and expressed in seventeenth-century

art and literature. The Bible itself was one guide that invited people to make certain associations in contemplating the realm of nature. Dutch education and church life, which gave great importance to the catechism, encouraged people to look at the world of nature with a sensitive degree of observation, based on the acknowledged spiritual and practical value of studying God's world. At the same time this upbringing provided a guiding framework for how to see nature. This study demonstrates that the Dutch were encouraged to see in the beauty, variety and order of creation, evidence of the creative majesty of God. The corruption of all earthly matter and the constant state of flux, the mutability of all things under the sun, human life included, left man dependent, ultimately, on the all-sufficient, unmoving and unchanging Creator. This outlook seems to have produced both the capacity and desire to celebrate all the diverse elements of God's creation in art and science. At the same time it served as a reminder that even in the midst of bounty, man should remain aware of his dependence on the providence of the Creator.

With respect to Ruisdael's own artistic development, it has been seen that he started out in the 1640s as an observant and precise painter of trees and sand dunes. In subject matter and composition, if not in technique, he followed the lead of artists such as Jan van Goyen, his uncle Salomon van Ruysdael, and his own father, Isaack van Ruysdael, with Cornelis Vroom another early and some-what different source of inspiration. His subject matter thus reflected, for the most part, the example of a group of artists who took the local landscape as their point of departure. They selected elements such as sandy roads, dunes and the indigenous vegetation, as well as woodland in Vroom's case, to create images of peace and rural well-being in a world of wind, storm and flux. Country folk are depicted not so much as workers of the land but rather as its typical inhabitants, resting by the wayside, returning home from the fields, pausing by a cottage or an inn, or passing on further. By the end of the 1640s Ruisdael was already inclined to subsume scrupulously observed elements of the native habitat into a more generalised and representative image of the abundance, virility and yet fragility of the natural world around him.

In the 1650s he turned his astute powers of observation, precision of execution and mastery of compostion to a broader range of motifs. He was stimulated both by his travels, in Holland and in the German/Dutch border country, and by sub-sequent exposure to the artistic life of Amsterdam. Pictorial artifice becomes more evident in the fusion and transformation of well-observed specifics. He employed motifs inspired by his travels, such as hilly, wooded landscapes with streams, castles, and watermills. His attention was also captured by ruins, water-falls and woodland swamps, inspired by mannerist landscapes and loaded with allegorical associations. By the end of the decade, exposure to the art of Allart van Everdingen and others had inspired him to paint imaginary waterfalls and mountain landscapes, as well as marines and winters. In painting these subjects he took his lead from artists who emphasised stormy effects and the drama and force of nature. In the *Haarlempjes* he developed a more comprehensive vision than that of his early isolation of a wind-swept bush on a nearby dune top. Ruisdael's imagery in the 1650s demonstrated his powers of observation and his ability to create detailed images which attracted and held the eye. The imagery selected also drew attention to contemporary ideas about nature and man as manifest in the essential characteristics and cycles of nature. As he developed his selected motifs, he found more articulate means to express his understanding of the essence of his subject. Gnarled oaks, ruins, fallen trees and waterfalls lent themselves to the

representation of the relation of time to the physical world and the life of man. In placing his figures, as travellers, in such settings, Ruisdael invited reflection on the duration of life. He used his powers of observation to bring an enhanced sense of reality to what were, in almost all cases, conventional subjects.

In works of the 1660s many of the same motifs were depicted and refined. He opened up the pictorial space to show broader spaces more richly and diffusely illuminated. His pictorial structures became less dense, motifs receded into the middle ground, the space and skies became more expansive, the light brighter, the mood calmer, but still imposing. He capitalised on his earlier experiments and created works of unprecedented force and majesty. He blended vividly rendered natural phenomena with a breadth of invention to create images of both domestic and imaginary foreign landscape that are richly illuminated and harmoniously unified. Their forceful yet serene image of the vigour, grandeur and ultimate transiency of nature's noble forms echoes man's dignified yet mortal existence. Ever present and never overwhelmed, man is seen as a peaceful traveller through ancient forests, past lily-clad swamps, and along country roads that skirt wind-blown cornfields, or lead back into villages in the cold of winter. In his marines, ships are seen close to land in bursts of sunlight riding waves blown up by storm and crashing over foreground breakwaters, recalling earlier images of contrasting peril and safety. During the 1660s Ruisdael paid closer attention to the sky, observing and depicting the forms and movement of cloud with the same scrupulous care and sensitivity that he had already focused on trees. Some may complain that even in his later works he still leaves Apollo only a small gap through which to project his rays on the land below, as Van Mander had written of an earlier generation of landscapists. But Ruisdael had discovered, as Constable later put it, that in landscape painting sky is the chief organ of sentiment. With his storm-clouds and light-beams Ruisdael created classic images of well-being in a mutable world. Many of Ruisdael's images from the 1660s display a grandeur of conception and a brilliance of execution that captivates the eye and stimulates the contemplative imagination.

In the 1650s and 1660s Ruisdael, like Rembrandt, had resisted contemporary taste for classical idealisation, which had attracted many landscapists. But in the 1670s, faced by recession in the art market and domination of classical taste, Ruisdael softened the force of his earlier production, and adapted his imagery to a gentler, more pastoral mood. He toned down the volume and wild character of his trees, opened up his pictorial space yet further, and placed less emphasis on decay and flux. His paintings were now mostly on a small scale and permeated by a calm mood. Trees show less their age, water is less turbulent, wind and storm are less evident. In a number of works he retreated into the domestic comfort of Amsterdam itself, but only to depict in with remarkable originality.

He was not true to the classical, academic ideal of a perfected nature, nor to that presented by the Italianate landscapists, but rather he embraced and revitalised a more traditional Northern vision. The cycles of nature reflect the bounty and majesty of the Creator and are evidence of the providential well-being enjoyed by mortals inhabiting a beautiful but transient world. However acute his observations, however realistic his representations, his works manifest a form of selective naturalness, in which the selection goes far beyond mere compositional exigencies. It is informed by his understanding of the world around him in all the depth of its significance. Ruisdael's works show a gradual increase in the range of motifs. Nevertheless he projected a relatively consistent and unified vision of the world and of man's place within it, betrayed somewhat in works of his last years.

Ruisdael's poetic mood is frequently referred to. He does not gloss over the harsher side of reality, nor is he crushed by it. His attentive response to the growth and decay of natural phenomena invites us to look with more care and fewer illusions, and to reflect with deeper understanding. The strength of his compositions has been much admired in this century. It is apparent that his compositional structures were organised as a powerful method of arranging pictorial elements. He also used them to accentuate selected aspects of the world around him, crafting images of well-being in a sensuously beautiful yet mutable world.

As the view of nature that underpinned his vision receded from view in the course of the eighteenth-century Enlightenment, the optimism of even his darkest canvasses was easily overlooked. Hence his pictures were seen as the projection of a melancholy temperament, rather than as expressions of his astute observation and deeply spiritual understanding of his subject. As Reyer Anslo had written in tribute to a Dutch landscape painter far inferior to Ruisdael: 'The painter depicts what is visible, the spirit will be engaged by it, since Nature, God's daughter, is rich in meaning.'

Some wider conclusions concerning the relationship between representation and meaning in landscape painting may also be drawn from this study. It is evident that images yielded by observable reality can and do embody preconceived ideas about the nature, value and meaning of what is depicted. A painted image, however realistic in appearance, is always a realised abstraction, that, fusing observation and reflection, is structured and represented according to a set of notions and values in the artist's mind. However deliberate or half-conscious the meaning of an image may have been, its use is always a thoughtful and sensitive human response to observed reality arising in and stimulated by a specific context. This will in turn be appreciated by the beholder, to a greater or lesser degree, according to the context in which it was made, bought and used. This context inevitably provokes in the beholder's mind a number of connotations in association with any given image, which are not necessarily aroused in the mind of someone outside that context.

For the present day viewer to discover something more of how these works were originally experienced, a full awareness of the relevant context is desirable. This context will vary and inevitably remain a question of judgment. The meanings embodied in landscape paintings can be pursued both in noting the selection of motifs and in the artistry with which aspects of nature have been manipulated and represented, inviting the beholder to look and reflect in certain ways. Such attention to artistry must, so far as is possible, be guided and controlled by whatever can be discovered of prevailing contemporary attitudes and pictorial conventions. Such an approach is inevitably imprecise and inconclusive, but it will enhance our appreciation for the work, while leaving the door ever open to new discoveries and fresh responses.

Notes

The full titles of books, articles and catalogues cited in abbreviated form will be found in the Bibliography, where exhibitions are listed under place. A list of other abbreviations used in the text and notes is given on p. 230.

Chapter I

1. Houbraken, III, pp. 65–66: '*JAKOB RUISDAAL, een groot vrient van* N. Berchem, was een Haarlemmer van geboorte, maar heeft de meeste van zyne levensjaren in' Amsterdam doorgebragt. Zyn vader die een Ebbenhoute Lystemaker was, had hem in zyn jeugt de Latynsche taal laten leeren, en verders in de wetenschap der Medicynen doen oeffenen, daar in hy zoo ver gekomen was, dat hy verschieden *manuale operatien* in Amsterdam, met veel roem gedaan heeft. Dog is tot Haarlem gestorven in 't jaar 1681, en begraven op den 16 van Slachtmaant, als my aan een der begravenis briefjes gebleken is. Hy schilderde inlandsche en buitenlandsche landgezigten, maar inzonderheid zulke, daar men 't water van d'een op de andere Rots, ziet neder storten, eindelyk met geruis (waar op zyn naam schynt te zinspelen) in en door de dalen, of laagtens zig verspreid: en wist de sprenkelingen, of het schuimende water door het geweldig geklets op de rotsen, zoo natuurlyk dun en klaardoorschynende te verbeelden, dat het niet anders dan natuurlyk water scheen te wezen. Dus heeft hy ook het zeewater weten te verbeelden, waneer 't hem luste eene onstuime zee, die met geweld van ryzende golven, tegens klip en duin aanbruisd, op het paneel te brengen. Zoo dat hy in die wyse van schilderen al van de beste is geweest. Egter heb ik niet konnen bemerken dat hy 't geluk tot zyn vriendin gehad heeft. Hy bleef tot het einde van zyn leven ongetrouwt; men zeit: om zoo veel meer dienst, aan zyn ouden vader te konnen doen'.

2. Houbraken's notice on Jacob van Ruisdael is followed by a shorter notice on Salomon, whom he took for Jacob's brother, and thereafter by a notice on a disreputable character called Ludowyk Smits, whom he introduces with the comment that 'it frequently happens that good painters are not the most fortunate, whereas experience shows that others of lesser ability have made great profits, because they knew how to apply their pencil according to the inclination or desire of the people of the period in which they lived' ('t Beurt dikwils dat de braafste Schilders de gelukkigste niet zyn, daar en tegen heeft de ondervindinge ons doen zien, dat anderen van min bekwaamheid groote winsten hebben gemaakt, om dat zy hun penceel wisten te vlyen na de geaardheid of zinlykheid der menschen van die eeuw, waar in zy leefden'). (Houbraken, III, pp. 66–67). In thus giving continuity to his narrative, Houbraken indirectly acknowledges Ruisdael's merit and artistic integrity, and also shows that he saw Ruisdael's misfortune as pecuniary, and not merely that he was unmarried. For Houbraken on Jan Griffier, see *Ibid*, III, pp. 357–60, on p. 358: 'Door zyn byzonderen yver en vlyt tot de Konst maakte hy zig by elk bemint, zoo dat hy somwyle toegang vont om der braafste meesters werken van zyn tyd te zien, als Lingelbach, Ad. van Velde, Ruisdaal, en Rembrandt'. *Ibid.*, p. 360: '. . . somwyl zyn penceel liet zwieren naar den wint van voordeel, dan eens op de wyze van Rembrandt, dan eens op de wyze van Poelenburg, Ruisdaal en anderen, zoo dat zyn werken dikwils voor egte stukken van die meesters verkogt zyn geworden'. An example of Griffier's imitation of Van Poelenburgh is the *Ruins and Bathing Nymphs* (Cambridge, Fitzwilliam Museum, No. 393; Stechow, 1966, Fig. 337). No painting by him in the style of Ruisdael has so far been located, but inclusion of Ruisdael among those worth copying reflects high contemporary estimation for him. He is grouped with the respected Italianate painters, whose works were consistently more highly rewarded.

3. Wijnman, p. 270. Wijnman's three articles in *Oud-Holland*, (*op. cit.*), provide a comprehensive account of the Ruysdael family, and its known branches, and summarises most of the currently known biographical material on the artist and his relatives.

4. *Ibid.*, pp. 51–60, & pp. 270–75. Positions in guilds may not have been included among public offices from which Mennonites were legally excluded.

5. *Ibid.*, pp. 51–52, 258–61, 271, noting, *inter alia*, the marriage of the painter Jacob Salomonsz. van Ruysdael to his cousin from Alkmaar.

6. Bredius, *Oud-Holland*, XXXIII, 1915, pp. 19ff., quoted Wijnman, p. 56

7. Ampzing, 1621, fol. E, r, quoted by Keyes, 1975, I, p. 12 & n. 25 in Dutch with English translation.

8. See Bengtsson for an account of the rise of realistic landscape painting in this period.

9. Protocol of notary W. van Trier of Haarlem (103, fol. 133, v.), published Bredius, *K-I*, II, p. 617 and quoted by Wijnman, p. 58.

10. Rolls of the Kleine Bank van Justitie (Inv. Haarlem, II, 1918, reg. 214, fol. 201, 203, 204 v.), quoted by Wijnman, p. 58. Isaack's second marriage, of 1628, is registered in the Alderman's Marriage-book, and quoted by Wijnman, p. 58.

11. The declaration of 1661 was published by Bredius, *Oud-Holland*, VI (1888), p. 21. But the ages of the other parties to the deed have subsequently proved to be inaccurate (Wijnman, p. 59, n. 1).

12. Obreen, *Archief voor Nederlandsche Kunstgeschiedenis*, 1877–78, I, pp. 235–92, quoted by Simon, 1935, p. 280.

13. Bredius, *Oud-Holland*, XXXVII (1919), p. 126, and quoted by Simon, 1935, p. 280

14. Bredius, *Burl. M.*, LXVII, 1935, p. 178, disputes that Isaack had the status of a painter, citing the 1634 dispute with the guild over Van Goyen. Simon, in reply, (Simon, 1935, pp. 279–80), questions Bredius's interpretation of this document, and supports his argument from the usage of the new *Ordonnantie* of the guild of 1631, and from the significance of Jacob being described as 'eldest son', on entering the guild in 1648. For the paintings by Isaack, see Bredius, *K-I*, I, 2, and *Oud-Holland*, XXXIII, 1915, p. 20, and referred to by Simon, 1935, p. 8, being a *Summer* and a *Winter* landscape in the inventory of an estate at Haarlem, dated 23rd June 1636; two small round pictures in the inventory of the Haarlem genre painter Jan Miense Molenaer, who died in 1668; and a further painting by Isaack recorded in September 1669 as being at Haarlem.

15. Simon, 1935, p. 8, compared Van Goyen's *Country Road* (Munich, No. 6398) of 1629 to the *Country Road* (Stockholm, No. NM 1173; catalogued as Gerrit van Hees, and falsely signed 'M.Hobbema'), which he attributed to Isaack van Ruysdael. The attribution to Hees was made by Hofstede de Groot and also by Bredius.

16. For the 1640 sale, see Van der Willigen, 1870, pp. 253f; and for the 1642 petition, see Bredius, *K-I*, VII, pp. 163–65.

17. For his remarriage and daughter's birth, see Wijnman, pp. 58–60 & 266; for Cruys, see

Bredius, *Oud-Holland*, XXXIII, 1915, p. 22, quoted by Wijnman, p. 174. For Cruys's stylistic links with the monochrome still-life painters, see N.R.A. Vroom, *Het Monochrome banketje*, Amsterdam, 1945.

18. For guild regulations, see note 12 above.

19. Vincent Laurensz. van der Vinne, *Naamlijst van Haarlemsche Schilders*, M.S. in 18th century hand, Gemeente Archief, Haarlem, quoted by Van der Willigen, 1870, pp. 253–61.

20. See note 14 above.

21. See Chapter IV below.

22. Houbraken, III, 321. According to the approximate birth date of Koene, this must have been in the early 1650s. Koene was born around 1637–40, giving his age on 18 January 1666 as 26 years, on 11th August 1677 as 40 years and he died in 1713 (see Thieme & Becker, XXI, 1927, p. 142, and Simon, 1935, p. 17).

23. See Chapter IV, note 7 below.

24. The possibility that he made at this time his first drawings of *The House Kostverloren on the Amstel near Amsterdam*, as it appeared before the fire of 1650, has now been convincingly discounted by Slive, 1988, pp. 132–68. See Chapter VII, note 4.

25. *View of Rhenen* (Leningrad, Hermitage, No. 5531; Giltay, 72) and *View of Rhenen* (Berlin-Dahlem, No. 14712, formerly Hermitage; Giltay, 21). The relationship of the painting, *The Banks of a River* (Edinburgh, National Gallery of Scotland, No. 75), dated 1649, to Rhenen's topography is discussed in Chapter IV below.

26. For Berchem's life, and the question of his travel to Italy, see Maclaren, p. 20, as modified by Blankert, 1978, p. 147, and see further, Sutton, 1987, p. 262.

27. There are many dated works by Ruisdael in the years 1646 to 1653, but none surviving from 1650, which, given the further evidence, suggests absence from the studio at this time. The *Country Road with Cottage* (Ksth. S. Nystad, The Hague, 1973, ex. F. von Mendelssohn Coll., Berlin; Ros. 488, illus.; Simon, 1930, illus. 3), which bears a signature and date 1650, is too weak in draughtsmanship to be considered authentic. More concrete evidence for dating their trip to 1650 is a drawing by Berchem of *Bentheim Castle* (Frankfurt, Städelsches Kunstinstitut) dated 1650, while Ruisdael made a painting, *Landscape with Bentheim Castle* (formerly Bremen, destroyed W.W. II) from the same viewpoint. Furthermore, on 22nd March 1649 (aged 28), Berchem made a Will (Sutton, 1987, p. 262), which may anticipate the perils of foreign travel.

28. The British Museum drawing, No. 1895.9.15.1926, was Exh., Amsterdam-Toronto, 1977, No. 78, as dated 1650–1660. Giltay, 1980, No. 76, dated it (p. 154): 'probably from around the mid-fifties'. Giltay (p. 151) dates the Stuttgart drawing

of the ruins of Egmond Castle, on stylistic grounds, 'around 1655'. But dating of these drawings is speculative, with little concrete evidence to provide any precise dating. For the dating of the *Jewish Cemetery*, see Chapter V below.

29. Bredius, *K-I*, VI, 1696, quoted by Wijnman, p. 176.

30. Rosenberg, 1928, p. 35ff, noting 1657 as the first record of Ruisdael in Amsterdam (when he requested baptism), and the date of 1657 on the *Windmill by a River* (Detroit, Institute of Arts, No. 53.352), which he took as representative of a group of similar *River Landscapes*, suggested that Ruisdael's move to Amsterdam was marked by a temporary break in his heroic style and the introduction of more realistic elements, such as these river scenes. The signature and date of 1657 on the Detroit painting subsequently proved to be false, eliminating the need to follow Rosenberg's theory, which goes against the further evidence of Ruisdael's works.

31. Protocol of the Church Council of the Reformed Church, Amsterdam, IX, fol. 207, quoted Wijnman, p. 176.

32. Wijnman's careful accounting for the various known members of different branches of the Ruysdael family supports this view. The baptism may have taken place at Ankeveen, near Naarden, because of his family links with the area, which also features in his paintings.

33. Howell, p. 26, and Feltham, p. 53, both quoted by Regin, p. 40.

34. Scheltema, VI, p. 95 (for Ruisdael), and *Idem*, IV, p. 64 (for Van Everdingen).

35. Bredius, *Oud-Holland*, XXXIII, 1915, p. 194f., and see further Wijnman, pp. 179–80 (for Hobbema's pupilage); and Wijnman, p. 180 (for Hobbema's marriage).

36. Maclaren, p. 206.

37. See act of notary Jac. Hellerus of Amsterdam, published by Bredius, *Oud-Holland*, VI, 1880, p. 21f., and Bredius, *K-I*, I, p. 348, quoted by Wijnman, p. 180.

38. Protocol of notary A. Oosthoorn of Amsterdam, published by Bredius, *Oud-Holland*, XVIII, 1900, pp. 181–82, and quoted by Wijnman, p. 180. Ruisdael's painting sold for fl. 60, compared to fl. 12–42 for the others.

39. De Keyser introduced this type of small, equestrian portrait in his later years. A dated example of 1660 is in Amsterdam, Rijksmuseum, No. A697. As Cornelis de Graeff died in 1664, a date between 1660 and 1664 is likely for this picture.

40. *Oud-Holland*, XXX, 1912, p. 199, quoted Wijnman, p. 181. the paintings cannot now be traced, unless they are to be identified with his two paintings of *A Country House in a Park* now in the National Gallery of Art, Washington and Berlin-Dahlem Museum, which however is unlikely, given

the inclusion of Norway spruces and lack of a topographical character in these paintings.

41. Wijnman, p. 259, with more details than the earlier publication in *Oud-Holland*, III, 1885, p. 312. For details of Kick (c. 1631–1681), see Bernt, 1948, II, p. 450; Cat. of the Ward Bequest, Ashmolean Museum, Oxford, 1950, No. 49, illus; Bol, 1969, p. 311ff.

42. Houbraken, II, pp. 333–34.

43. Bredius, *Oud-Holland*, XXXIII, 1915, p. 23ff., quoted Wijnman, pp. 258–59.

44. Van der Willigen, 1870, pp. 255–56.

45. Houbraken, III, p. 239.

46. Floerke, p. 108, and Albert Blankert, *Vermeer of Delft: Complete Edition of the Paintings*, Oxford, 1978, pp. 9–10.

47. The Register is preserved at the Municipal Archives, Amsterdam, and the extract was published in the *Algemene Nederlandse Familieblad*, No. 14 (1883), 5b. The entry was subsequently deleted, but his name is listed clearly and chronologically between the names of others presenting their credentials. The orthography of his family name is consistent with contemporary usage. Wijnman, pp. 261–62, notes that the registers of the faculty of medicine at Caen University commence only in 1702.

48. For the van der Hulk sale, see Immerzeel, pp. 41–42: Catalogue of the Johann van der Hulk sale, Dordrecht, 23 April 1720, lot no. 30: 'Een zeer kunstige Waterval en landschap door Doctor Jacob Ruisdael, heerlijk en plaisant geschildert' ('A very fine waterfall and landscape by Doctor Jacob Ruisdael, delightfully and splendidly painted'). For the connection between Houbraken and Van der Hulk, and the medical profession, see Houbraken, II, pp. 113–14 (for his personal comments on Van der Hulk and his collection), and further Simon, 1935, b, pp. 132–35, for Houbraken's own marriage. For Houbraken's contact with Jacob van Walscappelle, still then living in Amsterdam, see above and Houbraken, II, pp. 333–34. That Ruisdael, according to Houbraken, received 'great fame' as a surgeon, which is unlikely to be a complete fabrication, also indicates that his practice was well know.

49. Bredius, *Oud-Holland*, XXXIII, 1915, p. 25, published the deed placed before the Amsterdam Notary Cornelis Akerboom Doedens on 5 October 1682 by Ruisdael's heirs. It contains details of the loan to Dr Lamsweerde. (Notarial Archive, Amsterdam, reg. no. 4036). It is reproduced in full by Wijnman, p. 266, who adds details concerning Lamsweerde's dispute over medical practices, pp. 263–64.

50. See note 49 above.

51. See Chong, in Sutton, 1987, pp. 104–20, on the Dutch art market for landscape paintings, also giving comparative tables of prices for different types of landscapes, and for different artists, with commentary on

the type of patronage for these different artists and landscape types.

52. Three Ruisdaels are recorded in a Leiden inventory of 1653, and two in the estate of the Amsterdam art-dealer Pieter van Meldert, who died on 1 October 1653, see Wijnman, p. 176, from unpublished information supplied by Bredius (the Leiden inventory); Bredius, *K-I*, VI, p. 1696, quoted Wijnman, p. 176 (the Amsterdam inventory).

53. Protocol notary P. van Tol of Amsterdam, published by Hofstede de Groot, 1906, No. 232, and quoted by Wijnman, p. 268.

54. For the loss to the Spaaroogh collection, see the *Amsterdamsch Jaarboekje*, 1899, p. 152 and Professor Brugmans, *Geschiedenis van Amsterdam*, III, 1930, p. 773, with comments by Wijnman, pp. 259–61. For the Herman Becker collection, see Chong, in Sutton, 1987, p. 110. For the Douci collection, see Bredius, *K-I*, II, pp. 422–25, quoted by Wijnman, p. 268. For the estate of Mathijs Hals, see Hofstede de Groot, 1906, No. 250: 30 March 1662, Inventory of Mathijs Hals and his wife Maria de Bary, formerly living in Pijlsteegh, Amsterdam, who died shortly after one another. (From Ined. A. Bredius, Protocol Notary Nic. Listingh). The first painting listed, among many works by Haarlem painters, was a *Merry Company* by Dirck Hals, to whom Mathijs was probably related.

55. For the Asselijn collection, see Hofstede de Groot, 1906, No. 294, of 23 July 1667, and for the relationship of Thomas and Jan Asselijn, see *Idem*, No. 163; for Jan Post's estate, and for that of the baker, who died in 1660, see Wijnman, pp. 268–69, from unpublished information supplied by Bredius; and for Peter Mundy's comments, see Mundy, p. 70.

56. See Chong, in Sutton, 1987, pp. 104–20, as per note 51 above. The evidence of size as a determinant in probate valuations can be seen from the descriptions, sizes, and valuations given on 18 January 1669 by the prominent portrait painter Ferdinand Bol and the Amsterdam art-dealer Gerrit van Uylenburgh of the four Ruisdaels in the large Amsterdam collection of Laurens Mauritsz. Douci, three of them *Waterfalls*, and the fourth a *Haarlempje*: the *Haarlempje*, certainly the smallest of the four, was valued at fl. 24, one of the *Waterfalls* at fl. 36, another *Waterfall*, described as 'slightly larger', at fl. 42, and the other *Waterfall* also fl. 42. Six Van Everdingens in the same collection were valued from fl. 12 to fl. 80. (see Bredius, *K-I*, II, pp. 422–25, quoted Wijnman, p. 268). It should also be noted that probate valuations normally were lower than a painter's sale price, or current market value.

57. For a comparison of the value of Ruisdael's paintings to those of other landscapists, see

Chong, *op. cit.*; and for specific details, see also Wijnman, pp. 180, & 268–69 (drawing on Bredius, *K-I*, I, p. 101, & II, pp. 422–25, Bredius, *Oud-Holland*, XVIII, 1900, pp. 181–82, other unpublished information from Bredius, and on Hofstede de Groot, 1906, No. 232 & 344) listing comparisons of valuations between Ruisdael and other landscapists in the estate of Jan Willemsz. Bus (1660); the sale of Adriaen Banck's collection (1660); the estate of a baker (1660); the estate of Mathijs Hals (1662); the Alebrant sale (1664); the estate of Thomas Asselijn (1667); the Douci collection (1669); the estate of the widow of Isaack Swartepaert of Amsterdam (1670); the 1673 marriage settlement of Daniel Wulfraet of Amsterdam, including a large range of landscapes, of which Ruisdael's, at fl. 100 is not only valued the highest, but also considerably higher than those of the esteemed Italianates: Berchem (fl. 36), De Moucheron (fl. 70), and Dujardin (fl. 80), and of Philips Koninck, whose works were consistently highly valued, (fl. 60); the estate of the Amsterdam merchant Hans aux Brebis, containing many paintings (1678); the estate of the Amsterdammer Jacob Reyersz. (1682); and the estate of Jan Post (1684).

58. Brom, pp. 173–75 and 206–7. Brom, pp. 209–14, assumes that Vondel disliked the art of Ruisdael, Van Goyen, and Hobbema, although Vondel nowhere states this, whereas in his *Lucifer* of 1654 he had written of northern waterfalls in terms that accorded with paintings of Van Everdingen and later of Ruisdael (see Chapter VI, note 12).

59. For instance, Ampzing, 1628, p. 368 (Transl., Keyes, 1975, I, p. 12) praises Cornelis Vroom as occupying 'the crown of your City and Father'. Likewise Schrevelius, 1647 (quoted Keyes, 1975, I, p. 13) praises C. Vroom as the equal of his father and surpassing all who live. In like manner Vermeer was compared to Fabritius in Bon's poem included in Dirck Bleyswyck's *Beschryvinge der Stadt Delft* (printed by Arnold Bon), Delft, 1667.

60. Luyken, 1708, pp. 90–93 (esp. p. 92).

61. Fromentin, 1948 (1st Edn. 1876), pp. 136–46 (on p. 139).

62. For example, Leymarie, 1956, pp. 110–16; Janson, 1962, p. 430; and Stechow, 1966, p. 111 and *passim*.

63. Brom, p. 211.

Chapter II

1. Félibien, III, pp. 298–99, & V, pp. 161 & 204.

2. Reynolds, I, pp. 358–59. Reynolds discusses the Dutch school in his Fourth and

Sixth Discourses and in *A Journey to Flanders and Holland*.

3. Dumesnil, pp. 83–84, referred to by Ten Doesschate Chu, p. 13, n. 2.

4. Thoré-Bürger, 1858–60, I, p. 323, and see also *idem*, 1865 (1st Edn. 1860), pp. 288–90.

5. Fromentin, 1948, (1st Edn. 1876), pp. 97, 108–116 (on 108), and also pp. 136–46.

6. Bengtsson, p. 27 & n. 43, pp. 38–44, 54–55, & 74. See also Clark, 1976 (1st Edn. 1949), pp. 59–65; *idem*, 1969, pp. 193–201; Janson, 1963, pp. 399 & 429, and especially Alpers, I, IV, and *passim*.

7. Slive, 1962, pp. 469–500 (esp. 484, 487, & 500).

8. Ros./Slive, p. 168.

9. *Idem*, pp. 240–64 (esp. pp. 240, 242, 252, & 262–64).

10. Stechow, 1966, pp. 10–11.

11. See the contrasting views of Bruyn, Schama, and Sutton in Sutton, 1987, and, for a discussion of the motivations and context of the early seventeenth-century Dutch landscape printmakers, see Freedberg, pp. 9–20; and see also Haak, pp. 134–43, esp. p. 142.

12. Van Mander, *Levens Ned.*, 1604 Edn., 233r (1618 Edn., 153 r.a-154 r.b (on 153 v.a), with comments of Miedema, 1973, pp. 437–38; Huygens, *Autobiography*, p. 73; Anslo, pp. 169–70, quoted Beening, p. 226; Houbraken, *passim*.

13. Van Mander, *Grondt*, VIII, 12 (re. Apelles), and VIII, 34: 'Word hier Echo, en boots, o penselen, ook het gedruis van het water na, dat zich razend tussen verweerde stenen naar beneden stort' (From Miedema Edn., 1973). (Here be Echo, and also imitate, oh pencil, the roar of the water, that tumbles down between weathered stones.) Miedema, 1973, p. 555, notes that Van Mander refers to an epigram of Ausonius, in which the painter is challenged to paint the invisible Echo, a challenge related to the concept of painting as silent poetry. If the painter can paint so well as to evoke the sound of waterfalls, then painting is no more silent, but almost speaking poetry. Houbraken, III, pp. 65–66, probably with this same concept in mind, says that Ruisdael painted landscapes in which one sees water crashing down between rocks to spread out *in a roar* (*geruis*) into dales ('*dalen*'), thereby also alluding to his own name.

14. Angel, p. 41. De Jongh, 1976, pp. 14–16, notes that Angel made more than one reference to the eagerness of the public for natural imitation (Angel, pp. 39, 40, & 43), and concludes that there must be a relationship between public estimation for the 'illusion', the deceptive reality of Dutch paintings, and the choice for 'realism' of seventeenth-century Dutch painters. For Oudaan on Porcellis, see: Joachim Oudaan, *Poezy*, Amsterdam, 1712, II, pp. 115–16 (from a collection dated 1646).

15. Van Hoogstraeten, 1678, p. 25, quoted by De Jongh, 1976, p. 14. See, for example, Van Hoogstraeten's *Peepshow* (London, National Gallery, no. 3832), and *Still-life* of 1655 (Vienna, Akademie der bildende Künste).

16. For Van Mander's use of the term *naar het leven*, see *Grondt*, II, 13–15; V, 10: VIII, 9, 37; IX, 12; *Levens Ned.*, 1604 Edn.., 223r (1618 Edn., 153r.a-154 r.b (on 153 v.a), re Pieter Bruegel as one who could follow Nature so naturally ('soo eyghentlijck . . . de Natuere nae volghen'). See further Miedema, 1973, pp. 303, 345, 348, 435–36, & 467. For Van Mander's use of the term, 'uyt zijn selven doen' (rendered by Miedema: 'uyt den gheest'), see Van Mander, *Grondt*, II, 13–16, and *Levens Ned.*, *op. cit.*, for Pieter Bruegel as a landscapist who worked from the mind while following Nature. See also Miedema, 1973, pp. 414, 435–36, 437–39, 467, 570, & 594. The relationship between observation and imagination in Dutch landscape painting is also discussed by (*inter alia*) E. Haverkamp Begemann, *Willem Buytewech*, Amsterdam, 1959, p. 37; Stechow, 1966, *passim*; De Jongh, 1971, pp. 150–52; Fuchs, 1973, pp. 281–92; and Sutton, 1987, pp. 1, & 10–11.

17. Van Mander, *Grondt*, II, 15b, describes earthly things as representing, 'De Natuer in 't leven'. See Miedema, 1973, pp. 436–37, commenting on this, and further, *idem*, pp. 449 & 467 for Van Mander's conception of the relationship of the visible to the invisible world. See also Miedema, 1975, pp. 2–18 (esp. 5–7 & 10–11), in which Miedema, basing himself partly on Dirk V. Coornhert's *Zedekunst dat is Wellevenskunste*, . . . (w/o loc., 1586), which distinguishes insight from mere observation, points out that to 'draw from nature' would mean to a Dutch artist (such as Jacques de Gheyn) more than merely setting down what one sees, but rather is a combination of observation and a comprehension of the essence of things.

18. Van Hoogstraeten, 1678, p. 238.

19. For Van Mander on Bruegel, see n. 16 above. Houbraken, III, 274: 'de Konstenaars, die de zelve *natuurlykst* en *welstandigst* hebben weten te verbeelden hebben den groosten roem behaalt . . .' (emphases mine). Both Van Mander (*Grondt*, IV, 1d) and Houbraken (III, p. 274) used the term *welstand*, which, in Miedema's view (1973, pp. 448–49) is comparable to 'Decorum', the quality of representing something in a fitting manner, and so governed by the painter's understanding of his subject.

20. For Bengtsson, see n. 6 above. For Alpers on Vermeer, see Alpers, pp. 122–23 (with comments by E.H. Gombrich, 'Mysteries of Dutch Painting', *The New York Review of Books*, No. 10, 1983, pp. 13–17). For Alpers on De Gheyn, see Alpers, pp. 5–8, & 85–

90, and *passim*, for her overall view of the relationship between Dutch painting methods and the new science. With respect to seventeenth-century scientific conceptions of nature, see n. 23 below.

21. See Gombrich, n. 20 above.

22. Houbraken, III, p. 278. Likewise C.J. Visscher offered his series of engraved landscapes, 'Plaisante plaetsen, . . .' of *c.* 1608, as a means of enjoying nature without leaving one's home. It is striking that, in this context, Houbraken states, as Federico Borromeo had done one hundred years earlier, that therefore the closer the artists approximated reality, the more effectively their works served as surrogates for contemplation of the real thing. (For Borromeo, see n. 26 below). For other factors contributing to the 'realism' of Dutch landscapes, see Miedma, 1975, pp. 9–10; Schama, pp. 64–83, in Sutton, 1987; Sutton, 1987, pp. 1–2, 8–16, & 23ff; and Freedberg, pp. 9–20.

23. De Jongh, 1971, pp. 143–94 (esp. pp. 143–46), and pp. 150–52; Wiegand, *passim*, Fuchs, 1973, pp. 281–92. See also Kouznetsov, pp. 31–41; Kauffmann, 1977, pp. 379–397; Raupp, pp. 85–110; Haak, pp. 136–42; Sutton, 1987, pp. 12–13; and for a more extreme expression of this view, Bruyn, in Sutton, 1987, pp. 84–103. As to the widespread influence of religion on seventeenth-century perceptions of nature, whatever the influence of the new scientific methods on Dutch painters may have been (see Bengtsson and Alpers, n. 20 above), it seems that even for many of the scientists themselves, nature was not regarded in purely mechanistic terms to the exclusion of God. Robert Boyle, for instance, said that the man who compares the world with the clock of Strasbourg, could accept a God as a creator *and sustainer* of it (emphases mine) (R. Boyle, *A Free Enquiry into the Vulgarly Receiv'd Notion of Nature*, London, 1685/6, Sect. I, quoted by Hooykaas, p. 14 & n. 32). Hooykaas, pp. 13–16, discusses the compatibility of the mechanistic world picture of seventeenth-century scientists with a biblical world view. He also argues (p. 109) that it was only when, 'the methodological principle of causality passed from science into thoelogy', that determinism and deism took place. Similarly, Paul Hazard, *The European Mind 1680–1715*, Harmondsworth, 1964 (1st Edn., Paris, 1935, as *La Crise de la conscience européenne 1680–1715*, 2 Vols.), observes that a secularisation of thought and a shift in the intellectual assumptions of educated classes took place only in the very last decades of the seventeenth century and the first decades of the eighteenth century. Discussion of comets, for instance, in Balthasar Bekker's *Ondersoek van der Betekeninge der Komeeten*, 1683, also demonstrates that even the most 'en-

lightened' and rational of men still believed that natural phenomena revealed the glory and might of God. See further, n. 56 below. For the influence of religion on the perception of nature in Dutch literature, see Beening, *passim*, and Van Veen, *passim*; and with respect to genre painting, see for instance, Amsterdam, 1976 and Philadelphia, 1984; and with respect to still-life painting, Bergstrom, and Münster—Baden–Baden, 1979.

24. De Jongh, 1967, pp. 5–8, and 20–22, and *idem*, 1971, pp. 143–94 (esp. 143–46), and 150–52. For Visscher's maxim, see Roemer Visscher, *Sinnepoppen*, Amsterdam, 1614, 1 (modern re-print: I. Brummel, The Hague, 1949). See Schama, in Sutton, 1987, pp. 67–68, for the view that, on the contrary, the Dutch landscapist represented the particular *unlinked* from the universal.

25. *Belijdenis des Geloofs der Gereformeerde Kerken in Nederland*, Artikel 2: '. . . (de wereld) voor onze ogen is als een schoon boek, in hetwelk alle schepselen, grote en kleine, gelijk als letteren zijn, die ons de onzienlijke dingen Gods geven te aanschowen, namelijk, "zijn eeuwige kracht en Goddelijkheid", als de Apostel Paulus zegt, Rom. 1.20 . . .'. That God may be known through the creation, sustenance and government of the world is stated further in Article 1 of the *Belijdenis* and in the *Catechismus*, 9th Sunday; and for references to the Fall, and the consequent corruption of all earthly matter, see the *Belijdenis*, Articles 14 & 15, and *Catechismus*, 3rd Sunday; and for further reference to God's continuing sustaining providence, and the rejection of a purely mechanistic view of the universe, see the *Belijdenis*, Articles 12 & 13, and the *Catechismus*, 10th Sunday. From these and other sources one sees that one area where the religious outlook of the period most differs from that of later generations is in the view of God as the constant, omnipresent sustainer and ruler of life, which leaves its mark on the art and literature of the period.

26. See Jones, 1988, pp. 261–72.

27. Beening, pp. 452–68. Spiegel, Bk. V, lines 34–36: 'dit schepselboek . . . en ellik schepsel zelf een letter daar in es'. Huygens, IV, p. 307, lines 1601, 1599: 'het wonderlicke Boeck van sijn' sess wercke-dagen', 'het Boeck van alle dingh'. Luyken, 1771 (1st Edn., 1711), unpaginated Introduction: 'Leer leezen uit het groote Boek der dingen . . .'. Spiegel also wrote in *Hertspieghel*, V, lines 105–08, that for a knowledge of truth, one must learn first to read in the book of creation, without which all knowledge is null: 'Ghelijk ook niemand zonder letter-kund kan lezen,/Zo moet, voor waarheids kennis, noodlik by u wezen/ Eerst schepsel-letter-kund. Want zonder haar bediet/Wel grondigh te verstaan, is alle kennis niet'.

28. Cats, *Alle de werken* . . ., pp. 565–66: 'Men kan, waer groente wast, den grooten Schepper eeren . . . Wie in de velden voeght sijn oogen met de reden,/Die vint'er menigh dingh ten goede van de zeden'.

29. See also De Jongh, 1971, pp. 148–49. He refers, *inter alia*, to Johan van Beverwijk of Dordrecht, who wrote that nothing is present in the spirit that has not previously been an object of experience and passed through the senses (*Schat der Gesontheydt, Schat der Ongesontheydt*, II, Edn. Utrecht, 1651, 1). See also Hans Kauffmann on the five senses in Dutch art, in H. Kauffmann, 'Die funf Sinne in der Niederländischen Malerei des 17. Jahrhunderts', *Kunstgeschichtliche Studien. Dagobert Frey zum 23 April 1943*, Ed. Hans Tintelnot, Breslau, 1943, pp. 133–57.

30. Spiegel, Bk. V, lines 21–39; & *idem*, Bk. VII, lines 25–40: 'Antrekkelijk ghezicht! O schou-plaats der naturen,/ . . . Brengt zulk gevoel, ghezicht, gehoor, en reuk vermaaklik, . . . Dit schepsel boexe les leert meest beweeghlik dueght./En schaft het dankbaar hert staegh dankzeggighe vruegt'. An analogous progression from observation to contemplation is found in the works of Bredero: *Dram. W.*, I, 199, lines 67–71 & 90–92 and *Lied. en Ged.*, 258 (both quoted by Beening, pp. 95–96); Vondel, *W.B.*, X, pp. 118–19, lines 311–34 (quoted Beening, pp. 123–24); Johannes Vollenhoves *Poëzy*, Te Amsterdam, 1686, p. 179 (quoted Beening, p. 299); and later on in Poot, III, pp. 133–45 (quoted Beening, pp. 446–47).

31. Bijns, *Refereinen*, LXII, strophes 1–11; *Idem*, LXIII, (both quoted Beening, p. 35). Spiegel, Bk. V, lines 40–48; Van Lodensteyn, *Schepselen Niet en Jesus Al* (1661) in Van Lodensteyn, 1727, p. 133, (quoted Beening, p. 253); Luyken, *Hy doet my nederliggen in grazige weiden*, 1687, in Luyken, 1705, p. 143, (quoted Beening, p. 273); Poot, *Aen Godt*, in Poot, III, p. 8; and *Lantvermaek*, in Poot, III, pp. 79–85, (both quoted Beening, pp. 439–40).

32. Beening, pp. 452–68, and Price, pp. 85–89, 119ff, & 137–38.

33. Price, pp. 115–16. He also notes (89) the influence of such French writers as Du Bellay, Ronsard, and Du Bartas on Dutch literature. Du Bartas was of special importance for not only was he a Protestant, but also, as Price states, 'his contemplative verse dealt in a serious manner with religious and moral problems which were to exericse the Protestant poets of the Republic'. Price adds (p. 116) that although renaissance poetry with a religious stamp did not begin with the Dutch, in no literature was it as predominant as in that of seventeenth-century Holland.

34. These later poets, Bruin and Poot, merit quotation given the different pace of development between painting and literature, to which Beening drew attention. Their underlying outlook is consistant with that of their seventeenth-century counterparts, but their imagery is derived much more directly from the *actual* landscape, thus corresponding more closely to the earlier practice of the painters.

35. Spiegel, Bk. I, lines 103–06; Bk. II, lines 9–20; Bk. III, lines 369–78; Bk. V, lines 7–35; Bk. VII, lines 25–40; Bk. VII, lines 59–68; and see Beening, pp, 59–65.

36. Van Borsselen, 1611, *passim*, and (as a ladder), lines 1724–25: 'Laet dyne schepsels sijn een crommen wendel-trap/Die op dyn hooge woonst verheff' ons blinden stap'. Van Borsselen, 1613, *passim*, and see Beening, pp. 166–72.

37. Poot, *Mei*, in Poot, III, pp. 86–92; and *Zomer*, in Poot, III, pp. 93–98, quoted Beening, pp. 440–43. For Huygens, as quoted by Haak, see Haak, p. 136.

38. Huygens, III, pp. 78–80, and VI, 36 (quoted Beening, p. 136): 'Des Heeren goedheit blijckt aen elcken Duijn syn' top:/ Sout water roert wit sand; de stormen waeijen 't op;/Daer soo' noch slyck en holp noch geen geweld van delven,/Heeft God de zee belast, Gaet en bedijckt u selven'. ('The Lord's goodness is manifest on the top of every dune:/ Salt water stirs white sand; storms blow it up;/So just with earth, unaided by the toil of digging,/Has God restrained the sea; go and embank yourselves'). This fusion of observation and reflection in Huygens's thinking, which is paralleled in the art of his friend Jacques de Gheyn, needs to be born in mind when evaluating the thesis of Svetlana Alpers's *The Art of Describing*.

39. Cats in *Spiegel van den Ouden en Nieuwen Tijdt*, 1632, from *Alle de werken* . . ., p. 342, quoted Beening, p. 160; also in *Ouderdom en Buytenleven* (written 1653–56), from *Alle de werken* . . ., pp. 562–64, and see Beening, pp. 160–64.

40. For Vondel, see Vondel, WB, IX, p. 521, lines 385–91, and *idem*, WB, X, pp. 118–19, lines 311–34; for Luyken, see his *Vonken der Liefde Jezus*, 1687, 1705 Edn., p. 63, quoted Beening, pp. 272–73.

41. Bruin, 1730, 1st Edn. 1716, pp. 11–13, and see the Dedication in the same, and see further Beening, pp. 389–91.

42. Bredero, *Dram. W.*, I, 199, lines 67–71 & 90–92 (quoted Beening, p. 95): 'No things so slight, so frail,/ That we cannot learn from them, . . . consider the beautiful flowers,/ Examples to mankind, how enjoyable they are,/ How uncertain, how soon they fall to earth again'.

43. Van Lodensteyn, 1727, 1st Edn 1676, p. 145 (quoted Beening pp. 246–47): 'Den Hof die u den geest vermaackt/ Is slijck en aard . . ./ Dat bloemtje . . . morgen daalt,/ . . . Dien boom . . ./ Staat nu geknaagt van rat of worm,/ . . . Siet! siet! wereld en al is niet'.

44. Bruin, *Gezang, op het vervallen kasteel te Wijk te Duurstede*, in Bruin, 1730, 1st Edn. 1716, p. 133 (quoted Beening, pp. 402–03): 'De schoonste pracht der hoven,/ Net naar de konst gebouwt,/ Moet door den tyd verdooven,/ Indien men 't steeds beschouwt./ Natuur walgt van die dingen,/ Die altyd voor haar staan,/ Zy mint veranderingen,/ . . .'. ('The most beautiful splendour of country houses,/ built with such art,/ Must be deadened by time,/ If one comes to think of it./ Nature loathes things,/ that always stand before her,/ she loves change, . . .'). Bruin's sentiment concerning the impermanence of man's works echoes a comparable sentiment inscribed almost one hundred years earlier on Jan van de Velde's etchings (after Pieter Saenredam) of the ruins of Brederode Castle and of the Huis te Kleef made for Samuel Ampzing's 1628 praise of Haarlem: see Ampzing, 1628. Sutton, 1987, p. 24, mentions that the sites are also associated with the Dutch struggle for independence. While the latter sentiment was topical in 1628, the former held a more lasting place in Dutch thought, as Bruin's lines demonstrate.

45. Poot, III, 106–13 (quoted Beening, pp. 444–46). Note Poot's concluding sentiment in these lines: '. . . Zoo laet ons dan, terwyl we hier nogh zyn,/ De deugt uit vreugt, de vreugt uit deugt doen ryzen./ Ja laet ons zoo, by 's levens zonneschyn,/ Godts weldaen bly genieten, en hem pryzen'. ('So let us then, whilst yet we are here,/ Cause virtue to spring from joy, joy from virtue./ Yes, let us thus, with life's sunshine,/ Gladly enjoy God's benefactions, and praise Him').

46. Poot, III, 106–13 (quoted Beening, pp. 444–46): 'Zie, hoe d'Aertstroon zyn gunst nogh vallen laet/ Op nietigh stof, aeneengekleeft van zonden./ . . . 't Ryk najaer stort een' gullen overvloet/ Van ryp gewas in 't menschdoms ope wenschen . . .'. The theme of God's constant providence recurs in Poot's *Zomer* (III, 93–98, quoted Beening, pp. 442–43), where Poot recognises that God in His wisdom has given to each season its particular purpose.

47. Poot, III, 99–105 (quoted Beening, pp. 443–44): 'The thunder, lightning, wind and summer storm misses,/ Or strikes mildest and least the humble and pliant./ But you, whoever are suffering,/ Keep courage in hard times./ It is God, it is God alone, who causes tempest./ It is He, He alone, who makes it abate./ Realise without flagging, besides,/ That through those heavy notes,/ And with such a strong and frightful tongue/ The atmosphere sang to God's praise and

48. *Catechismus*, 10th Sunday, see n. 25 above.
49. Spiegel, I, lines 105, 119, 125–34. Spiegel also compares favourably the delights of his garden to the beauties of Greece (VII, 53–56). Miedema, 1977, p. 208, & n. 11, has also drawn attention to Spiegel's diatribe against allegorical poetry, and considered it as a plea for representation of the real Dutch landscape, and for recognition of God as God.
50. Bredero, *Aendachtigh Liedt*, in *Lied en Ged.*, p. 258; Hondius, 1621, *passim*, and see P.J. Meertens, *Letterkundig leven in Zeeland in de Zestiende en in de eerste helft van de Zeventiende Eeuw* (diss.), Utrecht, 1943, p. 350, and Beening, pp. 172–73.
51. Sluyter, 1716, 1st Edn. 1668, pp. 13–14 (quoted Beening, p. 255): ... Des hemels glory blinkt op 't veld,/ En word 'er sichtbaerlik vermeld...' ('The glory of heaven shines on the field,/ And is visibly manifest there ...'). Sluyter's poem expresses the traditional contrast between city extravagance and rural simplicity as 'Christianised' by D.V. Coornhert, and so adopted by Van Borsselen, Hondius, Huygens, and Cats, for which see Van Veen, 1960, *op. cit.*.
52. Bruin, 1730, 1st Edn. 1716, pp. 59–60 (quoted Beening, pp. 394–95): 'So this earth is created full of variation,/ For the use of men and cattle, that gather here their food/ According to each one's position and state ...'.
53. Spiegel, I, 135–40; Huygens, I, p. 225, lines 410–24; Van Borsselen, 1613, lines 521–36; Van Lodensteyn, *Morgenlicht ofte Jesus onsen Morgen-son*, 1727, written 1665, pp. 1–7; Sluyter, 1716, 1st Edn. 1668, pp. 10–14, and his *Morgen-gesang, als men 's Somers buyten gaet*, 1717, 1st Edn. 1661, pp. 12–14; Luyken, *De nacht is voorby gegaan, ende de dag is naby gekomen. Romans 13.12*, in *Vonken der Liefde Jezus*, 1705, 1st Edn. 1687, 211; and see Beening, pp. 142, 170, 250, 255, 260–61, & 273. The tendency to allegorise the morning sun is also found in Revius's hymn, *In 't oosten klaar laat blozen, Liedboek voor de kerken*, No. 376.
54. Poot, *Een schoone dagh...*, in Poot, III, 138–45 (quoted Beening, pp. 446–47): 'How her lustre plays through white-edged clouds,/ In space unlimited! ... Winged Day, shining clear in its parts,/ And wonderfully pleasant,/ You bring delight and jubilation down below,/ From God's happy realm./ You nourish, soothe, and bless land and water./ Through you its everywhere/ Full of life, full of movement, and peals of laughter,/ And growth, and fire, and dissolution'.
55. Anslo, 1713, p. 159 (quoted Beening, p. 222): '... Het scherpt door 't oog ons nutte lessen in,/ En volgt Natuur, Godts dochter, ryk van zin,/ En schept met verf op doeken op paneelen,/ Wat zichtbaar is, waar op de geest wil spelen'. The poem was written *c.* 1656.
56. See Hooykaas, pp. 13–16, & 98–114 (esp. 105–09), and Smith, pp. 133–34, & 176–78. For Kepler's and Bacon's reference to nature as God's second book, see Kepler to Herwart von Hohenberg, 26th March 1598, and Francis Bacon, *The Advancement of Learning*, London, 1605, Book I (both quoted by Hooykaas, 105). For Jan Swammerdam, see A. Schierbeek, *Jan Swammerdam*, Amsterdam, 1967. Haley, pp. 147–50, makes reference to both Swammerdam and Simon Stevin. See also n. 23 above.
57. Vondel, WB, IX, 521, lines 385–91: 'O lantschap, daer natuur zich zelf aen heeft gequeten,/ En elck om 't rijckst volwrocht, voltrocken, niets vergeeten!/ Wat ordineerder heeft die vonden uitgezocht,/ En elck zoo wel geschickt, en op zijn plaets gebroght,/ Den voorgront, achterdocht, dat flaeuwen, en verschieten;/ Hier bosch, daer korenvelt, gins weiden, elders vlieten,/ En ope lucht, en bron, die uit den heuvel springt?' (Oh landscape, on which nature has given herself completely,/ And everything so richly finished, consumated, with nothing forgotten!/ What Ordainer has imagined all these possibilities,/ And everything so fitting, and set in its rightful place,/ The foreground, background, that grows feint and fades;/ Here woodland, there cornfields, yonder grassland, elsewhere streams,/ And open sky, and a spring that bursts forth from the hill?').
58. Van Mander, *Grondt*, IV, 1 & 2: 'Den Hemel ... heeft d'Edel Natuer' oock willen by voegen ... De deucht der Schoonheyt, welstandich en constich, D'ooghe ghevend' een volcomen benoeghen ...'. The significance of this text, and the surrounding passage, is discussed by Miedema, 1973, pp. 447–50, with special attention to Van Mander's use of the term 'Nature', as an entity distinct from the visible world (a usage seen also in Vondel's lines quoted n. 57 above); and to Van Mander's usage of the term 'Beauty', as possessing a moral quality reflecting its origin in the true beauty and goodness of God; and also the term '*Welstandt*', as comparable to Decorum (see n. 19 above). Van Mander's sources were completely within the late Renaissance tradition, are occasionally mentioned by Van Mander himself (ie. *Grondt*, V, 26), and are discussed by Miedema, 1973, pp. 627–49. As to the modernity, however, of Van Mander's response to landscape, see Beening, pp. 50–59, & 466, where he observes that Van Mander's landscape descriptions are more developed in range, more natural, and more realistic in detail than those of his literary contemporaries.
59. Van Mander, *Grondt*, V, 20. For the pri-mary importance of the nude, see *Grondt*, II, 14. His concern for the representation of variety extends to care in distinguishing the different types of foliage and bark of trees (VIII, 36–40), and it is conceivable that his advice contributed to Dutch landscapists' move away from schematised trees towards more detailed and realistic representation.
60. For Van Mander's admiration for Pieter Bruegel's landscapes, see: *Grondt*, VI, 54a; VIII, 19d, 25c; XI, 10d; XII, 19d, and see also n. 16 above. For landscape details commended to the painter by Van Mander, see: *Grondt*, VIII, 30 & 31. For Van Mander's own poetic description of the wind driving through cornfields, see his *Boere-clacht*, included in *Den Nederduytschen Helicon*, Tot Haarlem, 1610, p. 264.
61. Van Mander, *Grondt*, VIII, 41–42. As noted by Sutton, 1987, p. 56, Gerard de Lairesse, in his *Het groot schilderboek*, Amsterdam, 1707 (reprinted, Soest, 1969), p. 349, looking back over the landscapists of the seventeenth century, distinguished between 'antique' and 'modern' landscapes, the latter (as represented by Van Everdingen and Ruisdael, among others) not requiring the typical staffage or activities of classical landscapes, but rather farm cottages, fishermen, various types of rural wagons, and 'such daily rural occurences which are proper to it' ('diergelyke dagelyksche landgevallen ... die daar toe zo wel als het antiek eigen zyn ...'). The concern of both Van Mander and later Lairesse is that the painted image be fitting and representative. Schama, in Sutton, 1987, p. 72, notes the importance of the type of staffage, as well as buildings and modes of transportation, in setting the tone for Dutch landscapes. Bruyn, in Sutton, 1987, pp. 84–103 (esp. 95ff), on the other hand, reads the much repeated motif of travellers, with or without wagons, as emblematic of the pilgrimage of life.
62. This ideal is also found in other contemporary writers, see Ogden, 1949, pp. 159–82. It represents a synthesis of sixteenth-century Christian and Humanistic ideals. Ogden & Ogden, 1955, pp. 38–40, & 49–51, define this outlook, also manifest in late sixteenth-century and early seventeenth-century Netherlandish paintings, as Christian optimism. Variety, as a show of artistic skill is indicated by Van Mander's reference to the example of Apelles (VIII, 12). The work of art considered by a seventeenth-century critic (Sir Henry Wotton, formerly English Ambassador to Holland) as an 'Artificiall Miracle' is discussed by Fuchs, 1978, pp. 103–04, & 109.
63. Houbraken, III, pp. 271–78. Houbraken's viewpoint also accounts for his praise of each painter's success in imitating a particular aspect of nature. Among painters mentioned by Houbraken as showing forth the wonder of creation in painting

flowers is Jan van Huysum (1682–1749) whose *Still-life with Flowers* (Amsterdam, Rijksmuscum, No. C1540) bears the inscription 'Aenmerk(t) de lelien des velts/ Salo (mo in) alle s(y)ne heer(ly)ck-heit ni(et) is bek(kleed) gewe(est gelijk ene van deze)' (Matthew 6. 28–29). Reference to this biblical text, in which the splendour of lilies serves as a reminder of divine providence, and Houbraken's consciousness of such associations in Dutch paintings, evidences that while such attitudes may not have been a pervasive motivation for Dutch landscapists, and still-life painters, it was nevertheless a perspective that had survived from earlier times and was still invoked by some.

64. Houbraken, III, 275–76; III, 273. This view also tends to contradict Schama's view that the Dutch landscapist represented the particular unlinked from the universal (see n. 24 above).

Chapter III

1. Houbraken, III, p. 277.
2. See Jan Brueghel's *Paradise with the Temptation of Adam and Eve* (with figures by PP. Rubens) (The Hague, Mauritshuis, Cat. 1977, No. 253) of around 1615; see also Brueghel's *Landscape with Animals Entering Noah's Ark* (private collection; Exh., London, 1979, No. 29 (dated 1613); a smaller version is in the Wellington Museum, London, No. WM 1637–1948). Examples by Savery, all in the Kunsthistorisches Museum, Vienna are *Paradise with the Fall* (No. 1003), dated 1628; its pair, *Landscape with Birds* (No. 1082), also dated 1628; *Orpheus among the Animals* (No. 3534); and *Landscape with Animals* (No. 1091). Savery's *Orpheus and the Animals* (Utrecht, Centraal Museum) of 1628(?) is reproduced in Bol, illus. 108. The fertility of the earth is the theme of several *Allegories of the Earth* by Jan Brueghel, i.e. in the Galleria Doria-Pamphili, Rome, Nos. 322, 328, 332, & 348; as well as in his *Ceres and the Four Elements* (with figures by H. van Balen) (Vienna, Kunsthistorisches Museum, No. 815) of 1604. See also further examples of such works by Jan Brueghel and Paul Bril, collected by Federico Borromeo for the purpose of religious contemplation, and now in the Pinacoteca Ambrosiana in Milan, discussed by Jones, 1988, pp. 261–72. Jones notes that Borromeo expressed the idea that God endowed nature with sensory appeal in order to attract contemplative minds, and that Borromeo himself responded with awe at the munificence of God as manifest in the type of variety that Jan Brueghel included in such landscapes, and that Brueghel, in painting them, was well aware of this.
3. See Floris van Dyck's *Still-life* (Haarlem, Frans Hals Museum, No. 79; Bol, 1969, illus. 13) of 1613, and his *Still-life* (Mr Willem M.J. Russell Coll., Amsterdam; Bol, 1969, illus. 14) of 1622.
4. See B. van der Ast's *Still-life of Seashells* (Rotterdam, Museum Boymans-van Beuningen, No. 2173; Bol, 1969, illus. 24), and Houbraken, III, p. 277.
5. Van Hoogstraeten, 1678, pp. 74–75; Houbraken, III, p. 277. It is striking that Houbraken's way of viewing landscapes and still-lifes, considering them the more naturalistically rendered, the better able to reflect the ingenuity of the Creator, is identical to the sentiment expressed one hundred years earlier by the Italian Counter-Reformer, Cardinal Federico Borromeo (discussed by Jones, see n. 2 above). Both were following the example of the Psalmist, and voicing a sentiment expressed equally by Dutch poets throughout the seventeenth century.
6. See Stechow, 1966, pp. 15–19; Freedberg, pp. 21 & 28ff; and I. de Groot, unpaginated Introduction.
7. The Dutch inscription on the title print of C.J. Visscher's series, 'Plaisante plaetsen' (Pleasant spots), a series of eleven landscapes with a title print (M. Simon, *Claes Jansz. Visscher* (Diss.), Freiburg i. B., 1958, pp. 127–38) reads: 'Plaisante Plaetsen hier, meught ghy aenschouwen radt./ Liefhebbers die geen tyt en hebt om veer te reysen,/ Gheleghen buyten de ghenoechelyke Stadt,/ Haerlem of daer ontrent, koopt sonder lag te peyse'. The Latin inscription on the same reads: Villarum varias facies, variosq. viarum/ Cernere qui gaudes anfractus, undiq. amoenos:/ His avidos planis oculos, age, pasce tabellis;/ Sylvosa Harlemi tibi quas vicinia praebet'./ The English translations are from I. de Groot, caption to her pl. 23. For the relationship of these prints to the genre of the country-house poem, see Freedberg, p. 13ff.
8. This is exactly the sentiment expressed on the title page of another series of landscape prints also published by C.J. Visscher (Amsterdam, 1615), and drawn by Mattheus Merian, entitled: *Verscheyden Playsante Lantschappen met sinnebeelden verciert* ('Various Pleasant Landscapes Adorned with Emblems'), and inscribed with the caption: 'Aensien doet gedencken' ('Seeing leads to reflection'), and thereunder the lines: 'Op t' Schoonste voor-gedaen en kan niet krencke/ Hoe meer vertoont hoe beter men vertiert/ Oock eer verkoopt, want aensien doet gedencken/ D'ervarentheyt hier van de waerheyt liert'. ('Displayed at its most beautiful and cannot offend/ The more it is shown, the better one is diverted./ Also honourably sold, for seeing leads to reflection/ The experience of it teaches the truth'.) (Illus. Haak, p. 139, pl. 282).
9. Schama (in Sutton, 1987, p. 71ff) appropriately considers both the figures and the particular kind of native habitat portrayed part of a self-conscious effort to promote a pride of place, emphasising the modest virtues of the newly liberated homeland, and with it the emergence of a native aesthetic. This seems to have arisen in part out of a consciousness that it was God who had given them their land and liberty, thus creating a concurrence of political, religious and aesthetic sensibilities.
10. Jan Brueghel's *Village Road* (Vienna, Kunsthistorisches Museum, No. 6329) and its pendant *The Road to Market* (No. 6328) of 1603, depict the interdependence of contrasting phenomena, town and country. Wagons, seen in both pictures, suggest the link between the two, in bringing country produce to the market. As pendants they thus treat a generalised theme, but manifest in the particular.
11. See De Jongh, 1967, pp. 77–91, and De Jongh, 1971, pp. 152–55, & 167–84; see also Bergstrom in Exh., Leiden, 1970 (unpaginated introduction).
12. Inscriptions on *Vanitas* images commonly carried exhortations to better oneself (see, e.g. Van Mander's *Allegory of the Life of Man*, of 1599, discussed below). One of their prime biblical sources for the *Vanitas* theme was the Book of Ecclesiastes, in the Old Testament, which concludes, after a long review of worldly vanities: 'The end of the matter; all has been heard. Fear God, and keep His commandments: for this is the whole duty of man'. (Eccles. 12.13)
13. Genesis 3. 17–19, & Romans 8. 18–25; also Job 14 & Amos 2.9. Flowers are found as an example of the frailty of earthly life in Job 14. 1–2; Psalm 103. 15–16; Isaiah 40. 6–8; James 1. 10–11; and I Peter 1. 23–25. Peter adds the element of hope that man is born again, not of corruptible seed, but of incorruptible seed, which is the word of God, the frailty of flowers thereby pointing man to his dependency on God.
14. The tabula held by the *Putto* invites us to reflect on the brevity of life and to be wise, citing Psalm 90.12. The tabula held by the Figure of Death urges man to virtue and to seek an eternal city. The tabula top left reminds man that he is a sojourner on earth, comparing man to grass and flowers. The tabula top right compares the world to a tree, and reminds man that he is like the leaf that grows and falls, citing, *inter alia* Job 14.12, where man's life is compared to water flowing away. This elucidates the waterfall image represented immediately below this tabula. The tabula lower left cites, *inter alia*, the text in Ecclesiastes 3.11: 'He has made everything beautiful in its time', a text in which the transiency, and the orderly beauty of the world are seen in relation to one another. The tabula

lower right gives the quoted conclusion: 'O Mensch ter wijl hier alles moet vergangen/ Soo wandelt recht voor Godt niet ijdel romt;/ Want beter hij nooit leven had ontfanghen/ Die niet en waeckt, wanneer de Heere comt'. It was a commonplace to compare the life of man to the growth and decay of trees, see for instance, Jacob Cats, *Doot-Kiste voor de Levendige*, Amsterdam (no date: *C.* 1656), p. 24f, where man is compared to a felled tree; a comparable analogy is found, in a later collection of old sayings: Hermannus van den Burg, *Versameling van uitgekorene Zin-Spreuken...*, Haarlem, 1743, No. 317: 'Afgehakt HOUT.../ Hoe zeer ook 't Hout en Graan, te pralen stond in 't veld,/ 't moet ook, als wy, vergaan; de dagen zyn geteld'. ('Felled TIMBER...However proudly the timber and corn stood in the field, it must likewise, as we, pass away; the days are numbered'); see further Kouznetsov, *Op. cit.*, on tree symbolism in Dutch landscapes. Bruyn, in Sutton, 1987, pp. 87 & 97ff, gives reasons to read the image of a castle, or church, set high on a remote hill approached only by a steep tortuous path, as to be seen, for instance, in the right background of Van Mander's print, as an image of 'the eternal city on Mount Zion', to which the tabula held up by the Figure of Death (adjacent to the representation of a hilltop castle) makes reference in its paraphrase of the words from Paul's letter to the Hebrews (13.14): 'No continuing city befits you here, man; therefore seek one to come'. This pictorial usage would seem to be derived from earlier examples, such as prints by both Dürer and Lucas van Leyden, of the choice between virtue and vice, in which the landscape shows a contrast between a low, easy road leading into a plain, and a steep, high road, leading to a castle or fortified city, see Dürer's *Hercules at the Crossroads* and Lucas van Leyden's *Abraham dismissing Hagar*. It should also be noted, however, that Van Mander himself, in his *Grondt*, VIII, 29, advised painters to set castles on rocky hilltops, difficult to destroy (Miedema Edn., 1973: 'kastelen op rotspunten, moeilijk kapot te krijken'). In this case his advice seems more to do with the creation of a typical and characteristic topographical situation, which, indeed, many artists included both before and after the time of Van Mander (later ones including Vroom, Van Everdingen, Ruisdael, Hackaert, and Herman Saftleven).

15. This association was based on the practice of the Franciscans, in imitation of St Francis, as well as the much earlier precedents of St Jerome, St Anthony, and Christ Himself. It has been suggested by Walter Gibson (on sixteenth-century world landscapes, in the session *Art into Landscape in the Netherlands*, CAA Boston, 1987), that the meaning of

the contrast found in landscapes from those of Joachim Patinir to those of Jan Brueghel the Elder and Paul Bril between highland and lowland is one between the active life (lowlands) and the contemplative life (highlands), the latter often containing the figure of the hermit saint, Jerome. Falkenburg, p. 117ff, on the other hand, with respect to the landscapes of Patinir with St Jerome, sees it as a contrast between the broad and easy way (lowlands) and the steep and narrow way that leads to virtue and salvation (highlands). In both cases, however, the association of remote highland is with spiritual quest.

16. Muziano's series comprised seven landscapes with Hermit Saints: Eustace, Francis, John the Baptist, Jerome (represented twice), Mary Magdalene, and Onuphrius. They were designed by Muziano around 1573–75, and all engraved by Cornelis Cort (Holl. 113–19) before 1578, when Cort died. Paul Bril used similar elements of waterfall, boulders, and fallen trees to suggest wilderness in his *Landscape with the Temptation of Christ* (Birmingham, No. P.10'63) of 1604 (or 1614?), and significantly, when using an almost identical composition for a pastoral landscape (Darmstadt, Hessisches Landesmuseum, No. GK167) of around 1620, eliminated the massive boulders and shattered trees of the Birmingham composition, replacing them with a scene of orderly well-being and flourishing trees. For Federico Borromeo as a patron of Brueghel and Bril, see Jones, pp. 261–72.

17. Early seventeenth-century Flemish Catholic examples are David Teniers the Elder's pair of landscapes with penitents Peter and Mary Magdalene, both surrounded by broken trees and a waterfall (Dulwich College Picture Gallery, Nos. 314 & 323). Transitional examples are found among the works of the printmaker Hieronymus Cock, and the painters Jan Brueghel the Elder, Gillis van Coninxloo, Gillis d'Hondecoeter, Alexander Keirincx, and Roelandt Savery (see, for example, Stec., Figs. 119, 122, 128 & 136). On the rare occasions thereafter when the hermit theme was depicted, the hermit was invariably depicted beside a waterfall and shattered trees (see for example G. Dou's *Hermit at Prayer* (London, Wallace Collection, No. P177, and Rembrandt's etching *St Jerome* of 1648(?) (Bartsch 103, Boon, Fig. 210). By this time the shattered tree and the waterfall had become established images within Dutch art associated with the mutability of life, independent of such supplicant figures.

18. The prototype for this theme was Dürer's engraving of 1498(?): *The Promenade: A Young Couple Threatened by Death*, (Bartsch 94; illus. E. Panofsky, *The Life and Art of Albrecht Dürer*, Princeton, 1943 (1955 Edn.),

p. 69 & Fig. 99), in which, as Panofsky points out, the beauty of the scenary, with its blossoms, which the young man points out to the girl, is belied by the spectre of destruction. Rubens recalls the theme in adapting the pose of Dürer's couple in his *Walk in the Garden* (Munich, Alte Pinakothek); and a contemporary Dutch example is Jan van de Velde's engraving *Young Couple surprised by Death* (Illus. Exh., Rotterdam–Paris, 1974–75, No. 201, pl. 39), which carries the text: 'In weelden sijn dickwils geseten/ de Doot veel naerder dan wij weeten' ('In prosperity we are often closer to death than we realise'). The same text appears on David Vinckboons's print *Couple in a Landscape stalked by Death* (Dresden, Kunstkabinet, No. 163–A 1909–346). In all cases the elegance of the costumes, as well as the theme of loving couple, is inherent to the meaning of the image, as is the element of landscape. It has also been noted by Hecht, pp. 173–87 (on pp. 182–83), that early seventeenth-century genre painters used distinct costume to differentiate contemplative observers, often a couple, who are given a lesson by the scene before them, from the 'actors' within the scene they observe. See also note 31 below. As well as the waterfall in Goltzius's drawing, other motifs in it, the bridge leading to a sunlit castle on a rocky hillside, conform to a pattern of combined motifs that Bruyn (in Sutton, 1987, p. 97) has interpreted, in relation to landscapes by Rembrandt and his school, as an allusion to the eternal city, the final destiny of the sojourner on earth, who here contemplates the transitoriness of earthly life. If Bruyn's interpretation is to be accepted, then Goltzius's design, as well as his woodcut *Fisherman by a Waterfall* (discussed below), may have been prototypes for Rembrandt.

19. The waterwheel, seen in conjunction with a river, would have associations for the contemporary beholder with notions of the passage of time and the wheel of fortune. Waterwheels appear in early seventeenth-century emblems as symbols of life's vicissitudes, see Sebastián de Covarrubias Orozco's *Emblemas Morales*, Madrid, 1610, III, No. 55 (Henkel & Schöne col. 1429), which carries the verse: 'The good of this transitory life,/ Which flows like a river,/ Are at one moment on the waterwheel,/ Which goes up full, and falls down empty...'. ('Los bienes desta vida transitoria,/ Que van corriendo bien como los rios,/ Son arcaduzes puestos en anoria,/ Al subir Ilenos, y al baxar vacios....'). For fishermen as exemplars of idleness (seen both here and in Van Mander's *Allegory of the Life of Man*), see Susan Koslow, 'Frans Hals's Fisherboys: Exemplars of Idleness', *Art Bulletin*, LVII, 1975, pp. 418–32. The smoke emitting from the mill's chimney,

as in Van Mander's *Allegory of the Life of Man*, (Holl. 344) here conforms to the same allegorical sentiment, (see Wiegand, p. 90, n. 491), although it was more commonly associated with the warmth of home and the awaiting evening meal: see Van Mander, *Bucolica en Georgica*, Amsterdam, 1597,5: 'Men siet alree van verr' in Dorpen roocken/ Schoorsteenen siet, om t'avondmael te koocken:/ . . . ' ('One sees already from far, one sees (from) smoking chimneys in villages that the evening meal is cooking'); likewise, Van Hoogstraeten, 1678, p. 124, advised, in evoking winter: 'steek dan den houtkliever vry in een warmen dos . . . Laet de locht dyzich zijn, en alle schoorsteenen rooken,' ('put the wood-splitter in warm dress . . . let the sky be misty and all the chimneys smoking'). In reading such images, careful attention to both context and specific combination of elements must guide our response to them. In Goltzius's woodcut, *Fisherman by a Waterfall*, combination of fisherman, waterfall, tree stump, waterwheel, and smoke, in such a composition and authored by Goltzius, a colleague of Van Mander, who used similar elements allegorically, supports an allegorical interpretation. It is also worth noting that Govaert Flinck's 1638 *Landscape with an Obelisk* (Boston, Isabella Stewart Gardner Museum, No. 2PIW24; illus. Sutton, 1987, pl. 84), a landscape from the Rembrandt circle replete with motifs that Bruyn has read as allegories (see n. 18 above) also contains a river with a waterfall, a waterwheel and, in the right foreground, a fallen tree, again re-enforcing the continuity of imagery from Goltzius to the Rembrandt circle.

20. It is noteworthy that just as the poet Van Lodensteyn, in his poem *Niet en Al, dat is, Des werelds ydelheyd, en Gods Algenoegsaamheyd* (1654) (see Ch. II, & n. 43 above) presents the all-sufficient God as a counterpoint to the transiency of all else, likewise in this painting Savery depicts, top right, beyond the rich array of transient earthly things, a radiant sunlit castle, with figures entering at the gate, an image that corresponds very closely to that which Bruyn, (in Sutton, 1987, pp. 96–101), has interpreted as an image of the eternal city. That Savery was the teacher of Allart van Everdingen, whose *Landscape with Waterfall* (Amsterdam, Trippenhuis; illus. by Bruyn in Sutton, 1987, p. 101, Fig. 26) Bruyn discusses in this context, evidences a continuity of ideas, which are also of relevance in considering Ruisdael's *Waterfalls* that are closely related to Van Everdingen's *Waterfall* in the Trippenhuis. For the associations of ruins, in such compositions, see Ch. II, n. 44 above. In the discussion of symbolism and meaning in Dutch landscapes, such allegorical interpretation

of imagery such as Savery's has been disparaged as depressing. This misses the mark, however, since the theme, like Van Lodensteyn's poem, invariably comprises a contrast of the inconstancy of all things under heaven (however beautiful) and the unshakable constancy of God. As the Psalmist writes of God in Psalm 144 as a rock and a fortress for man whose days are like a passing shadow and who is buffeted by the waves, likewise, in Psalm 39, the Psalmist both cries out: 'let me know how fleeting my life is!' (v. 4) and yet can say: 'My hope is in thee' (v. 7). In this context the Psalmist can conclude with a plea that God hear his prayer, 'For I am thy passing guest, a sojourner . . . ' (v. 12). By the same measure, just as Dutch still-life painters celebrated the beauty of creation, while also revealing its corruption, so landscapists, working in this mode, celebrate such beauty while equally revealing its corruption, witness the detailed depiction of bark, litchens and mosses on the fallen trees of Ruisdael's *Waterfalls*. Such earthly beauty, for the biblically-trained contemplative viewer, worthy in itself as God's creation, also foreshadows the heavenly Jerusalem, Mount Zion, which, as the writer to the Hebrews says (Hebrews, 12, v. 22ff) cannot be shaken, when all else is. In terms of the Christian optimism of the seventeenth century, this is hope in face of life's real uncertainties.

21. For the allegorical meaning of lovers stalked by death, see n. 18 above, and see also Jacques de Gheyn's own drawing *Woman approached by Death* of 1600 (Illus. Van Gelder, 1959, No. 29). With respect to the broken wheel, note that De Gheyn also included a wheel in his *Vanitas*, of 1603 (New York, Metropolitan Museum of Art; Haak, p. 118, & Fig. 218) (It is located lower right within the orb above the skull). A possible biblical source for the use of wheels as a Vanitas symbol, (besides the literary image of the 'Wagon of Life'), is Ecclesiastes 12.6, where, 'the wheel broken at the cistern' is one image among others of the transiency of life. It is, *inter alia*, beside a well that broken wheels are depicted in landscapes by Jan van Goyen, Salomon van Ruysdael, and others. With respect to De Gheyn's *Milking Scene . . .* , Bruyn, (in Sutton, 1987, p. 86), proposes allegorical interpretation of other elements of the composition that are not inconsistent with the reading proposed here.

22. Bruyn, in Sutton, 1987, pp. 95–98, has interpreted figures, similar to the traveller in the left background of Ruysdael's painting, who is heading towards the light, in comparable landscapes by Jan van Goyen, as 'purposeful travellers', or 'pilgrims on life's journey', in contrast to those who idle by the roadside or at a wayside tavern.

However, such a reading, perhaps justified in the more evidently allegorical, and genre-like landscapes of Abraham Bloemaert, seems harder to justify in face of the advice of Van Mander to have the roads travelled and the villages populated in a landscape, just as it is in life.

23. A cartwheel and a wicker basket are equally prominent in Van Goyen's *Oak by a Farm* (Leningrad, Hermitage Museum; Stec., Fig. 32) of 1634, and the same objects, besides a felled tree, are seen in the shadows beside the Holy Family in Abraham Bloemaert's *Landscape with Rest on the Flight into Egypt* (Utrecht, Centraal Museum, No. 23) painted in the second quarter of the century. Prominent cartwheels feature in several works by members of the Ruysdael family: Salomon van Ruysdael's *Farm in the Dunes* (Cambridge, Fitzwilliam Museum, No. 1049); Isaack van Ruysdael's *Village Road* (Bonn, Provinzial Museum, No. 91, attributed there to Gerrit van Hees; illus. Simon, 1935, pl. V, A) and his *Outskirts of a Village* (formerly Coll. H. Blank, Newark, N.Y.; illus. Simon, 1935, pl. IV, A); Jacob van Ruisdael's *Landscape with Blasted Tree by a Cottage* (Cambridge, Fitzwilliam Museum, No. 84) and his *Country Road with Cornfield* (recently Colnaghi, London). They also feature in various winter landscapes (where dead trees would be less effective as images of mutability), for example winters by Averkamp (Stec., Figs. 163 & 166), Aert van der Neer (Brunswick, No. 360), and Jacob van Ruisdael (Leipzig, No. 1057). Skeletons occasionally feature in the foreground, much like cartwheels, for example in landscapes by Jan Brueghel the Elder (Exh., London, 1979, No. 13), Avercamp (Amsterdam, Rijksmuseum, No. 1718), G. Dubois (Haarlem, Frans Hals Museum, No. 25) of 1647, and Jacob van Ruisdael's *Wooded Country Road*, (Los Angeles, Mr & Mrs Edward W. Carter; Ros. 339) of 1652.

24. For example Stec., Figs. 23, 24, 25 & 28.

25. Praise for the land's fertility is seen in more traditional landscapes, such as the harvest scenes of Pieter Bruegel the Elder and Rubens, and in milking scenes of Rubens and Cuyp, but these are not typical of Dutch seventeenth-century landscapes. Likewise, paintings of dawn light are rare, as, for example Rubens's *Autumn Landscape with a View of Het Steen* (London, National Gallery, No. 66), and Aert van der Neer's *Landscape at Sunrise* (The Hague, Mauritshuis, No. 912).

26. In an earlier *Allegorical Landscape* drawing by Marten de Vos (Leiden, Prentenkabinet der Rijksuniversiteit, , No. AW 769) a scene of baptism takes place at a crossroads between the broad and narrow way. Over the broad, easy way the sky is dark, while the narrow way is illuminated by a bright

sky. Divine grace, bestowed in baptism, is symbolised by the dove of the Holy Spirit with, above, Hebrew letters in a radiance symbolising God the Father. In Rembrandt's *Baptism of the Eunuch*, painted in 1636, divine grace, rendered symbolically by De Vos, is now conveyed by the manipulation of the actual lighting of the scene. For Rembrandt's use of dead trees as symbols of mortality (and hence the need for rejuvenation in baptism), see Kouznetsov, pp. 31–41, on 33ff.

27. For a more specifically allegorical reading of Rembrandt's *Stone Bridge*, see Bruyn, in Sutton, 1987, p. 97.

28. A shaft of light penetrating the landscape is also found as an element of the contemplative landscape with hermit saints, for example in Gerard Dou's *Hermit at Prayer* (London, Wallace Collection, No. P177), where the sunbeam strikes the little crucifix.

29. A shipwreck with castaways hoping for God's help is one of the most prominent features of Pieter Bruegel's drawing *Hope* of 1559 (Berlin–Dahlem, No. 715; Exh., Berlin, 1975, No. 70 pl. 100). The motif recurrs in his print *The Triumph of Time*. Likewise, his son Jan Brueghel's *Storm at Sea with Castaways*, (Exh., London, 1979, No. 6) includes a figure at prayer on a rock. Comparable are Elsheimer's *Shipwreck of St Paul* (London, National Gallery, No. 3535), and Rubens's *Shipwreck of Aeneas* (Berlin–Dahlem, No. 776E). Later examples include Bonaventura Peeters's *Sea Coast with a Storm* (Cambridge, Fitzwilliam Museum, No. 399), Simon de Vlieger's *Shipwreck*, (Stec., Fig. 227), and his *Storm with a Wreck* (Cambridge, Fitzwilliam Museum, No. 345), and Adam Willaerts's *Shipwreck* (Bol, 1973, illus. 72), dated 1656. For an extended study of tempests and shipwrecks in Dutch art, see Goedde, *passim*.

30. Whitney, No. 137, whose source was A. Alciati, *Emblematum Liber*, Antwerp, 1581 (1st Edn., Augsburg, 1531), No. 43. Bartholomeus Hulsius, *Emblemata Sacra*, 1631, p. 65 (noted by Christopher Brown in Exh., London, 1976, p. 67, in relation to Porcellis's *Dutch Ships in a Storm* (No. 80)). The ship as an image of man's life that lies entirely in the providential hand of God is also found in C.P.B., *Handt-Boecken der Christelijke Gedichten, Sinne-beelden ende Liedekens . . .* Hoorne, 1635, pp. 69–70. The German poet Andreas Gryphius, resident in Leiden from 1638 to 1643, as quoted by Bruyn, (in Sutton, 1987, pp. 94–95), likewise wrote a variant on this theme, contrasting the perils of the sea and the shelter of harbour, as an allegory of life in this stormy world and of eternal peace hereafter. Van Mander, *Grondt*, VIII, 13, advocated the representation of sea-storms with dark skies and lightning to arouse in man the fear of God. The long persistence

of such ideas is seen in Jan Luyken's echo of Van Mander's sentiment in his hymn: *Al ruisen alle wouden*, in the *Liedboek voor de Kerken*, No. 433, in which he writes that the trusting heart fears neither thunder, lightning, nor the wild sea, a sentiment found also in the poetry of Huygens (see Ch. II, n. 38) and Poot, in his poem *Summer Storm* (see Ch. II, n. 47). Church spires pointing to the light, as seen in Goltzius's woodcut and the *Seastorm* formerly attributed to Pieter Bruegel, are also found in North Italian art, for instance in Dosso Dossi's *Landscape with the Three Ages of Man* (New York, Metropolitan Museum of Art). Their symbolic meaning is emphasised by the blatant contrast of a prominent dead tree to a church spire pointing to the light in A. Verboom's *Landscape with Dead Tree* (London, Dulwich College Picture Gallery, No. 9). The church spires pointing out of dark landscapes to the source of light in Jacob van Ruisdael's paintings, while far more subtle, intone a comparable sentiment.

31. For the significance of spectator couples within paintings, contemplating a scene to which they are not participants, see n. 18 above. The passive, observing couple on the right of Isack Elyas's *Merry Company* (Amsterdam, Rijksmuseum, No. A1754) of 1620, serve in a similar function, they are being given a lesson on temperance (see Exh., Amsterdam 1976, No. 23). It is this usage that Porcellis here exploits. For a more specific allegorical interpretation of Porcellis's painting, see Goedde, pp. 5–6, & 186–88, and Walsh, pp. 114–15.

32. A late and remarkable incidence of a stormy seascape illuminated by a shaft of light, which in our view served as an allegory of faith, is found as the central panel of a Dutch ebony cabinet of C. 1680/90, now at Penshurst Place, Kent (the Tapestry Room). Above the seascape is a minute painting of Christ with orb in hand and outstretched hand; below is a still-life of a bunch of grapes, representing the sacrament of wine; other panels, above, below, and to the sides represent various saints. The significance of the central panel having been overlooked, it has been supposed that it was a later addition. The cabinet would have served as a house-altar for a Catholic family, and the panel was probably chosen for its discreet significance to avoid offence in a Protestant country.

33. Vergara, p. 187, discusses a similar use of the rainbow in Rubens's landscapes, a usage that is appropriate in this scene. For bleach symbolism, see F. Picinello's *Mundo simbolico . . .*, Milan, 1653, pp. 407–08, in the article 'Tela, Drappo, Pannus' (i.e. linen) linen is represented stretched out in fields lit by sunbeams, with the inscription 'HINC CANDOR' (From here purity). Picinello's representation of sunbeams fall-

ing on bleaching fields is comparable to the imagery of De Momper's *Spring*, and to Jacob van Ruisdael's subsequent representations of the bleaching fields of Haarlem. This does not mean that the paintings were intended as emblems of purity, as Wiegand concluded (Wiegand, pp. 99–106, with extensive references to emblems and literature). However, the relation of sunbeams to bleaching fields accentuated the notion, pictorially presented, that man's dependency on divine providence is apparent in the visible world. The association of the bleaching process with divine grace is derived from biblical passages such as Isaiah 61.10, Revelation 7.14, & 19.8, and Isaiah 1.16–18, all of which are quoted in contemporary sources (see Wiegand, pp. 99–106).

34. Drawn to my attention by Diane G. Scillia, in discussing Bening's miniatures as sources for Pieter Bruegel.

35. Van Mander, *Grondt*, VIII, 15.

36. See for example Stec., Figs. 24, 25, 28, 34, 63, 204, 219; for Salomon van Ruysdael, our Fig. 12, and Adriaen van Ostade's *Landscape with an Old Oak* (Amsterdam, Rijksmuseum, No. 4093).

Chapter IV

1. Hofstede de Groot lists twenty-four Ruisdaels dated from 1654 to 1678: but of ten now identifiable, four (HdG Nos. 47, 1059k (=881), 757, & 456) bear a false date; five are not by Ruisdael (HdG Nos. 280, 237, 365, 420 (=365), & 181); only one, the Amsterdam *Watermill by a Wooded Road* of 1661 is authentically dated. The painting illus. Simon, 1930, pl. 9 (dated 1661) is by a Ruisdael imitator. Thus there is disagreement in dating even his best-known works.

2. For Visscher's prints, see Ch. III, & Fig. 3, and I. de Groot, pls. 23–34. For Schama's comments, see Sutton, 1987, p. 71f.

3. The Hague–Cambridge, 1981–82, p. 29, & Cat. Nos. 98–100 (the etchings), and Nos. 57–62 (drawings from the 'Dresden Sketch Book').

4. The Hague–Cambridge, 1981–82, p. 32, dates the Paramaribo *Country Road and Cornfield* 1646. However, the date of 1645 was read when the picture was with H.M. Cramer, The Hague (Cat. 1975/6, XX, 78f, No. 40), to whom I owe the photograph, on which the date 1645 is legible. It was also catalogued as dated 1645, as Slive notes, in R. Fritz, *Sammlung Becker, Gemälde alter Meister*, Dortmund, 1967, No. 80. There seems no reason to doubt it. For the *Dune Landscape* in Leningrad, (Ros. 552) see The Hague–Cambridge, 1981–82, Cat. No. 3, and also Fekhner, pl. 63. The *Woodland Alley* published by Stechow, 1966, p. 71, pl. 135, as dated 1645 was subsequently sold in

London (Sotheby's 6 July 1966, No. 37), without mention of a signature or date (as Stechow, 1968, p. 250, n.3, himself noted).

5. Keyes, 1975, I, pp. 98–99, proposed, rather improbably, Van Mosscher as Ruisdael's first teacher.

6. Simon, 1935, p. 8. Attributed to Hees by HdG and Bredius, falsely signed Hobbema. Hees's style, as in the *Village Road* of 1650 (Haarlem, No. 159), is similar to that of Isaack and Jacob van Ruisdael, but he uses more local colour, his tree outlines are more compact, his buildings heavier and less well drawn.

7. Jacob's *Woodland Road* (Fig. 27) was Exh., Koetser, Autumn 1970, No. 15. Simon, 1935, p. 17, mentions the following paintings by Jacob with staffage by Isaack: *Dune Landscape* (Hermitage, Leningrad; Ros. 552); *Country Road and Cornfield* (Paramaribo; Ros. 534); and two further *Dune Landscapes* (Hermitage, Leningrad; Ros. 550 & 553). To these we would add the *Dune Landscape* (formerly Henle collection, Duisberg, Ros. 529).

8. Simon, 1935, p. 7, n. 8; the monogram is in the shadow of the first rush-covered box from the left, near the middle of the painting, and is visible on RKD neg. no. 11860. Brown, p. 193, notes Isaack's *View of Egmond* as with the dealer Hans Cramer, The Hague in 1981/82. Brown, pp. 190–94, on p. 193, reviewing the 1981/82 Ruisdael exhibition, also attributes Jacob's 1646 *View of Egmond* (Philips collection) to Isaack, reading the date as 1655 (as Fritz Duparc has also done), and noting the monogram as 'unusual'. The painting is only known to me from photographs, but has struck me as somewhat naïve. If Brown's observations and attribution are correct, then this eliminates pictorial evidence of Ruisdael having travelled to Egmond before 1648, the date of his Manchester *View of Egmond*. It also indicates that, if initially the son learned from the father, in time there was interchange, given the similarity in composition, if not in execution, between the *View of Egmond* attributed by Brown to Isaack and Jacob's similar but superior composition in Glasgow (No. 34; Ros. 31).

9. Published by Adrian Bury, 'Van Ruisdael after Cleaning', *The Connoisseur*, 170, 1969, p. 235, illus. It was then with Dennis Van der Kar, London; Exh. London, Alan Jacobs Gallery, 'Clarity in Perception', Autumn 1977, No. 23, who kindly provided the photograph. The date has been read as both 1645 and 1646. Slive, the current owner, assures me that the last digit is a '6'.

10. The dating of Ruisdael's *View of Egmond* (Glasgow, No. 34; Ros. 31) is problematic. Rosenberg, 1928, pp. 33–34, following the Museum Cat. of 1925, dated it 1655. But the catalogues of 1882–1911 mention no date. Since 1935 it has been catalogued as undated and no date is legible today. A version of Ruisdael's composition by Klaes Molenaer (Solingen, Galerie Müllenmeister; Bol, 1973, p. 284, illus. 287) is signed with an 'N' (for Nicolaes) rather than the later and more usual 'K' (for Klaes), is also stylistically more like Molenaer's early works, thus suggesting that its prototype, Ruisdael's composition, is also an early work. Another version (Stockholm, No. NM 618; Ros. 33; monogrammed JVR, and catalogued as Jacob van Ruisdael) is similar to the Solingen picture, was attributed by Gerson to Molenaer, but is believed by Slive (The Hague–Cambridge, 1981–82, p. 31) to be by Jacob van Ruisdael. Ruisdael's 1648 *View of Egmond* (Manchester), compared to all of these, manifests greater assurance in the handling of space and a more subtle and articulate treatment of the town buildings.

11. For Visscher's print of Egmond, see Haak, p. 139, Fig. 283. A further *View of Egmond* (Stuttgart, Staatsgalerie, No. 2714) by Salomon van Ruysdael was formerly considered a prototype for his nephew's composition. However, Slive (The Hague–Cambridge, 1981–82, p. 31) doubts its date, 1640, and monogram. Stechow (Stechow, 1966, p. 206, n. 24 and Stechow, 1975, No. 268), considers it a work by Salomon of the early 1660s, and hence cartainly later than either of Jacob's versions, or, if Brown is correct, those of Isaack (Philips Coll.) and Jacob (Glasgow). For the patriotic associations attributed to these Dutch fishing villages, see Schama, in Sutton, 1987, p. 76ff, also illustrating Visscher's lottery print (his Fig. 10).

12. George Keyes's Catalogue Raisonné of Ruisdael's Etchings (Keyes, 1977) supercedes all earlier studies. His numbering, followed by that of Dutuit, will be used throughout.

13. Simon, 1935, pp. 7–23, on p. 7f.

14. The fisherman in the Fitzwilliam painting is unusually prominent compared to the position of figures in other early works. Microscopic examination, kindly undertaken by Mrs A. Massing at the Hamilton Kerr Institute, Whittlesford (in 1980), shows however that the figure is part of the original paint structure, since a thin band of the surrounding green pigment runs over his hat, just above the brim.

15. The Hague–Cambridge, 1981–82, Cat. No. 4, illus. Its symbolism is discussed by Kouznetsov, 1973, p. 35ff.

16. Stechow, 1968, pp. 250–52, illus.

17. See for instance Van Goyen's *River Bank with Windmill and Castle Ruins* (Rotterdam, Boymans-van Beuningen Museum, No. 1250, illus. Cat. Old Paintings 1400–1900, 1972, p. 55, D) of 1644. For Jan van de Velde's *Summer*, see Freedberg, Fig. 30.

18. Giltay, p. 147f, and Cat. Nos. 37–47, of which Nos. 37, 39, 41, 43, 38, & 45 exhib. & illus., The Hague–Cambridge, 1981–82, as Cat. Nos. 57–62.

19. For mill symbolism, see Kauffmann, 1977, pp. 379–97, and for their economic and industrial, as well as moralistic associations, see also Chong, in Sutton, 1987, pp. 458–63 (discussing Ruisdael's *Mill at Wijk bij Duurstede*).

20. Visscher's etchings, Nos. 8 & 11 are illus. In I. de Groot, pls. 30 & 33. Bleaching fields also feature in Klaas Molenaer's 164(7?) *Bleaching Fields of Haarlem* (Leipzig, No. 1042); earlier examples are Joos de Momper's *Spring* (Brunswick, No. 64), and in the background of Quentin Massys's *Portrait of a Notary* (Edinburgh, National Gallery of Scotland, No. 2273) of around 1510–20, in which symbolic meaning may be intended.

21. Formerly Major Mills collection, Hilborough; monog. & dated 164–(6?); sold London, Sotheby's, 9th July 1975; photo: Witt). It is similar to Isaack's *Landscape with Three Windmills* (Simon, 1935, pl. IV, B); it was exhib. & illus., The Hague, 1981–82, 3a (but not in The Hague–Cambridge, 1981–82 catalogue). See also Hoogsteder-Naumann, pp. 71–74, illus. VII, where it is recorded as monogrammed and dated, lower left, JvR 1646, and discussed in relation to the works of Jan van Goyen, Salomon van Ruysdael, and Jacob's other works of the same, or similar motif.

22. Ledermann, pp. 9ff, 140ff, & 167ff. This idea, adopted by Rosenberg and Simon in their Ruisdael monographs, has been criticised by Blankert in the revised edition of his catalogue of the Italianate Landscape Painters: Exh. Cat. Utrecht, 1965 (1978 Edn), p. 41, n. 29.

23. Other early Ruisdaels with prominent foreground tree trunks include the *Dune Landscape* (Leningrad, Hermitage, No. 939; The Hague–Cambridge, 1981–82, Cat. No. 3, illus.) of 1646 and his drawing *Huntsman in a Wood with Three Dogs* (Berlin–Dahlem, No. 2618), also, of 1646. The figures and animals in the Hamburg painting are traditionally attributed to his friend Nicholaes Berchem but the suggestion is discounted by Slive in The Hague–Cambridge, 1981–82, p. 29, citing the opinion of Eckhard Schaar, author of 'Studien zu Nicholaes Berchem' (diss.), Cologne, 1958. A version of the Hamburg composition in the Whitbread collection (Canvas 75 by 106 cm, falsely signed lower left towards centre and dated 1646; photo: Witt, No. B60/1026), published by Stechow, 1968, p. 250, Fig. 2, and by Slive in The Hague–Cambridge, 1981–82, p. 29, & Fig. 6, as Jacob van Ruisdael, is found on inspection to be a later pastiche, crudely painted.

24. Monogram on path to right, above foreground bushes, IVR. The figures are comparable to that in the *River Landscape with high wooden Bridge* (formerly Gebr. Douwes, Amsterdam; attributed to Isaack by Simon, 1935, p. 7, pl. III, E; RKD neg. no. L 55618), and the highlights on the boundrush fence to those in the Stockholm *Country Road* (No. NM 1173) and in the Philips collection *View of Egmond* (Ros. 28, as by Jacob). A similar subject to Jacob's and Isaack's *Dune landscape with wooden Fence* recurs, in mirror image and with added detail, in the *Landscape* (Hamburg, No. 628) attributed by Gerson to Klaas Molenaer.

25. Perhaps Jacob's Munich painting stimulated his father to produce what is, if attributable to him, his finest work: the *Landscape with Planks* (Vienna, Akademie der bildenden Künste, No. 893). Its style is similar to both Hees and Jacob van Ruisdael, but the figures more like Isaack's. The signature, reproduced in the 1927 catalogue and visible on the RKD photo, but no longer visible on the painting, was comparable to that on Isaack's *Courtyard with a Woman laying out Linen*, although spelt 'Ruisdal'. The conception of Jacob's Munich painting recalls Pieter Molijn's drawing of a *Dune Landscape* (New York, Pierpont Morgan Library, III, 166), and Cornelis van der Schalcke's *Road through the Dunes with oncoming Shower* (Philadelphia, E. Bok collection; Bol, 1969, illus. 180, considered by Bol a work of the 1640s, influenced by Molijn). In the early 1650s Philips Wouwerman also produced such dune landscapes under blustery skies (e.g. Berlin–Dahlem, No. 900E). With respect to the travellers in Ruisdael's Munich *Bush on the Dunes*, Bruyn, in Sutton, 1987, p. 95f, has interpreted comparable figures of travellers, heading towards the horizon, as metaphoric of the pilgrim on life's path. Unless supported by a related series of other motifs that Bruyn discusses, such as rivers, waterfalls, bridges, and distant hill-top castles, or cities, extension of this notion to such dune landscapes as those of Ruisdael, his uncle Salomon and Van Goyen, seems unwarranted in light of the advice of Van Mander and others to populate landscapes with figures going about their typical daily round of activities (see Ch. II, n. 61), which is exactly what one sees in most Dutch landscape paintings. Whether Ruisdael's characterisation of life in the world was always intended to arouse the notion of a pilgrimage is questionable.

26. For the painting, *Dunes by the Sea* (private collection; Ros. 567) see The Hague–Cambridge, 1981–82, pp. 42–43, & Cat. 8; for technical observations on the condition of the drawing, *Oaks by the Zuider Zee* (London, British Museum, No. 1895-9-15-1299), see *idem*, pp. 170–71, & Cat. 64.

27. For the development of panoramas in Dutch landscape painting, see Stechow, 1966, pp. 33f, esp. pp. 37–39

28. For the influence of Rembrandt's landscapes on Ruisdael, see Stechow, 1966, p. 39, and Kouznetsov, 1973, pp. 31–41, on p. 33. The latter proposes Rembrandt's etching *The Omval* (Bartsch 209; White, pl. 304) of 1645 as a precedent for the composition, spatial juxtaposition, and dead tree motif in Ruisdael's 1648 *View of Egmond*. More compelling, however, is the similarity Kouznetsov draws between the shape and character of the dead tree in Rembrandt's *The Angel appearing to the Shepherds* (Bartsch 44, I; White, pl. 26) of 1634 and Ruisdael's *Landscape with a dead Tree* (Hermitage, Leningrad; Kouznetsov, Figs. 3 & 4). The proximity, detail, and starkness of the battered tree are striking in Rembrandt's *St Jerome beside a pollarded Willow* (Bartsch 103, I; White, pl. 315) of 1648, executed the same year as Ruisdael's painting. With respect to identification of the stark tree in Ruisdael's picture as an elm, and for other perceptive comments on the accuracy of Ruisdael's remarkably detailed observations of a range of trees and plants, see Ashton, Slive, and Davies, pp. 2–31, kindly drawn to my attention by Alice Davies.

29. See also the ancient and decaying tree in Van Goyen's *The Oak* (Leningrad, The Hermitage, No. 806; Stec., Fig. 32) of 1634, in which a broken cartwheel, another *Vanitas* motif, is placed prominently in the foreground. For tree symbolism, see Kouznetsov, 1973, pp. 31–41, and Ch. III above. The experiment with warmer colour seen in his 1648 *View of Egmond* may account for the unusually bright tones of a series of small river landscapes attributed to Ruisdael, such as the *Farm by a River* (London, National Gallery, No. 2565) and the *River Landscape with Windmill* (private collection, Scotland; Ros. 116; panel 24.5 by 35 cm, monog. left). He appears to have continued to depict such motifs, in more developed form, in the early 1650s, see his *Windmill on a River Bank* (private collection; Ros. 112; The Hague–Cambridge, 1981–82, Cat. No. 24.; our Fig. 81).

30. Restoration in 1975 brought out the detail and colour. The last digit of the date is faint, but more likely '8' than '5' (see for instance, the form of the '8' on Ruisdael's drawing *Oaks by the Zuider Zee*, of 1648). Loss of surface detail accounts for some awkward transitions between the vegetation and the sandy road.

31. Schrevelius, 1647, quoted Keyes, 1975, I, p. 13.

32. Fot the interchange between Vroom and Ruisdael, see Keyes, 1975, I, pp. 96–98, & pp. 101–02, and for the mood of Vroom's landscapes, see *idem*, I, p. 53.

33. Claes van Beresteyn's drawing *Wooded Landscape with Cornfield* (Fondation Custodia, collection F. Lugt); (Exh., Paris, 1974, I, No. 2, pl. 10) and his related etching (Holl. 5) are very similar in subject and style indicating his proximity to Ruisdael and Vroom at this time.

34. Another similar picture by Vroom, his *Pool in a Forest* (Paris, Malla collection; Keyes, 1975, No. P. 33, & Fig. 58) is dated 1648. The foreground figure in Ruisdael's Nancy picture appears to be in a later style. A version of this picture, also dated 1649, in the Bentinck–Thyssen collection, Ros. 451, was Exh., 'Landschaft aus vier Jahrh.', Kunsthalle Bielefeld, 1973, No. 9, illus.

35. The drawing in the Musée Condé, Chantilly (No. 369), usually considered a preparatory sketch for this etching, is too weak for Ruisdael. The lines running up the trunks and branches are dull and monotonous compared to his handling in the 1646 *Huntsman in a Wood* (Berlin–Dahlem, No. 2618). The penmanship is more similar to Jan van Kessel, cf. his 1665 *Country Road with Mansion and Trees* (Paris, École des Beaux-Arts, No. 305), but possibly it is an eighteenth-century pastiche, as Keyes, 1977, p. 11, n. 25, suggested.

36. The identification of the ruined church as possibly that of Soest was made by G. Hos (note at the RKD), based on its similarity to a print in *Het verheerlykt Nederland of Kabinet van hedendaagsche gezigten*, Vol. VII, Amsterdam, 1745–1774, No. 210, as noted by Slive in The Hague–Cambridge, 1981–82, p. 173. It is striking how frequently, in works of the 1640s and 1650s, Ruisdael depicts ruined churches, and how rarely, before the later Haarlempjes, intact ones. This coincides with the period of his art in which the *Vanitas* theme is most forcefully projected.

37. Published by J.W. Niemeijer, 'Varia Topografica', *Oud-Holland*, LXXVII, 1962, pp. 61–63, & 72, illus. 4.

38. The location of the buildings indicates that Ruisdael's prospect, though not strictly topographical, overlooks the river Grift, a small tributary that joins the Neder Rijn at Rhenen. It is visible in the foreground of Van Goyen's 1646 *View of Rhenen* (Washington, Corcoran Gallery of Art), as are the twin towers of the watergate, and the two mills on the hill. Van Goyen has exaggerated the proportions of St Cunera's tower; a more accurate representation of the church is Saenredam's drawing of 1641 (Haarlem, Teylers Museum, No. O.81; Exh. Cat., London, 1970, No. 17, pl. 17).

39. Pieter Bruegel the Elder used such a foreground coulisse in his series *The Seasons*. It was used early in the seventeenth century by Paul Bril, also before a river prospect in his 1621 *Landscape with Cephalus and Procris* (Rome, Galleria Nazionale d'arte antica in Palazzo Corsini, No. 1084; Exh. Utrecht, 1965 (1978 Edn.), No. 5, Illus. 5). Keyes,

1975, II, p. 184, points to works of the early Italianate landscapists, such as Poelenburgh and Breenbergh (artists inspired by Bril), as sources for Vroom's own composition. It is therefore evident that such a long-used device can neither be attributed to Claude nor considered an import of the 1640s. See further, Blankert, in Utrecht, 1965 (1978 Edn.), pp. 13–20 (esp. pp. 19–20).

Chapter V

1. See, for instance, Michel, 1890, p. 56; Bode, 1909, pp. 115–16 & 165; Rosenberg, 1928, p. 24; Martin, 1942 (1st Edn. 1936), pp. 293–310; Gerson, 1966, unpaginated introduction; and Rosenberg and Slive, 1972 (1st Edn. 1966), pp. 262–66, who summarised these views with the observation that Ruisdael's 'romantic sense was attracted by the rolling, wooded country with castles and streams', also noting an increased power of stylisation in his art at that time. See Ashton, Slive, and Davies for an illuminating, interdisciplinary study of Ruisdael's trees, which emphasises both the extreme botanical accuracy of his trees, and the fact that his travels did not add to the repertoire of trees he studied and depicted in the 1640s, although he did enlarge their scale.

2. Ruisdael's travels were more limited than those of many other Dutch landscapists. For artists who depicted the Rhineland, see Stechow, 1966, pp. 167–68, and Exh., *Rheinische Landschaften und Städtebilder 1600–1850*, Bonn, 1960–61. Shortly before Ruisdael travelled, in 1646/7, Roelant Roghman was sketching in Gelderland (see Schulz, p. 67, No. 145), and in 1652 Guilliam Dubois from Haarlem travelled to Cologne (see Giltay, 1977, p. 146). For Van Everdingen's travels, see Davies, p. 35, and for Frans Post's travels and Brazilian landscapes, see Stechow, 1966, pp. 168–69, and R.C. Smith, Jr., 'The Brazilian Landscapes of Frans Post', *The Art Quarterly*, I, 1938, p. 239ff. Pieter Claesz.'s place of birth is given by Van der Willigen, 1870, p. 76.

3. The identity of the castle was established by Maschmeyer, pp. 64–66, as was kindly drawn to my attention by John Ingamells. Castles seen from imaginary high viewpoints had been depicted earlier by, for example, David Vinckboons, e.g. his drawing in the Albertina, Vienna, No. 8343; see also the Pseudo-Vinckboons drawing *Panoramic Landscape with a Castle* (Exh., *Flemish Drawings in the Witt Collection*, 1977, No. 34). Hendrick Hondius's 1620 etching *Landscape with the Return of the Prodigal Son* (I. de Groot, 100), also represents a castle from a high viewpoint.

4. The distinct form of Ruisdael's signature, with a flourish on the final 'l', is found on his last group of etchings, as well as on the 1651 *Bentheim Castle* (English private collection; Ros. 15), the Wallace Collection *Hilly Landscape with Burgsteinfurt*, the 1652 Frick Collection *Wooded River Valley*, the 1652 Carter Collection *Wooded Country Road*, the Vienna, Kunsthistorisches Museum *Woodland Road* (No. 426), the Detroit *Jewish Cemetery*, the Washington, National Gallery *Woodland Waterfall*, and the New York, Metropolitan Museum *Hilly Woodland with Waterfall* (No. 89.15.4).

5. The device of horsemen descending into a valley from a raised foreground is found in Cornelis Vroom's 1649 *Path in an Upland Wood* (formerly S. Nystad, The Hague; Keyes, 1975, No. P23, & Fig. 61). The device was also used by Guilliam Dubois in his *River Valley from Wooded Hills* (Plietzsch, 1960, illus. 164), painted after his German trip of 1652.

6. Wiegand, pp. 93–98, on Bentheim Castle as an allegory of the vanity of pride. But this topos has the castle struck by lightning and its vulnerability thus exposed. Bruyn, in Sutton, 1987, p. 99, & n. 52, rejecting both Wiegand's interpretation and a topographic interest, sees it as a metaphor for the 'the eternal city on Mount Zion'. On the other hand, hill-top castles had been a feature of the painterly tradition since the time of Patinir onwards. They were set on hills, not to suggest their vulnerability, but their impregnability. Van Mander, *Grondt*, VIII, p. 29, advised painters to set castles on rocky hilltops, difficult to destroy (Miedema Edn., 1973: '*Kastelen op rotspunten, moeilijk kapot te krijgen*'). Such hilltop castles also occur in drawings and paintings after Van Mander's time: Vroom treats them, not only in his early mannerist works (e.g. Keyes, 1975, I, Figs. 9–12), but also in a drawing of 1653 (Keyes, 1975, I, Fig. 71); they are frequent in the drawings and paintings of Van Everdingen (e.g. his painting of 1644, *Mountain Castle with Water* (Davies, No. 21 & Fig. 63), as well as in the works of Jan Hackaert and Herman Saftleven. Aesthetically hilltop castles provide an accent in the landscape and a contrast to natural forms. They also hold appeal as regional features observed on foreign travels. Ruisdael's manner of representing Bentheim Castle, while not strictly topographical, falls in this last category, there being insufficient supporting elements to justify either Wiegand or Bruyn's allegorical interpretations, the artificial hilltop setting following the precedent of the pictorial tradition, much as his Wallace Collection *Hilly Landscape with Burgsteinfurt*, in viewing the castle down below, from the vantage of an imaginary hill, likewise followed pictorial precedent, as observed in n. 3 above.

7. In a drawing attributed to Ruisdael, and falsely signed Huysmans f', (Dresden, Kupferstichkabinett, No. C1134), Bentheim Castle is represented from the same angle as in the Dresden painting (No. 1496).

8. Gainsborough's *Rocky Wooded Landscape with Rustic Lovers and Cattle at a Watering Place* (Viscount Camrose collection; John Hayes, *Gainsborough's Landscape Paintings*, London, 1981, No. 113; Exh. London, Tate, 1980–81, No. 116, & colour pl. p. 114.), of around 1773–74. Considered by Hayes as one of Gainsborough's most consciously Claudean compositions, the debt to Ruisdael, whom Gainsborough also admired and emulated, has been overlooked. Gainsborough's somewhat later *Watering Place* (London, National Gallery), exh. R.A. 1777, is a related composition. In both pictures, however, while the composition derives from Ruisdael, the mood and atmosphere is quite different.

9. *Trees over a Mountain Torrent* (Rotterdam, No. J.V. Ruisdael-7; Giltay, No. 96). An etching by Anthonie Waterloo (I. de Groot, 148; Dut. 3) represents an almost identical subject, with trees growing on rock arching over a stream. Whether this was derived from Ruisdael's drawing, or from nature, is unknown. Waterloo went to Hamburg and Danzig, so would have taken a similar route to Ruisdael's. He also represented watermills (e.g. Berlin–Dahlem, drawing No. 14423, Schulz, No. 212, illus. 59) similar to those of the Bentheim region represented by Ruisdael.

10. The painting is in the collection of the Hon. Hanning Philipps, Picton Castle. Ruisdael's 1652 *Wooded Country Road* (Los Angeles, Carter Collection) is recorded by Smith, HdG, and Rosenberg as signed, remarkably, by Berchem as well as Ruisdael, but Berchem's signature is no longer visible.

11. See The Hague–Cambridge, 1981–82, p. 253, citing Josef Schepers, *Haus und Hof westfälischer Bauern*, 1960, 3rd Edn., Münster, 1976, *passim*.

12. See I. de Groot, 108, 110 (Simon de Vlieger); 143, 147 (Herman Saftleven); 112, 113 (Jan Both); 156 (Anthonie Waterloo); and 233, 234 (Jan Hackaert). The reactionary quality of Ruisdael's etchings was clearly to be seen in the Exh., *Prenten van Buiten*, Amsterdam, Rijksprentenkabinet, 1975.

13. Giltay in Sutton, 1987, p. 444, quoting Lairesse's *Het Groot Schilderboek*, 1707, as cited by J.A. Emmems, 'Rembrandt en de regels van de kunst', in *Verzameld Werk*, Amsterdam, 1979, II, p. 158.

14. The top left tabula in Van Mander's text commences; 'O *Mensch ghij sijt een wandel gast op aerde. /U vleijs is hooij, U heerlijkheijt een blom*'. ('O man you are a sojourner on earth, /Your flesh is hay, your glory like a flower').

15. Ashton, Slive, and Davies, pp. 24–25, note that Ruisdael, in this etching, shows a pow-

erful oak rising out of stagnant water, and beeches likewise in paintings of the 1660s, and comment that neither tree thrives with water-logged roots.

16. The significance to the spectator of the decadent elements of the landscape is to be understood in the light of the popular adage: 'In weelden sijn wij dickwils geseten, de Doot veel naerder dan wij weeten'. ('In prosperity we are often closer to death than we realise'). For a mannerist prototype with an elegant couple in the foreground confronted by fallen timber and trees in a swamp, and a further couple viewing a waterfall beyond, see Nicholaes de Bruyn's 1602 engraving, after Gillis van Coninxloo, *Woodland* (Hol. 167). See further, Chapter III, n. 18.

17. For a painted variant of Ruisdael's etching, see his *Pool in a Forest* (Cambridge, Mass., Fogg Art Museum, No. 1966.32; Stec., 1966, Fig. 143) a painting stylistically close to Ruisdael's 1653 *Wooded Road* (Amsterdam, No. A350), our Fig. 84.

18. The cropping on all four sides has been confirmed by technical examinations, see Giltay in Sutton, 1987, p. 444, citing Braunschweig, Cat. 1983, *Die holländischen Gemälde*, catalogue by Rüdiger Klessmann, 1983, pp. 177–78. The painting, unusually, no longer bears a signature, which was presumably close to the lower border. As noted by Giltay in Sutton, 1987, p. 444, the stout tower with steeply pitched polygonal roof among the complex of building at the right has been identified by Korn, 1978, p. 114, as the 'Buddenturm' of Steinfurt Castle, a building also depicted in Ruisdael's *Hilly Landscape with Burgsteinfurt* (London, Wallace Collection, No. P.156). In neither case is Ruisdael's representation strictly topographical.

19. See Giltay in Sutton, 1987, pp. 444–45, also referring to Falkenburg, 1985, pp. 144–45, who, with reference to the sixteenth-century landscapes of Joachim Patinir, interprets the contrast between cultivated farmland on one side of a composition divided by a large central tree and wild nature on the other as a reference to the two paths of life, the worldly and the arduous path of the virtuous pilgrim. As Giltay comments, it is debatable how far one may presume similar interpretations in the seventeenth century.

20. Brown, 1982, p. 193, also notes that the sky immediately above the castle buildings is painted by a later hand over the branches of a tree which Ruisdael had included on the right, presumably done to balance the composition after the picture was significantly cropped on the right.

21. The two figures on the left are weaker, wooden, and more elongated than the others; they may be a later addition. A smaller, weaker version of the same subject is in Berlin–Dahlem (No. 884B). The figure on the rock in the Berlin version wears a frock coat and breeches not worn before the eighteenth century, his posture is also more characteristic of that time, and it is presumably a later addition. A third version of the composition (London, National Gallery, No. 991) is a crude, later pastiche.

22. Ruisdael's beeches are sometimes described as birches, because of their glistening trunks. This is incorrect, see Ashton, Slive, Davies, p. 28.

23. These watermills appear, in various states of repair, in many paintings by or attributed to Ruisdael, see Maclaren, 1960, pp. 359–61, and The Hague–Cambridge, 1981–82, pp. 78–81. They are not however, as indicated in the 1981–82 Ruisdael exhibition catalogue, pp. 78–81, inspired by the watermills of Singraven, which are linked in an 'L' shape and were later painted by both Ruisdael and Hobbema, but rather, as Hagens, 1982, pp. 7–12, has demonstrated, are much more similar in structure and type to the watermills of Haaksbergen, south-west of Enschede.

24. For a discussion of this painting, its subject, and iconography, see Giltay in Sutton, 1987, pp. 441–42, and with respect to identification of the watermills, Hagens, 1982, p. 9, and also Hagens, 1978, p. 85.

25. This topographic information kindly given me by H. Hagens, by letter of 15 May 1979. Ruisdael has thus synthesised features from two disparate regions into one composite image.

26. See Chapter II, *passim*, and Beening, p. 458.

27. *Farm by a River* (London, National Gallery, No. 2565); *Farm by a River* (Detroit, No. 37.21); *Windmill by a River* (Detroit, No. 53.352); *Windmill by a River Bank* (Berlin–Dahlem, No. 11852); and a version of the Berlin picture, formerly in the Cremer collection, Dortmund, No. 470 (Panel, 31 by 41.5 cm), repr. Broulhiet, p. 155 (as Hobbema). These last two pictures appear to be variants or copies of Ruisdael's *Windmill on a River Bank* (our Fig. 81; private collection; Ros. 112; Exh. The Hague–Cambridge, 1981–82, No. 24, repr.). Cornelis Decker's *Cottages on a River Bank* (Sankt Gilgen, F.C. Butôt collection; repr. Bol, 1969, p. 208), dated 1652, is closest to the London and Detroit paintings. The *Evening River Scene with an Angler* (private Coll.; repr. The Hague–Cambridge, 1981–82, p. 17, Fig. 3), dated 1649 is related to the London and Detroit pictures, though more plausibly by Ruisdael. See also Chapter IV, n. 29.

28. See Giltay, pp. 148 & 166–67; Cat. No. 28, & Fig. 38. A second, closely related sketch, also formerly in Bremen (Giltay, No. 29, & Fig. 39), as Giltay notes, p. 166, corresponds to the Detroit *Windmill by a River* (No. 37.21), mentioned n. 27 above, the authenticity of which Gerson has also questioned.

29. For the identity of the flowering bush as either a wayfaring bush or an elder, see Ashton, Slive and Davies, pp. 19–20. The bramble bush in the left foreground features in at least four other paintings, three dated 1653, the fourth dateable *c*. 1653/4: the 1653 Amsterdam *Wooded Road*, the 1653 Beit Collection *Bentheim Castle*, the 1653 *Landscape with Small Waterfall* (Mr & Mrs Carel Goldschmidt, Mount Kisko, USA; Ros. 490); and the Detroit version of the *Jewish Cemetery*, which shares a number of features and techniques of execution with works of around 1653 such as these.

30. Very similar figures recur in Ruisdael's *Pool in a Forest* (Cambridge, Mass., Fogg Art Museum, No. 1966.32), which is related to both his etching *Woodland Morass with Travellers* (Keyes, 6) and the 1653 Amsterdam *Wooded Road*, but with dense, marshy woodland filling the left hand side.

31. For Rosenberg's view of the Italianate influence, see Rosenberg, 1928, pp. 20–21. For examples of ruins in earlier Dutch landscape prints and drawings, see, for Goltzius, Stec. 1966, pl. 12; for Buytewech, I. de Groot, pl. 13; and for Seghers, HB 39, & Rowlands, pl. 69; for Buytewech and C.J. Visscher's representations of the Huis ter Kleef, see I. de Groot, pl. 14 & 34 respectively; for Jan van de Velde's etchings, after drawings by Pieter Saenredam, see Ampzing, 1628, & Chapter II, n. 44.

32. For Class Bruin, see Chapter II, n. 44; for Vroom's depiction of a ruined church, see Keyes, 1975, II, Fig. 78; and for Jan van de Velde's etching *Dead Tree among Ruins*, see I. de Groot, pl. 79.

33. The Alkmaar drawing is dated by Giltay, p. 154, as 'probably from around the mid 1650s'. The two drawings of *The Jewish Cemetery* he supposes, (pp. 150–51) to be from around the middle or second half of the 1650s, assuming a move by Ruisdael to Amsterdam 1655–56. The *Egmond* drawing in Stuttgart, he supposes, (p. 151), to be around 1655, basing himself more on the presumed date of the related painting of *The Jewish Cemetery*, than on any compelling stylistic grounds. In our view the two versions of *The Jewish Cemetery* should be dated around 1653/4, on the grounds of their stylistic and iconographic affinity to dated works of 1653, and hence these related drawings would also have been executed that much earlier.

Chapter VI

1. Other paintings by Ruisdael from the early 1650s with colourful staffage are the *Land-*

scape with Bentheim Castle (English private collection; Ros. 15) and *The Two Oaks* (formerly Von Schubert collection, Berlin; Ros. 276), both of 1651; and the *Wooded Country Road* (Los Angeles, Mr & Mrs Edward W Carter; Ros. 339), of 1652, staffed by Berchem.

2. The majority of critics have dated both versions to the mid-fifties (e.g. Rosenberg, 1928, p. 32: *c.* 1655; Simon, 1935, a, p. 162: 1653–55; Gerson, 1952, p. 45: *c.* 1655; Scheyer, 1977, pp. 133–46: both versions *c.* 1653–55; Slive, in The Hague–Cambridge, 1981–82, p. 73: mid-fifties, the Detroit painting the earlier of the two). They are occasionally dated to the 1660s (e.g. Valentiner, 1926, p. 55ff: 1660s; Stechow, 1966, p. 139: neither version far from 1660); while Zwarts, 1928, pp. 232ff, attempted to date both versions after 1674, when St Urban's Church, Ouderkerk lost its spire in lightning. But there is nothing sight-specific in the ruins as painted, and, as Slive noted (The Hague–Cambridge, 1981–82, p. 73) the masonry of the tower remained intact and there is no record of additional damage to the church. An alternative view, proposed by Sluijter–Seiffert, 1984, '*stellingen*' No. 3, questions the priority of the Detroit version and dates the Dresden painting to the mid-fifties, with the Detroit version 'at least ten years later', which is followed by Sutton (Sutton, 1987, p. 455), proposing respective dates of 'about 1655–58' (Dresden) and 1668–72 (Detroit). For extensive documentation and evaluation of critical opinion concerning dating, priority and iconography, see Slive in The Hague–Cambridge, 1981–82, pp. 67–75, and for stylistic grounds to support a date for both in the mid-fifties, *Idem*, p. 73.

3. This possibility was expressed by H. Janse, Head of the Department of Architectural Research and Documentation of the Rijksdienst voor de Monumentenzorg, and is supported by an engraving of 1680 by A. Rademaker of the twin towers of the *Abdey en Buerkerk te Egmond Binnen* (see Scheyer, 1977, note 34).

4. Goethe (see Gage, pp. 210–15, on p. 213), in a pioneering article of 1816, imagined the Dresden painting to be a memorial to the past, 'without allowing any rights to the life of the present'. Smith, VI (1835), p. 4, in his preface noted that both versions 'are evidently intended as allegories of human life', and, in his catalogue entry (No. 60) on the Detroit version, further remarked that 'the artist has evidently intended to convey a moral lesson of human life'. Variations of these views, stressing the transiency of earthly things, are found in Bode, 1907 (1st Edn. 1906), p. 137; Valentiner, 1926, pp. 56–58; Rosenberg, 1928, p. 30; Martin, 1936, II, p. 302; Slive, 1962, p. 488; Stechow, 1966, p. 140; and Ros./Slive, 1972 (1st Edn.

1966), p. 267; more detailed and diverse analysis is given by Wiegand, 1971, pp. 57–85, who concludes that all the imagery derives from well-known baroque literary topoi, refering to the theme of *vanitas*, while the ruined church and splendid, but cracked Jewish tombs are admonitions not to trust in outward religion; Scheyer, 1977, pp. 133–46, concentrating on the significance of the Jewish tombs, (first identified and discussed in relation to their setting by Castro, 1883, pp. 17–18) sought an explanation in imagined circumstances of commission, about which nothing is actually known. Slive (The Hague–Cambridge, 1981–82, pp. 67–75) is doubtful that Ruisdael would have considered Jewish customs and tombs examples *par excellence* of man's vanity. He considered the paintings as much more general allegories on transience and 'the ultimate futility of man's endeavours', counterbalanced by 'the promise of hope and new life' offered by the burst of light, the rainbow, and luxuriant growth seen in both paintings. For references to and review of the further literature, see The Hague–Cambridge, 1981–82, pp. 67–75.

5. Blootelingh's engravings of 1670 after Ruisdael's drawings are reproduced by Scheyer, 1977, Figs. 5 & 6, and R. de Hooghe's engraving *Burial of Jews outside Amsterdam*, 1675, by Scheyer, 1977, Fig. 14.

6. De Hooghe's 1675 engraving represents the elaborate ceremony of Jewish burial, which Adrianus Hofferus's *Nederduytsche poëmata*, Amsterdam, 1635, pp. 129–30, condemned as outward religion, like washing and circumcision. Jan Luyken adopts a similar position in *De onwaardige wereld*, Amsterdam, 1749 (1st Edn. 1710), p. 99, as Wiegand, p. 75, points out.

7. See Chapter III, *re* the meaning of the rainbow in a landscape of Joos de Momper, a meaning that Vergara, p. 187, also notes in relation to rainbows in Rubens's landscapes. Jan Luyken, *Beschouwing der Wereld*, 1708, pp. 322–23, associated the rainbow with the passage in II Peter 3, as a reminder to live uprightly.

8. See the margin of the top left tabula of Van Mander's *Allegory of the Life of Man*. The text inscribed on the *Still-life with Vase of Flowers* (private collection) attributed to Jan Brueghel the Elder (Illustrated by Haak, p. 118, Fig. 219) reads: 'Wat kyckt ghy op dees blom die u soo schone schynt, /En door des sonnen cracht seer lichtelyck verdwindt, /Ledt op godts woordt alleen dwelck eeuwich bloeyen siet, /Waerin verkeert de rest des werelts dan, In niet'. ('How you gaze at this flower, which seems to you so fair, /Yet it is already fading in the sun's mighty glare. /Take heed, the one eternal bloom is the word of God; /What does the rest of the world amount to? Nothing').

9. Houbraken, *Schouburgh*, III, pp. 272–73.

10. For instance, the *Hilly Woodland with Waterfall* (New York, Metropolitan Museum of Art, No. 89.15.4), the *Woodland Road with Pool* (Montacute House (loan); Ros. 336), and the drawing *Woodland Road with Pool* (London, British Museum, No. 1910-2-12-195), which corresponds to the composition of his painting *Woodland Road with Pool* (Mülhausen Museum; Ros. 349). The scheme of forest road and screened vista may have been derived from woodland drawings and paintings by Simon de Vlieger, who had moved to Amsterdam around 1650 (see his *Entrance to a Forest* (Rotterdam, No. 1924; Stec., Fig. 133) and his drawing in Berlin–Dahlem, No. 5751, Schulz, No. 206 & illus. 56). Such screened woodland vistas were also produced by Cornelis Vroom in the late forties and early fifties (e.g. Keyes, 1975, Figs. 57, 58, 63, & 66), but Ruisdael's open, spacious scheme is more similar to that of de Vlieger, and derives ultimately from earlier mannerist painters and printmakers, such as Hieronymus Cock, Gillis d'Hondecoeter, Alexander Keirincx, and Jacob van Geel (see Stec., Figs. 119, 123, 126, 128, and 130).

11. See Davies, pp. 216–31 for the influence of Van Everdingen's *Waterfalls*.

12. Vondel: *Volledige Dichtwerken en Oorspronkelijk Proza*, Verzorgd en Ingeleid door Albert Verwey, Amsterdam, 1937, p. 375, b. Van Everdingen was already painting *Waterfalls* in the late 1640s, viz. Davies, No. 29, Fig. 99 (of 1647), & No. 46, Fig. 133 (of 1648). The date of 1650 is visible on the Munich *Waterfall* (No. 387), and confirmed by Stechow, 1966, p. 144, n. 14, and by Davies, No. 58, p. 52 & 153. Rosenberg had read the date on the Munich painting as 1656 and cited the *Waterfall* (Leningrad, Hermitage, No. 463; Ros. 180), attributed to Ruisdael and bearing the date 1659, as Ruisdael's earliest dated *Waterfall* closely following Van Everdingen. Many subsequent critics have been misled into the assumption that Ruisdael began to paint such *Waterfalls* around 1660, and not much earlier.

13. Advice on the geological aspects of the *Waterfalls* of Van Everdingen and Ruisdael was generously given by Dr Warrington Cameron, formerly of the Department of Mineralogy, Cambridge University.

14. A further copy of Ruisdael's composition was attributed by Broulhiet to Hobbema (B 150). But its loose execution, lack of detail, and weak draughtsmanship indicate an inferior hand.

15. Van Everdingen's *River in a Mountain Valley* (Paris, Louvre) developed elements from paintings executed earlier in the fifties, such as his *Norwegian Landscape with Waterfall* (Davies, No. 63 & Fig. 169, as a work of the early fifties), and his *Landscape with Rocks* (Budapest, Museum of Fine Arts, No. 210;

Davies No. 92 & Fig. 208, as a work of the fifties). If Davies's dating of these works is correct, this establishes Van Everdingen's priority over Ruisdael with respect to mountainous landscapes too. The relative prices of their works in the Amsterdam art market, showing Van Everdingen with a more established reputation than Ruisdael, would tend to confirm Van Everdingen's leading rôle, even though later generations have judged Ruisdael's works artistically superior. Ruisdael's *Extensive Mountain Landscape with a Castle* is one of a small group of such compositions, others being the Hermitage *River in a Mountain Valley*, discussed below, and a very similar painting, *Mountainous Landscape with a River* (Capetown, The Old Town House, Max Michaelis Collection; Ros. 401; illus. The Hague–Cambridge, 1981–82, p. 147, Fig. 59). They have consistently been considered late works (e.g. by Rosenberg, 1928, pp. 66–67, perhaps following Bode, 1909, pp. 166–67; Stechow, 1966, p. 139, and Slive, in The Hague–Cambridge, 1981–82, p. 147), and sometimes (as by Stechow and Slive, *op. cit.*) as inspired by the mature landscapes of Nicholas Poussin or his followers. Given their close affinity to those of Van Everdingen, an artist who patently inspired Ruisdael in the 1650s, this view is unconvincing. It is also undermined on stylistic grounds, the foreground detail in the Hermitage painting being more comparable to his handling in the fifties than to the often thin, dry execution of his late works.

16. Davies, p. 68.

17. See Chapter III, and note 30 of same. This theme is paralleled in Poot's poem *Zomerönweer*, quoted in Chapter II, with translation, n. 47. Goedde, 1989, pp. 190–91, relates Ruisdael's *Sailing Vessels in a Stormy Sea* (The Hague; Ros. 587), with its lightning and rainbow, to a specific type of marine painting which he interprets as allegories of the peril of pride, humbled by divine wrath, and the virtue of humility.

18. For an analysis of the significance of the beacon in Ruisdael's *Rough Sea* in indicating the safety of harbour, its possible allegorical significance, and its relationship to a work of Van Everdingen, see Goedde, 1989, pp. 190–93. See also The Hague–San Francisco, 1990–91, pp. 394–98, kindly drawn to my attention by Anne Adams, Kimbell Art Museum.

19. Dating of Ruisdael's *Winters* remains as tentative as when Rosenberg, 1928, p. 40, proposed that Ruisdael first experimented with *Winters* soon after 1655, on moving to Amsterdam. Stechow, 1966, p. 96, linked Ruisdael's *Winter Town View with Wooden Bridge* (formerly J.C.H. Heldring collection, Oosterbeek; Ros. 614: Stec., Fig. 189) to the manner of Jan Beerstraten's *Castle*

of Muiden in Winter (London, National Gallery, No. 1311), dated 1658. He also noted the influence of Jan van de Cappelle and Allart van Everdingen, to whom Ruisdael owed much in other respects. Slive, in The Hague–Cambridge, 1981–82, p. 101, pays more attention to motif, articulation of space, and composition, than to manner of execution. He relates Ruisdael's Kettwig *Winter Landscape with View of the Amstel and Amsterdam* (Ros. 605; our Fig. 108) to the Blootelingh etching (The Hague–Cambridge, 1981–82, p. 210, Fig. 79) after Ruisdael's lost drawing of about 1663 of *A View of the Hooge Sluis from a Bank of the River Amstel*, and hence dates the Kettwig painting to the first half of the 1660s.

20. The effect of the Buckingham Palace painting (No. 59; Ros. 119) is diminished by its poor condition, the sky being particularly thin. The British Museum drawing (No. 1895–9–15–1297) is not catalogued by either Rosenberg, 1928, or by Giltay, 1980, but Slive, The Hague–Cambridge, 1981–82, pp. 46–47, & Fig. 18, appears to accept it.

21. The authenticity of the monogram and date 1660 on the *Dunes and Bleaching Fields* (Lugano, Thyssen Collection, No. 271) is dubious. The painting was examined under inadequate conditions, and detailed photographs, kindly supplied, have proved equally inadequate. The picture appears to be an inferior version of the undated *Dunes and Bleaching Fields* (Sale, London, Christie's, 23rd March 1973, No. 76).

22. For the dating of Vroom's panorama, see Keyes, 1975, I, p. 88, & II, pp. 185–87 (P 25), with further comments. Vroom's sketch *Country House before an inland Sea* (Paris, Fondation Custodia, collection F. Lugt; Keyes, 1975, II, D 31 & Fig. 45), as well as the 'presentation drawing' based on it (New Haven, Yale University Art Gallery; Keyes, *op. cit.*, D 26 & Fig. 46), may also have provided a prototype for Ruisdael, as it did for Cornelis van der Schalcke's *Extensive River Landscape* (London, National Gallery, No. 974). The scheme of Vroom's Heino *Panorama* is also imitated by Jacob van der Croos in his 1655 *Landscape with Ruined Castle of Brederode and distant View of Haarlem* (Gateshead, Shipley Art Gallery, No. 349), which is evidence of interest in Vroom's panoramic scheme in the mid-fifties.

23. For Koninck's panoramas, see Stechow, 1966, Figs. 75 & 76.

24. See Boudewijn Bakker, 'Maps, Books and Prints: The Topographical Tradition in the Northern Netherlands', in Exh., Amsterdam–Toronto, 1977, pp. 66–75, on p. 72. See also Stone-Ferrier, pp. 417–36, especially pp. 425–28, for the combination of city views and bleaching fields in the

Dutch cartographic and print tradition, and her interpretation of the inclusion of bleaching fields outside the city as an expression of civic pride in a local industry of significant economic importance.

25. Burke, 1974–75, pp. 3–11, on p. 3, with reference to M. Eisler, *Geschichte eines Holländisches Stadbildes*, The Hague, 1914, which publishes Wils's map.

Chapter VII

1. Compare Hobbema's *A Group of Trees on the Bank of a River* (Glasgow Art Gallery, No. 469; Broulhiet 463; Stechow, 1959, Fig. 7), dated by Stechow, 1959, pp. 3–18, on p. 10, to around the years 1658 and 1659, to Ruisdael's *Evening River Scene with an Angler* (private collection; The Hague–Cambridge, 1981–82, p. 17, Fig. 3) of 1649. Ruisdael's *Farm by a River* (Detroit, No. 37.21), one of a group of river landscapes with farms and windmills of questionable attribution (see Ch. V, n. 27), was compared by Stechow, 1966, p. 60, & Fig. 113, to Hobbema's *Cottage near a River Bank* (Amsterdam, Rijksmuseum; Stechow, 1966, Fig. 114). Closely related is Hobbema's *View along the Amstel* (formerly London, Nicholas Argenti collection; Stechow, 1959, p. 13, & Fig. 11), in which, as Stechow, following Frits Lugt, noted, n. 18, the ruins of the house Kostverloren are just visible behind the trees. Kostverloren recurs in other works of both Ruisdael and Hobbema, datable *post* 1658 (see below). While this indicates Ruisdael's influence on Hobbema already around 1658, Stechow, 1959, pp. 14–15, sees more the influence of Salomon van Ruysdael, and even Vroom, than that of Ruisdael, on this early phase of Hobbema's development.

2. Stechow, 1966, pp. 76–77, & Fig. 150, dates it around 1662 on the basis of its brown tonality, derived from Ruisdael, which, in Stechow's view, is characteristic of a short phase in Hobbema's development, around 1662.

3. Details of the history of the house Kostverloren, relevant to the timing of Ruisdael's drawings of it in the summer of 1658, are given by I.H. van Eeghen, *Rembrandt aan de Amstel* (Genootschap Amstelodamum), 1969, unpaginated, and discussed by Giltay, 1980, pp. 159–60, and by Slive, 1988, pp. 132–68.

4. Of five drawings of Kostverloren generally ascribed to Ruisdael, Giltay, 1980, p. 159, accepts two: the one in Haarlem, Teylers Museum, No. Q★52 (Giltay, No. 59; Exh. London, 1970, No. 42, illus, with comments and bibliography), which shows just the tower standing, and the one in Paris,

Fondation Custodia, F. Lugt collection, No. 242 (Giltay, No. 92; Exh. New York–Paris, 1977–78, No. 97, & pl. 41, with comments and bibliography), showing the house as Slive, 1988, pp. 132–68, has convincingly demonstrated, as it appeared after the reconstruction of 1658, and considered, New York–Paris, 1977–78, p, 142, datable around 1660. Two other drawings of Kostverloren, closely related to Ruisdael's Paris, Lugt collection drawing, and showing the house in the same state and from the same direction, are in the Kunsthalle, Hamburg, Nos. 22451 (discussed and illustrated by Stubbe, p. 43, No. 85, pl. 74) and 22452. They are both attributed by Giltay, 1980, p. 159, note 33, following Carlos van Hasselt, and by Slive, 1988, p. 139, to Jan van Kessel. As Slive has pointed out, the fenestration on the Amstel façade differs from that of the old house as seen in Simon Frisius's etching, but is the same as that seen on Rademaker's later drawing, published by Slive, 1988, p. 164, Fig. 6.27. Furthermore, it should be noted that while the dormer windows on Frisius's print show a two-step gable, the Ruisdael drawing in the Lugt collection, the two Hamburg drawings, and Rademaker's all show a one-step gable, further evidence that these drawings show the reconstruction, not the original building, and are therefore all executed after 1658. Related drawings and paintings by Hobbema and Jan van Kessel of Kostverloren are discussed below, and in the cited sources.

5. Broulhiet (No. 433) attributes a second picture of Kostverloren to Hobbema. A further comparable composition in Budapest (Museum of Fine Arts, No. 258), has been attributed to various Dutch masters of the second half of the seventeenth century, including Hobbema and Jan van Kessel.

6. Compare to the other drawings here attributed to Hobbema, and to those on Giltay's tentative list of Hobbema drawings (Giltay, 1980, p. 203). Slive, 1988, p. 138, on the other hand considers it a drawing by Jan van Kessel, of the sixties, after Ruisdael's Teylers sheet.

7. The earliest surviving work by Hobbema featuring a watermill (formerly Hage Collection, Nivaa; Broulhiet, No. 33) is dated 1662.

8. The advice of H. Hagens of the Rijksmuseum Twenthe concerning different mill constructions, and the possible identity of that in Ruisdael's Toledo and Melbourne paintings, is gratefully acknowledged.

9. An inferior drawing of the same composition is in the Albertina, Vienna (No. HS32–10110), and an even more stylised version is in The British Museum, London (Hind, No. 18). A painted version (Panel, 62.2 by 81.3), attributed to Jan van Kessel, was in the Spring Exhib., Leonard Koetser

Gallery, London, April–May 1973. It included a more extensive landscape to the left.

10. Although Broulhiet, 1938, No. 1, attributed the drawing to Ruisdael, L.C.J. Frerichs in Selected Drawings from the Print-room, Rijksmuseum, Amsterdam, 1965, No. 73, illus., attributed it to Hobbema. I concur with Giltay in attributing it to Ruisdael, given both the difference to Hobbema's drawing of the same subject (Haarlem, Teylers Museum, No. R37) and its close affinity to Ruisdael's painted version in Toledo. An inferior version of the Toledo Watermill was formerly with Habestock, Berlin (Canvas, 56 by 67.5; HdG 169; Ros.–; Simon, 1930, 41, & illus. 10, as a work of c. 1665). Its poor execution is not attributable to Ruisdael.

11. Giltay, 1980, p. 203, tentatively attributes both the drawing in London (British Museum, No. 00-11-242) and Paris (Louvre, No. 23.014) of Deventer Mill to Hobbema, apparently unaware that the latter served as the basis for a composition etched in 1782 by J.J. de Boissieu after Ruisdael. The date on Hobbema's Edinburgh View of Deventer, traditionally given as 1689, on close inspection may be read as 1680.

12. Maschmeyer, pp. 61–71, on pp. 61–2, and see The Hague–Cambridge, 1981–82, p. 93, where it is noted that the position of Bentheim Castle is not strictly topographically correct.

13. See The Hague–Cambridge, 1981–82, pp. 118–19, No. 40. Hagens, 1982, pp. 11–12, points out that while the sluice in the Toledo painting does resemble that at Singraven, this type of sluice is found at various Twenthe watermills, and even further afield.

14. The drawing Landscape in the Rain: near Bentheim (?) (Leningrad, Hermitage, No. 3868) is attributed by Giltay, 1980, p. 203, III, & Fig. 50, to Hobbema. Maschmeyer, 1978, pp. 68, 71, Fig. 5, considers it a landscape in the immediate vicinity of Bentheim. A later work by Ruisdael which includes Bentheim Castle is the Waterfall with Bentheim Castle (Amsterdam, Rijksmuseum, No. A347).

15. Hobbema's fresh little Waterfall (Edinburgh, National Gallery of Scotland, No. 1506), perhaps derived from the composition of Ruisdael's Waterfall (Frankfurt, Städelsches Kunstinstitut, No. 1156), is his only effort to emulate this aspect of Ruisdael's production and quite foreign to the latter's interpretation of the theme.

16. While Hobbema's Wooded Road with Cottages (Philadelphia, Museum of Art, No. E'24-3-7; Sutton, 1987, No. 45, & pl. 108) of 166[2], a date corroborated by recent technical examination (Sutton, 1987, p. 347), uses the older Ruisdaelian mode of spot-

lighting, a more diffuse mode of lighting is seen already in Hobbema's 1662 The Farm (Paris, Louvre, No. R.F. 1526; Sutton, p. 347, Fig. 1) and is fully developed in Hobbema's 1663 Wooded landscape with Cows (Blessington, Ireland, Sir Alfred Beit collection; Sutton, 1987, p. 349, Fig. 1).

17. The ratio of sky to land is increased further in a small scale, upright version of this composition (Amsterdam, Rijksmuseum, No. A351).

18. See Jan van Kessel's Bleaching Fields with View of Haarlem (Brussels, Musées Royaux des Beaux-Arts, No. 776; Haak, p. 468, Fig. 1028). The naïveté and awkward spatial transitions reveal Kessel's inexperience, indicating a date in the early 1660s. See also Jan Vermeer van Haarlem's unsigned View of Haarlem (Budapest, No. 58.6), sometimes attributed to Jan van Kessel. Its highlights on the trees, and triangular wedge of foreground dune, descending from the skyline, seen also in a smaller version of the same subject (Cologne, Wallraf–Richartz Museum, No. 2367; Stechow, 1966, Fig. 81), are characteristic of Vermeer of Haarlem.

19. See Exh., Amsterdam–Toronto, 1977, pp. 73–75, and for Nooms's etchings, ibid., No. 42. Hobbema's drawing for his View of Haarlem Lock, Amsterdam (London, National Gallery, No. 6138; Stechow, 1966, Fig. 262) must have pre-dated 1662 (see Exh. Cat. entry). Jan van Kessel's drawing, The Heiligewegspoort, Amsterdam (Berlin-Dahlem, No. 2853; Schulz, No. 102 & illus. 53) is dated 1664.

20. All six of Blootelingh's prints of Amsterdam city views after Ruisdael, and Ruisdael's two surviving drawings for them are reproduced and discussed by Slive in The Hague–Cambridge, 1981–82, pp. 208–12.

21. It was dated by Rosenberg, 1928, p. 29, c. 1655, which was followed by Stechow (1966, p. 74), Jones (p. 17), and Slive (in The Hague–Cambridge, 1981–82, p. 62). However, Ruisdael's tree types, dispersed lighting, more open spatial articulation, colour and brilliant manner of execution in the Oxford painting are much more consistent with works of the 1660s.

22. Houbraken, III, p. 273, & pp. 275–76, as noted, Ch. II, n. 64 above.

23. The swift execution of the trees in Hobbema's Frankfurt Edge of a Forest, combined with his treatment of light and the sunlit vista, indicate a work of about 1663, the approximate date generally ascribed to Hobbema's more refined Wooded Landscape with a Pool and Water Mills (Cincinnati, Taft Museum, No. 1931.407; Sutton, 1987, No. 45, & pl. 108), a painting whose conception and composition, but not its more particularised details of rural life, like the Frankfurt painting, suggests knowledge of Ruisdael's Oxford Edge of a Forest.

The lighting of Ruisdael's Oxford painting shares the new experiments in lighting seen in Hobbema's paintings of around 1663, and was probably painted at about the same time.

24. Corroboration of the customary dating in the 1660s of Ruisdael's *Woodland Swamps*, such as the Leningrad painting (noted by Stechow, 1966, p. 200, n. 41, and Slive, in The Hague–Cambridge, 1981–82, pp. 108–109, & Fig. 51) is provided by the compositionally closely related *Wooded landscape with a Pond* (H.A. Clowes sale, London, Christie's, 17th February 1950, No. 49; HdG 548) which is recorded as inscribed; 166[?], but this has not been verified in recent years. Its composition is even closer to Savery's *Woodland Swamp* than the Leningrad painting, but the structure of the main trees is unusual and overly exaggerated for Ruisdael, so that its authority should be taken with caution until it can once more be examined directly.

25. Bredero, *Lied. en Ged.*, pp. 20–21, quoted Beening, pp. 93–94. Samuel van Hoogstraeten, 1678, pp. 136–37, linked *Bosschen en Wildernissen* (Woods and Wildernesses) as landscape types, so associating woodland with the wilder aspects of nature that were associated with religious contemplation. Van Mander, *Grondt*, VIII, 36 (with commentary by Miedema, 1973, p. 535) emphasised the contemplative ambience of woodland, ideal for a painter or a poet.

26. For Hobbema's Cincinnati painting, see Sutton, 1987, No. 45, & pl. 108. A larger version of Hobbema's Lugano *Woodland Swamp* (measuring 101 by 144 cm) is in The National Gallery of Victoria, Melbourne (Felton Bequest 1949/50). It bears Hobbema's signature and the date 1662, but its lifeless draughtsmanship is inferior to the Lugano picture, and is not therefore a reliable guide to the date of the latter. The execution of the Lugano painting may, however, be compared to the lively handling of Hobbema's *Woodland Landscape* (Philadelphia, Museum of Art, William L. Elkins collection, No. E'24.3.7; Sutton, 1987, No. 44, & pl. 107) which is signed and dated 166[2], as noted n. 16 above, the date of 1662 being confirmed by recent examination.

27. Jan van Kessel's signature, although painted over and covered by a false Ruisdael signature, is still just visible.

28. I am indebted to James Golob, formerly of the University of Cambridge, for information and a photograph of the Buijs watercolour after Ruisdael.

29. For a discussion of tree symbolism in relation to the Berlin painting, see Sutton, 1987, pp. 456–58. The relationship of this composition to Ruisdael's Leningrad *Woodland Swamp*, and to the left-hand side

of Hobbema's *Woodland Landscape with a Pool and Water Mills* (Cincinnati, Taft Museum, No. 1931.407; Sutton, 1987, No. 45, & pl. 108) of *c.* 1663, mentioned also in n. 23 above for its relationship to Ruisdael's Oxford *Edge of a Forest*, should be noted as confirming the interrelationship of this group of works.

30. See Allart van Everdingen's *Mountain Landscape with River Valley* (Copenhagen, Statens Museum for Kunst, No. SP513) of 1647, Philips Wouwerman's *Travellers awaiting a Ferry* (New York, private collection) of 1649, and Herman Saftleven's *Rhineland Fantasy View* (New York, private collection) of 1650, all illus. in Sutton, 1987, pls. 90, 91, & 92 respectively. For a prototype for these compositions, and Ruisdael's, see the engraving of Pieter Bruegel the Elder's *St Jerome in the Desert* and his 1566 etching, *Landscape with Rabbit Hunters* (illus., H. Arthur Klein, *Graphic Worlds of Pieter Bruegel the Elder*, New York, 1963, pp. 13 & 27.

Chapter VIII

1. For Van Mander on the painting of waterfalls, and Houbraken's reiteration of the challenge to evoke the noise of falling water, itself seen as an allusion to the artist's own name, see Ch. II, n. 13 above. For Houbraken's commentary on Ruisdael's *Waterfalls*, see Houbraken, III, pp. 65–66, the Dutch text of which is given, in full, Ch. I, n. 1 above.

2. For a discussion of Ruisdael's pictorial and typological precedents in painting waterfalls, and their common allegorical associations, see Ch. III above, and n. 14–17, 19, & 20 of the same.

3. For the iconographic sources of Ruisdael's *Waterfall with Hilltop Castle* (Brunswick), see the references in n. 2 above. See further, Bruyn, in Sutton, 1987, p. 101, & Fig. 26, on the opposition of a hilltop church and a waterfall in Allart van Everdingen's *Landscape with Waterfall* (Amsterdam, Trippenhuis), a painting whose composition is related to Ruisdael's; Giltay, in Sutton, 1987, pp. 450–51, on the iconography of Ruisdael's *Waterfall with Castle and a Hut* (Cambridge, Fogg Art Museum, 1953.2); and Slive, in The Hague-Cambridge, 1981–82, pp. 102–05, who compares the Fogg painting to a group of four others, including the Brunswick composition.

4. For the symbolism of corn in Dutch paintings, see, e.g., the 1676(?) *Vanitas still-life* (Karlsruhe, Staatliche Kunsthalle) by Jacques de Claeuw, Jan van Goyen's son-in-law, and comments thereon in Exh., Leiden, 1970, No. 7, illus. A further example is C.N. Gysbrechts's 1664 *Vanitas still-life* (Hull, Ferens Art Gallery, No. 577).

In both paintings, and others like them, ears of corn are draped over a skull. As Wiegand noted (note 498), Gabriel Rollenhagen's *Nucleus Emblematum . . .* , Cologne, 1611, no. 21, represents a skull and hourglass by a grave, with blades of corn sprouting from the eye and cheek cavities of a skull, and a harvest of corn beyond. Much later, Jan Luyken, *Het overvloeiend herte*, Haarlem, 1767 (published posthumously), p. 49, quotes in this context John 12.24 and I Corinthians 15.36. Both references associate sown corn with resurrection and eternal life. The significant position of the cornfields in Ruisdael's Amsterdam *Woodland Waterfall* is also discussed by Bruyn, in Sutton, 1987, p. 99.

5. An horizontal *Waterfall* (English private collection; Ros. No. 222), perhaps derived from the composition of the Leningrad *Waterfall*, bears a false Ruisdael signature and date 1661. Comparison to the Leningrad picture shows up its poor draughtsmanship and crude design as the work of an imitator. In forging the signature it was overlooked that a flourish on the final '1', found on works of the early fifties, was thereafter discontinued. Rosenberg, 1928, No. 222, read the date as 1669, accepting it as a Ruisdael, and Simon, 1930, p. 37f, p. 63, & illus. 9, accepted it as a key to Ruisdael's development in 1661.

6. See, for example, the *Wheatfields* (Basle, Offentliche Kunstsammlungen, No. 924), the *Country Road with Cornfield* (Blessington, Ireland, Sir Alfred Beit collection), the *Cornfields with a Distant Town* (Los Angeles, Mr and Mrs Edward Carter collection; Los Angeles–Boston–New York, 1981–82, No. 21 & col. pl.), the *Country Road with Cornfields* (formerly Thos Agnew & Sons Ltd., London; our Fig. 180), and the *Cornfields by the Zuider Zee* (Lugano, Thyssen collection, No. 270; our Fig. 181). See Chong, in Sutton, 1987, pp. 445–48, discussed in Chapter X for the view that Ruisdael's paintings of wheatfields depict what was a rare and economically significant element of a specific region, to the south and east of the Zuider Zee. He also expresses the view that for the contemporary observer these economic and topographic features, like Ruisdael's interest in the 'industries of the land – such as bleaching fields and windmills', would have been the most important associations aroused by these pictures. He notes that, in painting such economically significant subjects, Ruisdael was unique. See also Los Angeles–Boston–New York, 1981–82, pp. 84–87, kindly drawn to my attention by Mrs Edward Carter, for a discussion of Ruisdael's *Cornfields with a distant Town* (Los Angeles, Mr and Mrs Edward Carter collection) in relation to his other depictions of this motif.

7. Fuchs, 1973, pp. 281–92, using a method of analysis derived from semiotics, saw in the formal organization of the picture a semantic structure, by which a series of visual contrasts consistently represent two sides of nature: land/water, wild nature/cultivated nature, summer/winter, growth/decay, so manifesting a number of general characteristics of 'nature in the world', the painting thus serving as a *speculum naturae*, intended for contemplation. His method of analysis can be fruitfully applied to many of Ruisdael's compositions, despite the misgivings of Chong, in Sutton, 1987, p. 447.

8. See Imdahl, pp. 1–32, on p. 3, and The Hague–Cambridge, 1981–82, pp. 114–17, & Fig. 53, for further historical and topographical details about the subject of Ruisdael's painting, and a drawing of 1750 showing the mill and Vrouwen Poort, from the opposite direction.

9. Imdahl, p. 5, suggests that the three women on the road may allude to the Vrouwen Poort (Women's Gate), which Ruisdael omitted, so enhancing the towering effect of the mill. Figures carrying bags of grain to or from a mill are also, however, part of the traditional iconography, as seen in C.J. Visscher's etching *Landscape with Windmill* (our Fig. 157).

10. Stechow, 1966, Figs. 100, 101, & 102.

11. See Kauffmann, 1977, pp. 379–97, for a detailed iconological study of Ruisdael's *Mill at Wijk*. He mentions, *inter alia*, that Jan G. Swelincks's etching of a windmill, on a bulwark illuminated by light beams from behind dark clouds (itself a selected detail, in reverse, of C.J. Visscher's etching *Landscape with a Windmill*; our Fig. 157), was used by Zacharias Heyns in his *Emblemata* (Rotterdam, 1625) to illustrate the theme 'Mill' (illus. The Hague–Cambridge, 1981–82, p. 116, Fig. 54). The etching appeared under the motto *Spiritus vivificat* (The Spirit gives life), and above the text from II Corinthians 3.6: 'the letter kills, but the Spirit gives life', alluding to the fact that just as the mill (and equally the ship, with its limp sails, in Ruisdael's painting) is lifeless without the wind, so is man without the Spirit of God. He also quotes Jan and Caspar Luyken, *Spiegel van het menselijk bedryf*, Amsterdam, 1694 & 1730, No. 48: *De Molenaer* (The Miller), with woodcut and motto: 'Den Heemel geeft, Wie vangt die heeft (Heaven gives, who grasps it has it). For the significance of the light beams as an image of divine providence, explicit in the emblems and landscape prints here mentioned, see Chs. II & III *passim*.

12. See Simon Schama, *The Embarrassment of Riches: An Interpretation of Dutch Culture in the Golden Age*, New York, 1987, Ch. II: Patriotic Scripture, esp. 93ff, which captures the characteristic Dutch mix of prosperity and piety; p. 629, n. 78, refers

to further literature on the 'Netherlands–Israel' analogy; and p. 130, where he quotes from Melchior Fokkens 1665 Description of Amsterdam (*Beschryvinge der Wijde-Vermaerde Koop-Stadt Amstelredam*): 'As it was said by men in the Olden Times that there was a land that flowed with milk and honey . . . So that truly it may be said that our Holland overflows with butter, cheese and milk and that these blessings we receive from the hands of the Almighty.' Chong, in Sutton, 1987, pp. 458–63, dismisses any moralising and symbolic meanings in Ruisdael's *Mill at Wijk* as 'subsidiary, indirect associations'. He believes that seventeenth-century observers would have been more interested in Ruisdael's mill as an 'industrial structure, with its functions and special features' (p. 461). For Chong, Ruisdael celebrates a more direct meaning: the windmill, 'an acknowledged factor in the economic strength of the country', and, like his paintings of bleaching or cornfields (see n. 6 above) showing 'the productivity in the landscape' (p. 462). Chong, sensing keenly the Dutch concern with prosperity, appears to miss the dynamic tension, captured well by Schama, between prosperity and piety, to which the pictorial structure, historical precedents, lighting, and overall tone of Ruisdael's picture quietly but forcefully testify.

13. See The Hague–Cambridge, 1981–82, pp. 124–26, for a review of the literature concerning the identity of the church depicted, and reasons to see it as, at least, an allusion to the vicinity of Blaricum, in Gooiland, the dwelling place of his ancestors. If this was intended by Ruisdael, then one could further speculate that perhaps the ruined castle was also an allusion to the little castle of Ruisschendaal, near Blaricum, whence his family took their name. But there is no evidence to support these personal associations. The painting was dated by Rosenberg, 1928, p. 54, to the second half of the sixties; but Jan van Kessel's imitations of it indicate a somewhat earlier date. See Jan van Kessel's *Extensive Landscape with Ruined Castle and Village Church* (Rotterdam, No. 1399); a superior version of the same (canvas, 59.7 by 109 cm) was formerly with Alfred Brod Gallery, London (advertisement, *Apollo*, September 1968; photo: Witt); see also Kessel's *Landscape with Bleaching Field and Castle Ruin* (formerly Frank P. Wood, Toronto, as Ruisdael). The *Country Road with Church and Cornfields* (Northampton, Mass., Smith College of Art, No. 1943.16, as Ruisdael, lacks the firm structure and incisive strength of Ruisdael's hand, and may also be by Jan van Kessel. For Ruisdael's own variants, see Maclaren, 1960, pp. 361–65.

14. See Chong, in Sutton, 1987, pp. 104–20, esp. pp. 106–09.

15. See Willem van de Velde's 1658 *Strong Breeze* (London, National Gallery, No. 2573; Stechow, 1966, Fig. 241.

16. Dated by Rosenberg, 1958, pp. 144–46, about 1670, 'when Ruisdael's interest in extended spaciousness manifests itself in various categories'. We consider its qualities of composition, colour, space, and lighting comparable to the *View of Haarlem* (The Hague, Mauritshuis), the Oxford, Worcester College *Edge of a Forest*, and the London, National Gallery *Extensive Landscape with Ruined Castle*, and that, like them, it is a work of the first half of the sixties.

17. Stechow, 1966, Figs. 234 & 240.

18. Stechow, 1966. pp. 110–11.

19. Houbraken, III, p. 238.

20. For Van Kessel's drawing of 1664, see Ch. VII, n. 19 above. The Heiligewegspoort was demolished in 1670. For comparison to Jan Beerstraaten, see his *The Dam, Amsterdam, in Winter*, and his 1659 *Ouderkerk aan de Amstel* (both Amsterdams Historisch Museum; Exh., Amsterdam–Toronto, 1977, Nos. 100 & 101, illus.).

21. Ros./Slive, 1972, p. 271, and see further Slive, in The Hague–Cambridge, 1981–82, pp. 122–23, quoting Stechow, 1960, p. 183, who writes of the Amsterdam *Winter* in terms of Romantic tragedy and pathos. As precedents for Ruisdael's characterisation of winter, see e.g.: Van der Neer (London, Wallace Collection, No. P159); Van Goyen (Manchester, City Art Gallery, Trustees of the Assheton–Bennett Collection); Wouwerman (Berlin–Dahlem, No. 900F); Berchem (Amsterdam, Rijksmuseum, No. A28); and brighter, but subdued, Jan van de Cappelle (Enschede, Rijksmuseum Twenthe, Stechow, 1966, Fig. 187).

22. Van Mander, *Bucolica en Georgica*, T'Amsterdam, 1597, p. 5, with text and translation given Ch. III, n. 19 above.

23. Sutton, 1987, pp. 448–49, by contrast to Slive and Stechow (see n. 21 above), interprets this painting, and others related to it, in terms of poetic realism rather than romantic projection of tragic human emotion.

Chapter IX

1. See Ros./Slive, 1972, Fig. 272 (for Lairesse) & Fig. 270 (for Weenix).

2. The date of 1678 on his Dublin *Hilly Landscape* (Stechow, 1966, Fig. 148) was doubted by Simon (1928). It does not appear to conform to authentic examples, and in 1978 the Museum restorer orally expressed the doubt that it would survive cleaning. For the Hannover picture, see Stechow, 1966, p. 75, & Fig. 147.

3. Details concerning the market are noted by

Martin, 1942, p. 304, n. 413. I.Q. van Regteren Altena, reviewing the Catalogue of the Frick Collection, in *Oud-Holland*, LXXXV, 1970, p. 59, says that Ruisdael had a studio overlooking The Dam from 1670 until his death in 1682. Oldewelt, 1942, pp. 163–67, identifies this as the second house from the corner of the Rokin, on the south side of the Dam, above the shop of the book and art dealer Hieronymus Sweerts. Already in 1657 he lived close by, living at 'De Silvere Trompet' on the Beursstraat at the time of his 1657 baptism, and in the Kalverstraat across from the 'Hof van Holland' in 1667, when he made his Will. His studio at the corner of the Rokin would provide a view comparable to that in the Frick painting. A version of the Frick painting is in the Boymans-van Beuningen Museum, Rotterdam (No. 1744; canvas, 53.3 by 67.2 cm). The *View of The Dam, Amsterdam* (Berlin–Dahlem, No. 885D; canvas, 52 by 65 cm; our Fig. 186) is sometimes considered its pendant, appearing together in the sale, Engelberts and Tersteeg, Amsterdam, Van der Schley, 13 June 1808. Its qualities, however, approximate more to the Frick painting (canvas, 52 by 66 cm).

4. See Martin, 1931, p. 17, and Roggeveen, 1948, pp. 91–94. The *Panorama of Amsterdam and Its Harbour* (English private collection; Ros. 2; our Fig. 165) depicts the city from an even more remote bird's eye view, as discussed below. For the cultural life of Amsterdam in the last quarter of the seventeenth century, see Regin, pp. 182–213.

5. For the topographical details of the Leipzig drawing and of the Fitzwilliam painting derived from it, and the implications for the dating of each, see Slive in The Hague–Cambridge, 1981–82, pp. 155–57, basing himself on A.E. d'Ailly, *Repertorium van de profielen der stad Amsterdam en van plattegronden der schutterswijken*, Amsterdam, 1953, pp. 68–69 (identifying Het Besjehuis in the Leipzig drawing) and D.C. Meijer, 'Groei en Bloei der Stad', *Amsterdam in de Zeventiende Eeuw*, Vol. I, The Hague, 1897, pp. 186–87 (giving the building dates for Het Besjehuis as begun 1681, completed November 1683, and J. Smith's print thereof, of C. 1700). Slive notes that Ruisdael died before its completion and that in the Fitzwilliam painting, where he completes the building in his imagination, he departs from its final structure. He gives it more dormers and chimneys than it actually finally had. For a close-up view of the Portuguese Synagogue, see Romeyn de Hooghe's etching in Exh., Amsterdam–Toronto, 1977, No. 45, and *Idem*, No. 122, for further details about the Fitzwilliam painting.

6. See Slive in The Hague–Cambridge, 1981–82, pp. 216–17, for a review of the literature on this drawing, and for reasons to date it to about 1665, rather than about 1647. Giltay, 1980, pp. 161–63, leans towards the earlier date, owing to the old inscription and the absence of the Nieuwekerk in the foreground, but acknowledges that this is not consistent with the drawing style. One only has to imagine the effect of including the large form of the Nieuwekerk to understand why Ruisdael omitted it.

7. For Sweerts as publisher of the Blootelingh prints, see The Hague–Cambridge, 1981–82, p. 153.

8. The traditional attribution of the figures to Gerard van Battem, a painter resident in Rotterdam, seems unlikely, given the abundance of figure painters available in Amsterdam itself.

9. Exh., Amsterdam–Toronto, 1977, No. 104, illus.

10. Cf. Nooms's 1659 view of *The Houtkopersburgwal with the Zuiderkerk, Amsterdam* (Leipzig, Museum der bildenden Künste; Exh., Amsterdam–Toronto, 1977, No. 120, illus; Van Everdingen's *View of Alkmaar* (Paris, Fondation Custodia, Collection F. Lugt; Stechow, 1966, Fig. 258), painted *c.* 1670; and Hobbema's *The Haarlem Lock, Amsterdam* (London, National Gallery, No. 6138; Stechow, 1966, Fig. 262), painted *c.* 1666/68, from an earlier drawing, probably pre-dating 1662, see Exh., Amsterdam–Toronto, 1977, pp. 73–75.

11. Cf. Van Everdingen's *Hunting Party in the Park of a Chateau* (formerly Weitzner, New York; Davies, No. 159 & Illus. 389), and Jan Steen's 1677 *A Party in the Open Air* (private collection; illus. J.M. Nash, *The Age of Rembrandt and Vermeer*, Oxford, 1979 (1st Edn. 1972), pl. 174). Steen's picture of 1677 shows both a country house similar in style to those in works of Ruisdael, Philips Koninck, and Van Everdingen, and, significantly, men with long hair and exceptionally broad-rimmed hats, as in Ruisdael's Berlin painting (No. 885A) mentioned below, thus serving as some guide to the date of the latter.

12. Figures similarly dressed to those in the Berlin and Washington paintings recur in Ruisdael's *Road Lined with Trees* (Cambridge, Mass., Fogg Art Museum, No. 1966.168) and in his *Woodland Alley* (Dresden, No. 1500), which must also date from the second half of the seventies. Their dull execution and poor composition also indicate a distinct decline in Ruisdael's faculties.

13. The *Coast near Muiden* (Polesden Lacy, National Trust; canvas, 55.5 by 69.5; Ros. 572a; Exh., The Hague–Cambridge, 1981–82, No. 49, illus.) has been considered a companion piece. The land and sea are on opposing sides and the two pictures have virtually identical dimensions. They also had the same history between 1772 and 1893 (see Maclaren, 1960, pp. 365–66; and,

for an opposing view, rejecting them as pendants, Slive, in The Hague–Cambridge, *op.cit.*). A comparable composition to the London painting is in The Hermitage, No. 5616, illus. Fekhner, pl. 72, with detail of the boats, pl. 74. Of three other versions, Ros. 566, 572 and the painting in the Mauritshuis, The Hague, No. 154, the latter is probably by Jan van Kessel. For Adriaen van de Velde's 1665 *Beach Scene* (The Hague, Mauritshuis), see Stechow, 1966, Fig. 214.

14. For Simon de Vlieger's *Scheveningen Beach* (Cologne), see Stechow, 1966, Fig. 207.

15. For the Lugt *Winter Landscape with a Windmill* see Exh., The Hague–Cambridge, 1981–82, pp. 148–49, No. 53, illus. and compared to a group of other late *Winters* by Ruisdael (*Idem*, p. 148, Figs. 60–62).

16. For Rembrandt's Kassel *River Landscape with Ruins*, see Stechow, 1966, Fig. 276; and for his Brunswick *Landscape with a Thunderstorm*, see Bruyn, in Sutton, 1987, p. 97, Fig. 20, with discussion of its iconography.

17. See, for example, his *Hilly Woodland with Waterfall*, (New York, Metropolitan Museum of Art, No. 89.15.4), and his *Woodland Road with Pool* (Montacute House (loan); Ros. 336), and see further Ch. VI, n. 10.

18. Stechow, 1968, pp. 250–61, on pp. 252–53.

19. See Jones, pp. 10–22, for a detailed discussion of the Krannert *Ford in the Woods*, which he dated *c.* 1660, as about five years later than the Oxford, Worcester College *Edge of a Forest*, which he supposed was painted *c.* 1655, following Rosenberg and Stechow. Reasons to reject this supposition are given, Ch. VII, n. 21 & 23.

20. Comparable characteristics are manifest in two further waterfalls of like size to the Berlin *Waterfall* and to each other: the *Waterfall with Bentheim Castle* (Amsterdam, Rijksmuseum, No. A347) and the *Waterfall with a Chapel* (Sale, London, Sotheby's, 6 December 1972; Ros. 207), possibly executed as pendants, the cornfields by the chapel (in the latter), and the autumn tints on the trees below the castle (in the former) possibly evoking a contrast of summer and autumn, and perhaps even of the temporal (castle) and spiritual (chapel) life.

21. The dull outlines of the Agnews painting may result from paint loss. It was exhibited in 1819, No. 51, as 'Landscape, with Figures and Cattle Ruysdael and A. Vandevelde', the owner was the Earl of Musgrave. Constable's sketch was Exh., London, Tate, 1976, No. 167 (The Executors of Lt. Col. J.H. Constable).

22. For identification of the Grote Kerk in Alkmaar, see Sutton, 1987, pp. 463–65, discussing the building seen in the Boston painting.

23. In a further *View of Haarlem* (Sale, London, Christie's, 8 May 1953, No. 93 an even

more remote view-point is used. By around 1670 his *Haarlempjes* had become conventionalised and much imitated, even being used, in 1671, as a background to Jan Andrea Lievens's portrait of *Dirck Decker on Horseback with Distant View of Haarlem* (Cambridge, Fitzwilliam Museum, No. 28). The background refers to Decker having been born at Bloemendaal, north of Haarlem, where his father Cornelis was a bleacher (see Fitzwilliam Museum Catalogue, p. 71, No. 28).

24. Constable's replica was Exh., London, Tate, 1976, No. 292 (loan to the Minories, Colchester, from the Trustees of the Will of H.G. Howe, descd.).

25. For comparison of the Philadelphia *Winter* to other *Winters* from Ruisdael's later years, such as that on loan to Birmingham City Art Gallery, the Lugt collection picture, and the one formerly in the Cook collection, Richmond, all featuring windmills under high, cloudy skies, see The Hague–Cambridge, 1981–82, pp. 148–49, pl. 53, & Figs 60–62.

26. For a discussion of these two drawings of the Dam (now in Brussels, Koninklijke Musea voor Schone Kunsten, De Grez collection, Nos. 168 & 169), their relationship to the Berlin painting of *The Dam*, and Slive's suggestion of how they might once have been joined, see The Hague–Cambridge, 1981–82, pp. 152–54 (for their relationship to the painting), & pp. 226–28, Cat. Nos. 93 & 94 (for the drawings themselves).

27. In a similar *View of Amsterdam from the Amstel* (Philips Collection, Eindhoven; Ros. 5; Canvas, 52.1 by 66), the viewpoint is even further from the city.

28. See H. Wagner, *Jan van der Heyden 1637–1712*, Amsterdam, 1971, & Richard J. Wattenmaker in Exh., Amsterdam–Toronto, 1977, pp. 30–31.

Chapter X

1. Lairesse, 1708, as quoted by Sutton, 1987, pp. 56–57; Luyken, 1708, pp. 90–93.

2. Félibien, 1706 (1st Edn. 1666–88), III, pp. 298–305; IV, p. 136; V, pp. 161, & 204. See also Chapter II.

3. Quoted from De Piles, 1706, XVII, pp. 35–36. For his account of the Dutch & Flemish painters, see De Piles, 1715 (1st Edn. 1699), Bk. VI.

4. Lairesse, as per n. 1 above.

5. Houbraken, III, p. 358, and III, pp. 65–66, quoted in full in Chapter I.

6. See Immerzeel, p. 41, and also, G. Hoet, *Catalogus of Naamlyst van Schilderyen*, 2 vols, The Hague, 1752, listing details of sale catalogues from 1684 to 1752. Continued by P. Terwesten, *Catalogus of Naamlyst van*

Schilderyen, The Hague, 1770. See Hayes, 1965, pp. 38–45, and 1966, pp. 188–97, & pp. 444–451, on British patrons and landscape paintings.

7. Hayes, 1966, pp. 190–92.

8. Hayes, 1978, pp. 230–33.

9. Gerson, 1942, p. 429.

10. For Gainsborough and Ruisdael's *Woodland Ford* (Paris, Louvre, No. 1817), see Woodall, 1935, pp. 40–45. A further example of Gainsborough's imitation of Ruisdael, not previously published, is the *Rocky Woodland Landscape* (Lord Camrose; Exh., *Thomas Gainsborough*, London, Tate, 1980, No. 116, with colour plate, as 'one of Gainsborough's most consciously Claudean compositions' of about 1773–74). Although Claudean in colour and poetic mood, its composition, and the herdsman, cattle, rocks, and central vista are directly derived from Ruisdael's *Hilly Wooded Landscape* (Selkirk, Bowhill, The Duke of Buccleuch and Queensberry collection, No. D. 176; Ros. 402; our Fig. 67; exh., London, Agnews, 1978, No. 37, illus; and The Hague–Cambridge, 1981–82, No. 15, illus.) Gainsborough's *The Watering Place* (London, National Gallery; Exh. R.A., London, 1777), is a closely related composition, perhaps derived from the earlier Camrose composition. For Gainsborough's comment on *Cornard Wood* (London, National Gallery, No. 925), see Woodall, 1961, p. 35, No. 5: Letter from Gainsborough to Henry Bate, 1788.

11. Woodall, 1961, p. 91, No. 43: Letter from Gainsborough to Thomas Harvey, 22 May 1788.

12. Reynolds, *14th Discourse*, in *Literary Works*, II, p. 89f; *4th Discourse*, in *Idem*, I, pp. 358–59. For Reynolds on Dutch art, see Chapter II.

13. For Desfriches, see Gerson, 1942, p. 110. For Fragonard, see Jacques Wilhelm, 'Fragonard as a Painter of Realistic Landscapes', *The Art Quarterly*, Autumn 1948, pp. 296–305; also Georges Wildenstein, *The Paintings of Fragonard*, 1960, Cat. Nos. 152 & 172. For Le Prince, see Diderot, *Oeuvres complètes*, ed. Assézat, III, pp. 11, 15.

14. Burgess, pp. 114–16, and, for Van Goyen, pp. 69–70. The section on Ruisdael is an inaccurate transcription of Houbraken's account. Burgess gives Ruisdael's birth date (erroneously) as around. 1640, and adds a fanciful story of Ruisdael's encounter with Berchem in Rome. Mention is made of painters who staffed his landscapes (Ostade, Van de Velde, & Wouwerman), of four etchings by his hand, and of several engravings after his works, including Blootelingh's six *Views of Amsterdam*, and two *Views of the Jewish Cemetery at Ouderkerk*, and the *View of Scheveling* (sic) engraved by Le Bas.

15. Reynolds, Letter to *The Idler*, No. 79

(Saturday 20 October 1759), quoted in *Literary Works*, London, 1835, II, pp. 127–30.

16. Reynolds, *A Journey to Flanders and Holland in the Year 1781*, in the *Literary Works*, II, pp. 205–07. Reynolds's pair of Ruisdael landscapes (HdG 1070 & 1071) are described merely as *Landscapes and Figures* (46 by 56 cm), see Simpson, pp. 39–42.

17. Walpole, III, p. 193, & IV, p. 313, p. 357. Martyn, iii–iv, & I, pp. 117–43 re Mr Jennens's collection, & *passim*.

18. See further, Richard Kingzett in the Introduction to the Exh., London, Agnews, 1978; see also Waterhouse, pp. 137–45.

19. Von Holst, p. 189.

20. See Eric Jan Sluijter, 'Hendrik Willem Schweickhardt (1746–1797); een Haagse schilder in de tweede helft van de achttiende eeuw', *Oud–Holland*, 89, 1975, pp. 142–212, on p. 159. See also J.W. Niemeijer, '*Egbert van Drielst, de Drentse Hobbema, 1745–1818*', exh. cat., Assen, 1968, pp. 4–6; and see further Fock & Brenninkmeyer-de Rooij, pp. 113–137 (reviewed by E.J. Sluijter in *Oud–Holland*, 91, 1977, pp. 298–99.

21. Mason, Bk. I, pp. 8–10, lines 130–131, 159–161, & 165–179, kindly drawn to my attention by Professor A.G.H. Bachrach of the University of Leiden.

22. Ed. C. Bruyn Andrews, *The Torrington Diaries*, 1934–38, IV, p. 94, quoted by Hayes, 1966, p. 450.

23. Uvedale Price, *An Essay on the Picturesque, as compared with the Sublime and the Beautiful*, London, 1794, referred to by Hayes, 1966, pp. 448–50. Hayes also notes (p. 450) that Richard Payne Knight in *The Landscape*, London, 1794, pp. 14–15, included Hobbema, Ruisdael, Ostade, and Waterloo among the models from whom the landscape gardener might learn, as well as from Claude Lorrain and Salvator Rosa.

24. The Gazetteer, May 1790, quoted by William T. Whitley, *Thomas Gainsborough*, London, 1915, p. 300. Philip Reinagle (1749–1833) is a prime example of such a copyist.

25. J.F. Weitsch's *Woodland* (Brunswick, No. 625) of 1792 is modelled on Ruisdael, and his 1795 *Waterfall* (Brunswick, No. 769) is a detailed copy of Ruisdael's *Waterfall* (No. 378 in the same collection). For Bruandet, see Gerson, 1942, p. 116. A landscape by Georges Michel is described as painted in the style of Ruisdael, in the Inventory of Louis Boilly, June 1795 (Bulletin de la Société de l'histoire de l'art français, 1929, p. 24), quoted by Gerson, 1942, p. 117, note 3.

26. See further, Exh., London, Tate, 1959, pp. 58–61; and Exh., The Hague–London, 1970–71, *passim* which was devoted to the Dutch inspiration of English landscapists. For Dutch influence on French painters, see

Gerson, 1942, pp. 127–33, 345–46, & 434–39, and Ten Doesschate Chu, pp. 2–31.

27. Beckett, *Corr.*, II, pp. 8–9: Constable to J.T. Smith, 16 January 1797.

28. Beckett, *Corr.*, II, p. 272: Constable to his wife, 15 November 1821.

29. Constable's copies of Ruisdael include: the *Landscape with Windmills* (London, Dulwich College Picture Gallery), copied around 1797; the 1648 etching *Trees by a Cornfield* (Fig. 55), in 1818; the *Country Road with Cornfields* (formerly Agnews, London; Fig. 180), in 1819; and the *Village with Windmills in Winter* (Philadelphia; Fig. 184), in 1832. The value Constable set on these copies is indicated by his comments in a letter of 17th July 1819 to John Fisher (Beckett, *Corr.*, VI, p. 45). For Constable on Berchem, Both, and the Italianates, whose style he considered 'an incongruous mixture of Dutch and Italian style . . . destitute of the real excellence of either', see Beckett, *Discourses*, pp. 34, 56, 58. Ruisdael's varied landscape types were listed by Constable in some lecture notes of 1832 (Beckett, *Discourses*, Appendix B, 6 [p. 88]). Constable refers to Ruisdael's waterfalls in a letter of 17th November 1824 to John Fisher (Beckett, *Corr.*, VI, pp. 180–81). His print of 'Scheveling' (its description when the painting was in the collection of the Duc de Choiseul) is mentioned in a letter to his wife, 25 October 1812 (Beckett, *Corr.*, II, pp. 89–90). Constable's *Weymouth Bay* is illustrated in C.R. Leslie, *Memoirs of the Life of John Constable*, London, 1951, pl. 13.

30. Beckett, *Corr.*, VI, pp. 227–29, on p. 229: Constable to Fisher, 28 November 1826, and *Idem*, VI, pp. 180–81: Constable to Fisher, 17 November 1824. In this letter Constable emphasises that 'freshness' is his own cherished goal.

31. Beckett, *Discourses*, pp. 63–64.

32. Finberg, pp. 181–82, & 193, LXXII: 'Studies in the Louvre' Sketch Book, 14a–15, 22a–23, & 81, which was kindly drawn to my attention by A.G.H. Bachrach. Bachrach, 1980, pp. 20–22, points out that Turner's criticisms of Ruisdael's observations fail to take account of the differences between the Dutch and English coastal waters. For Turner and the Dutch, see also A.G.H. Bachrach, 'An English Painter's Holland', *The Dutch Quarterly Review of Anglo-American Letters*, VI, 1976, pp. 83–115. Tennyson's lines are from his poem *In Memoriam* of 1850. Poot's lines are from his *Zomerönweer* (Summer Storm), see Poot, III, pp. 99–105. For the significance of seastorms in Dutch art, see Chapter III, and Goedde, 1989, *passim*.

33. Ruskin, 1888 (1st Edn., 1843), I, pp. 339–40, 344. For Ruskin's dismissal of the Dutch school as a mean art whose good workmanship did not redeem its all present vulgarity, see *Idem*, III, p. 332ff, & V, p. 281ff.

34. See Grate, p. 188.

35. See Ten Doesschate Chu, pp. 18–19.

36. For the accessibility of Dutch paintings in France, see Ten Doesschate Chu, pp. 2–8, for their evaluation by French critics, *Idem*, pp. 9–17, and for their influence on French landscapists, *Idem*, pp. 18–31. Examples of the inspiration of Ruisdael's etching *Woodland Morass with Travellers*, cited by Ten Doesschate Chu, are Corot's *Forest of Fontainebleau* (Washington, National Gallery of Art,; her plate 6); Daubigny's *Marsh with Herons* (Louvre; plate 33) of 1857. Théodore Rousseau's *Edge of the Forest of Fontainebleau* (Louvre; plate 20) is compared to Ruisdael's *Woodland Swamp* (Hermitage, Leningrad), a painting of similar nature to the etching.

37. Delacroix, pp. 160–61. In 1857 he visited the Nancy Museum and admired the 'fine work by Ruisdael' (i.e. the 1649 *Two Oaks by a Pool*) (*Ibid*, p. 595).

38. Dumesnil, pp. 83–84, discussed by Ten Doesschate Chu, p. 13, note 2.

39. See Ten Doesschate Chu, p. 13–14, who discusses its development from the old antithesis of pagan Ancients and Christian Moderns, between Southern and Northern culture. This had been propagated by the Schlegal brothers and introduced by Madame de Staël to France where it found several adherents, i.e. Michiels, Dumesnil, Proudhon, and Taine. Hegel's theory was expounded in *Vorlesungen über die Aesthetik* (1835), see his *Sämtliche Werke*, Stuttgart, 1949–61, XIV, pp. 121–24, quoted by Ten Doesschate Chu, p. 14, note 1.

40. Gage, pp. 210–15.

41. Gage, pp. 210–15, on p. 215. Goethe's comment in *The Propyläen* is quoted in Lorenz Eitner, *Neoclassicism and Romanticism, 1750–1850* (Sources & Documents), Englewood Cliffs (New Jersey), 1970, II, p. 41. Schelling's Nature-philosophy and its relationship to landscape painting, especially to Caspar David Friedrich, is discussed by Eitner, *op. cit.*, pp. 40–56. For Goethe's letter to J.D. Falk, 14 June 1809, see Gage, p. 73.

42. Niewenhuys, 215–220, on 216 & 218. The dimensions and description of the *View of Haarlem* correspond to the Berlin painting.

43. Smith, VI (1835), pp. 2–6, and Cat. Nos. 2 (*Seascape*), 19 & 20 (*Coastal scenes*), 60 (*Jewish Cemetery*), 210 (*Winter Landscape*), and 214 (*Flat Landscape*).

44. Waagen, 1838, I, p. 56; II, 20–21, 74–75, 398–403; III, 127.

45. Planche, pp. 756–87, esp. pp. 780–81. For Planche as an art critic, see Grate, pp. 130–33.

46. See Grate, pp. 172 & 190.

47. Thoré-Bürger, 1860, I, pp. 270–72; II, pp. 132–38.

48. Fromentin, 1948 (1st Edn. 1876), pp. 136–46, & 162.

49. Michel, 1890, *passim*. These views are reiterated in his *Great Masters of Landscape Painting*, London, 1910 (trans. from the French edn. of 1906), pp. 140–57. Charles Blanc's *Jacques Ruysdael* in the *Histoire des Peintres de toutes les Ecoles*, Paris, no date, adopts a similar view to that of Michel, as does F. Cundall's *The Landscape and Pastoral Painters of Holland*, London, 1891.

50. Waagen, 1860, I, pp. 437–44, and, on Northern realism, I, p. 50ff; II, p. 257ff.

51. Bode, 1872, pp. 275–78, and, for more contemporary expressions of this view, cf. Ros./Slive, 1972, pp. 262–64 and Kahr, 1978, pp. 211–18. More recently Haak, pp. 134–46, and *passim*, and Sutton, 1987, pp. 1–62, have abandoned this schema for a more varied and subtle approach to categorising developments in Dutch landscape painting.

52. For example Van der Willigen, Scheltema, and Bredius, whose findings are referred to in Chapter I.

53. Bode, 1909 (trans. of 1906 Edn.), pp. 152–67. Bradley, pp. 153–174, writing in 1917, noted that Bode's comments applied equally to Ruisdael's etchings. The authority of Bode's writings furthered the romantic conception that nature is seen primarily through the artist's temperament, while also drawing closer attention to Ruisdael's compositional powers.

54. Works listed by Hofstede de Groot, but not Rosenberg, are listed as HdG 00.

55. HdG, 1912, IV, pp. 3–4.

56. Ledermann, p. 9ff, p. 140ff, & p. 167ff. Blankert, in Exh., Utrecht, 1965, rejected the idea of Claude's influence, but accepted and elaborated on Ledermann's second point. In the 1978 edition of the catalogne (with new Introduction), he expressed doubts about this second point as well (p. 41, note 29).

57. Rosenberg, 1928. Simon's 1927 dissertation on Ruisdael's development, published in Berlin, 1930 (see Simon, 1930), was somewhat unsatisfactory and has been overshadowed by Rosenberg's publication.

58. Martin, 1936, II, pp. 293–310. See also Rosenau; Zwarts; Simon, 1935, a; Simon, 1935, b; Simon, 1935, c; Bredius, 1935; and Wijnman, 1932.

59. Gerson, 1950–61, II, 1952, pp. 44–47, 50, 53, 57, & 63. In 1966 Gerson adopted a slightly different viewpoint, noting the anthropocentric quality of Ruisdael's landscapes, symbolising the transitoriness of human life: see Gerson, 1966, unpaginated introduction. The symbolism of Ruisdael's landscapes was also discussed by M.J. Friedlander, *Landscape, Portrait, Still–Life*, New York, 1963, p. 99.

60. Ros./Slive, 1972 (1st Edn., 1966), pp. 262–71.

61. Stechow, 1966, p. 46, pp. 110–11, p. 140, pp. 144–45, & *passim*.

62. Stechow, 1960, pp. 175–89, on p. 183.

63. Stechow, 1966, p. 75, p. 97, p. 106, pp. 110–11, pp. 139–40, pp. 183–84, & *passim*. A number of articles from the late 1920s onwards depart little from the views of Rosenberg, and later of Stechow: See Valentiner, 1926, pp. 55–58; Richardson, 1936/7; Cunningham, 1940; Rich, 1948; E. Smith, 1951; Stampfle, 1959; Stechow, 1968; Carter, 1976; Rosenberg, 1952/53 & 1958; and Levey, 1977. More extensive were: Burke, 1974/75, pp. 3–11, on the topographic aspects of Ruisdael's *View of Haarlem* (Montreal, Museum of Fine Arts), and Jones, 1978, pp. 10–22, on Ruisdael's *Ford in the Woods* (Krannert Art Museum), in relation to the development of Ruisdael's woodlands. Meanwhile, Ruisdael's importance for English landscapists, especially Gainsborough, Constable and Turner, was underscored by the exhibition 'The Shock of Recognition' (The Hague–London, 1970–71), in which Ruisdael was exceptionally well represented.

64. Keyes, 1977, pp. 7–20, and Giltay, 1980, pp. 141–208. Meanwhile, Keyes, 1975, I, pp. 98–100, in his monograph on Cornelis Vroom, which included discussion (*passim*) of the relationship between Vroom and Ruisdael, also suggested Jacob van Mosscher, a minor painter of dune landscapes, as Ruisdael's first master.

65. Kahr, pp. 211–218, on pp. 217–18, and Murray, 1976 (1st Edn., 1959), pp. 398–99.

66. Haak, 1984, pp. 380–82 & 462–64.

67. Ruisdael's *Extensive Wooded Landscape with Church and Cornfield* (Formerly Slatter Gallery, London; photo: RKD, The Hague) had previously appeared in the Sale, London, Christie's, 21 October 1949, No. 51 (photo, RKD), with a group of cattle and a Ruisdaelian rock in the foreground, perhaps added to meet eighteenth-century academic demand for prominent figures in landscapes and admiration for his rocky waterfalls. These elements had been removed before the painting reached the Slatter Gallery. When the painting next appeared (London art market, as formerly in the collection of Mr & Mrs Norton Simon, Los Angeles; photo, RKD), it had been cropped, eliminating the 'baroque' living and dead trees on the right, leaving a typical Dutch flat landscape, like the popular *Haarlempjes*. Ruisdael's prestige is such that when the severed 'offending part' was offered independently for auction (London, Christie's, 1 December 1978, No. 28), it attracted a buyer. Some of the different strands of Ruisdael's critical fortunes converge in this one painting.

68. Wiegand, pp. 9–35, & pp. 37–56 (esp. pp. 34–35 & 53–56) and *passim*.

69. Fuchs, 1973, pp. 281–92, and see further Fuchs, 1978, pp. 36–38, & Fuchs, 1978, pp. 103–23.

70. Kouznetsov, 1973, pp. 31–41.

71. Kauffmann, 1977, pp. 379–97.

72. Bruyn, in Sutton, 1987, pp. 84–103, esp. pp. 98–101. His views attracted heavy criticism from David Freedberg and Simon Schama at the College Art Association in Boston, 1987, in their Session 'Art into Landscape in the Netherlands', and again in 1988 at the symposium, 'Masters of Seventeenth-Century Dutch Landscape Painting', Museum of Fine Arts, Boston (from the same individuals).

73. Freedberg and Schama, verbally, as noted, n. 72 above. Their own views are represented in Freedberg, 1980, and by Freedberg's lecture at the 1988 above-mentioned Boston symposium: 'Rembrandt as a Landscapist; *Inventor Novissimus in Depingendo Rure*', stressing the fresh, observant eye and the aesthetic sensitivity of the Dutch landscape painters and printmakers. For Schama, see Sutton, 1987, pp. 64–83, stressing the geographic and patriotic cultural context.

74. Chong, in Sutton, 1987, pp. 445–48, & pp. 458–62 and Stone-Ferrier, pp. 417–36.

75. For example, Scheyer, 1977, pp. 133–46, interpreting *The Jewish Cemetery* from the perspective of possible circumstances of commission, and Duparc, 1981–82, pp. 225–30, on the same painting. Also the topographical studies of Maschmeyer, 1978, Korn, 1978, and Hagens, 1982; and the careful analysis of Ruisdael's trees and plants in Ashton, Slive and Davies, 1982.

76. See Exh. Cat., The Hague-Cambridge, 1981–82, by Seymour Slive, reviewed by Christopher Brown, 'Jacob van Ruisdael at the Fogg', *Burlington Magazine*, 124, March 1982, pp. 190–94, and Denys Sutton, 'Jacob van Ruisdael–Solitary Wanderer', *Apollo*, 115, March 1982, pp. 182–85.

77. See Exh. Cat., Amsterdam–Boston–Philadelphia, 1987–88: *Masters of 17th-Century Dutch Landscape Painting*, Boston, Mass., 1987 (cited as Sutton, 1987), and see Bruyn, pp. 84–103, esp. pp. 99–101; Chong, pp. 445–48, & pp. 458–63; Schama, pp. 64–83, esp. pp. 78–80; Sutton, pp. 1–63, esp. pp. 49–52, & pp. 448–49, pp. 451–58, & pp. 463–65; and Giltay, pp. 437–45, & pp. 450–51, all in Sutton, 1987.

List of Abbreviations

Bartsch 00:	Bartsch, A., *Catalogue raisonné de toutes les estampes qui forment l'oeuvre de Rembrandt, et ceux de ses principaux imitateurs, composé par Gersaint, Helle, Glomy et Yver; nouvelle édition, . . . augmentée par Adam Bartsch*, Vienna, 1797
Broulhiet 00:	G. Broulhiet, *Meindert Hobbema*, Paris, 1938
Burl. M.:	*The Burlington Magazine*
Dut. 00:	Eugène Dutuit, *Manuel de l'amateur d'estampes*, VI, Paris, 1885
FARL:	Frick Art Reference Library, New York
Giltay 00:	Jeroen Giltay, 'De tekeningen van Jacob van Ruisdael', *Oud Holland*, 94 (1980), 141–208
I.de Groot 00:	Irene de Groot, *Landscape Etchings by the Dutch Masters of the Seventeenth Century*, London, 1979
HB 00:	Egbert Haverkamp Begemann, *Hercules Segers: The Complete Etchings*, Amsterdam, 1973
HdG:	C. Hofstede de Groot, *A Catalogue raisonné of the Works of the Most Eminent Dutch Painters of the Seventeenth Century*, trans. by E.G. Hawke, 8 vols., London, 1908–1927
Holl. 00:	F.W.H. Hollstein, *Dutch and Flemish Etchings, Engravings, & Woodcuts, c. 1450–1700*, 1–1, Amsterdam, 1949–11
Keyes 00:	G. Keyes, 'Les eaux-fortes de Ruisdael', *Nouvelles de l'Estampe*, 36 (1977), 7–20
RKD:	Rijksbureau voor Kunsthistorische Documentatie, The Hague
Ros. 00:	Jacob Rosenberg, *Jacob van Ruisdael*, Berlin, 1928
Ros./Slive:	J. Rosenberg, S. Slive, & E.H. ter Kuile, *Dutch Art and Architecture: 1600 to 1800*, Harmondsworth, 1972 Edn.
Rowlands, 00:	John Rowlands, *Hercules Segers*, London, 1979
Stec.:	Wolfgang Stechow, *Dutch Landscape Painting of the Seventeenth Century*, London, 1966
Sutton, 1987:	Amsterdam-Boston-Philadelphia, 1987–88 Exh.: *Masters of 17th-Century Dutch Landscape Painting*, 1987–88. Catalogue by Peter C. Sutton et al.
Witt:	Witt Library, Courtauld Institute of Art, University of London

Bibliography

Exhibitions are listed under place

Alpers, Svetlana, *The Art of Describing: Dutch Art in the Seventeenth Century*, Chicago, 1983

Ampzing, 1621: S. Ampzing, *Het lof der Stadt Haerlem in Hollandt*, Haarlem, 1621

Ampzing, 1628: S. Ampzing, *Beschrijvinge ende lof der Stad Haerlem in Holland*, Haarlem, 1628

Amsterdam, 1976: Exh., Amsterdam, Rijksmuseum, *Tot Lering en Vermaak*, 1976

Amsterdam–Toronto, 1977: Exh., Amsterdam, Amsterdams Historisch Museum, & Toronto, Art Gallery of Ontario, *The Dutch Cityscape in the 17th Century and its Sources*, 1977

Amsterdam–Boston–Philadelphia, 1987–88: Exh., Amsterdam, Rijksmuseum, Boston, Museum of Fine Arts, and Philadelphia, Museum of Art: *Masters of 17th-Century Dutch Landscape Painting*, 1987–88. Catalogue by Peter C. Sutton et al.

Angel: Philips Angel, *Lof der Schilder-Konst*, Leiden, 1642

Anslo, 1713: R. Anslo, *Poëzy*, ed. by Joan de Haes, Rotterdam, 1713

Ashton, Slive, and Davies: Peter Shaw Ashton, Seymour Slive, and Alice Davies, 'Jacob van Ruisdael's Trees', *Arnoldia*, 42, 1982, pp. 2–31

Bachrach, A.G.H., 'Turner, Ruisdael and the Dutch', *Turner Studies*, I, 1980, pp. 19–30

Beckett, *Corr.*: R.B. Beckett, *John Constable's Correspondence*, compiled and annotated by R.B. Beckett, 6 Vols., Ipswich, 1962–1969

Beckett, *Discourses*: R.B. Beckett, *John Constable's Discourses*, compiled and annoted by R.B. Beckett, Ipswich, 1970

Beening: Theo H. Beening, 'Het Landschap in de Nederlandse Letterkunde van de Renaissance' (diss.), Nijmegen, 1963

Beenken, Hermann, 'Die landschaftsschau Jacob van Ruisdaels', *Neue Beiträge deutscher Forschung, Wilhelm Worringer zum 60. Geburtstag*, Königsberg, 1943, pp. 1–12

Bengtsson: Å, Bengtsson, *Studies on the rise of realistic landscape painting in Holland 1610–1625*, (Figura, III), Stockholm, 1952

Bergstrom, Ingvar, *Dutch Still-Life Painting*, New York, 1956

Berlin–Dahlem, 1974: Exh., Berlin–Dahlem, Kupferstichkabinett, *Die Holländische Landschaftszeichnung 1600–1740*, 1974. Catalogue by W. Schulz.

Berlin, 1975: Exh., Berlin–Dahlem, Kupferstichkabinett, *Pieter Bruegel d. Ä. als Zeichner, Herkunft und Nachfolge*, 1975

Bernt, 1948: Walther Bernt, *Die niederländischen Maler des 17. Jahrhunderts*, 3 Vols., Munich, 1948; Vol. 4 (supplement), 1962

Bijns, *Refereinen: Refereinen van Anna Bijns*, ed. by Helten, Rotterdam, 1875

Blankert, 1978: See Exh., Utrecht, 1965 (1978 Edn.)

Bode, 1872: W. von Bode, 'Die Künstler von Haarlem', *Zeitschrift für bildende Kunste*, VII, 1872, pp. 275–78

Bode, 1909 (trans. of 1906): W. von Bode, *Great Masters of Dutch and Flemish Painting* (trans. from the German by M.L. Clarke), London, 1909 (original German Edn: *Rembrandt und seine Zeitgenossen*, Leipzig, 1906)

Bol, 1969: Laurens J. Bol, *Holländische Maler des 17. Jahrhunderts nahe den grossen Meistern, Landschaften und Stilleben*, Brunswick, 1969

Bol, 1973: Laurens J. Bol, *Die Holländische Marinemalerei des 17. Jahrhunderts*, Brunswick, 1973

Boon: K.G. Boon, *Rembrandt, The Complete Etchings*, London-New York, 1963

Borsselen, Van, 1611: Philibert van Borsselen, *Strande*, Haarlem, 1611 (photographic reprint in: P.E. Muller, 'De dichtwerken van Philibert van Borsselen . . .' (diss.), Utrecht, 1937)

Borsselen, Van, 1613: Philibert van Borsselen, *Den Binckhorst*, Amsterdam, 1613 (photographic reprint in: P.E. Muller, as above)

Bradley: W.A. Bradley, 'The Etchings of Jacob Ruysdael' *The Print Collector's Quarterly*, VII, 1917, pp. 153–74

Bredero, *Dram. W.: Werken var G.A. Bredero: Dramatische Werken*, I, ed. by J.A.N. Knuttel, Amsterdam, 1921

Bredero, *Lied. en Ged.: Werken van G.A. Bredero: Liederen en Gedichten. Proza*, ed. by J.A.N. Knuttel, Amsterdam, 1929

Bredius, 1887–88: A. Bredius, *Die Meisterwerke des Rijksmuseum zu Amsterdam*, Munich, 1887–88

Bredius, 1888: A. Bredius, 'Het geboortejaar van Jacob van Ruisdael', *Oud-Holland*, VI, 1888, pp. 21–24

Bredius, 1915: A. Bredius, 'Twee testementen van Jacob van Ruisdael', *Oud-Holland*, XXXIII, 1915, p. 19ff.

Bredius, *K-I*: A. Bredius, *Künstler Inventare: Urkunden zur Geschichte der holländischen Künstler des XVI., XVII., und XVIII. Jahrhunderts*, 8 Vols., The Hague, 1915–22

Bredius. 1935: A. Bredius, 'Isaack van Ruisdael', *Burl. M.*, LXVII, 1935, p. 178

Brom: G. Brom, *Schilderkunst en literatuur in de 16e en 17e eeuw*, Utrecht/Antwerp, 1957

Broulhiet, G., *Meindert Hobbema*, Paris, 1938

Brown, Christopher, 'Boston: Jacob van Ruisdael at the Fogg', *Burlington Magazine*, 124, 1982, pp. 190–94

Bruin, 1730 (1st Edn. 1716): Claas Bruin, *Kleefsche en Zuid-Hollandsche Arkadia . . .* , Amsterdam,1730 (1st Edn., 1716)

Bürger, W., see Thoré-Bürger

Burgess: *Extracts from A.J. Dezallier d'Argenville's Abrégé de la vie des plus fameux peintres*, selected and transl. by James Burgess, London, 1754

Burke, 1974–75: J.D. Burke, 'Ruisdael and his Haarlempjes', *A Quarterly Review of the Montreal Museum of Fine Arts*, 6, 1974–75, No. 1, pp. 3–11

Burke, 1976: J.D. Burke, *Jan Both: Paintings, Drawings and Prints*, New York–London, 1976

Bury Adrian, 'Van Ruisdael after Cleaning', *The Connoisseur*, 170, 1969, p. 235

Carter: David G. Carter, 'Northern Baroque and the Italian Connection', *Apollo*, Vol. CIII, No. 171, May 1976, pp. 392–401

Castro, 1883: De Henriques de Castro, *Keur van Grafsteenen op de Nederl.–Portug.–Israël. Begraafplaats te Ouderkerk aan den Amstel*, Leiden, 1883

Cats, *Alle de werken . . .*: *Alle de werken van Jacob Cats*, Rotterdam (bij D. Bolle), w/o date

Clark, 1969: Kenneth Clark, *Civilization: A Personal View*, London, 1969

Clark, 1976: Kenneth Clark, *Landscape into Art*, London 1949 & 1976

Cundall, F., *The Landscape & Pastoral Painters of Holland*, London, 1891

Cunningham, 1940: C.C. Cunningham, '"View of Haarlem from the Dunes" by Jacob van Ruisdael (1628–1682)'. *Bulletin of the Museum of Fine Arts, Boston*, XXXVIII, 1940, pp. 15–17

Cunningham, 1950: C.C. Cunningham '"Bleaching grounds near Haarlem" by Jacob van Ruisdael', *Bulletin of the Wadsworth Atheneum*, Hartford, Conn. 2nd series, No. 20, 1950, p. 3

Davies: Alice I. Davies, *Allart van Everdingen*, New York–London, 1978

Delacroix: Eugène Delacroix, *The Journal of Eugène Delacroix*, transl. from the French by Walter Pach, New York, 1948

Deperthes, 1818: J.B. Deperthes, *Théorie du paysage*, Paris, 1818

Dubiez, 1967: F.J. Dubiez, 'Beth Haim, Huis des Levens: de Portugees Israëlietische begraafplaats te Ouderkerk aan de Amstel', *Ons Amsterdam*, XIX, 1967, pp. 178–86; pp. 205–12

Dumesnil: Alfred Dumesnil, *La foi nouvelle cherchée dans l'art. De Rembrandt à Beethoven*, Paris, 1850

Duparc, 1981–82: Frits J. Duparc, Jr., '"Het Joodse Kerkhof" van Jacob van Ruisdael', *Antiek*, 16, 1981–82, pp. 225–30

Dutuit: Eugène Dutuit, *Manuel de l'amateur d'estampes*, VI, Paris–London, 1885, pp. 275–84

Eisler, M. *Geschichte eines Holländisches Stadbilder*, The Hague, 1914

Erasmus, Kurt, 'Roelant Savery: sein Leben und seine Werke' (Doctoral Diss. Halle–Wittenberg), Halle a.s., 1908

Falkenburg, 1985: R.L. Falkenburg, 'Joachim Patinir: Het Landschap als beeld van de levenspelgrimage', Amsterdam (diss.), 1985

Falkenburg, Reindert L., *Joachim Patinir: Landscape As an Image of the Pilgrimage of Life* (Oculi Ser: Vol. 2) (Benjamins, North Am.), Philadelphia, 1989

Fechner, E.Y., *Jacob van Ruisdael and his paintings in the National Gallery Ermitage*. Leningrad, 1958 (Russian text)

Fekhner: H. Fekhner, *Le Paysage Hollandais du XVIIᵉ Siecle à l'Ermitage*, Leningrad, 1963 (Russian text)

Félibien, 1706: A. Félibien, *Entretiens sur les vies et les ouvrages des plus excellents peintres*, 5 Vols., Paris , 1666–88, & 6 Vols., Amsterdam, 1706

Feltham: Owen Feltham, *A Brief Character of the Low-Countries*, London, 1670

Finberg: A.J. Finberg, *A Complete inventory of the drawings of the Turner Bequest . . .* Arranged chronologically by A.J. Finberg, 2 Vols., London, 1909

Floerke: H. Floerke, *Studien zur niederländischen Kunst-und Kulturgeschichte, Die Formen des Kunsthandels, das Atelier und die Sammler in den Niederlanden von 15.–18. Jahrhundert*, Munich-Leipzig, 1905

Fock & Brenninkmeyer-de Rooij: C. Willemijn Fock en B. Brenninkmeyer-de Rooij, 'De Schilderijengalerij van Prins Willem V op het Buitenhof te Den Haag', *Antiek*, 11, 1976, pp. 113–137

Freedberg, David, *Dutch Landscape Prints of the Seventeenth Century*, London, 1980

Friedländer, M.J., *Landscape, Portrait, Still-life*, Oxford–New York, n.d. (1950)

Fromentin, 1948 (1st Edn. 1876): Eugène Fromentin, *The Masters of Past Time: Dutch & Flemish Painting from Van Eyck to Rembrandt*, trans. by A. Boyle, ed. by H. Gerson, London, 1948 (1st Edn., Paris, 1876, as *Les Maîtres d'autrefois*)

Fuchs, 1973: R.H. Fuchs, 'Over het landschap. Een verslag naar aanleiding van Jacob van Ruisdael, "*Het Korenveld*"', *Tijdschrift voor geschiedenis*, 86, 1973, pp. 281–92

Fuchs, 1978: R.H. Fuchs, *Dutch Painting*, London, 1978

Gage: John Gage, *Goethe on Art*, selected, ed. and trans. by John Gage, London, 1980

Gelder, J.G. van, 'Review of Å. Bengtsson, *Studies on the rise of realistic landscape painting in Holland, 1610–1625*', *Burl. M.*, XCV, 1953, p. 314

Van Gelder, 1959: J.G. Van Gelder, *Dutch Drawings and Prints*, London, 1959

Gerson, 1934: H. Gerson, 'The Development of Ruisdael', *Burl. M.*, LXV, 1934, pp. 76–80

Gerson, 1942: H. Gerson, *Ausbreitung und Nachwirkung der Holländischen Malerei des 17. Jahrhunderts*, Haarlem, 1942

Gerson, 1952: H. Gerson, *De Nederlandse Schilderkunst, II, Het Tijdperk van Rembrandt en Vermeer*, Amsterdam, 1952

Gerson, 1966: H. Gerson, *Jacob van Ruisdael* (I Maestri del Colore, 183), Milan, 1966

Ghent, Musée des Beaux-Arts, Exh., *Roelandt Savery*, 1954

Gibson, Walter S., "*Mirror of the Earth*": The World Landscape in 16th-Century Flemish Painting*, Princeton, 1989

Giltay, 1977: J. Giltay, 'Guilliam Du Bois als tekenaar', *Oud-Holland*, 91, 1977, pp. 144–65

Giltay, 1980: Jeroen Giltay, 'De tekeningen van Jacob van Ruisdael', *Oud Holland*, 94, 1980, pp. 141–208

Goedde, 1989: Lawrence O. Goedde, *Tempest & Shipwreck in Dutch & Flemish Art: Convention, Rhetoric, & Interpretation*, University Park, Pa., 1989

Gombrich, 1950: see Gombrich, 1966

Gombrich, 1966: E.H. Gombrich, *The Story of Art*, London, 1950, and 11th Edn., 1966

Gombrich, E.H., *In Search of Cultural History*, Oxford, 1969

Grate: Pontus Grate, *Deux critiques d'art de l'époque romantique: G. Planche et T. Thoré*, (Figura: 12), Stockholm, 1959

Groot, I. de: Irene de Groot, *Landscape Etchings by the Dutch Masters of the Seventeenth Century*, London, 1979

P.S.H. 'Wooded landscape by Jacob van Ruisdael', *Bulletin of the J.B. Speed Art Museum, Louisville, Kentucky*, 21, No. 11, 1960, pp. 6–8

Haak, Bob, *The Golden Age: Dutch Painters of the Seventeenth Century*, New York, 1984

Hagels, Herman, 'Die Gemälde der niederländischen Maler Jacob van Ruisdael und Nicolaas Berchem vom Schloss Bentheim im Verhältnis zur Natur des Bentheimer Landes', *Jahrbuch des Heimatvereins der Grafschaft Bentheim*, 1968, p. 41 ff.

Hagens, 1982: H. Hagens, 'Jacob van Ruisdael, Meindert Hobbema en de identificatie-zucht', *'t inschrien*, 14, 1982, pp. 7–12

The Hague–London, 1970–71: The Hague, Mauritshuis, and London, Tate Gallery, *Schok der Herkenning. Het Engelse Landschap der Romantiek en zijn Hollandse Inspiratie (Shock of Recognition. The English Landscape of the Romantic Period and its Dutch Inspiration)*, 1970–71

The Hague–Cambridge, 1981–82: Exh., The Hague, Mauritshuis and Cambridge, Mass., Fogg Art Museum, *Jacob van Ruisdael*, 1981–82. Catalogue by Seymour Slive

The Hague, 1981–82: Exh., The Hague, Mauritshuis, *Jacob van Ruisdael, 1628/29–1682*, 1981–82. Exhibition album for The Hague–Cambridge, 1981–1982

The Hague–San Francisco, 1990–91: Exh., The Hague, Mauritshuis and San Francisco, The Fine Arts Museums, *Great Dutch Paintings from America*, 1990–91. Catalogue by Ben Broos

Haley: K.H.D. Haley, *The Dutch in the Seventeenth Century*, London, 1972

Hamburg 1974: Exh., Hamburg, Kunsthalle, *Kunst um 1800. I: Caspar David Friedrich*, publ. Munich, 1974

Haverkamp Begemann, Egbert, *Hercules Segers: The Complete Etchings*, Amsterdam, 1973

Hayes, 1965–66: John Hayes, 'British Patrons and Landscape Painting. I: The Seventeenth Century. II: Eighteenth Century Collecting. III: The Response to Nature in the Eighteenth Century' *Apollo*, LXXXII, 1965, pp. 38–45, and LXXXIII, 1966, pp. 188–97, & pp. 444–451

Hayes, 1966: see Hayes 1965–66

Hayes, 1978: John Hayes, 'Ebenezer Tull, "The British Ruysdale":

An Identification and an Attribution', *Burl M.*, CXX, April 1978, pp. 230–33

Hazard, Paul, *The European Mind 1680–1715*, Harmondsworth, 1964 (1st Edn., Paris, 1935, as *La Crise de la conscience européenne 1680–1715*)

Hecht, Peter, 'The debate on symbol and meaning in Dutch seventeenth-century art: an appeal to common sense', *Simiolus*, 16, 1986, p 173–87

Henkel & Schöne: Arthur Henkel, & Albrecht Schöne, *Emblemata: Handbuch zur Sinnbildkunst des XVI. und XVII. Jahrhunderts*, Stuttgart, 1967

Hind: A.M. Hind, *Catalogue of Drawings by Dutch and Flemish Artists . . . in the British Museum*, 4 Vols., London, 1915–1931

Hoet, G: G. Hoet, *Catalogus of Naamlyst van Schilderyen*, 2 vols., The Hague, 1752 (contd. by P. Terwesten, *Catalogus of Naamlyst van Schilderyen*, The Hague, 1770)

Hofstede de Groot, 1906: C. Hofstede de Groot, *Die Urkunden über Rembrandt (1575–1721)*, The Hague, 1906

Hofstede de Groot: C. Hofstede de Groot, *A Catalogue raisonné of the Works of the Most Eminent Dutch Painters of the Seventeenth Century*, trans. by Edward G. Hawke, 6 Vols, London, 1908–1927 (Ruisdael, Vol. IV, 1912)

Von Holst: Niels von Holst, *Creators, Collectors and Connoisseurs: The anatomy of artistic taste from antiquity to the present day*, (trans. from the German by Brian Battershaw), London, 1967 & 1976

Hondius, 1621: *Petri Hondii Dapes inemptae of de Moufe-schans . . .*, Leiden, 1621

Hoogsteder–Naumann: Catalogue Hoogsteder–Naumann, *A Selection of Dutch and Flemish 17th Century Paintings*, New York, 1983

Hoogstraeten, 1678: Samuel van Hoogstraeten, *Inleyding tot de Hooge Schoole der Schilder-konst*, Rotterdam, 1678

Hooykaas: R. Hooykaas, *Religion and the Rise of Modern Science*, Edinburgh, 1972 (Paperback Edn., 1973)

Houbraken: A. Houbraken, *De groote schouburgh der Nederlandsche Konstschilders en schilderessen*, 3 Vols., Amsterdam, 1718–21

Howell: James Howell, *Epistolae Ho-Elianae*, London 1726

Huygens, *Autobiography*: Constantijn Huygens, *De Jeugd van Constantijn Huygens door hemzelf beschreven*, trans. & ed. A.H. Kan, with an essay by G. Kamphuis, Rotterdam, 1946

Huygens: *De Gedichten van Constantijn Huygens*, ed. by J.A. Worp, 8 vols., Groningen, 1892–1898

Imdahl: Max Imdahl, *Jacob van Ruisdael. Die Mühle von Wijk*, (Werkmonographien zur bildenden Kunst, in Reclams Universal Bibliothek, No. 131), Stuttgart, 1968

Immerzeel: J. Immerzeel, *De levens en werken der Hollandsche en Vlaamsche kunstschilders, enz.*, 3 Vols., Amsterdam, 1842–43

Janson, 1962: H.W. Janson, *A History of Art*, London, 1962

Jantzen, H., 'Review of Jacob Rosenberg, *Jacob van Ruisdael*', *Deutsche Literaturzeitung*, 1929, pp. 1194 ff.

Jones, 1978: A.L. Jones, 'Jacob van Ruisdael's "Ford in the Woods"' *Bulletin, Krannert Art Museum, Univ. of Illinois*, III, No. 2, 1978, pp. 10–22

Jones, 1988: Pamela M. Jones, 'Federico Borromeo as a Patron of

Landscapes and Still-Lifes: Christian Optimism in Italy ca. 1600', *The Art Bulletin*, LXX, June 1988, pp. 261–72

Jongh, De, 1967: E. de Jongh, *Zinne– en minnebeelden in de schilderkunst van de zeventiende eeuw*, Nederlandse Stichting Openbaar Kunstbezit, Amsterdam, 1967

Jongh, De, 1971: E. de Jongh, 'Réalisme et réalisme apparent dans le peinture hollandaise du 17ᵉ siècle', in Exh Cat., Brussels, *Rembrandt et son temps*, 1971, pp. 143–94

Jongh, De, 1976: E. de Jongh, in Introduction to Exh. Cat., Amsterdam, Rijksmuseum, *Tot Lering en Vermaak*, 1976, pp. 14–28

Judson, J.R., 'Marine symbols of salvation in the sixteenth century', *Essays in Memory of Karl Lehmann*, New York, 1964, pp. 136–52

Kahr: M.M. Kahr, *Dutch Painting in the Seventeenth Century*, New York, 1978

Kauffmann, H., Review of Jacob Rosenberg, *Jacob van Ruisdael*, in *Kunst und Künstler, Monatsschrift für bildende Kunst*, Berlin XXXVII, 1929, pp. 404–406, and in *Oud-Holland*, 48, 1931, pp. 229–30

Kauffmann, 1977: Hans Kauffmann, 'Jacob van Ruisdael: Die Mühle von Wijk bei Duurstede', *Festschrift für Otto von Simson zum 65. Gebortstag*, Frankfurt/Berlin/Vienna, 1977, pp. 379–97

Keyes, 1975: George Keyes, *Cornelis Vroom: Marine and Landscape Artist*, 2 Vols., Alphen aan den Rijn, 1975

Keyes, 1977: G. Keyes, 'Les eaux-fortes de Ruisdael', *Nouvelles de l'Estampe*, 36, 1977, pp. 7–20

de Klijn, M, *De invloed van het Calvinism op de Noord-Nederlandse landschapschilderkunst 1570–1630*, Apeldoorn, 1982

Kolks, Z., 'Een tot nu toe niet bekend gezicht op Ootmarsum in Munchen', *Jaarboek Twenthe*, XVII, 1978, p. 89ff.

Kolks, Z., 'Ruisdael's gezicht op Ootmarsum', *'t inschrien*, XI, No. 2, 1979, pp. 21–24

Korn, 1978: U.D. Korn, 'Ruisdael in Steinfurt', *Westfalen: Hefte für Geschichte, Kunst und Volkskunde*, 56, 1978, pp. 111–14

Kouznetsov, 1973: Kouznetsov, I., 'Sur le symbolisme dans les paysayes de Jacob van Ruisdael', *Bulletin du Musée National de Varsovie*, 14, 1973, pp. 31–41

Lairesse, 1707: Gerard de Lairesse, *Het groot schilderboek*, Amsterdam, 1707. Reprint: Soest, 1969

Ledermann: I. Ledermann, 'Beiträge zur Geschichte des romanistischen Landschaftsbildes in Holland und sein Einflusses auf die nationale schule um die Mitte des 17 Jahrh.' (diss.), Berlin, 1920

Leiden, 1970: Exh., Leiden, Museum De Lakenhall, *Ijdelheid der Ijdelheden: Hollandse Vanitas-Voorstellingen uit de Zeventiende eeuw*, 1970

Leslie, C.R., *Memoirs of the Life of John Constable*, London, 1951 (1st Edn., 1843)

Levey: Michael Levey, *Ruisdael: Jacob van Ruisdael and other Painters of his Family*, Themes and Painters in the National Gallery, Series 2, Number 7, London, 1977

Leymarie: Jean Leymarie, *Dutch Painting* (trans. from the French by Stuart Gilbert), Geneva–New York, 1956

Lodensteyn, Van, 1727 (1st Edn. 1676): Judocus van Lodensteyn, *Uytspanningen*, Amsterdam, 1727 (1st Edn. 1676)

London, Tate, 1959: Exh., London (Arts Council for the Council of Europe), Tate Gallery, *The Romantic Movement*, 1959

London, 1970: Exh., London, Victoria & Albert Museum, *Drawings from the Teylers Museum, Haarlem*, 1970

London, 1976: Exh., London, National Gallery, *Art in Seventeenth Century Holland*, 1976

London, Tate, 1976: Exh., London, Tate Gallery, *Constable: Paintings, Watercolours & Drawings*, 1976

London, 1977: Exh., London, Alan Jacobs Gallery, *Jan van Goyen (1596–1656), Poet of the Dutch Landscape*, 1977

London, Agnews, 1978: Exh., London, Thos Agnew & Sons Ltd, *Dutch & Flemish Pictures from Scottish Collections*, 1978

London, 1979: Exh. London, Brod Gallery, *Jan Brueghel the Elder*, 1979

London, Tate, 1980: Exh., London, Tate Gallery, *Thomas Gainsborough*, 1980. Catalogue by John Hayes

London, 1986: London, National Gallery, *Dutch Landscape: The Early Years, Haarlem and Amsterdam 1590–1650*, 1986. Catalogue by Christopher Brown *et al.*

Los Angeles–Boston–New York, 1981–82: Exh., Los Angeles County Museum of Art, Boston, Museum of Fine Arts, and New York, The Metropolitan Museum of Art, *A Mirror of Nature: Dutch Paintings from the Collection of Mr and Mrs Edward William Carter*, 1981–82. Catalogue by John Walsh, Jr and Cynthia P. Schneider

Luttervelt, R. Van, 'Een gezicht op Haarlem van Jacob van Ruysdael', *Historia*, 14, 1949, pp. 223–25

Luyken, 1705: Jan Luyken, *Vonken der Liefde Jezus*, Amsterdam, 1705 (1st Edn., 1687)

Luyken, 1708: Jan Luyken, *Beschouwing der Wereld*, Amsterdam, 1708

Luyken, Jan, *Het overvloeiend herte*, Haarlem, 1767

Luyken, 1771 (1st Edn., 1711): Jan Luyken, *Het Leerzaam huisraad*, Amsterdam, 1771 (1st Edn. 1711)

Luyken, Jan, *De bykorf des gemoeds*, Amsterdam, 1779 (1st Edn. 1711)

Maclaren, 1960: N. Maclaren, The National Gallery Catalogues, *The Dutch School*, London, 1960

Mander, Van, *Grondt*: see Van Mander, *Het Schilder-Boeck*

Mander, Van, *Levens Ned.*, 1604 Edn.: see Van Mander, *Het Schilder-Boeck*

Mander, Van, *Levens Ned.*, 1618 (1st Edn. 1604): see Van Mander, *Het Schilder-Boeck*

Mander, Karel van, *Het Schilder-Boeck . . .*, Haarlem, 1604; 2nd Edn., 1618 (containing, *inter alia*, 'Den Grondt der Edel vry Schilder-Const . . .' [*Grondt*], and 'Het Leven der Doorluchtighe Nederlandtsche en Hoogdhuytsche Schilders' [*Levens Ned*]); see also Edn., H. Miedema, 1973

Mander, Karel van, *Den Nederduytschen Helicon*, Tot Haerlem, 1610

Martin W., Review of Jacob Rosenberg, *Jacob van Ruisdael, Repertorium für Kunstwissenschaft*, 50, 1929, pp. 164–68

Martin, 1931: W. Martin, 'Amsterdamsch stadsgezicht door Jacob van Ruisdael', *Groene Amsterdammer*, 25th July 1931, p. 17

Martin, 1936: see Martin, 1942

Martin, 1942 (1st Edn. 1936): W. Martin, *De Hollandsche schilder-kunst in de zeventiende eeuw*, 2 Vols., Amsterdam, 1935–36, 2nd Edn., 1942

Martyn: Thomas Martyn, *The English Connoisseur . . .*, 2 Vols., London 1766

Maschmeyer: Dietrich Maschmeyer, 'Jacob Isaackszoon van Ruisdael und Meindert Hobbema malen Motive aus der Grafschaft Bentheim und ihrer Umgebung', *Jahrbuch des Heimatvereins der Grafschaft Bentheim*, 1978, pp. 61–71

Mason, William Mason, *The English Garden: A Poem. In Four Books*, London, 1772–1781

Mayer, A.L. 'Review of Jacob Rosenberg, *Jacob van Ruisdael*', *Pantheon, Monatsschrift für Freunde und Sammler der Kunst*, Munich, III, 1929, p. 12

Michel, 1890: Emile Michel, *Jacob van Ruisdael et les paysagistes de l'école de Harlem*, Paris, 1890

Michel, Emile, *Great Masters of Landscape Painting*, London, 1910 (trans. from *Les Maîtres du paysage*, Paris, 1906)

Meidema, 1973: H. Miedema, ed., *Karel van Mander, Den grondt der edel vry schilder-const*, Utrecht, 1973

Miedema, 1975: Hessel Miedema, 'Over het realisme in de Nederlandse schilderkunst van de zeventiende eeuw', *Oud Holland*, 89, 1975, pp. 2–18

Miedema, 1977: Hessel Miedema, 'Realism and comic mode: the peasant', *Simiolus*, 9, 1977, pp. 205–19

Mundy: *Travels of Peter Mundy*, ed. R.C. Temple, London, 1924

Münster–Baden-Baden, 1979: Exh., Münster, Westfälisches Landesmuseum, and Baden-Baden, Staatliche Kunsthalle, *Stilleben in Europa*, 1979–80

Murray, 1976: Peter & Linda Murray, *The Penguin Dictionary of Art & Artists*, Harmondsworth, 1959 & 1976

New York–Paris, 1977–78: Exh., New York, Pierpont Morgan Library and Paris, Institut Néerlandais, *Rembrandt and his century: Dutch Drawings of the Seventeenth Century*, 1977–1978

Niemeijer, J.W., 'Varia Topografica', *Oud-Holland*, LXXVII, 1962, pp. 61–63 & 72

Nieuwenhuys: C.J. Nieuwenhuys, *A Review of the Lives and Works of Some of the Most Eminent Painters*, London, 1834

Obreen, F.D.O., *Archief voor Nederlandsche Kunstgeschiedenis*, 7 vols., Rotterdam, 1877–1890 (Reprint: Soest, 1976)

Ogden, 1949: H.V.S. Ogden, 'The Principles of Variety and Contrast in Seventeenth Century Aesthetics, and Milton's Poetry', *Journal of the History of Ideas*, X, No. 2, April 1949, pp. 159–82

Ogden & Ogden, 1955: H.V.S. Ogden & M.S. Ogden, *English Taste in Landscape in the Seventeenth Century*, Ann Arbor, 1955

Oldewelt, W.F.H., 'Jacob Ruisdael en zijn Damgezichten', *Amsterdamsche Archiefvondsten*, Amsterdam, 1942, pp. 163–67

Paris, 1974 – I: Exh., Paris, Institut Néerlandais, 'Acquisitions Récentes de toutes Epoques', 1974

Paris, 1974 – II: Exh., Paris, Institut Néerlandais, 'Dessins Flamands et Hollandais du Dix-Septième Siècle', 1974

Parival, 1697: J. de Parival, *Les Délices de la Hollande*, Amsterdam, 1697

Philadelphia–Berlin–London, 1984: Exh., Philadelphia, Museum of Art, Berlin (West), Staatliche Museen Preussischer Kulturbesitz, and London, Royal Academy of Arts, *Masters of Seventeenth-Century Dutch Genre Painting*, 1984. Catalogue by Peter C. Sutton *et al.*

De Piles, 1706: Roger de Piles, *The Art of Painting*, London, 1706. *To which is added, An Essay towards an English School, with the lives and characters of above 100 Painters*, by B. Buckridge

De Piles, 1715; Roger de Piles, *Abrégé de la vie des peintres*, Paris, 1699, 2nd Edn., 1715

Planche: Gustave Planche, 'Les paysages et les paysagistes. Jacob van Ruisdael, Claude Lorrain, Nicolas Poussin', *Revue des deux mondes*, Paris, 2e. pér. IX, 1857, pp. 756–87

Plietzsch, 1910: Eduard Plietzsch, *Die Frankenthaler Maler*, Leipzig, 1910

Plietzsch, 1960: E. Plietzsch. *Holländishe und flämische Maler des XVII. Jahrhunderts*, Leipzig, 1960

Poot: *Gedichten van Hubert Korneliszoon Poot. Eerste deel*, Delft, 1722; *Idem, Tweede deel; Idem, Derde deel*, (from the 3rd Edn., Leiden, 1766) (Poems in Vol. III were written *c.* 1728–33)

Price: J.L. Price, *Culture and Society in the Dutch Republic During the 17th Century*, London, 1974

Rademacher, Franz, 'Jacob van Ruisdael's "Westfälische Landschaft mit Hünengrab" (Landesmuseum, Bonn)', *Pantheon. Monatsschrift für Freunde und Sammler der Kunst*, XXVI, 1940, pp. 223–24

Raupp, H.J., 'Zur Bedeutung und Symbol für die holländische Landschaftsmalerei des 17. Jahrhunderts', *Jahrbuch der Staatlichen Kunstsammlungen in Baden-Wurttemberg*, 17 1980, pp. 85–110

Regin: Deric Regin, *Traders, Artists, Burghers: A cultural history of Amsterdam in the 17th Century*, Assen–Amsterdam 1976

Renaud, J.G.N., 'De iconografie van het slot te Egmond', *Maandblad voor beeldende Kunsten*, XVII, 1940, pp. 338–45

Regteren Altena, J.Q. van, *Dutch Master Drawings of the Seventeenth Century*, New York–London, 1949

Regteren Altena, J.Q. van, 'J van Mosscher', *Oud-Holland*, XLIII, 1926, p. 18ff.

Reynolds: Sir Joshua Reynolds, *Literary Works. To which is prefixed a memoir of the author by Henry Wm. Beechey*, 2 Vols., London, 1835

Rich: D.C. Rich, 'Two Great Romantic Landscapes', *Bulletin of the Art Institute of Chicago*, XLIII, 1948, pp. 20–22

Richardson: E.P. Richardson, '"The dunes", by Jacob van Ruisdael'; '"A canal scene" by Jacob van Ruisdael'; and '"Landscape with a watermill" by Jacob van Ruisdael', *Bulletin of the Detroit Institute of Arts*, XVI, 1936/37, pp. 9–13; XXI, 1941/42, pp. 22–23; and XXIX, 1949–50, pp. 82–85, and *The Art Quarterly*, XIII, 1950, pp. 172–176

Roggeveen, 1948: L.J. Roggeveen, 'Een gezicht op het Damrak van Jacob van Ruisdael', *Phoenix*, III, 1948, pp. 91–94

Rosenau: H. Rosenau, 'The Dates of Jacob van Ruisdael's "Jewish Cemeteries" ', *Oud-Holland*, LXXIII, 1958, pp. 241–42

Rosenberg, 1926: J. Rosenberg, ' "The Jewish Cemetery" by Jacob van Ruisdael', *Art in America*, XIV, 1926, pp. 37–44

Rosenberg, 1927: J. Rosenberg, 'Hobbema', *Jahrbuch der preussischen kunstsammlungen*, XLVIII, 1927, p. 139ff.

Rosenberg, 1928: Jacob Rosenberg, *Jacob van Ruisdael*, Berlin, 1928

Rosenberg, J., 'Review, Wijnman "Het Leven der Ruysdaels' , *Zeitschrift für Kunstgeschichte*, II, 1933, pp. 237–38

Rosenberg, 1952/53: Jacob Rosenberg, 'A Waterfall by Jacob van Ruisdael', *Fogg Art Museum, Harvard University, Annual Report*, 1952–53, p. 11

Rosenberg, 1958: Jacob Rosenberg, 'A Seascape by Jacob van Ruisdael', *Bulletin of the Museum of Fine Arts, Boston*, LVI, 1958, pp. 144–46

Rosenberg, Jacob, 'A seascape by Jacob van Ruisdael', *The Connoisseur*, 141, 1958, p. 124; *Art News*, 57, 1958/9 No. 10, p. 58

Ros./Slive, 1972: J. Rosenberg, S. Slive and E.H. ter Kuile, *Dutch Art and Architecture: 1600 to 1800* (Pelican History of Art) Harmondsworth, 1966, revised edn. 1972

Rotterdam–Paris, 1974–75: Exh., Rotterdam, Boymans-van Beuningen Museum, & Paris, Institut Néerlandais, *Willem Buytewech*, 1974–1975

Rowlands, John, *Hercules Segers*, London, 1979

Ruskin, 1888: John Ruskin, *Modern Painters*, 5 Vols., Orpington, 1888 (1st Edn., London, 1843)

Saisselin: R.G. Saisselin, 'Art is an Imitation of Nature', *The Bulletin of the Cleveland Museum of Art*, LII, 1965 pp. 34–44

Schama, Simon, *The Embarrassment of Riches: An Interpretation of Dutch Culture in the Golden Age*, New York, 1987

Scheltema: A. Scheltema, *Aemstel's Oudheid . . .*, Amsterdam, IV, 1861; VI, 1872

Scheyer, 1977: Ernst Scheyer, 'The Iconography of Jacob van Ruisdael's "Cemetery" ', *Bulletin of the Detroit Institute of Arts*, 55, No. 3, 1977, pp. 133–46

Schrevelius, 1647: Theodorus Schrevelius, *Urbus Harlemensis . . .*, Haarlem, 1647

Schulz: See Exh. Berlin–Dahlem, 1974

Simon, 1930: Kurt Erich Simon, *Jacob van Ruisdael, eine Darstellung seiner Entwicklung* (diss., Berlin, 1927), Berlin, 1930

Simon, 1935: 'Isaack van Ruisdael', *Burl. M.*, LXVII, 1935, pp. 7–23; commented on by A. Bredius, *Idem*, p. 178; answered by Simon, *Idem*, pp. 279–80; see also John Hewitt, *Burl. M.*, LXVIII, 1936, p. 103, and in *Die Weltkunst*, X, 1936 No. 39/40, p. 2

Simon, 1935a: K.E. Simon, 'Wann hat Ruisdael die Bilder des Juden friedhofs gemalt?', *Festschrift für Adolph Goldschmidt*, Berlin, 1935, pp. 158–63

Simon, 1935b: K.E. Simon, ' "Doctor" Jacob van Ruisdael', *Burl. M.*, LXVII, 1935, pp. 132–35

Simon, K.E., 'Ruisdael aanschouwt Amsterdam', *Historia*, V, 1939, p. 23–25

Simpson: Frank Simpson, 'Dutch paintings in England before 1760', *Burl. M.*, XCV, 1953, pp. 39–42

Slive, 1962: S. Slive, 'Realism & Symbolism in seventeenth century Dutch Painting', *Daedalus*, 1962, pp. 469–500

Slive, 1973: S. Slive, 'Notes on three drawings by Jacob van Ruisdael', *Album Amicorum J.G. van Gelder*, The Hague, 1973, pp. 274–77

Slive, 1981: See The Hague–Cambridge, 1981–82

Slive, 1987: Seymour Slive, 'Dutch pictures in the collection of Cardinal Silvio Valenti Gonzaga (1690–1756)', *Simiolus*, 17, 1987, pp. 169–90

Slive, 1988: Seymour Slive, 'The Manor Kostverloren: Vicissitudes of a Seventeenth-Century Dutch Landscape Motif', in *The Age of Rembrandt: Studies in Seventeenth-Century Dutch Painting*, Ed. by Roland E. Fleischer and Susan Scott Munshower, (papers in Art History from The Pennsylvania State University, Vol. III), 1988, pp. 132–68

Sluijter-Seijffert, 1984: Nicolette Sluijter-Seijffert, 'Cornelis van Poelenburch, *ca.* 1593–1667', Leiden (diss.), 1984

Sluiter, Wilhelm, *Psalmen, Lofzangen ende geestelycke Liedekens*, Amsterdam, 1717 (1st Edn., 1661)

Sluyter, Willem, *Buyten-Eensaem Huys-Somer-en Winter-leven*, 6th Edn., Amsterdam, 1716 (1st Edn., 1668)

Smith: Alan G.R. Smith, *Science and Society in the Sixteenth and Seventeenth Centuries*, London, 1972

Smith, E: Elizabeth Smith, 'An Early Landscape by Ruisdael', *Bulletin of the Currier Gallery of Art*, Dec. 1950; *The Art Quarterly*, XIV, 1951, p. 359f.; *The Connoisseur*, 128, 1951, p. 218

Smith, VI (1835): see John Smith, *A Catalogue Raisonné . . .* 1829–42

Smith, John, *A Catalogue Raisonné of the Works of the Most Eminent Dutch, Flemish & French Painters*, 9 Vols., London, 1829–42 (Vol. VI, 1835, on Jacob van Ruisdael)

Snoep-Reitsma, 1967–68: Ella Snoep-Rietsma, 'Een Beperkt Uitzicht op het Hollandse Landschap: Wolfgang Stechow, *Dutch Landscape Painting of the Seventeenth Century*', *Simiolus*, II (1967–68), pp. 100–3

Spiegel: H.L. Spiegel, *Hertspieghel en andere zedeschriften*, Amsterdam, 1723 (1st Edn., 1614)

Stampfle: Felice Stampfle, 'An Early Drawing by Jacob van Ruisdael', *The Art Quarterly* XXII, 1959, pp. 160–63

Stechow, 1959: W. Stechow, 'The Early Years of Hobbema', *The Art Quarterly*, XXII, 1959, pp. 3–18

Stechow, 1960: W. Stechow, 'The Winter Landscape in the History of Art', *Criticism*, II, No. 2, 1960, pp. 175–89

Stechow, 1966: W. Stechow, *Dutch Landscape Painting of the Seventeenth Century*, London, 1966

Stechow, 1968: Wolfgang Stechow, 'Ruisdael in the Cleveland Museum', *Bulletin of the Cleveland Museum of Arts*, LV 1968, pp. 250–61

Stechow, 1975: Wolfgang Stechow, *Salomon van Ruysdael, eine Einfuhrung in seine Kunst*, rev. 2nd Edn., Berlin, 1975 (1st Edn., 1938)

Stone-Ferrier, Linda, 'Views of Haarlem: A Reconsideration of Ruisdael and Rembrandt', *The Art Bulletin*, LXVII, 1985, pp. 417–36

Stubbe: W. Stubbe, *Hundert Meisterzeichnungen aus der Hamburger Kunsthalle 1500–1800*, Hamburg, 1967

Sutton, D., 1982: Denys Sutton, 'Jacob van Ruisdael-Solitary Wanderer', *Apollo*, 115, 1982, pp. 182–85

Sutton, P., 1982: P. Sutton, 'Ruisdael Retrospective', *Art Journal* 42, 1982, pp. 147–51

Sutton, 1987: See Exh., Amsterdam-Boston-Philadelphia, 1987–88

Taverne, E., 'Salomon de Bray and the re-organisation of the Haarlem Guild of St. Luke in 1631', *Simiolus*, VI, 1972/1973, pp. 50–69

Ten Doesschate Chu: Petra ten Doesschate Chu, *French Realism and the Dutch Masters: The Influence of Dutch Seventeenth Century Painting on the Development of French Painting between 1830 and 1870*, Utrecht, 1974

Thieme, U., and Becker, F., *Allgemeines Lexikon der bildenden Künste*, 37 Vols., Leipzig, 1907–1950

Thoré-Bürger, 1860: see Thoré-Bürger, 1858–60

Thoré-Bürger, 1858–60: W. Bürger, *Musées de la Hollande*, 2 Vols., Paris, 1858–1860

Thoré-Bürger, 1865 (1st Edn. 1860): W. Bürger, *Trésors d'Art en Angleterre*, Paris, 1865 (1st Edn., Brussels & Ostende, 1860)

Thoré-Bürger, W., 'Études sur la galerie Suermondt', *Gazette des Beaux-Arts*, 1869, p. 179 ff.

Utrecht, 1965 (Edn., 1978): Exh., Utrecht, Centraal Museum, *Nederlandse 17ᵉ eeuwse Italianiserende landschapschilders*, 1965 (revised and enlarged, Soest, 1978)

Valentiner, 1926: W.R. Valentiner, '"The Cemetery" by Jacob van Ruisdael', *Bulletin of the Detroit Institute of Arts*, VII, 1926, pp. 55–58

Veen, P.A.F. van, 'De Soeticheydt des Buyten-Levens, Vegheselschapt met de Boucken' (diss.), Leiden, 1960

Vergara: Lisa P. Vergara, *Rubens and the Poetics of Landscape*, New Haven and London, 1982

Vollenhove, Johannes, *Poëzy*, Amsterdam, 1686

Vondel, W.B.: *De Werken van Vondel*, Wereldbibliotheek

Waagen, 1838: Gustave Friedrich von Waagen, *Works of Art and Artists in England*, trans. by H.E. Lloyd, 3 Vols., London, 1838

Waagen, Gustave Friedrich von, *Treasures of Art in Great Britain*, 4 Vols., London, 1854–57

Waagen, 1860: G.F. von Waagen, *Handbook of Painting. The German, Flemish, and Dutch Schools*, 2 Vols., London 1860

Walford, E.J., 'Jacob van Ruisdael and the Perception of Landscape', Cambridge (diss.), 1981

Walpole: Horace Walpole, Earl of Orford, *Anecdotes of Painting*, 3 Vols., 1762–63, 4th Vol., 1771; 3rd Edn., 4 Vols., London 1782

Walsh, John, Jr, 'Jan and Julius Porcellis: Dutch Marine Paintings', Columbia University, New York (diss.), 1971

Waterhouse, Ellis K., 'British Collections and Dutch Art', *Museums Journal*, 56, 1956, pp. 137–45

White, Christopher, *Rembrandt as an Etcher: A study of the artist at work*, 2 Vols., University Park and London, 1969

Wiegand: W. Wiegand, 'Ruisdael-Studien. Ein Versuch zur Ikonologie der Landschaftsmalerei', Hamburg (diss.), 1971

Wijnman: H.F. Wijnman, 'Het leven der Ruysdaels', *Oud-Holland*, XLIX, 1932, pp. 49–60; pp. 173–81; pp. 258–75

Willigen, Van der, 1870: A. van der Willigen, *Les Artists de Harlem*, Édition revue et augmentée, Haarlem and The Hague, 1870 (1st Dutch Edn., 1866)

Woodall, 1935: Mary Woodall, 'A Note on Gainsborough & Ruisdael', *Burl. M.*, LXVI, 1935, pp. 40–45

Woodall, Mary, *Thomas Gainsborough: His Life and Works* (British Painters Series), London, 1949

Woodall, 1961: M. Woodall, *The Letters of Thomas Gainsborough* London, 1961, & Greenwich, Conn., 1963

Wurzbach, A. Von, 'Der Meister Izack van Ruisdael', *Zeitschrift für bildende Kunst* XII, 1877, p. 381

Zwarts: J. Zwarts., 'Het Motief van Jacob van Ruisdael "Jodenkerkhof"', *Oudheidkundig Jaarboek*, VIII, 1928, pp. 232–49

Index